GERMAN MASTERS
OF THE
NINETEENTH CENTURY

Paintings and Drawings from the Federal Republic of Germany

GERMAN MASTERS

Paintings and Drawings from

THE METROPOLITAN
New

Distributed by

OF THE NINETEENTH CENTURY

the Federal Republic of Germany

MUSEUM OF ART
York

Harry N. Abrams, Inc., Publishers, New York

This book was published in connection with an exhibition
at The Metropolitan Museum of Art, New York,
from May 2–July 5, 1981,
and at the Art Gallery of Ontario, Canada,
from August 1–October 11, 1981

The exhibition and the catalogue have been generously supported
by Miles Laboratories Inc., Elkhart/Indiana, Bayer Aktiengesellschaft,
Leverkusen/West Germany, and Lufthansa German Airlines, New York/N.Y.

Cover: Caspar David Friedrich, *The Sea of Ice (The Failed
North Pole Expedition; The Wrecked "Hope"),* 1823–24 (no. 34)

Published by The Metropolitan Museum of Art, New York
Bradford D. Kelleher, Publisher
John P. O'Neill, Editor in Chief
Emily Walter, Editor
Gerald Pryor, Designer

Distributed in the United States by The Metropolitan Museum of Art
and Harry N. Abrams, Inc., New York

Printed and bound in West Germany
Catalogue printed by
Albert Hentrich, Berlin
Color separations by
Meisenbach Riffarth & Co, Berlin

Contents

Note: *Paintings in the catalogue are cited as no. 1–no. 96, drawings as d1–d54.*

Foreword

The exhibition *German Masters of the Nineteenth Century: Paintings and Drawings from the Federal Republic of Germany* will come as a revelation to most of those who view it because few German paintings from this period are in American museums. Their neglect here is due to the almost total concentration by American collectors on artists of the French school and should not be taken as an indication that German nineteenth-century painting lacks the luster or significance of other national schools in Europe or America. Indeed, one has only to view any collection of nineteenth-century American landscape and genre painting to realize the profound influence that German painting has had on artists of the United States.

The exhibition thus serves as a splendid introduction to a highly important period in art and complements not only the Museum's strong holdings in American painting but also its focus on European art, one that is almost exclusively French. In view of the richness, complexity, and scope of German painting in the nineteenth century, it was important, when planning this exhibition, to avoid the confusion that would inevitably arise from any attempt to present a comprehensive survey of the century's many artistic currents and crosscurrents. We have therefore limited the selection to works by relatively few artists, all of whom are major figures. (Regrettably, there is no painting by Karl Friedrich Schinkel, but all possible loans had been preempted by an important exhibition in Germany celebrating the two-hundredth anniversary of his birth.) Included are several key works by each artist that reveal the special achievement and character of nineteenth-century German painting and drawing. The works in the exhibition represent the five most important artistic movements of the period and suggest both the diversity and continuum of the German artistic tradition in the nineteenth century. Romanticism, the Nazarenes, Idealism, Realism, and Impressionism are all fully represented.

We are deeply indebted to Dr. Stephan Waetzoldt, General Director, Staatliche Museen Preussischer Kulturbesitz, Berlin, for his central role in the genesis and organization of the exhibition. Furthermore, we are especially grateful to the Staatliche Museen Preussischer Kulturbesitz for their contributions to the exhibition; the Nationalgalerie alone has lent twenty-eight paintings and several drawings. Charles S. Moffett, Associate Curator of European Paintings, The Metropolitan Museum of Art, deserves special credit for his skillful coordination of the exhibition in New York and for his invaluable contributions to the text of the catalogue. It should be recorded that many of the works might not have traveled to this country without the indemnification supplied by the Arts and Artifacts Indemnity Act.

We are extremely grateful to the Federal Republic of Germany for making this exhibition possible, and we hope that it will signal further cooperative ventures between the German government and The Metropolitan Museum of Art. Indeed, future exchanges are already in the planning stages: Islamic art from the Metropolitan Museum will be shown next spring in the Museum für Islamische Kunst, Berlin-Dahlem, and Central Asian art from Berlin will be shown in 1982 at the Metropolitan.

Philippe de Montebello
Director

Acknowledgments

Many individuals have made significant contributions to the creation of the exhibition and this catalogue, and all of them deserve the Museum's special thanks. Dr. Stephan Waetzoldt not only selected and planned the exhibition but also wrote an important essay for the catalogue. Professor Gert Schiff worked selflessly and generously on behalf of the exhibition and wrote the informative essay on German nineteenth-century artists and their works that forms an integral part of this volume. We are deeply indebted to Dr. Waetzoldt's staff, particularly to Dr. Verena Haas for her efforts in connection with the entries and biographies, and to Dr. Janni Müller-Hauck for coordinating all phases of planning in West Germany. For the Metropolitan Museum, Philippe de Montebello, Director, James Pilgrim, Deputy Director, Sir John Pope-Hennessy, Consultative Chairman, Department of European Paintings, and Peter Nisbet, a research assistant, should be thanked for their help during the formative stages of the exhibition. I would also like to thank Chief Curator Roald Nasgaard for his role in the planning and coordinating of the exhibition for the Art Gallery of Ontario.

For their assistance with the catalogue entries, I am extremely grateful to Elizabeth Streicher, Alison de Lima Greene, Denise McColgan, Stephan Waetzoldt, Janni Müller-Hauck, Alan Salz, Peter Nisbet, and Lucius Grisebach. In addition, Alison de Lima Greene carefully researched the artists' biographies, and Denise McColgan compiled the extensive bibliography.

Members of the Museum's publications staff played indispensable and varied roles: Bradford D. Kelleher, Publisher, and John P. O'Neill, Editor in Chief, rendered astute advice throughout the project. Emily Walter's unstinting and sagacious editorial skills greatly benefited the text, and the catalogue could not have done without the assistance of Joan Ohrstrom, who edited the bibliography and references. Joan Holt patiently oversaw the production of the catalogue, and Gerald Pryor provided the excellent design. Christopher With translated the German texts, and Ilse Daniel provided additional assistance as a translator. Karl-Ulrich Majer served as coordinator for printing and publishing the catalogue in West Germany. Finally, I should like to express the Museum's deepest thanks to the dozens of people in Berlin and New York without whose help this project could not have been completed.

Charles S. Moffett
Associate Curator
Department of European Paintings

Lenders to the Exhibition

Berlin, Kunstbibliothek, Staatliche Museen Preussischer
 Kulturbesitz
Berlin, Kupferstichkabinett, Staatliche Museen Preussischer
 Kulturbesitz
Berlin, Nationalgalerie, Staatliche Museen Preussischer Kulturbesitz
Berlin, Staatliche Schlösser und Gärten,
 Schloss Charlottenburg
Bremen, Kunsthalle Bremen
Coburg, Kunstsammlungen der Veste Coburg
Cologne, Wallraf-Richartz-Museum
Darmstadt, Hessisches Landesmuseum
Dortmund, Museum für Kunst und Kulturgeschichte der Stadt
 Dortmund, Schloss Cappenberg
Düsseldorf, Kunstmuseum
Essen, Museum Folkwang
Frankfurt am Main, Freies Deutsches Hochstift, Frankfurter
 Goethemuseum
Frankfurt am Main, Städelsches Kunstinstitut und Städtische Galerie
Hamburg, Hamburger Kunsthalle
Hamburg, Museum für Kunst und Gewerbe
Hannover, Niedersächsisches Landesmuseum
Heidelberg, Kurpfälzisches Museum
Kaiserslautern, Pfalzgalerie des Bezirksverbandes
Karlsruhe, Staatliche Kunsthalle
Kiel, Gemäldegalerie der Stiftung Pommern
Koblenz, Schlossverwaltung Stolzenfels
Lübeck, Museen für Kunst und Kulturgeschichte
Mainz, Mittelrheinisches Landesmuseum Mainz
Mannheim, Städtische Kunsthalle Mannheim
Munich, Schack-Galerie, Bayerische Staatsgemäldesammlungen
Munich, Staatliche Graphische Sammlung
Munich, Städtische Galerie im Lenbachhaus
Münster, Westfälisches Landesmuseum für Kunst und
 Kulturgeschichte
Neuss, Quirinus-Gymnasium
New York, The Metropolitan Museum of Art
Nürnberg, Germanisches Nationalmuseum
Saarbrücken, Saarland-Museum
Stuttgart, Staatsgalerie Stuttgart
Wiesbaden, Museum Wiesbaden
Wuppertal, Von der Heydt-Museum

An Epoch of Longing:

An Introduction to German Painting of the Nineteenth Century

Gert Schiff

A discussion of German painting in the nineteenth century, as any discussion of modern German history, must take into account that Germany at this time was a nation without a state, divided into autonomous territorial entities—divided, even more fatefully, into the Catholic southwest and the Protestant northeast. In the year 1789 the languishing Holy Roman Empire of the German Nation comprised exactly 1,789 such entities.[1] They ranged from important monarchies, such as Austria and Prussia, or secular and ecclesiastical electorates to small principalities, from imperial cities to tiny, yet autonomous market towns. This was an unhealthy situation. Yet it favored in some measure the spread of culture, for several of the more eminent courts were centers of art and learning. Academies of art had already been established in Nürnberg, Berlin, Dresden, and Vienna during the Baroque age; Bayreuth, Mannheim, Mainz, Stuttgart, Frankfurt, Gotha, and Prague established theirs during the spread of Neoclassicism.[2] Yet these regional centers could not compensate for the absence of a vital and binding tradition in the arts as had existed in France since the founding of the French Academy in 1648. Henceforth, French art remained state-oriented, thereby creating a collective style that continued to develop even during the disruptions of the French Revolution and the reign of Napoleon. When, as a result of the Napoleonic invasion, a wave of national feeling swept over Germany, the art that emerged was in its Protestant manifestations introspective and in its Catholic expression retrospective.

In April 1792 France declared war on Austria. Prussia and Austria at first joined forces, but in 1795 Prussia withdrew from the coalition in the Peace of Basel, leaving the left bank of the Rhine to France against a guarantee that North Germany remain uninvaded. This peace lasted a year beyond Napoleon's victory over Austria at Austerlitz and a few months beyond the foundation of the *Rheinbund,* or Confederation of the Rhine, and the ensuing dissolution of the Holy Roman Empire (1806). Through this confederation Napoleon laid down the boundaries of the South German states much as they exist today. These states became French vassals without great qualms, for Napoleon left them considerable civic and cultural freedom. In Prussia and the north the eleven years of neutrality brought about an unparalleled cultural blossoming.

The center was Weimar. Goethe, Schiller, Herder, Wieland, and Jean Paul were among the writers who gathered there. But of greater importance for painting was the nearby university town of Jena where, about 1800, a group of young men in their twenties initiated the widespread and influential movement known as German Romanticism. This group included the philosophers Schelling, Steffens, and Fichte; the brothers Schlegel, philologists, critics, and poets; the poet and playwright Ludwig Tieck; and, more inspired but also more fragile than the others, Friedrich von Hardenberg, called Novalis. The group had no manifesto, and its aims were varied, hence hard to define. Within a few years their political orientation changed from republicanism to monarchism, from cosmopolitanism to patriotism. One

might come closest to a definition of their aspirations by stating that "longing" *(sehnen)* was the first and almost the last word of German Romanticism. According to Fichte this "longing," a "hankering after something completely unknown," was at the root of both man's thirst for knowledge and his need for a binding moral law. It engendered all the aspirations of the Romantics: their desire to transcend the boundaries of the ego and of the known world; their interest in the occult in nature and in the soul; their search for a national identity, and the ensuing search for the mythic origins of the Germanic nation; finally, their wish to escape the harsh realities of the present through immersion in an idealized past. They felt most deeply the historical exhaustion and vitiation of conventional Christianity. As a consequence Friedrich Schlegel called with impassioned rhetoric for the creation of a new mythology which the Romantics then tried to derive from a philosophy of nature, such as that outlined by Schelling. He taught that one generative spirit permeated the whole of creation, a doctrine that paved the way for the poetic spiritualization of nature in the work of Philipp Otto Runge. Another impulse came from the Berlin Protestant minister Friedrich Ernst Daniel Schleiermacher, who equated religion with the recognition of the infinite, both in nature and in the human soul. Hence religion was considered neither metaphysics nor morality, but—and here one cannot help thinking of Caspar David Friedrich—contemplation of the universe.[3] Consequently, Friedrich Schlegel proclaimed a little later: "Only he can be an artist who has a religion of his own, an original view of the infinite."[4]

The search of the Romantics for new spiritual nourishment was given yet another direction when Ludwig Tieck introduced them to ideas and discoveries that his short-lived friend Wilhelm Heinrich Wackenroder had set down in a curious little book called *Effusions of an Art-Loving Monk (Herzensergiessungen eines kunstliebenden Klosterbruders,* 1797). Wackenroder, a Protestant, had a revelation while visiting the Catholic cathedral of Bamberg. Both its architecture and its function as the center of a colorful cult and a joyous religious community convinced him of the still-unbroken vitality of the Christian tradition, which he believed was capable of restoring art to its lost splendor. An emulation of the pious masters of the Middle Ages and, above all, a reestablishment of the union of art and religion should accomplish this end. This was Wackenroder's doctrine; in actual fact, he knew very little medieval art, and what he knew—the Gothic buildings of Nürnberg—he did not approve of. Wackenroder's essays are permeated by a strange paradox: he writes about the artists of the Early and High Renaissance, about Piero di Cosimo, Francesco Francia, as well as Leonardo, Raphael, and Dürer, as though they were medieval masters, totally disregarding their classicism, stressing only the Christian character of their art.[5] Ignorant of Dürer's learned humanism, Wackenroder presents him as a simple and untrained craftsman, inspired only by his piety and his honest mind. This wish-image was quickly adopted by the Romantics; witness Schlegel's

aphorism: "The German artist has no character, or he has the character of an Albrecht Dürer, Kepler, Hans Sachs, of a Luther or Jakob Böhme. Righteous, ingenuous, thorough, precise, and profound is this character, thereby innocent and a little clumsy."[6] The importance of Wackenroder's instantly popular book for the art of the next few decades was enormous. Tieck edited another manuscript by his dead friend, *Phantasies on Art (Phantasien über die Kunst,* 1799), and wrote his own novel, *Franz Sternbald's Travels (Franz Sternbalds Wanderungen,* 1798), about a pupil of Dürer's who travels to Italy in pursuit of religious art and romantic love. With these three books a new creed was born. That its emphasis on religious art and medieval, pre-Reformation Christianity should bring its Protestant spokesmen close to Catholicism was only natural. Novalis took the lead when, in the hymnic prose of his *Christendom or Europe (Die Christenheit oder Europa,* 1799, published 1826), he created a transfigured image of the Christian Middle Ages; the essay ends with a vision of "the holy time of eternal peace, when the New Jerusalem will be the capital of the world,"[7] thus anticipating the ultimate political aims of the Catholic restoration after 1815. But the paradox of Wackenroder's views of art pervaded Tieck's views as well and, as will be shown, the painting inspired by both.

The ideas of the Romantics gained wide acceptance among the German artists—much to the dismay of Goethe who, in his periodical *Propyläen* (1798–1800) and through annual competitions for artists (1799–1805), tried, unsuccessfully, to stem the rising tide of Romanticism and to uphold the standards of Neoclassicism. It was not only in aesthetics that Germany's leading poet was at variance with the young. As chief minister of state of the duchy of Weimar, he maintained an enlightened, humane absolutism. He admired Napoleon and believed for a long time in the validity of his reorganization of Europe. Until the Russian campaign he thought him invincible. Goethe did not believe in the unification of Germany.

Events seemed to prove him right. In 1806 Prussia's war against France ended in total defeat. Prussia lost half its territory, and most of North Germany was first occupied, then annexed by France. Austria hardly fared better with her brief uprising in 1809. Napoleon, married in 1810 to Marie Louise, daughter of the Austrian emperor Francis I, had reached the zenith of his power; the harshness of his regime, however, served to mobilize intellectual forces that paved the way for the liberation. Prussia had for a short time a liberal premier, Baron vom Stein, who desired national unity. Scharnhorst, Gneisenau, and Clausewitz worked toward the modernization of the Prussian army. The Romantics, originally apolitical, became patriots. However, if their artistic interest in the German past had prepared them for a stronger national identification, their idealized conception of the Catholic Middle Ages led them in the direction of political conservatism. One circle in Berlin included the poets Achim von Arnim and Heinrich von Kleist and the economist Adam Müller, all three enemies not only of French oppression but

also, in the sense of Edmund Burke, of the principles of the Revolution. They wanted Prussia to remain an agrarian state, and they opposed modern industry, cosmopolitanism, and international commerce. A convert to Catholicism, Friedrich Schlegel developed his philosophy of the state along the lines laid down by Novalis: a universal theocracy after the model of the Holy Roman Empire. That meant, in practice, the maintenance of a feudal system based on domination by the aristocracy and denial of political rights to the middle and lower classes. It was under these auspices that Schlegel contributed to the resistance against Napoleon when, in 1809, he took part in the Austrian insurrection as speech writer to the Archduke Karl, and his house in Vienna became the meeting place for patriotic intellectuals, among them the painter Joseph Anton Koch. The philosopher Johann Gottlieb Fichte meanwhile made himself spokesman for the German resistance. His *Speeches to the German Nation (Reden an die deutsche Nation),* delivered in Berlin during the winter of 1807–8, filled his listeners with pride and determination; yet their insistence upon German supremacy sowed the seeds of the nationalistic hubris that burgeoned at the end of the century. Napoleon's defeat in Russia gave the long-awaited signal for the War of Liberation. When he was finally exiled to St. Helena, a program for the reconstruction of Germany had already been established at the Congress of Vienna.

This was largely the work of Austria's skilled chancellor, Metternich. The Holy Roman Empire was not revived. Germany became a confederation consisting of thirty-five monarchies and four city republics. In actual fact it consisted of Prussia and Austria with the smaller states between them. Prussia extended its territory across the country through the acquisition of parts of the Rhine Province and Saxony; this laid the foundation for its later hegemony. The great philosopher Georg Wilhelm Friedrich Hegel hailed the disciplined Prussian state as the logical fulfillment of history. The Catholic conservatives hoped the multinational Austrian Empire would realize their ideal of a universal, clerical state. None of the democratic ideas of the French Revolution had taken root in Germany. A long period of restoration and reaction had begun.

* * *

This is the background against which the development of German Romantic painting must be seen. If one distinguishes, with Herbert von Einem,[8] a Protestant and a Catholic line, one finds that those painters—most notably Runge and Friedrich— who, in the sense of the young Friedrich Schlegel, endeavored to create a "new mythology" were Protestants. Lutheran Protestantism has always favored in its adherents the emergence of a personal, secular piety, both by its insistence upon the individual conscience as sole intercessor between the individual and God, and because of its organization as a compulsory state church. This organization deprived its members of their shared responsibility in church affairs, and diverted their religious impulses from the life of the congregation to a cult of the inward self.[9]

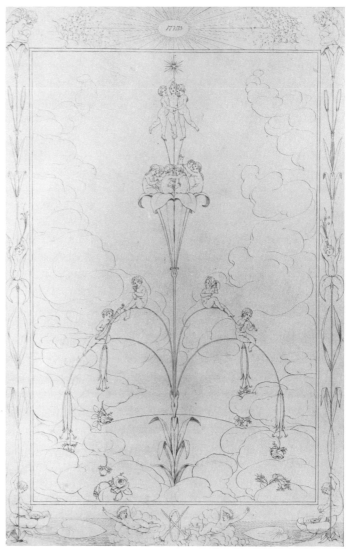

1. Philipp Otto Runge. *Morning* (from *Four Times of Day*), 1803. Pen and ink on paper, 71.5 x 48 cm (28 x 19″). Hamburger Kunsthalle, Hamburg

Such was the case of Philipp Otto Runge (1777–1810). His work, though it remained fragmentary, expresses his spiritual beliefs with a rare clarity. The training he received in Copenhagen taught him craftsmanship and provided a rational foundation for his art. Originally a believer in Goethe's classical ideal, Runge worked hard to win an award in one of his competitions, which were organized by the Weimarer Kunstfreunde; when his depiction of *Achilles's Fight with Skamandros* failed to convince the judges in Weimar, however, he broke with Neoclassicism. He decided instead to rely exclusively upon his own inner voice. Ancient Greek and conventional Christian subjects had lost for him their force as inspiration; for Runge, therefore, "everything tended toward landscape." Runge's belief in nature as the self-revelation of the Creator, as a hieroglyphic script through which his intentions could be intuitively grasped, was

confirmed by his reading of Novalis and of Ludwig Tieck, who became his friend. However, this same belief engendered the strange paradox of Runge's art, namely, that he never painted pure landscapes but only allegorical ones. In them flowers, trees, water, and air are inhabited by genii which appear primarily in the form of children, personifications of the forces of nature, or of the artist's awed response to them. This concept of landscape (which may have been influenced by Hindu mythology, then a principal interest of the Romantics)[10] found its first expression in *Four Times of Day* (1803). Runge's symbolic representations of Morning, Day, Evening, and Night are in a linear style that owes as much to John Flaxman's outline drawings as to Dürer's marginal designs for the prayer book of Emperor Maximilian I and to Raphael's *grottesche* in the Logge of the Vatican. In their freshness and beauty they rank among the finest nineteenth-century drawings. Each composition is rigidly symmetrical and, in the silhouetted plants and flowers as well as in the music-playing, slumbering, embracing, and rejoicing children, of the utmost graphic precision. A wealth of allegorical meaning went into their elaboration, for Runge linked the *Four Times of Day* with the seasons, the ages of man, the four temperaments; with nascency and growth, decline and fall of nations; and with the religious fate of mankind, Creation, the Fall, Redemption, and the return of the soul to its Maker. The central incident is always expressed through phases from the life of nature or from the life of man, while the corresponding Christian symbols appear in the framing borders. Of the four, *Morning* (fig. 1) is most densely wrought with meaning, for it hints at both the cyclical renewal of the universe and the ascent of the soul into heaven. Runge imagined that designs such as these eventually would be transferred to the walls of private or public interiors; he dreamed of an academy where, under his direction, hosts of unemployed artists would find work carrying out his ideas. His newly found formula would create a collective style, his metaphysics of nature would provide the icons of a new religion. He had, for example, always envisioned *Four Times of Day* as monumental murals on the walls of a neo-Gothic temple, where they would be contemplated to the accompaniment of choral hymns.[11]

Runge's art from this time on was an attempt to represent the unity of Nature, God, and Man. When in 1804 he was commissioned to illustrate the Ossianic poems, he transformed them into an allegory that was simultaneously pantheistic and Christian. By visual analogy he linked the birth of Fingal to the sunrise and, by implication, to the birth of Christ. The grown-up Fingal is similarly characterized as a solar hero, the rays of the sun emanating from his circular shield. The battle scenes are linked to growth and decay in nature. An illustration of 1809, *The Condition of the Fatherland,* depicts a woman tilling the soil under which her hero-husband lies buried; passion flowers wind around the dead man's wrists and ankles and climb the shafts of flanking lances, thus connecting the renewal of the fatherland with the renewal of the earth and with man's salvation

through Christ.[12] Runge's profound study of the theory of color, about which he corresponded at length with Goethe, also combined scientific observation with mystical speculation; in a letter to his mother dated November 7, 1802, he wrote, "Light is the sun which we cannot look upon, but when it bends down to the earth, or to man, the sky becomes red. Blue keeps us in a certain awe, that is the Father, and red is properly the Mediator between earth and Heaven; when both disappear, then fire comes in the night; that is yellow and the Comforter who is sent to us—the moon also is only yellow."[13]

Yet these esoteric preoccupations did not prevent Runge from becoming one of the most penetrating portraitists of his time. His self-portraits constitute a moving record of his growing spiritualization and of the progressive erosion of his health from tuberculosis. The portrait of his parents, 1806 (Hamburger Kunsthalle), is a monument to middle-class Protestant ethics. His portraits of children, in their total lack of sentimentality, became a model for those painted a century later by Otto Dix in the spirit of New Objectivity *(Neue Sachlichkeit).*

The painting *Wife and Son of the Artist,* 1807 (no. 72), is unfinished, but its state seems to enhance its candor and informality. Dressed in her working apron, Runge's wife, Pauline, during a brief respite from her work, carries her son, Otto Sigismund, through the garden. Household chores and the care of the child have hardened the features of the barely twenty-year-old woman. The boy seems earnest, sensitive, and quite self-willed for his two years; the thrust of his hand shows how headstrong he can be. His mother looks past him into the distance, perhaps envisioning the time when he will no longer need her.

In his *Rest on the Flight into Egypt,* 1805–6 (no. 71), which was conceived as an altarpiece for the Protestant Marienkirche in Greifswald, Runge treats the incident in terms of his own mythology of nature. It is daybreak; the rising sun illumines the valley of the Nile. Joseph extinguishes the fire which has warmed them during the night. Mary looks with amazement, almost shyly, at the Child. Runge, a Protestant, has depicted her without the aura of divinity. The blossoming tree is enlivened by angels (only two of which are completed) who play music to enchant the divine Child; one shows him a lily, symbol of heavenly love. The answering gesture of the awakening Jesus corresponds to the awakening of nature. The cosmic renewal of life thus confirms each day the promise of man's salvation through the birth of Christ.

From here it is only one step to the cosmic allegory of Runge's *Morning* (no. 73). The present exhibition shows the second version of 1808–9. It was divided into sections by one of Runge's descendants and later reassembled, with the missing parts painted in neutral gray. Runge's pictorial mastery, however, triumphs over the damage.

The correspondence between the child in the meadow and the Child in the *Rest on the Flight into Egypt* can be seen at a glance. Again the promise of man's salvation is expressed

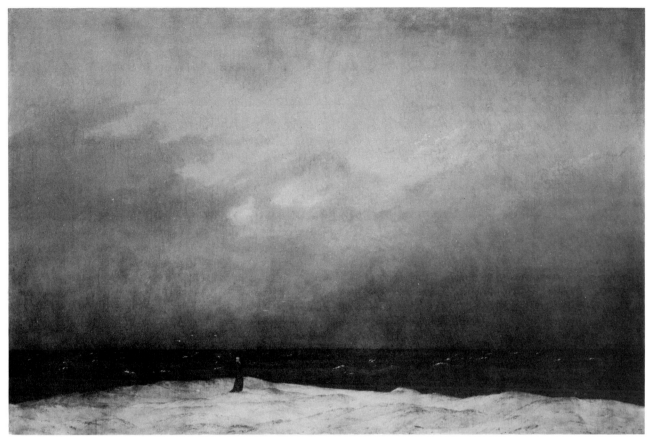

2. Caspar David Friedrich. *Monk by the Sea,* 1808–9.
Oil on canvas, 108 x 170 cm (42½ x 67").
Schloss Charlottenburg, Staatliche Schlösser und Gärten, Berlin

through the birth of the divine child, which coincides with the birth of light. The newborn looks up to Aurora, his mother, who is also the Madonna and Venus, as the giver of life. The eschatological symbolism has its roots in the writing of the German mystic Jakob Böhme (1575–1624), who maintained that each daybreak symbolically heralds the Last Day, and that the lily in its growth toward the light symbolizes the soul's reunion with God. If here as elsewhere in Runge's art the various levels of meaning are not self-explanatory, the picture nevertheless speaks through the magic of color and light. The dewy meadow extends toward the tree-lined horizon. The goddess emanates from the purple- and orange-colored mists, or rather from her own flaming hair, of which she carries a strand like a torch. Behind her rises the lily of light. Genii spring forth from its offshoots and greet the young day with their music; they embrace each other in the central bloom and circle beneath the morning star. The "trinitarian" colors of the sky fade from yellow, Runge's color of night, to the reddish reflection of the sunrise, to the awe-inspiring blue of the fully awakened day. From the white of the lily, their divine matrix, the three primary colors emerge. Through the underpainting Runge attempts to give the air-filled space a feeling of roundness. He uses light both to dematerialize the aerial spirits and to corporealize the earthbound ones. In the roses, their offerings to the child, the sunlight assumes a tangible form.

Runge's premature death spared him the disappointment of realizing that his subjective spiritualization of nature would never replace, or renew, the exhausted traditions of conventional Christianity. No cult grew around his philosophy and, as an artist, he had no following. Caspar David Friedrich (1774–1840) met Runge when both artists were in their twenties, and their mutual esteem was not least founded upon the fact that for Friedrich also, albeit in a very different way, landscape was the expression of religious feeling.

Friedrich, unlike Runge, was a solitary man with no aspirations at founding a community. "No one is the measure for all," he wrote, "each person is only his own measure and sets a standard only for himself, and for more or less kindred spirits." "You must see with your own eye and faithfully reproduce how things appear to you."[14] These principles drawn to their logical conclusion would also allow the viewer to perceive Friedrich's paintings "with his own eye," to give them a subjective interpretation. For example, the tremendous *Monk by the Sea* (fig. 2) inevitably calls upon the viewer to identify himself with the Capuchin friar and thus to become, in the words of Kleist, "the only spark of life in the wide realm of death, the lonely center in the lonely circle."[15] Whether this results in a dispassionate contemplation of the universe or a harrowing realization of his own isolation depends ultimately upon the viewer. In paintings such as *Wanderer Above the Sea of Fog,* 1818 (Hamburger Kunsthalle),[16] or *Woman in the Morning Sun,* 1818–20 (Museum Folkwang, Essen),[17] center-foreground figures are seen from

13

the back; the viewer participates in their dialogue with nature, for his angle of vision is identical to theirs. What is not known, however, is why they are engaged in this solitary dialogue. It could be their love of nature, pantheistic piety, their estrangement from society or their sorrow at the oppression of Germany, their disparagement of contemporary aesthetics or their resignation to human suffering.

The Cross in the Mountains (Tetschen Altar) (fig. 3), however, presents a very specific iconography. A crucifix on a rock is surrounded by fir trees and illumined by the setting sun. On the carved frame is the Eye of God flanked by a sheaf of wheat and a vine, symbols of the Eucharist; the Gothic columns are extended by arched palm branches through which appear a glory of angels. Here, as in Runge's *Four Times of Day,* the traditional Christian iconography complements Friedrich's personal symbolism; the rock represents an enduring faith, the evergreen, eternal hope in Christ. The painting was commissioned by Count Anton von Thun-Hohenstein as an altarpiece for his private chapel. The unprecedented use of landscape as a devotional image drew an alarmed protest from the art historian Baron Ramdohr, who took the painting as an example of "that mysticism which wants to pass off symbols and fantasies for

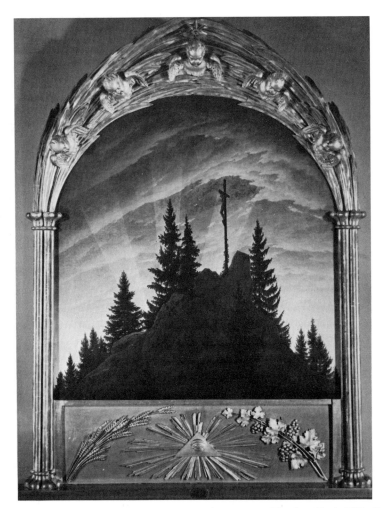

3. Caspar David Friedrich. *The Cross in the Mountains (Tetschen Altar),* 1807–8. Oil on canvas, 115 x 110 cm (45¼ x 43⅜").
Gemäldegalerie Neue Meister, Staatliche Kunstsammlungen, Dresden

pictorial and poetic images . . . which tends to confound the more vigilant and vigorous enthusiasm, so compatible with the true religion of Christ, with pining pseudo-worship of the Cross. . . ."[18] But Ramdohr was also the first to enumerate, with remarkable acumen, the most vital of Friedrich's formal innovations: his disregard for linear and aerial perspective, his unwillingness to construct a continuous space from interconnected layers, his nonnaturalistic handling of light, the absence of a unifying tonality in his use of color.[19] These violations of accepted techniques in fact determine the magic of Friedrich's landscape space, its abrupt confrontation of foreground and far distance, its hyperclarity of detail, and its emotionally wrought coloring. The mountain peak in *The Cross in the Mountains,* placed without the modifying presence of a foreground zone and silhouetted against a void, creates an aura of inaccessibility and extreme height, thereby achieving the iconic quality required by the painting's function as altar.

Morning in the Riesengebirge, 1810–11 (no. 31), can be considered a secular version of the *Tetschen Altar.* It is also an example of Friedrich's use of synthetic composition—the foreground scenery and the distant mountains are taken from different regions. The subtle gradation of tonal values results from the methodical process by which Friedrich worked. He would lay down the entire composition, first in pen and chalk, then in monochromatic underpainting, so that the tonal gradation was established before he even mixed his paints. Vast open space replaces the precipitous rise of the isolated peak in the earlier painting. Yet here, too, the cross is the focus of attention. The artist is guided to the cross by a woman as, according to Schleiermacher, the love of woman leads to God; or, as Goethe would put it twenty years later,

Das Ewig-Weibliche
Zieht uns hinan.[20]

Friedrich's depiction of the woman was criticized by a contemporary reviewer who objected to the figure "because the modern and the personal become petty amid the great simplicity of nature."[21]

Unlike other paintings by Friedrich, which call for subjective interpretation on the part of the viewer, these are paintings whose symbolic content is evident. The same holds for Friedrich's church ruins in winter landscapes and his visions of luminous Gothic cathedrals. If the former reflect the decline of the Roman church, the latter suggest the future renewal of Christianity.[22] Friedrich's patriotic pictures are no less accessible in their symbolism. Prehistoric tombs signify the mythical greatness of primeval Germany.[23] *The Tomb of Arminius,* c. 1813 (Kunsthalle Bremen),[24] commemorates the leader of the German tribe, the Cherusci, who, during the first century A.D., crushed the Roman invaders. In 1814, when Dresden was occupied by the Napoleonic forces, Friedrich painted a French chasseur cut off from his troops in a snowy forest, where a raven's song harbingers his death (Private collection, Bielefeld).[25] And *The Tomb of Ulrich von Hutten,* c. 1821 (Staatliche

14

Kunstsammlungen, Weimar),[26] while it memorializes the Renaissance freedom fighter, also protests against the reactionary forces of the restoration.[27]

The Sea of Ice, 1823–24 (no. 34), whose subject was suggested to Friedrich by William Edward Parry's expeditions to the Arctic in search of the Northwest Passage, is another painting that has been understood as political metaphor; the foundering of the ship has been interpreted as a hidden allusion to the failure in Germany to achieve a representative government and civic liberties.[28] But it seems more likely that the picture deals with the manifestation of fate in the destructive forces of nature.

This would be in keeping with Friedrich's existential pessimism. His frequent depictions of sea and mountain deserts, of night and winter desolation, of graveyards and ruins—his depictions generally of "uncomfortable" subjects—puzzled and repelled many of his contemporaries. They were to a certain extent anticipated in the aesthetic of the Sublime, in graveyard poetry, and eighteenth-century Alpine painting. But no painter before Friedrich had rendered so poignantly the silence of inaccessible spaces, the chill of empty plains, the weary resignation of dawn, and the relentless resumption of life at daybreak. No other painter's work is so consistently permeated by death. Yet the ubiquity of death must be understood in the context of Friedrich's own experience: "Why, the question is often put to me, do you choose so often as a subject for painting death, transience, and the grave? In order to live one day eternally, one must submit oneself to death many times."[29] In the same spirit he once described snow as "the essence of the highest purity, whereby Nature prepares herself for a new life."[30] Hence death leads to resurrection. It has also been emphasized that alienation is a constant in Friedrich's world and that his men and women, even in their most absorbed contemplation, remain aware of their own isolation and experience nature as the inaccessible Other. Yet in such pictures as Moonrise on the Sea, 1822 (no. 33), these elements are absent. The return of the ships coincides with the illumination of the night sky. The two young women and their shy, deferential friend are united in rapture and gratitude.

Friedrich's "refusal to make the art student's traditional pilgrimage to Rome may have been prompted by his opposition to ultramontane spiritual influence."[31] Moreover, he was devoted to his native Germany and scorned the younger landscape painters who sought inspiration in Italy—especially those under the influence of Joseph Anton Koch.[32] Although Koch lived at the same time as Friedrich, his work, as the fulfillment of the Neoclassical spirit, belongs to an earlier stage in the development of landscape painting. His Italian and Alpine views embody the Enlightenment ideal of rational harmony; his ordered landscapes, even when they are not shaped by human cultivation, reflect the ethical law that pervades the universe. Koch's landscapes are always compartmentalized; hence, despite their vastness, they do not suggest infinitude. Their masses are sculptural, their light is clear and cool; if they include allegorical trappings,

these are humanistic and historical, not religious or mystical. A comparison between Friedrich's Mountain Landscape with Rainbow, 1810 (no. 30), and Koch's Landscape After a Thunderstorm, c. 1830 (no. 39), exemplifies these distinctions. In Friedrich's painting the solitary wanderer (probably the artist himself) leans against a rock and looks out on a valley and dark mountains which extend indefinitely under the restlessly drifting clouds of the night sky. The sudden illumination of the foreground zone is inexplicable, and the rainbow appears to be an afterthought. The irrational meeting of day and night creates an unresolved tension. In Koch's landscape, on the other hand, we foresee how the hunter with his booty and the shepherd with his flock will proceed along the bay toward the settlement at the left. The rainbow is an indication of the cyclical resolution of the elements. The picture conveys peace and confidence in the beneficence of domesticated nature.

Carl Gustav Carus (1789–1869) is notable among Friedrich's followers. A physician and naturalist as well as a philosopher and painter, Carus was steeped in the Romantic philosophy of nature and developed a theory of landscape painting whose objective was the visualization of the inner workings of geological phenomena, which he called "Erdlebenbildkunst" (pictorial art of the life of the earth). Carus believed the viewer should be able to determine from the canvas the physical properties of a particular rock and to deduce its geological history. It was Carus's intention to transform Friedrich's metaphysical landscape into a scientific one.[33] He painted High Mountains: View of the Mont Blanc Group from Montenvers near Chamonix, 1821–24 (no. 12), after a sketch he had made from nature. Friedrich later used this sketch for a similar composition.[34] A comparison of the two shows that Carus emphasized physiological accuracy while Friedrich stressed atmosphere and mood.

Karl Friedrich Schinkel (1781–1841), the architect who determined the physiognomy of nineteenth-century Berlin, as a painter shared with Friedrich the theme of the visionary Gothic cathedral. This theme occurs in three paintings by Schinkel, of which Gothic Church on a Rock by the Sea, 1815 (Nationalgalerie, Berlin) is the last. Each shows a cathedral on a steep rock, against the glow of the setting sun, at some distance from an imaginary city and in the vicinity of a seaport or harbor. In the first two examples the fantastic structures are syntheses of historical models—Milan, Batalha, and the neo-Gothic cathedral of Orléans in one case; Cologne, Reims, and Strasbourg in the other.[35] The church in Gothic Church on a Rock by the Sea is Schinkel's own invention, and in spite of its fantastic dimensions it points to the sober, rectilinear Gothicism of his later Protestant churches. The second of the earlier paintings includes the arrival of a medieval emperor, which probably symbolizes the victorious end of the War of Liberation. This scene is replaced here by a festive but less pompous cavalcade. The cathedral rises in the middle of open, unsettled land which, especially in the filigree of the elm tree above the votive tablet, is akin to Friedrich. The conspicuously southern port points to Schinkel's lifelong

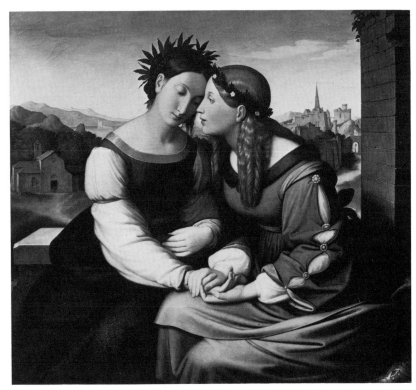

4. Johann Friedrich Overbeck. *Italy and Germany*, 1811–15–28.
Oil on canvas, 94 x 104 cm (37 x 41"). Neue Pinakothek,
Bayerische Staatsgemäldesammlungen, Munich

attempt to fuse the classical with the Gothic. At the time he was painting these pictures Schinkel was also designing a Prussian national cathedral to be erected in Berlin that , if executed, would have been a monument not only to Protestantism but also to Prussian patriotism and culture; he later constructed the Monument to the War of Liberation, and he was among the most fervent advocates of the reconstruction and completion of Cologne cathedral. *Gothic Church on a Rock by the Sea* combines the principal Romantic tenets of Christianity, nature, patriotism, and medievalism.

* * *

The Nazarene movement, representing the Catholic line of German Romanticism, came into being when several students at the Academy in Vienna, headed by Johann Friedrich Overbeck of Lübeck (1789–1869) and Franz Pforr of Frankfurt (1788–1812), found themselves in opposition to the rigidity of its classical instruction. On July 10, 1809, they formed the Brotherhood of St. Luke. From the beginning their objective was the renewal of Christian art, based on the stylistic principles and the "innocent" spirit of German Gothic and Italian quattrocento painting and in keeping with the theories of Novalis, Wackenroder, and Friedrich Schlegel. Schlegel, who in his youth had called for a new mythology (later realized in the work of Runge) had maintained since 1802 that it was imperative "to follow the old masters, particularly the earliest ones, assiduously imitating what is just and naïve in their works, until it becomes second nature to the eye and to the mind."[36] All this was of course to be carried out in an orthodox Catholic spirit. The young artists

moved to Rome in 1810, established themselves in the abandoned cloister of Sant'Isidoro, and soon attracted to their circle many of the most gifted German artists, including Peter Cornelius, Wilhelm Schadow,[37] Philipp Veit, and Julius Schnorr von Carolsfeld. A retrospective movement thus united Germany's avant-garde. Rome, which for more than half a century had been the stronghold of the revival of antiquity owing to the presence of Winckelmann, Mengs, David, Carstens, Canova, and Thorvaldsen, became now the stage for a revival of the Christian Middle Ages. Such a course of events was favored by the cultural stagnation of the Eternal City; in the absence of a liberal middle class or a progressive, patriotic nobility, Rome was dominated by the Vatican which, after liberation from French occupation in 1814, consolidated its power and commissioned the decoration of many churches.[38] The Nazarenes, as they were dubbed by the Romans because of their long hair and Christ-like appearance, soon considered themselves the only true heirs to Rome's spiritual and artistic legacy. They believed that the union of Latin beauty and German inwardness, consummated in the true spirit of Christianity, would unfailingly bear the fruit of another Renaissance. Overbeck's *Italy and Germany* (fig. 4) represents personifications of the arts of the two countries. Leaning toward one another with hands joined, a Roman basilica behind Italy and a German town to the right, the figures give expression to this hopeful vision. The demonstration of national superiority is unmistakable. Germany's attitude conveys eager courting and gentle instruction; her southern sister submits.

Although almost every artist to come within the orbit of the Nazarenes converted to Roman Catholicism—a few, such as Overbeck, out of deep inner necessity, many others merely following an intellectual vogue—in their lifestyles and art there remained a strong residue of Protestant puritanism. Their self-image is conveyed in Overbeck's beautiful portrait of his friend Franz Pforr, 1810 (no. 66). In his "old German" dress the earnest, meek young artist leans on the ledge of a vine-covered bay window. Behind him his imagined future spouse knits while reading a religious book; a lily, her attribute, likens her to the Madonna. The view through the opposite window shows, as in *Italy and Germany,* a northern medieval street against an Italian coastal landscape. The paintings of the short-lived Pforr were among the most innovative of the whole movement: *The Entry of the Emperor Rudolf of Habsburg into Basel in 1273,* 1809–10 (Städelsches Kunstinstitut, Frankfurt am Main), radical in its archaizing linearism and two-dimensionality, left its mark on the art of Ingres.[39]

The Nazarenes encompassed a great variety of talents and temperaments; they did not create a collective style but worked in eclectic idioms. Both their enthusiasm and their success made it easy for them to blind themselves to the fact that it was impossible, in the face of the most radical political, philosophical, and economic changes, to revive the spirit of medieval Christianity; nor did they recognize that their allegiance to Cath-

olic dogma deprived them of the freedom of imagination that Runge and Friedrich had drawn from their personal religion and secular piety. The Nazarenes based their styles upon sources ranging from Dürer to the Umbrians, Pinturicchio, Perugino, and the early Raphael, and from Fra Angelico to Masaccio. But they drew also upon High Renaissance sources, especially the late Raphael and Michelangelo, thus reflecting the contradictions inherent in Wackenroder's ideas about art. They were helped also by the Italian landscape and by the beauty of the natives; witness Overbeck's portrait of their favorite model, *Vittoria Caldoni,* 1820–21 (no. 68). The fifteen-year-old daughter of a vintager of Albano possessed the fullness that inspired Overbeck's simplified, volumetric treatment of her in a style that foreshadows certain Neoclassical figures by Picasso. It has been observed that gesture and attitude link the figure to representations of Melancholy.[40] It seems to be based upon Giulio Romano's depiction of Psyche despairing at her task of separating the grain (fig. 5).

It was the ambition of the Nazarenes to paint monumental frescoes in their new style on the walls of cathedrals and public buildings in Germany; however, they received their first commission in Rome, from the Prussian consul general, Jakob Sal-

omon Bartholdy. In 1816 and 1817 Overbeck, Veit, Wilhelm Schadow, and Peter Cornelius decorated one room of his residence, the Palazzo Zuccari, with paintings illustrating the Old Testament story of Joseph in Egypt. Veit (1793–1877), a convert from Judaism, had received his intellectual training in Vienna, in the home of his stepfather, Friedrich Schlegel. Schadow (1788–1862) was the son of the leading sculptor in Berlin. Cornelius (1783–1867), the most important of the four, was the son of the superintendent of the Düsseldorf Gallery. Born a Roman Catholic, he was spared the inner struggles and excesses of religious zeal that characterized the many converts in the group. His career began with not overly successful contributions to Goethe's art competitions, such as *Athena Teaching the Women to Weave,* 1807–8 (no. 18). *The Wise and the Foolish Virgins,* 1813–19 (no. 20), bears witness both to Cornelius's youthful eclecticism and his intrinsic classicism. Jesus, surrounded by saints of the Old and New Testaments, steps out of Paradise and receives the enraptured tributes of the Wise Virgins, while in the background the Foolish Virgins helplessly raise their empty oil vessels. The Gates of Paradise are based upon Ghiberti's Baptistery doors; the Wise Virgins upon a group of muses in Raphael's *Parnassus;* the Foolish Virgins and the background

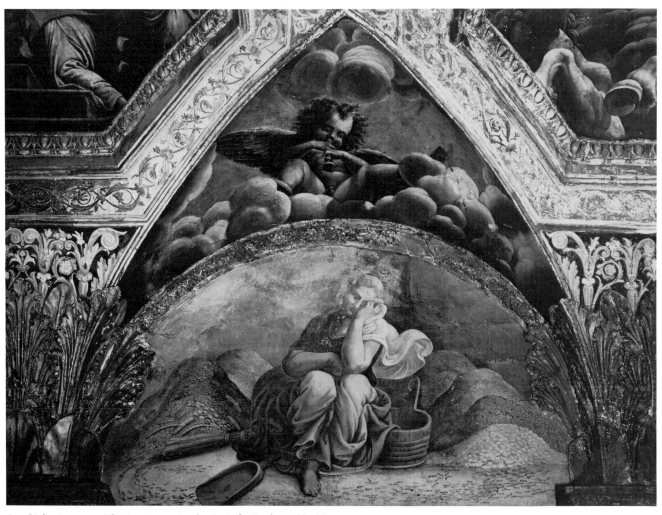

5. Giulio Romano. *The Ants Separating the Grain for Psyche,* 1528–30.
Fresco. Sala di Psiche, Palazzo del Te, Mantua

architecture upon Raphael's *Fire in the Borgo*. The splendor accompanying the heavenly apparition contrasts effectively with the gloomy, moonlit night. Thorvaldsen, who owned the painting, derived from it his statue of Christ for the Cathedral of Our Lady in Copenhagen.[41]

An interesting document combines in a decorative mount copies by each of the four artists of their frescoes in the Casa Bartholdy (no. 21). It is assumed that the consul general sent these copies to the Prussian chancellor, Prince Karl August von Hardenberg, in order to obtain for his protégés additional commissions in Germany. Among the five contributions, those by Cornelius and Overbeck are clearly superior. In *Joseph Interprets the Pharaoh's Dreams* Cornelius juxtaposes the quiet, erect figure of Joseph with those of the nervous courtiers, who respond to his interpretations with doubt, malice, astonishment, and awe. The distant landscape in its subdued lyricism is reminiscent of early Renaissance painting.

Overbeck created in the lunette *The Seven Lean Years* a harrowing image of dearth and starvation. The despairing mother is based upon Michelangelo's Sibyls, yet with the starved children surrounding her, particularly the languishing boy leaning against her to her right, she appears to anticipate later depictions of Dante's Ugolino. The figure stands in marked contrast to Veit's robust earth goddess in his corresponding lunette, *The Seven Years of Plenty*. If Veit's *Joseph and Potiphar's Wife* demonstrates how a striving after the linear purity of the Early Renaissance could lead to vacuity, Schadow's *Bloodstained Cloak* shows that reliance upon High Renaissance models, especially the late Raphael, could engender theatricality. The Casa Bartholdy frescoes are thus uneven both in style and quality;[42] yet they were much admired in their day, and in 1822 they brought the group another, more extensive commission, namely, to paint episodes from Dante, Tasso, and Ariosto on the walls and ceilings of three rooms in the garden house of the Massimo family near the Lateran. This turned out to be a splendid, though stylistically divergent monument. Cornelius was given the Dante room, but he relinquished the project when, in 1819, he was called to Munich by Crown Prince Ludwig of Bavaria; Philipp Veit and Joseph Anton Koch executed the frescoes. Overbeck did not finish his Tasso frescoes either, because in his later years he wanted to paint nothing but strictly religious subjects. Only Julius Schnorr von Carolsfeld completed his Ariosto cycle.[43]

This talented young artist had received his initial training in Vienna, from Koch and from his future father-in-law, Ferdinand Olivier (1785–1841). Olivier was the only member of the Brotherhood of St. Luke who never set foot in Italy; but his art was of fundamental importance for Nazarene landscape painting. His late work *Forest Landscape with a Cardinal on Horseback,* 1839 (no. 65), is Nazarene in its use of fresh primary colors—especially in the group around the cardinal—and in its contemplative mood and ecclesiastical subject; compositionally, with the group of towering trees and the space constructed out

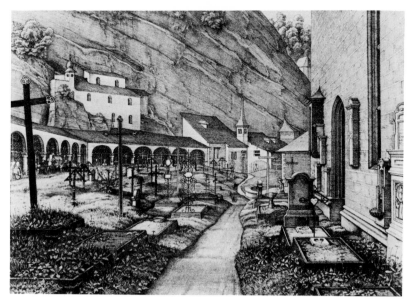

6. Ferdinand Olivier. *The Cemetery of St. Peter in Salzburg* ("Saturday," from *The Days of the Week*), 1818–22. Lithograph, 196 x 275 cm (77⅛ x 108¼"). Albertina, Vienna·

of parallel layers, it harks back to earlier models, to the landscapes of Koch and Claude Lorrain. However, Ferdinand Olivier's lasting achievement is his early landscape drawings.[44] Meticulously constructed out of crystalline planes, crosshatched as in copper engravings, they depict quiet corners in and around Vienna and Salzburg with peasants' huts, quarries, churchyards, and open meadows, enlivened by square, archaizing figures in frozen postures. These drawings combine the rigid geometry of the Dutch seventeenth-century artist Saenredam with the hushed stillness of Friedrich's spaces; they are religious landscapes, not in the sense of Friedrich or Runge, but by virtue of a Franciscan love for all things created (fig. 6).

Olivier infused some of this spirit into the early work of Julius Schnorr von Carolsfeld (1794–1842). During his first years in Rome Schnorr combined this influence with a devout study of quattrocento artists, especially Fra Angelico. In paintings such as *The Annunciation,* 1820 (Nationalgalerie, Berlin), and *The Flight into Egypt,* 1828 (Kunstmuseum, Düsseldorf), the Protestant Schnorr pays homage to the Madonna in the spirit of Wackenroder's art-loving monk. Some of these pictures come deceptively close to their art-historical sources; nevertheless, their seeming naïveté is contrived by the most strained intellectual effort. They cannot disguise the self-conscious refinement and uneasy aestheticism of a late culture.

For Schnorr this was only a passing phase. Already in his Casino Massimo frescoes, he drew his inspiration from the High Renaissance. In his later murals in the Munich Residenz of King Ludwig of Bavaria—scenes from the *Nibelungenlied*[45] and from the history of the German emperors—his art degenerated into the turgid history painting that became the hallmark of the later Munich school headed by Wilhelm von Kaulbach. With the exception of Overbeck, who remained in Rome, all the major surviving Nazarenes became directors of important German academies or art galleries: Cornelius in Düsseldorf and

Munich, Schnorr in Dresden, Veit in Frankfurt and Mainz, Schadow in Düsseldorf. The international reputation of the Düsseldorf school is due largely to Schadow's timely recognition of the new trend toward Realism in the 1830s.[46]

Schnorr, Veit, Cornelius, and Overbeck each created toward the end of his life one crowning work, or body of works, which in every case constitutes a summary of the Nazarene spirit. For Schnorr, it was his 240 illustrations for the Bible, published in 1860, which had an enormous influence in England.[47] Veit painted for the Städelsches Kunstinstitut in Frankfurt the *Introduction of the Arts into Germany Through Christianity,* 1832–36, and later the frescoes for Mainz cathedral. Cornelius received important commissions in Munich from Ludwig when he was crown prince and later when he was king. In 1816 he painted frescoes in the Glyptothek, Leo von Klenze's building for the royal collection of antique sculpture. In his elaborate program he tried to deal with ancient mythology in the spirit of Christianity, or rather, to disclose the "secret Christianity" of the Greeks. Thereafter he was given a royal commission to decorate Friedrich von Gärtner's Ludwigskirche. The scheme includes a mural of the Last Judgment, which Cornelius painted without assistance from 1836 to 1839, on a wall higher and wider than that covered by Michelangelo's *Last Judgment* in the Sistine Chapel. But the king was dissatisfied and withdrew his patronage from the aging artist. Cornelius, however, found a new patron in Frederick William IV of Prussia, "the Romantic on the throne," who dreamed of the reconstruction of the German Empire under the Habsburgs, and of a universal church that would bridge the gulf between the Christian confessions. This anachronistic ruler responded to the artist's cherished idea of a great Christian fresco cycle. Cornelius was to carry it out on the walls of a projected Campo Santo, adjacent to the rebuilt Berlin cathedral. Its subject was to be the Christian universe, culminating in the Salvation of Man. The style was to be based on Italian art of the High Renaissance and on the sculptures of the Parthenon, which Cornelius had studied in London. From 1843 he worked on the cartoons for the frescoes, mostly in Rome, and was in contact with Overbeck. The project was abandoned by the king in the wake of the Revolution of 1848. But Cornelius, in an effort that is testimony to the loyalty of an artist to his dream, devoted the rest of his life, almost twenty years, to this series of gigantic charcoal drawings—in spite of the fact that there could never conceivably be any other place for them than in the storerooms of the Nationalgalerie in Berlin, where they are to this day. Working thus in a void, the artist felt a supreme peace of mind, for, having lost both his public and his patronage, he no longer had to concern himself with communicability, execution, or color, which had in fact always been incidental to his work. For Cornelius, these cartoons represented his highest achievement; he believed they would last a thousand years. And the first drawing, *The Apocalyptic Riders* (fig. 7), is indeed a weird masterpiece.

Overbeck's ultimate statement was his great painting *The Triumph of Religion in the Arts* (fig. 8). The lower half shows the reunion of those artists whose art has been in the service of religion, and in the upper half there appears a vision of the Madonna surrounded by saints of the Old and New Testaments. The composition is derived from Raphael's *Disputà* and *School of Athens.* Leonardo da Vinci (center background) leads his pupils in a discussion. Overbeck, Veit, and Cornelius (extreme left) converse modestly behind the mighty figure of Dante. Overbeck himself explains that the iconographic program is also a condemnation of both classical antiquity and Protestantism and is therefore, by implication, a declaration of faith in the theocracy of the old Holy Roman Empire. Thus the work seals the evolution of German Romanticism, a movement originally radical in its espousal of individualism and freedom of personal expression, now paradoxically the executor of the Catholic restoration.

The influence of the Nazarenes was far-reaching and enduring. It can be traced in Italy to their followers, the Purists;

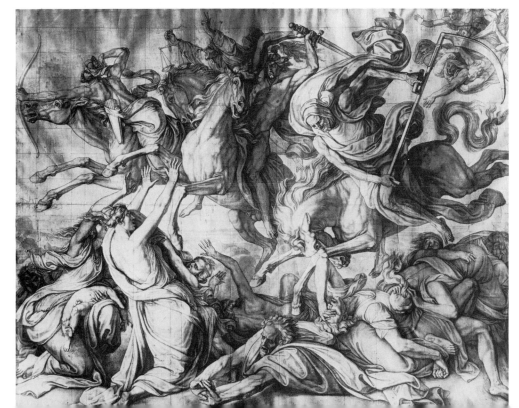

7. Peter von Cornelius. *The Apocalyptic Riders,* 1846. Charcoal on paper, 472 x 588 cm (186 x 231″). Formerly Nationalgalerie, Berlin

it can be traced in France from the renewal of sacred art in the school of Lyons through Péladan's Salons de la Rose + Croix (1892–97) to Sérusier and Maurice Denis; in England, from the decoration of the new Houses of Parliament through the Pre-Raphaelite movement and well into the end of the Victorian era; in Germany, through much of the official art of the nineteenth century into one of the last centers of religious art, the school of Beuron.[48]

* * *

The years following the Congress of Vienna were the period of the Holy Alliance between Prussia, Austria, and Russia, forged with the express purpose of securing monarchical authority in Europe. In Germany the wish for constitutional government and national unity lived on, mainly among the academic youth. But when their ideas were voiced too loudly, as happened at the Wartburg Festival of 1817, the greater states were fast to join forces in establishing censorship and police surveillance, thereby drastically curtailing assembly rights and freedom of the press. The result was political stagnation. France's July revolution of 1830 had very few repercussions in Germany. But in 1848 uprisings in all parts of the country resulted in the convening in Frankfurt of the German Constituent National Assembly, whose members, liberal representatives of the German states, determined the principles of a German constitution. The parliament was faced with a dilemma. The multinational

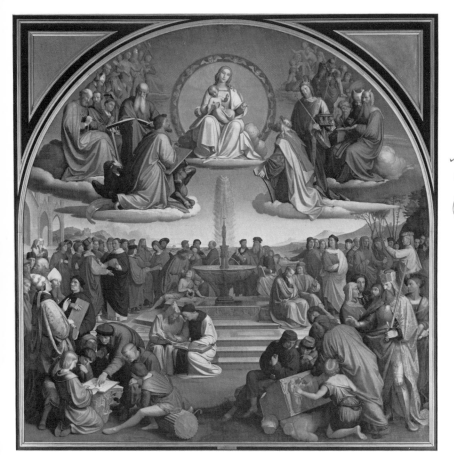

8. Johann Friedrich Overbeck. *The Triumph of Religion in the Arts,* 1832–40. Oil on canvas, 392 x 392 cm (154⅜ x 154⅜").
Städelsches Kunstinstitut und Städtische Galerie, Frankfurt am Main

Austrian Empire could not be part of a German national state; nor would a Catholic Austrian emperor submit to the authority of the Protestant Prussian king if the imperial dignity were conferred upon the latter. Hence a constitution was drafted for a *Kleindeutschland* ("small Germany"), without Austria, and Frederick William IV was elected emperor.

Frederick William, however, refused to accept the crown from liberals and democrats; believing himself a divinely appointed ruler, he would accept it only from his peers. Furthermore, during the riots in Berlin the revolutionaries had forced him to pay his respects to the dead of the barricades, an incident commemorated in a remarkable, though unfinished painting by Adolph von Menzel, *The Lying-in-State of the Dead of March 1848 in Berlin* (fig. 9).

Thus the first attempt to unite Germany under a liberal constitution had failed, partly because of the anachronistic thinking of its leading monarch and partly because of the still-prevailing political indifference of large parts of its population. A new period of restoration and reaction followed, with mass emigrations of liberals and patriots to the United States.

On the other hand, this was the period during which Germany achieved economic unity through the *Zollverein* (Customs Union) and changed from an agrarian to an industrial country. It was also a period of slow but radical intellectual and social change. In the words of Golo Mann: "From the post chaise to railway, steamship and telegraph; from the faith of the fathers to naked atheism and materialism; from Goethe to Heine; from Hegel to Marx; from *Faust* to the *Communist Manifesto*—this is an enormous movement of society and spirit."[49]

With the exception of such Düsseldorf painters as C. F. Lessing and J. P. Hasenclever, Germany in 1848 had no artists who by any standards could be called radical. The greatest Düsseldorf painter, Alfred Rethel (1816–1859), was a conservative; in his well-known series of woodcuts *Another Dance of Death, in the year 1848,* he dealt with the revolution in a spirit of deep historical pessimism (fig. 10). And a new kind of Romantic painting, represented by, among others, Moritz von Schwind and, in a very different way, Carl Spitzweg, was downright escapist.

Moritz von Schwind (1804–1871) was Austrian by both birth and temperament, but he spent most of his life in Munich and was therefore always considered a German artist. During his student years in Vienna he was stimulated by the work of Ferdinand Olivier, by the plays of Franz Grillparzer, and above all by the music of Franz Schubert. Music became for Schwind an intrinsic element of his pictorial world. In 1853–55 he painted the contest of the minstrels from Wagner's *Tannhäuser* on the walls of the Wartburg where it had taken place in 1207. His last fresco cycle in the Vienna Opera House was dedicated to Mozart's *Magic Flute.*

Schwind's love for music found expression also in one of his few portraits. *Caroline Hetzenecker,* 1848 (no. 79), depicts the celebrated soprano of the Munich Opera. Schwind admired

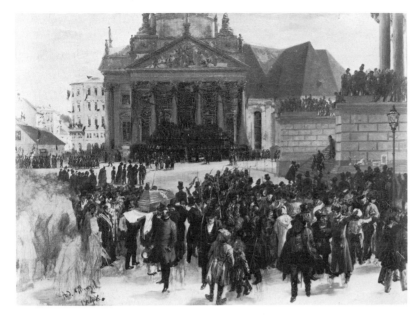

9. Adolph von Menzel. *The Lying-in-State of the Dead of March 1848 in Berlin,* 1848. Oil on canvas, 66 x 78 cm (26 x 30¾"). Hamburger Kunsthalle, Hamburg

her and sketched her in many roles, including Leonore, Donna Elvira, and Iphigenia. She also sang in concerts held at Schwind's house. After her marriage in 1848 she left the stage and performed only in churches and concert halls, such as Klenze's Odeon. Schwind portrayed her during one of the Odeon concerts, in front of the busts of Gluck and Beethoven[50]—an impeccable and dignified muse.

Schwind's Romantic bent shows itself most clearly in the curious fact that he, the respected professor at the academies of Karlsruhe and Munich, dreamed for many years of leading the life of a Christian hermit in a forest. The woods and glades around Vienna and Munich were his natural inspiration. He would animate them with giants and gnomes, with the moonlit revels of elves, and with pale, lithe nymphs emerging from misted ponds. Such paintings are not, like Runge's, visualizations of a personal mythology; rather, they are illustrations of fairy tales such as Melusine and Cinderella. Schwind's art is to a great extent rooted in the old German folk tales collected by the Brothers Grimm, and in Achim von Arnim's and Clemens Brentano's equally important collection of folk songs, *The Youth's Magic Horn (Des Knaben Wunderhorn,* 1806–8). Hence, Schwind's nymphs and gnomes are not the embodiments of an esoteric religion of nature, but figments of the popular imagination, deliberately treated in a naïve, earthy, predominantly linear, and essentially realistic style. Schwind's Romanticism is the Romanticism of the age of Positivism. In his contemporary subjects—strolling beggar-musicians, young couples on their honeymoon, traveling artists or students[51]—he depicted, in an age of growing industrialization, a time that seemed to be dimly remembered, but that never existed. Schwind retained his escapist vision well into the epoch of Realism and Impressionism.

Still, it was not a vision devoid of depth. *Rübezahl,* 1851–59 (no. 81), is the depiction of a sturdy and uncouth mountain sprite who amuses himself by paralyzing the horses or breaking

the wagon wheels of solitary travelers. He might fling a hail of stones or an army of hornets into their faces, but he might also smuggle a lump of gold into a poor fellow's knapsack. He hates mankind in general, but is capable of compassion for individuals. Once betrayed in his love for a mortal, he longs for redemption from his animal nature, for the soul that only the love of a mortal can give him. This explains the melancholy with which the figure is infused; a brooding Aurignacian, he stamps through the woods as rugged and as dead as his own inner world.

Carl Spitzweg (1808–1885) shares with Schwind the escapist tendency, but he is a much more "painterly" painter. In the German-speaking countries "Spitzweg" is a household word, "Spitzweg figures" designating certain old-fashioned and slightly ridiculous, but on the whole likable people: harmless eccentrics, bizarre old spinsters, pedantic bureaucrats, dignified sextons. And indeed, these are the characters who inhabit this painter's idyllic, deliberately parochial, and above all strikingly unreal world. Like his friend Moritz von Schwind, Spitzweg turned his back on the technological advances of his time and remained politically neutral. He was also largely unaware of the more radical developments in painting—the Realism of Courbet and Leibl, and the beginning of Impressionism—although his depiction of light and the "pointillist" element in his style after 1851 owe something to the Barbizon school, especially to Diaz. A shy and skeptical bachelor, Spitzweg created his self-sufficient dreamworld to make up for satisfactions that life had not granted him. Thus he would paint the typical small old German town with its steep, narrow streets and its paneled houses with shingled roofs, juttings, and signboards—an ideal stage for such scenes as the watchful mother intercepting the love letter of her unsuspecting daughter, or street musicians at nighttime serenading a young girl. Sleeping sentinels, materialistic monks, secluded bookworms, and cultivators of cacti, but also Bavarian peasant girls and youths in sunny valleys are among Spitzweg's

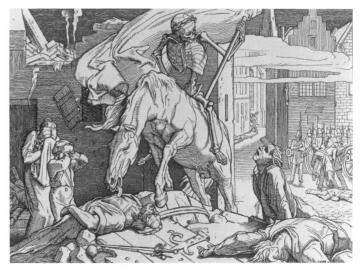

10. Alfred Rethel. *Death on the Barricades* (from *Another Dance of Death, in the year 1848),* 1848–49. Woodcut, 22 x 32 cm (8⅝ x 12⅝"). Hamburger Kunsthalle, Hamburg

subjects. Spitzweg is not so much a Romantic as a Biedermeier painter.[52] The term "Biedermeier," a compound of the names of two characters from the satirical journal *Fliegende Blätter,* Biedermann and Bummelmeier, designates bourgeois smugness, or *Gemütlichkeit.* As a style of cozy, unostentatious furniture in fruitwood, based, as it were, upon a pared-down version of French Empire, Biedermeier became popular after the fall of Napoleon and lasted until the Revolution of 1848. Biedermeier painting flourished between 1830 and 1850 and can be characterized as a sunny, idyllic depiction of everyday life in a realistic style. Both Biedermeier painting and furniture were destined for the middle-class living room; hence the predominantly small format of the pictures. Ideologically, Biedermeier painting opposed the classicism and the heroic history painting of the academies, as well as Romantic art.

A painting like *The Butterfly Hunter,* c. 1840 (Museum Wiesbaden), however, shows that Spitzweg's art retained Romantic features, albeit in ironic distortion. In a "tropical" landscape of sun-drenched palm trees and very untropical underbrush, a traveling entomologist is faced with the impossible task of catching two mammoth butterflies in his tiny net. The two fabulous moths are blue, the color of the infinite, the Romantic color par excellence. The overawed amateur can be seen as a parody of Friedrich's lonely figures confronting the mystery of nature. But he stands also in a long line of intellectuals—poets,[53] metaphysicians, scientists, theologians—whom Spitzweg liked to ridicule by depicting them as marginal characters, scurrilous, ossified, and utterly ignorant of the ways of the world.[54] This attitude is in keeping with the middle-class mentality which, as a consequence of Germany's political stagnation and industrial ascent, tended increasingly to consider efficiency and the accumulation of wealth as absolute values. Whenever this attitude comes to the fore, Spitzweg enjoys renewed popularity.

Another transitional painter is Karl Blechen (1798—1840). Despite a morbid Romanticism he had an intense personal vision of uncultivated nature. As one of the first German plein-air painters he excelled in oil studies that were neither preparatory, or fragmentary, or unfinished; this aspect of his art anticipated certain works by Menzel, the Barbizon painters, and even the Impressionists, and can be seen as a step toward the late nineteenth-century conception of the picture as an autonomous visual fact. The other, more extreme side of his art points ahead even further to certain twentieth-century modes of experiencing reality. But Blechen's Berlin audience could not accept his unrefined vision. According to his friends, it was above all this lack of recognition that drove him to mental illness and an early death.

In his earliest works Blechen imbued Friedrich's melancholy subjects with Hoffmannesque horror; he would paint a dilapidated and overgrown church ruin, its crypt drowning in water, its vaults and pillars cracked, with a young monk lying precariously asleep. Or he would imagine a pathless ravine with frost-covered rocks emerging from the murky twilight of a winter night, in the foreground the ghost of a tree and an unlikely statue of the Virgin, at the end, two tiny lit windows gleaming like the eyes of a bird of prey.[55] Small wonder, then, that in those years of the triumph of Weber's *Der Freischütz,* the great Schinkel, himself active for the Berlin Opera, suggested Blechen as set designer for the Königstädtisches Theater. The young artist worked there from 1824 to 1827, but his primary focus was landscape painting. In this he was encouraged by the Norwegian Johann Christian Clausen Dahl, a close friend and follower of Friedrich. Dahl differed from Friedrich in two important respects: he was less interested in a metaphysical interpretation of nature than in the objective rendition of natural phenomena, such as clouds, and, unlike Friedrich, he had been to Italy. Blechen's trip to Italy in 1828–29, which may have been prompted by Dahl's, gave him an enormous sense of artistic freedom and power. He painted famous sites in and around Rome, such as the Villa Borghese and the Villa Albano, Tivoli, and Subiaco, and he traveled as far as Naples and Paestum. Blechen's was a new vision of Italy, equally removed from the eighteenth-century *vedute* as from Koch's idealistic, or the Nazarenes' medievalizing conceptions: scorched plains with scant vegetation, desolate hills and motionless seas, sun-drenched walls under opaque skies—painted with an unusually broad, free brushwork, without drawing or black.

The closest European parallels or prototypes for Blechen's Italian landscapes are those by Bonington and the early Corot. In Germany the Bavarian Johann Georg von Dillis (1759–1841),[56] principal aide to King Ludwig I in the formation of his great collection of paintings housed in the Alte Pinakothek, arrived at a hardly less radical kind of plein-air painting. His *View of St. Peter's from the Villa Malta, Rome,* 1818 (no. 22), shows, in the rooftops bathed in the afternoon sun, the same dissolution of outline and volume. But these Roman landscapes were conceived in a quieter, more contemplative mood.

Another Bavarian, Carl Rottmann (1797–1850), painted landscapes of Italy and Greece as studies for frescoes commissioned by Ludwig I for the historical education of his subjects. The Italian frescoes (1830–34) decorated the arcades surrounding Munich's Hofgarten; the Greek landscapes decorated a separate hall in the Neue Pinakothek. Rottmann's oils, though only preparatory studies for the frescoes, share with Blechen's work their freedom of handling and, in their heightened rendition of light and meteorological effects, a certain theatricality. The frescoes themselves were conceived with two aims in mind: to show the geological history of the sites, an objective derived by Dillis from the ideas of Carl Gustav Carus, and to show the dignity imposed upon them by time, an objective specified by the king, who was eager to present himself as heir to the many German rulers whose destiny was fulfilled in Italy. Compositionally these historical landscapes are based upon the work of Joseph Anton Koch, and similarly emphasize the tectonic structure of mountains and architecture and the rational order of compartmentalized spaces. *Cefalù,* 1829 (no. 69), which depicts an old Greek

settlement, is shown protected by a mighty promontory; both city and mountain suggest permanence.[57]

Blechen dwells instead upon the whims of nature, upon what is impermanent and unpredictable; hence his frequent depictions of changing weather and natural catastrophe, such as a destructive flash of lightning.[58] *Sans Souci Palace,* c. 1830–32 (no. 3), is a ravishing picture of the transitory in nature. "It is significant that (here) the fountains of Sans Souci are depicted, not, as one would expect, in sunny and festive surroundings, but between two showers of rain, in an atmosphere that itself is already heavy with dampness. For a moment, a weak ray of sun has illumined the picture's foreground on the lower part of the palace; but in the background everything fades into the blue darkness of the clouds."[59] Pictures such as this lend plausibility to the assumption that Blechen in Rome in 1829, if he had not actually met J. M. W. Turner, had at least seen the exhibition of his work.[60] No doubt Blechen had a heightened, perhaps even a pathologically heightened, perception of visual reality, of which he was painfully aware—witness his heartrending question at the outbreak of his mental illness: "Is it optical fraud that I see the world as I do?"[61] Blechen's acute sensibility compelled him to depict unusual subjects in strange light, e.g., *Rolling Mill near Neustadt-Eberswalde,* c. 1834 (Nationalgalerie, Berlin),[62] one of the first industrial landscapes in German painting, rendered in a mood of uneasy foreboding; or the royal Palmarium, a palm house on Berlin's Pfaueninsel.[63] Blechen painted unpretentious cuts from nature not only in Italy but also in his homeland, the Mark Brandenburg—sand dunes, forests, quarries. In *View of Rooftops and Gardens,* c. 1835 (no. 4), Blechen treats the scene of suburban backyards with a complete disregard for traditionally accepted composition; the image is cut arbitrarily on all sides, its subject is neither picturesque nor noble. Yet it sparkles and is coloristically exquisite. This side of Blechen's art ranks highest in the estimation of those critics who envisage nineteenth-century art as an evolution toward "pure painting"; in this view, inconspicuous subject matter plus emotional neutrality equals purity. But it may well be argued that Blechen painted these pictures in an effort to control his nervous unrest, that his true self is to be found instead in his depictions of alienated nature: terror brooding over empty Italian plains in the hour of Pan, the Villa d'Este turned into a shimmering Fata Morgana, a dark ravine threatened by avalanches. Expressionism, Surrealism, and the rediscovery of Mannerism have prepared us for Blechen's experience of reality with its underlying fear of the absurdity of existence; but he was born too early and was soon forgotten.

* * *

In 1858 Prince William of Prussia took over the regency from his brother Frederick William IV, who had become mentally ill; in 1861 William became king. The following year he appointed Otto von Bismarck prime minister. This great statesman was to determine the course of German politics well into the twentieth century. He paved the way toward the unification of Germany, i.e., "small Germany", under the hegemony of Prussia by putting through, against constitution and parliament, a military reform wanted by the king; by using a lingering conflict over the duchies of Schleswig and Holstein for a war against Austria, which ended with her permanent separation from Germany; and by forging the North German Confederation. He achieved German unity after the defeat of France in the Franco-Prussian War, proclaiming William I German emperor in the hall of mirrors in the palace at Versailles on January 18, 1871.

The new Reich was not a true national state for, while large parts of the German population remained outside its borders, it also incorporated splinters of foreign nationalities, such as the Danes of north Schleswig, the Poles of Danzig, Thorn, Posen, and so forth, and the inhabitants of the newly annexed Alsace-Lorraine, who felt French. Furthermore, the Reich represented an artificial compromise between established Prussian traditions and more recent ones. As king of Prussia, William I was a near-absolute monarch, supported by the landed aristocracy east of the Elbe. As German emperor he was titular head of a confederation of twenty-five states. However, among these Prussia was so clearly the superior power that their equality was merely nominal. Each member state retained its own governmental structure, yet the policy of the Empire was shaped by the imperial chancellor, Bismarck. It took a man of Bismarck's cunning and ruthlessness to govern with a parliament characterized by constantly shifting alliances among Conservatives and Liberals, and in which the Social Democrats and the Catholic Center Party gained more and more ground—just because of Bismarck's antagonism. It was Bismarck's great accomplishment to maintain peace while in office and to lay the ground for its preservation for years to come. That he failed to democratize Germany was largely due to his character and aristocratic frame of mind, but it was also a consequence of Germany's belated and problematical unification.

The growth of industry, an expanding army, an increasing population and the development of an urban proletariat, a growing dependence upon foreign trade—these were among the factors that changed the character of the German nation. Germany became one of the world's leading industrial and military powers—without attaining national identity, without enabling her citizens to identify with a conception of the state that had evolved organically and was ethically binding. Small wonder, then, that the nation of Goethe and the Romantics became a nation of materialists, dominated by a striving for efficiency and for success at any cost, loyal above all to military and bureaucratic virtues.

The resulting split between political and cultural thinking, between official art and the independence of creative minds, was inevitable. It deepened with the ascent to the throne in 1888 of the vainglorious William II, a sworn enemy of plein-air painting and naturalistic drama. True, the court of the Hohenzollern

23

11. Karl Theodor von Piloty. *Seni at the Corpse of Wallenstein*, 1856.
Oil on canvas, 411 x 365 cm (161⅞ x 143⅜").
Neue Pinakothek, Bayerische Staatsgemäldesammlungen, Munich

12. Anton von Werner. *In the Base Quarters in Paris, 1871*, 1894.
Oil on canvas, 120 x 158 cm (47¼ x 62¼").
Nationalgalerie, Staatliche Museen Preussischer Kulturbesitz, Berlin

found its spirited chronicler in the aging Adolph von Menzel and its portraitist in that prince among painters, Franz von Lenbach, a friend of Bismarck's. Arnold Böcklin admired the Prussian state, and the novelist Theodor Fontane described Prussian society with urbanity and psychological insight. But the Empire recognized itself in the writings of nationalistic bards, in Renaissance factories and Gothic railway stations, in the history painting of Karl Theodor von Piloty, and later, in the painted propaganda of Anton von Werner (figs. 11, 12). It also recognized itself in the operas of Richard Wagner. But this was at least partly due to a misunderstanding, for neither the *Liebestod* nor Parsifal's craving for salvation was compatible with the pragmatic philosophy of the new meritocracy. Wagner had started out as a revolutionary during the Dresden uprising of 1849; after the nationalistic errors of his middle years, he became increasingly disgusted with the pomp and hubris of the Empire. Wagner today shares with Nietzsche the bitter fate of being considered a precursor of developments he would have despised. And Nietzsche, advocate of the Will to Power, was, strange as it may seem, the Empire's most devastating critic. It seems hardly surprising, then, that some of Germany's most gifted painters, for lack of resonance at home, spent their lives in Italy.

In the case of Anselm Feuerbach (1829–1880) isolation and neglect were due primarily to the fact that his art was too rarefied for the tastes of the new German upper and middle classes; consequently, he was hardly less acrid than Nietzsche in denouncing their materialism and lack of culture. So deliberately was he at variance with his time that his relative lack of success appears almost self-imposed. His restlessness and irritability, his alternating between delusions of grandeur and near-suicidal depression may have been in part a hereditary disposition; there was in his family an unusual amount of talent but of mental imbalance as well. A fanatical worker, but also a dandy with an irrepressible need for luxury, Feuerbach could never have endured the anxieties to which he was subjected without the support of his stepmother, Henriette. Only seventeen years older than Feuerbach, she called him from the very beginning "a son and a friend." Feuerbach's letters to his stepmother are unique in their combination of egoism, petulance, self-pity, idealism, and artistic compulsion. In response she sold his paintings and arranged for their exhibition, conferred with critics and buyers, and presented his most impudent claims to his patrons, who included the grandduke of Baden and Count Schack. Her noble portrait, 1878 (no. 28), put the seal on a bond that lasted well beyond Feuerbach's death. For Henriette continued to devote herself to the promotion of his art. From his letters and autobiographical notations she compiled a book of memoirs which, under the slightly presumptuous title *A Testament (Ein Vermächtnis),* ran to forty-five printings. Feuerbach's posthumous fame was largely due to the popularity of this book. This fame, however, was based upon a misunderstanding. For we know today that by tendentious editing, the old lady presented her son as a forceful idealist, unshaken in his resolution

to revive the "noble simplicity and tranquil grandeur" of the Greeks.[64] This misrepresentation eliminated every trace of the deep insecurity that stamped both his art and his personality.

One of the least discussed areas of Feuerbach's art is his compositions with children, of which there are three different categories. The most conventional are allegories with putti personifying the arts, or idylls with putti wrestling, bathing, or serenading a little girl. Another group includes mythological scenes, such as *Gods of the Winds Stealing Grapes from Sleeping Bacchus,* or *Amorette Abducting the Infant Pan to Olympus.*[65] These pictures share their harmless appeal with certain works by Reynolds such as *The Childrens' Academy, Infant Hercules,* or *Infant Johnson.*[66] In each case the viewer is asked to find piquancy in the fact that children perform actions or express emotions indigenous to adulthood. The discrepancy between their awkward little bodies and the seriousness with which they go about their inappropriate tasks ridicules adult self-importance. The third category shows older, yet still prepubescent children dallying amorously in Arcadian landscapes, as in the splendid *Ricordo di Tivoli,* 1867 (no. 26). Here the little boy plays a tune and the little girl listens, but her thoughts take her far, far away. In another painting she looks at him longingly, while he remains completely absorbed in his music. In a third painting the girl herself tries his lute, and the boy eyes her critically, almost spitefully. (In these two versions the children are watched by seemingly alarmed nymphs.) Here, too, the children are not portrayed as children. They conform to amorous conventions and affect sentiments inconsistent with their age. And for once, childhood is not passed off as paradise. The absence of communication between the young lovers fills these pictures with a peculiar sadness, a sadness with a slightly neurotic tinge.

The "longing" that inspired the Romantics is also the leitmotif of Feuerbach's art. But whereas the Romantics found fulfillment in the contemplation of the infinite, in immersion in an idealized past, Feuerbach's ideal remains elusive. His *Iphigenia,* 1871 (Staatsgalerie Stuttgart), longs for a Greece she has never known.[67] The painter stylized his art and his life according to his concept of a higher and nobler humanity, after the model of the Greeks. But an artist who projected his own estrangement even into his interpretation of childhood could not revive Hellas for the late nineteenth century. His vision was enfeebled by self-doubt and decadent aestheticism. One of Feuerbach's most ambitious paintings, *The Judgment of Paris* (fig. 13), could almost be taken as a metaphor of his own condition. The shepherd seems absentminded, as though, in a reverie about abstract beauty, he has lost sight of the living beauty he is supposed to judge. Furthermore, with the flocks of amorini, a period prettiness sneaks into the picture which is as incompatible with its dreamy mood as this mood is incompatible with the spirit of classicism.

13. Anselm Feuerbach. *The Judgment of Paris,* 1870.
Oil on canvas, 228 x 440 cm (89¾ x 173¼").
Hamburger Kunsthalle, Hamburg

14. Anselm Feuerbach. *Nanna,* 1861.
Oil on canvas, 119 x 97 cm (46⅞ x 38¼"). Staatsgalerie Stuttgart

Still, as far as beauty was concerned, fate favored Feuerbach quite exceptionally. Twice, in 1860 and in 1866, he met in Rome women who corresponded to his ideal. Nanna Risi became his *Iphigenia,* Lucia Brunacci his *Medea.*

Nanna particularly, a cobbler's wife and much in demand as a model, possessed, with her sumptuous hair, her near-masculine profile, and her stately frame, that "truly majestic, forbidding tranquility" which he sought. Feuerbach portrayed her as Poesy and as Bianca Cappello, as Lucrezia Borgia and as Miriam, as the Madonna and, time and again, as herself. Sometimes he based her portraits upon Renaissance models, such as the *Mona Lisa.* Nanna appears virginal or ripe, demonic or tender, sensual or haughty. At times she is a "noble animal," at others a sophisticated society belle, wearing with great style the opulent taffeta robes then in vogue, complete with ivory brooch, watch chain, and fan (fig. 14). The taffeta and Nanna's hair gave Feuerbach ample opportunity to set off nuances of shining black against his favorite gray purple, mauve, or muted green. In every pose or role Nanna is remote, her shaded eyes impenetrable. A secret is concealed behind her impeccable composure; her melancholy veils cruelty.

Feuerbach's art is one of suggestion rather than explication. His historical paintings invariably depict moments of hesitation, of suspended or merely contemplated action; Medea,[68] in front of the vessel that will carry her into exile, cannot decide whether to kill her children or to leave them to Jason. In another version Medea broods alone; the terrible deed she ponders is known only because it is depicted on a grotesquely unantique urn.[69]

Feuerbach's deliberate avoidance of archaeological accuracy (evident also in his two paintings of Plato's Symposium) strongly indicates that he did not really feel at home in the Athens of Socrates and Alcibiades. When, toward the end of

his career, he painted the Fall of the Titans on the ceiling of the Doric aula of the Vienna Academy, he abandoned Neoclassical composition and resorted to Baroque illusionism. In one of the preliminary studies he borrowed two figures from Delacroix's *Massacre of Chios,* 1821–24 (Louvre, Paris).

The art of Hans von Marées (1837–1887) has some features in common with Feuerbach's: its roots in Italy, its general reference to antiquity, its implied rejection of the artist's own time. But the differences are much more important. As opposed to Feuerbach's muted palette, Marées's was deep and luminous. Whereas Feuerbach was dependent upon both live models and literary subjects, Marées depicted his generalized figures in freely invented scenes, in states of mere vegetative existence. Although one cannot say that Marées's was an art of "pure form," as has been suggested,[70] for it is not entirely devoid of incident, myth, and symbol, these intellectual elements do not predominate; in the course of Marées's development they were gradually absorbed by formal pictorial elements until the narrative was completely dissolved in self-contained and resplendent images.

Self-Portrait with Lenbach, 1863 (Neue Pinakothek, Munich), dates from Marées's years in Munich. It is delightfully unconventional and only slightly marred by Marées's clumsily unfinished hand. Marées was at the time twenty-six, Lenbach only one year his senior; but the young painter seems to have taken pleasure in making his more accomplished friend seem much older, as he looks out from under the broad brim of his hat, his thick glasses concealing a morose expression. The contrasts in this painting antithesize established rules: the foreground figure is fully exposed, yet shaded and not fully delineated, the background figure is half-hidden, yet brightly illumined and more solid in form. Lenbach is a near-caricature, Marées a study in wicked humor. The contrast of their skin tones is softened by the subtle interplay of color, as the picture's mockery is softened by its charm.

Already in Munich Marées had found the vaguely mythological subjects that would occupy him through most of his career. In 1864 he went to Italy, which became his adopted country. In Rome he met the critic and theoretician Konrad Fiedler, with whom he traveled to Spain, France, Belgium, and Holland, and who became his lifelong patron. Another newly won friend was the sculptor Adolf von Hildebrand, who joined Marées in a particularly happy and fruitful enterprise: the decoration in 1873 of the library of the German Marine Zoological Station in Naples.

These still little-known frescoes are among the most accomplished nineteenth-century murals.[71] Painted from nature in a straightforward Realist style, yet with an exquisite sense for tectonic values, they are meant to express, according to the painter's own words, "the joys of sea and beach life." On the west wall are two groups of nude fishermen in front of two steep rocks, carrying their nets and pushing their boat into the water. The broad north wall is covered by a large seascape with a long boat. Four powerful, sunburnt Neapolitans row a dreaming woman, an old man, and a child across the bay. *The Oarsmen,* 1873 (no. 56), is a study for this part of the fresco. The artful overlapping of their bodies creates a relief effect which captures the immediacy of the moment while it simultaneously monumentalizes it. The study also indicates the forceful thrust of the oars against the direction of the tide. What this close-up view cannot convey is how in the fresco the group stands out against the wide sky with its pink streaks of clouds, how the space seems to expand while the boat slides swiftly through the rippling sea, with foam trailing behind and a white gull following its course. The fresco on the south wall depicts an orange grove with laborers, and two women on a bench exchanging confidences. The composition is reminiscent of Overbeck's *Italy and Germany* (see fig. 4), which Marées could have seen during his first stay in Rome; but half a century separates the older, more didactic, and historicizing work from this unaffected depiction of humanity. On the east wall is the reunion of Marées and Hildebrand with the founders of the Marine Zoological Station in an osteria. Behind them is a ruin with parallel rows of receding arcades. This transformation of their gathering place was perhaps suggested by the illusionistic architecture of Pompeian wall painting;[72] Hildebrand uses Pompeian motifs in the decorative framework he designed for the frescoes. Marées's cycle summarizes Italy's meaning to the generations of eighteenth- and nineteenth-century Germans who, like him, had made it their home. Tired of modern civilization, these northerners reveled in the simple, unrestrained life under the Mediterranean sun. They understood the unaffected manners of the people as remnants of archaic forms of life. Marées seems to have experienced his familiarity with the fishermen as antiquity reborn. His frescoes can be seen as a gesture of gratitude for his artistic and personal liberation.

Yet the fresco cycle was only a transitional work. Its surface realism had to be eliminated. *The Ages of Man,* 1873–78 (no. 58), exemplifies the painter's continuing effort to convey the harmony between man and nature by achieving, in scenes with minimal action, a balance between the generalized figure and a generalized landscape, between planar surface and spatial depth. The painting is a preliminary work. It shows how Marées developed his conception of the nude through careful study of such early Renaissance masters as Signorelli and Perugino. He used a traditional iconographic scheme and filled it, as L. D. Ettlinger has pointed out, with autobiographic content: the spatial distance between the couple and the apple-plucking man is a reference to Marées's isolation after Hildebrand and Fiedler both had married.[73]

The development of Marées's art culminated in his four great triptychs: *The Judgment of Paris,* 1880–81 (Nationalgalerie, Berlin), *The Hesperides,* 1884–87 (Neue Pinakothek, Munich), *Three Saints on Horseback: St. Martin, St. Hubert, and St. George,* 1885–87 (Neue Pinakothek, Munich), and *The Wooing,* 1885–87 (Neue Pinakothek, Munich). In *The Hesperides* (fig. 15) the central

15. Hans von Marées. *The Hesperides.* Triptych, 1884–85.
Oil and tempera on wood, 304 x 482 cm (134 x 190″).
Neue Pinakothek, Bayerische Staatsgemäldesammlungen, Munich

panel depicts the beautiful daughters of Hesperus; the lateral panels are invented scenes of the Golden Age. Yet the effect is more mythical and otherworldly than in other, more literal mythological paintings of the time. The three figures are striking in their radiant surfaces. In his late works Marées used tempera overpainted many times with oils, so that the color seemed "intangible"; the more one particular pigment lost its substance in the compound of colors, the more luminous the figure became. Julius Meier-Graefe found in these late paintings effects that reminded him of Japanese lacquer or of iridescent Tiffany glass. Marées believed that in the course of constant overpainting, his works would grow like living organisms; this was confirmed by the biologist Kleinenberg, a friend from the days of the Naples frescoes, who believed that art was the counterpart of the organic.[74] Marées's complicated technique, which has not always withstood the test of time, here affords the glowing quality to the golden orange nudes as they emerge from deep darkness. They are solidly modeled, yet partially outlined; their facial features and hair seem almost accidental strokes of the brush. Like Runge's *Morning* (see no. 73) they are inaccessible and remote, clad in their own radiance, their regal attire. In a realm beyond time, they dwell in beauty.[75]

Arnold Böcklin (1827–1901), a Swiss from Basel who spent most of his working life in Florence and Rome, was not opposed to the developments in Germany. He was a conservative at heart, and his experience in Paris in 1848 filled him with a lasting aversion to everything French. Instead he found instant patronage in Germany. With his German fame rising, he became an ardent admirer of Bismarck. The Franco-Prussian War inspired him to create several versions of the Battle of the Centaurs, in the words of Georg Schmidt, "the dipiction of the most brutal and brainless struggle among men. . . . Only the victor can

see war in this way."[76] Böcklin's seventieth birthday, honored by exhibitions in Berlin, Hamburg, and Basel, marked the peak of his celebrity. A few years after Böcklin's death Meier-Graefe launched a frontal attack against him, describing him as a "block on the road of progress in art," meaning the road that led from Constable—via Delacroix, Corot, and Manet—to Cézanne. Böcklin's art has since then been much debated.[77] Its influence can be seen in Symbolism, Art Nouveau, and Surrealism; and there is no doubt about its renewed relevance today, in view of the recent wholesale rehabilitation of academic art. And indeed, a proper evaluation of Böcklin's strengths and weaknesses could serve to establish a more reasonable attitude toward the *pompiers* among his contemporaries.

The majority of Böcklin's paintings can be explained as an attempt to personify the forces of nature as such mythological beings as satyrs, nymphs, the great god Pan, centaurs, tritons, and nereids. His style changed considerably about 1858, after his first sojourn in Italy. In his earlier paintings atmospheric landscapes saturated with sunlight, not unlike the early works of Corot, were predominant; the figures were small and merely incidental. Later, the ratio was reversed, and along with the preponderance of the figures, Böcklin's naturalism increased. Now his figures were rendered with meticulous detail, and harsh light was cast on strident local colors. But the mythological figures remained the same, continuing to express Böcklin's vision of nature. The natural forces they represented—wind and weather, fertility, the sea—were not endowed with religious significance as those of Runge and the Romantics had been. Böcklin's art is informed by a "naïve, uncritical materialism";[78] hence the contemporary description of his work as "Darwinistic" mythologies.

The success and failure of these paintings, apart from their

pictorial properties, can be measured by the degree to which landscape and incident, myth and nature are mutually integrated. Within Böcklin's oeuvre *Prometheus* (fig. 16) represents the highest standards. In a tempestuous landscape similar to those of Ruysdael, the titan's body stretches across a row of mountains. He throws his limbs about in an effort to break his fetters. His skin reflects the murky sky, his spasms reverberate in the clouds, as though his helpless rage will unload itself in the rising storm. All nature mirrors his pain. The surge of the waves against the rocks is as futile as his struggle against his chains. A ray of sun pierces the darkness as trenchantly as the iron cuts into his flesh. And it is an act of exquisite artistic discretion that the gleaming cliffs and treetops (these latter reminiscent of Dupré and Diaz) are emphasized more than the faint flickers on Prometheus's body.

Measured against this summit achievement *The Birth of Venus,* 1868–69 (no. 6), appears unresolved even beyond its unfinished state. Böcklin said that he was aiming at a composition that "grew out of a narrow base and unfolded higher up." In the monochromatic blue, he wanted to "visualize a felt pictorial harmony."[79] Great care has been taken to allow the foam of the waves to materialize in the goddess's veil. The amorini's extending of this veil, however, is lacking in purpose, and Venus remains too much the model, posing rather embarrassedly on the beach.

Böcklin's favorite subjects are the divinities of the sea. The sea gods of antiquity invariably express an unappeased longing, symbolizing the eternal surge of the sea against the land and the impossibility of a fusion between the two.[80] Böcklin creates moving correspondences between moods in nature and the human condition as in the two versions of *Triton and Nereid* (1873–74, Staatsgemäldesammlungen, Munich; 1875, formerly Nationalgalerie, Berlin).[81] However, his *Naiads at Play*, 1886 (Kunstmuseum Basel),[82] are merely a group of screaming tourists at a bathing resort.

Böcklin, while painting one of his five versions of *Island of the Dead* (see nos. 9 and 10), is recorded to have said: "It shall become so quiet that you are frightened by a knock at the door."[83] And it is in fact evident that he composed the picture with this effect in mind; too calculated are the parallels between the veiled figure, her coffin, and the marble mausoleum built into the rocks, and between the figure's erect stance and the cypresses, so implausible on a rocky island. Too obvious also is the invitation to ponder death in a realm of absolute lifelessness; one turns away from this imposition as from a musty smell. Yet the painting served the purposes of the painters Nolde, de Chirico, Dali, Max Ernst, and Ernst Fuchs, the composers Rachmaninoff and Reger, and the playwright Strindberg. The advertising industry also bears witness to its seemingly endless popularity.

In contrast, *Murder at the Castle,* 1859 (no. 5), is both more plausible and more vital. Setting, mood, and incident are in accord. The desolate morning, the wild vegetation, the ancient stairs, and the elegant but deteriorating castle create the mood of world-weariness and decay in which Böcklin excels. He thus creates just the right setting for the shadowy scene of abduction, which unfolds with cinematic rapidity.

* * *

The art of Adolph von Menzel (1815–1905) is for many synonymous with Prussian history and the Prussian Empire. Nowhere in nineteenth-century art is the ideal of naturalistic history painting, to recreate the past as a living present, as fully realized as in his depictions of the life and times of Frederick the Great. His later representations of life at the court of William I are incisive portrayals of the customs and mores of the period, yet at the same time they are paintings of unusual atmospheric brilliance. This rare accomplishment points to the central paradox of Menzel's artistry. He was a genius, possessed of an extraordinary pictorial vision, yet he was a pedant, ensnared by an obsessive striving after historical accuracy and rigid attention to meticulous detail. These were qualities hard to reconcile; and in much of his prodigious output Menzel's genius was in fact held in check by his sense of duty,[84] an eminently Prussian as well as Protestant value which compelled him to draw whatever he saw. The equal rights of all things visible assert themselves more forcibly in Menzel's art than in that of any other artist of the period; posterity owes to this compulsion thousands of meticulous and masterly nature studies. When in 1839 the twenty-three-year-old, self-taught artist was commissioned to illustrate Kugler's *History of Frederick the Great,* he scoured the archives and armories for relevant materials, from the operational plans of Frederick's battles to the sword hilts and stirrups of his hussars; this encyclopedic knowledge ulti-

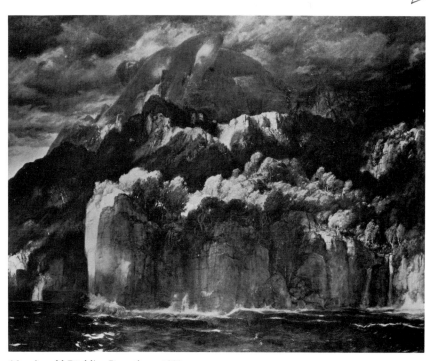

16. Arnold Böcklin. *Prometheus,* 1882.
Oil on canvas, 116 x 150 cm (45⅝ x 59"). Private collection

17. Adolph von Menzel. *The Dinner Conversation* (illustration for Franz Kugler's *History of Frederick the Great*), 1839–42. Wood engraving, 142 x 102 cm (55⅞ x 40⅛″).

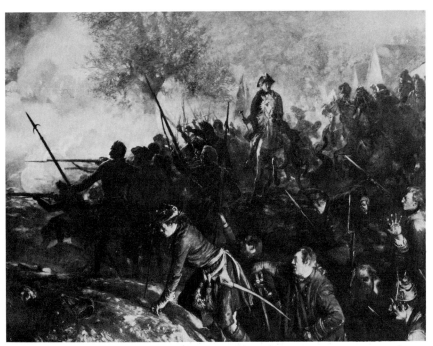

18. Adolph von Menzel. *Frederick and His Men in the Battle at Hochkirch,* 1856. Oil on canvas, 295 x 378 cm (116⅛ x 148⅛″). Nationalgalerie, Staatliche Museen Preussischer Kulturbesitz, Berlin

mately was absorbed into a vibrant graphic shorthand (fig. 17). In accordance with liberal middle-class ideology on the eve of the German Revolution of 1848, Menzel stressed the enlightened, reformist, and humanitarian aspects of Frederick's rule; but he also stressed the horrors of his wars.[85] In the following decade Menzel embarked upon an ambitious series of large paintings, similarly illustrating incidents from the life of the king. In several of these he achieved a balance between information and pictorial breadth, as in the ghostlike *Frederick and His Men in the Battle at Hochkirch* (fig. 18)—characteristically, a scene from a lost battle—in which the wildly agitated king gallops between the front lines of his grenadiers as they fire at an unseen enemy. But the painted version of Frederick conversing with Voltaire at table and the all too popular *Frederick the Great's Flute Concert*, 1850–52 (Nationalgalerie, Berlin),[86] are studied and dry.

From the 1840s on Menzel painted a series of pictures entirely different from the rest of his work. These remained virtually unknown during his lifetime, although they created a sensation at the commemorative exhibition of 1905; they are still considered by most critics superior to Menzel's history paintings and perhaps to his other works, with the exception of his best portraits. *Prince Albert's Palace Garden,* 1846 and 1876 (no. 61), and *The Berlin-Potsdam Railroad,* 1847 (no. 62), random cuttings of urban nature, have in their broad atmospheric treatment precedents in some works by Blechen (see no. 4), but the way in which in *Palace Garden* the skeleton of the poplar is bared by the light, or in the *Railway* the loamy soil and the dark trees are brushed in inevitably recall Constable. No less unusual within their time are certain family scenes, such as *The Artist's Sister with a Candle*, 1847 (Bayerische Staatsgemäldesammlungen, Munich), or depictions of empty interiors, above all *Room with a Balcony*, 1845 (Staatliche Museen, Berlin),[87] both remarkable for their "recognition of greatness in the unpretentious" (Novotny) and for their all but Impressionist treatment of light. The incomparable *Théâtre du Gymnase*, 1856 (no. 63), anticipates later developments in Degas.

These pictures were for Menzel, however, with all their charm, of subordinate importance; it was into his historical works that he put the whole weight of his artistic intelligence and his highest aspirations.

Menzel did not record the events of war that occurred during his lifetime. During the Austro-Prussian War he followed the army to the battlefield of Königgrätz, but only to assure himself of the accuracy of his own historical battle scenes.[88] His sole tribute to the Franco-Prussian War was the *Departure of King William I for the Army on July 31, 1870*, 1871 (no. 64), a piece of patriotic reportage[89] in spite of the crying Queen Augusta; Menzel could hardly have known that the king was at heart as unwilling to wage this war as he later was to accept the imperial crown. The crowd that gathered on this as on any other afternoon on Berlin's Unter den Linden is Berlin's high society. Here, as in his later depictions of court balls and imperial galas,[90] Menzel treats the crowd not as an amorphous mass but

as a conglomeration of individuals; that he manages to unify these crowds in broad, pictorial rhythms is not the least of his artistic triumphs.

How did Menzel, the liberal sympathizer of 1848 (see fig. 9), become the chronicler of a society whose arrogance and mediocrity he disparaged, and which made him, the dwarfish Little Excellency, the butt of its tactless jokes. Part of the answer is to be found in the paintings themselves, for at close inspection they are anything but flattering; for the rest one may turn to a letter of Menzel's, written as early as 1836: "The artist has always created and accomplished only what was desired in his time. . . . Art has gone along, and will always go along, with every advance and every aberration of the evolution of the spirit . . . for as is mankind in general, so are artists but part of their epoch and subject to its demands."[91]

These words would surprise no one if they had been said by Franz von Lenbach (1836–1904) who, as a society portraitist and creator of a "gallery of potentates,"[92] is on a par with Sir Thomas Lawrence, Franz Xaver Winterhalter, and Giovanni Boldini. Lenbach started out as a journeyman mason in Schrobenhausen, Upper Bavaria; by the end of his life he had married into the aristocracy and resided in grand style in a neo-Renaissance villa.[93] Among his sitters were the internationally renowned of all professions, including Eleonora Duse and Gladstone, the physicist and physiologist Hermann Helmholtz, the statesman and Arctic explorer Fridtjof Nansen, Richard Wagner (see no. 45), Liszt, the historian Theodor Mommsen, and the singer Yvette Guilbert. Only in 1858–59, during and after his first stay in Rome, was his work in its plein-air naturalism akin to that of Menzel, as in *The Arch of Titus in Rome* (fig. 19). Lenbach envisioned the monument as part of the contemporary scene, dazzling in the Roman light, a beacon to peasants and goatherds.

Lenbach was helped on his way to prosperity by the Viennese Hans Makart, a friend from their student days in the class of Piloty. Makart[94] created his excessive, oversized, and erotically charged history paintings, and his Titianesque portraits of society ladies, in a studio cluttered with antiques and oriental bric-a-brac, which became the model for upper-class interiors during the last decades of the nineteeth century, known as the "boom period." Lenbach's career was helped further by his friendship with Bismarck, which inspired some of his finest works (see no. 47). He portrayed his sitters as they wanted to be seen, in postures indicative of their class and success. When his commissions increased he developed a set formula: the face, dramatically lit, is executed in detail, while the sketchy body blends into the luminous *Galerieton.* Quite often he painted from photographs which he took himself. He also painted directly on photographs which he had had enlarged and printed upon canvases prepared with coatings of silver salts.[95] It was inevitable that a large part of Lenbach's immense output was facile, routine work, salvaged only occasionally by an unusual ability to render physiognomy. Lenbach dominated the Munich art world in

19. Franz von Lenbach. *The Arch of Titus in Rome,* c. 1860 (dated 1858 or 1859). Oil on canvas, 179 x 120 cm (70½ x 47¼"). Szépmüvézeti Múzeum, Budapest

20. Franz von Lenbach. *Gabriele Lenbach,* 1902. Oil on cardboard, 47 x 35 cm (18½ x 13¾"). Private collection, Cologne

narrow-minded opposition to the more advanced movements—Art Nouveau, Symbolism, neo-Impressionism, and so-called German Impressionism. Lenbach perceived his art in the tradition of the portraiture of Titian, Velázquez, Rubens, and Rembrandt. Toward the end of his life, as a doting father, he became a master of children's portraits. *Marion Lenbach,* 1900 (no. 48), is a portrait of his older daughter and *Gabriele* (fig. 20), his gypsylike favorite, a three-year-old fully aware of her charms.

There could have been no agreement between Lenbach and Wilhelm Leibl (1844–1900). In contrast to Lenbach's cosmopolitanism Leibl spent his life in remote Bavarian villages. While the older artist won international acclaim with his flattering virtuoso style, the younger one found his austere veracity denounced, at least in Germany, as a "cult of ugliness."[96] Against Lenbach's old-master technique Leibl upheld his ideal of painting alla prima, without underpainting or glazes. He too made portraiture his principal concern; but he painted only his relatives and close friends or people of simple peasant stock. Leibl has often been quoted as saying: "I paint men as they are; the soul will be there anyway"; and indeed, even his earliest portraits convey an ineluctable inner truth.

Already at the Munich Academy Leibl had a following among his fellow students, and he impressed, and eventually alienated, his masters, who included Ramberg and Piloty, through his talent and his strong, self-willed personality. When Courbet saw his works in the first Munich International Exhibition of 1869, he proclaimed Leibl the finest contemporary German painter. It may have been due to Courbet's recommendation that the young artist received a private grant which allowed him to work in Paris until the outbreak of the Franco-Prussian War. The two principal works of this period introduce two different modes of painting which Leibl would use alternately throughout his career: *Old Parisienne* (fig. 21) is built up from broad, choppy brushstrokes; and in the so-called *Cocotte* (fig. 22) the rich painterly detail is smoothed over so as to create a shimmering, enamellike surface. In Paris, where the painter received the first of several gold medals, he was hailed as "Holbein redivivus."

Upon his return to Munich in 1870 the so-called Leibl circle was formed; it included, among others, Wilhelm Trübner, Carl Schuch, Johann Sperl, and the Americans William Merritt Chase and Frank Duveneck. This group maintained contact with another, similar group which had formed in Frankfurt around Viktor Müller and included Otto Scholderer, Louis Eysen, and Hans Thoma.

All these young painters were in various ways affected by

21. Wilhelm Leibl. *Old Parisienne,* 1869.
Oil on wood, 81.5 x 64.5 cm (32⅛ x 25⅜").
Wallraf-Richartz-Museum, Cologne

22. Wilhelm Leibl. *Young Parisienne ("Cocotte"),* 1869.
Oil on wood, 64.5 x 52.5 cm (25⅜ x 20⅝").
Wallraf-Richartz-Museum, Cologne

the art of Courbet;[97] in order to give a firm basis to their own Realist aspirations, they embraced Leibl's principle of rendering essential nature under the impact of light in a unified tonality. Trübner (1851–1917; see no. 96) adopted the open form of the *Old Parisienne;* he systematized his short, unconnected brushstrokes into a kind of mannered mosaic. According to his artistic creed the subject was irrelevant, and only "good painting" mattered; hence the cool and intellectual quality of his coloristically delicate art. In this and in his elegant, bourgeois subject matter he differed radically from Leibl. Eysen (1843–1899) also developed in a direction quite different from that of Leibl: his ascetic treatment of simple subjects, evident already in the early *Still Life with Shell, Glass of Water, and Spoon,* 1869 (no. 23), made him a forerunner of the post-World War I style of New Objectivity. Thoma (1839–1924) excelled in sunny, intensely lyrical landscapes, mostly of his native Black Forest. Figures such as the young woman plucking flowers in *In the Forest Meadow,* 1876 (no. 94), express the artist's joy. Courbet's exhibition of 1868 left a deep impression on Thoma, as can be gathered from the portrait of Ida Müller, 1877 (Städelsches Kunstinstitut, Frankfurt am Main), whose dreamy expression is reminiscent of Courbet's *Gabrielle Borreau* (fig. 23). The young Thoma also painted some outstanding scenes from peasant life for which his relatives posed. In the mid-seventies, however, his style changed under the influence of Böcklin. From this time on idyllic and allegorical subjects prevailed, and Thoma's painterly approach gave way to an often harsh and unmelodious linearism. He also painted religious subjects in a neo-Nazarene vein and scenes from fairy tales which made him an epigone of Moritz von Schwind. After 1900 he was the most popular contemporary German painter, the result of his upholding—in the face of Expressionism—retrospective, Romantic traditions.

Like most artists' associations the Leibl circle was short-lived, and Leibl's direct influence on the two groups came to an end when, in 1873, he left Munich for an independent life as a villager in the foothills of Upper Bavaria. Postwar chauvinism had turned establishment opposition to his art into open hostility since he was considered the principal promoter of French influence on German painting and was, in addition, a friend of the Communard Courbet. Hence Leibl found it easy to withdraw from the scene of his battles, especially since he was given to the joys of hunting and mountain climbing. He was accompanied by his devoted friend, the landscapist Johann Sperl, with whom he collaborated on several paintings, among them, *Orchard in Kutterling,* 1888 (no. 42). In his new surroundings Leibl's palette brightened, and he began to paint in flaky particles of softly modulated colors, enveloping his subjects in a luminous veil. This, together with his empathy for his—now mostly female—sitters, raised the quality of his art to a new level. Yet Leibl felt compelled to strive increasingly for truth to detail in nature. The well-known *Hunter,* 1876 (formerly Nationalgalerie, Berlin), Leibl's only plein-air painting, was the first in this new style. If *Countess Rosine Treuberg,* 1877 (no. 41),

23. Gustave Courbet. *Reverie: Portrait of Gabrielle Borreau,* 1862. Oil on canvas, 63.5 x 77 cm (25 x 30⅜"). Private collection

so haunting in its suggestion of a secret inner life, had been finished, it would have shown the same hyperclarity that we find in *Three Women in Church* (fig. 24).

The spiritual veracity of the painting represents Leibl at his best. The unity it achieves, despite its attention to detail and its psychological intensity unhampered by its cameralike objectivity, cannot be surpassed. Ironically Leibl achieved these effects while using a working method that was anything but rational, for he worked without even the sketchiest preliminary outlines. In this painting, for instance, he might have begun with one corner of the young woman's embroidered scarf; these few meticulously painted square inches would then determine the proportions, spatial relationships, plasticity, texture, light, and tonality of the entire painting. He required that his sitters appear every day in the same attitude, on the same bench, even if he finished no more than part of the brim of a hat. Only this most singular combination of concentration, willpower, and inner vision—not to speak of the collaboration of his models—enabled Leibl to work according to this method; when it failed because of mistaken proportions, as happened in his following works, *Girl with a Carnation,* c. 1880, and *The Poachers,* 1882–86, he cut the canvases to fragments.

Following these experiences Leibl went into a deep depression, from which he did not emerge until five years later, in full possession of a serene final style. In his last paintings everything is muted; the outlines dissolve in twilight, and the vibrations of the colors are as intangible as the vibrations of the sitters' souls (see no. 43).

The so-called German Impressionists include Max Liebermann, Lovis Corinth, and Max Slevogt. But this traditional

24. Wilhelm Leibl. *Three Women in Church,* 1878–82.
Oil on wood, 113 x 77 cm (44½ x 30⅜").
Hamburger Kunsthalle, Hamburg

Dog, 1879, no. 84). Finally, both Slevogt and Corinth were largely painters of literary, religious, and mythological subjects.

Max Liebermann (1847–1935) shared with the Impressionists their emphatically contemporary subject matter. In his later years he adopted also their opinions concerning the relative unimportance of the subject, as well as the equal right of all things visible to be represented pictorially. In his long career Liebermann painted only three literary (biblical) subjects; the "socialist" themes of his youth were a passing, albeit an important phase. "Fantasy in painting"[99] meant to him nothing but the pictorial transformation of something seen; painting was an end in itself, not to be tainted by extraneous elements. By taking this position Liebermann joined critics such as Julius Meier-Graefe and Karl Scheffler in their view of nineteenth-century painting as culminating in French Impressionism, which to them was an art based exclusively upon visual experience. We know today, however, that French Impressionism itself was not in fact devoid of "extraneous"—intellectual, historical, and symbolic—elements; nor is the road from Constable to Cézanne considered the only valid one in the nineteenth century. In its essence Liebermann's theory runs counter to German tradition, and it did not deeply affect the course of German art; yet, as indicated by the critical fates of Menzel, Blechen, and Böcklin, it did have its impact on criticism. Liebermann's own broad-mindedness can be seen by the fact that he made Böcklin an honorary member of the Berlin Secession. Moreover, he defended Edvard Munch when his 1892 exhibition in Berlin was closed at the instigation of Anton von Werner (see fig. 12); he did, however, oppose Nolde, the Brücke Expressionists, and the young Beckmann, out of what he termed "respect for the ideality of nature."

Liebermann's art and theory were a clear expression of his personality. His rationalism, his work ethic, and his profound respect for the simple facts of life were as much a Prussian as a Jewish legacy. He came from an extremely wealthy family of Jewish merchants and industrialists whose enterprises thrived under the direction of his father, and he grew up in a palatial house next to the Brandenburg Gate. Both he and his father maintained their Jewish and their Prussian roots. Liebermann, the liberal *grand bourgeois,* considered himself heir to the revolutionaries of 1848; his political hero was Ferdinand Lassalle, the founder of the first German socialist workers' party. With his democratic convictions Liebermann found himself in opposition throughout his life; he condemned the imperialist delusions of William II as well as radical tendencies in the 1920s. In 1933, during the rise of Hitler, Liebermann resigned under pressure as honorary president of the Prussian Academy of the Arts; his fame and his death spared him worse persecution. His wife was later the victim of Hitler's racial policy.

Liebermann's early enthusiasm for Munkácsy, as a painter of peasant subjects, soon gave way to a deep appreciation of Munkácsy's models, Courbet, Millet, and the painters of the Barbizon school.[100] Paradoxically it was Liebermann's privi-

designation needs to be modified. From 1898, primarily through the Galerie Paul Cassirer in Berlin, French Impressionism found its way into museums and private collections, and thus into the public awareness of Germany. That certain painters, above all the three just mentioned, would be inspired by the great French artists was inevitable; Liebermann himself formed a distinguished collection of works by Manet, Monet, Degas, and Cézanne.[98] It was also inevitable that certain critics would compare their respective styles to those of the French Impressionists, with whom the German painters shared plein-air subjects, bright tonality, suppression of detail, quick brushwork, and eventually even colored shadows. However, those critics overlooked the fact that the Germans adopted none of the most radical French innovations: the division of color into its spectral constituents, the organization of space by means of color alone, and the dissolution of matter in light. While Liebermann, through his predominantly gray color scale and his insistence on corporality, remained loyal to his roots in Naturalism, Corinth and Slevogt moved occasionally into the orbit of Expressionism, Corinth through subjective deformation of shape, Slevogt through non-naturalistic color (as, for instance, the foliage in *Red Arbor with*

leged upbringing that made him sensitive to the dignity of peasants and farmhands, and sensitive as well to their deprivations. Not surprisingly, his first great compositions, *The Geese Pluckers,* 1872 (Nationalgalerie, Berlin), *Women Cleaning Vegetables,* 1872 (Private collection, Winterthur), and *Potato Harvest,* 1875 (Kunstmuseum, Düsseldorf),[101] brought him the title "apostle of ugliness." Liebermann also scandalized his audiences, both Christian and Jewish, with his painting *Jesus in the Temple* (fig. 25), because it was staged with contemporary models; the twelve-year-old Jesus was an Italian street urchin. As had happened thirty years earlier to the Pre-Raphaelites, Liebermann's veracity was denounced as blasphemy. This venture, however, gave rise to other scenes in contemporary costume from the life of Christ—by the Munich painter Fritz von Uhde, who called himself the "first idealist of Naturalism," and by Corinth and Slevogt.

The shallow ostentation of his own class made Liebermann seek a simpler life in a community close to nature. Holland, a country he visited almost every year, 1872–1913, had an unbroken democratic tradition, and artists (Frans Hals as well as Jozef Israels), a culture, and social institutions that corresponded to his ideals; the Dutch schools, orphanages, and old-age asylums provided exemplary care for the poor among the old and the very young; a Dutch village was in essence the cooperative society as outlined by Lassalle. These subjects the young Liebermann found worth depicting. *Old-Age Home for Men in Amsterdam,* 1880 (no. 50), is a well-known example from

26. Max Liebermann. *Leisure Hour in the Amsterdam Orphanage,* 1881–82. Oil on canvas, 78.5 x 107.5 cm (30⅞ x 42⅜"). Städelsches Kunstinstitut und Städtische Galerie, Frankfurt am Main

this group, *Leisure Hour in the Amsterdam Orphanage* (fig. 26) its masterpiece. But Liebermann was not a social revolutionary. Matthias Eberle argues convincingly that the gradual disappearance of such subjects during the 1890s had to do with the abolition of Bismarck's legislation against socialists, and with the introduction of compulsory insurance for workers in Germany. With these basic issues settled Liebermann could depart from an "art engagé," leaving its practice to lesser artists.

It was also during the 1890s that the Naturalism of Liebermann's earlier works gave way to his so-called Impressionism. The paintings in this style, of which *Men by the Sea,* c. 1874 (no. 59), and *Man and Woman Riding on the Beach,* 1903 (no. 52), are examples, are predominantly of bodies in motion, sketchily rendered in bright daylight. Yet Liebermann is reported to have said: "That business about the divided colors is all nonsense. I have seen it [many times]: nature is simple and gray." Increasingly Liebermann turned to subjects concerned with his own class—beach and country life, rendered with a pictorial elegance unparalleled in German art. He also became the portraitist for the intellectual elite. After World War I his subjects were confined to his own family, house, and garden.

The second member of this triad, Lovis Corinth (1858–1925), studied for eight years in Königsberg and Munich with minor masters of the peasant genre, after which, from 1884 to 1887, he studied in Paris with Bouguereau; he remained remarkably unreceptive to Courbet, Manet, and the Impressionists. From the outset Corinth was possessed by an insatiable optical hunger, an ever-ready visual excitability which made him paint instinctually, unhampered by conventional standards of taste. The rhythm of his life was a constant vacillation between

25. Max Liebermann. *Jesus in the Temple,* 1879. Oil on canvas, 150 x 132 cm (59 x 52"). Private collection

27. Lovis Corinth. *Self-Portrait with a Skeleton*, 1896.
Oil on canvas, 66 x 86 cm (26 x 33⅞").
Städtische Galerie im Lenbachhaus, Munich

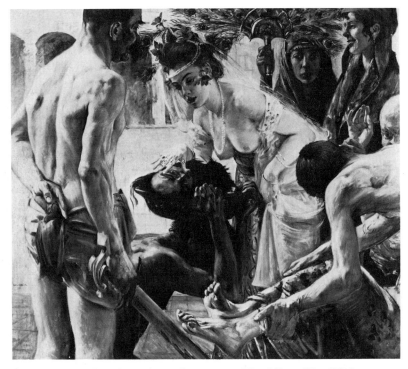

28. Lovis Corinth. *Salome*, 1899. Oil on canvas, 127 x 147 cm (50 x 57⅝").
Museum der bildenden Künste, Leipzig

29. Lovis Corinth. *Walchensee-Panorama*, 1924.
Oil on canvas, 100 x 200 cm (39⅜ x 78¾").
Wallraf-Richartz-Museum, Cologne

euphoria and depression. While he was cunning in pursuit of his career, he was naïve in his aesthetic orientation. Both these qualities account for his extended period of study, the many stylistic changes of his youth, and his long dependence upon certain artistic and intellectual fashions of his time.

Corinth came into his own in 1891, when he settled a second time in Munich. He was fast to adopt the new Idealist tendency, but he imbued his symbolic and mythological subjects with his own deep-rooted materialism. It suffices to compare, as has often been done, his *Self-Portrait with a Skeleton* (fig. 27) with Böcklin's *Self-Portrait with Death as Fiddler,* 1872 (no. 8). Corinth does not depict Death but an anatomical model; while Böcklin seems tempted by the tune from the netherworld, Corinth manifests his will to live, despite a physique stamped by alcoholism. Corinth turned quite often to butcher shops as subjects of potential pictorial brilliance (see no. 13). Memories of his father's tannery accounted for this predilection; that the subject could seem vulgar or repulsive would never have occurred to him. At his best Corinth could make a rack of freshly slaughtered beef look like, in painterly terms, the most ravishing profusion of fruit and flowers; at his worst he painted odalisques and bacchants like raw meat, and *The Blinding of Samson,* 1907 (Mittelrheinisches Landesmuseum Mainz), as a butchery.[102] *Salome* (fig. 28) brought him instant success when he moved to Berlin in 1900, but the modern viewer is no longer susceptible to the ostentation and theatricality of such pictures, to their superficial realism, or their echoes of vulgarized Nietzschean Superman ideology or of Weininger's concept of the battle of the sexes. As a portraitist Corinth was capable of profound characterization and of great tenderness, as in his portraits of his wife (see no. 14). In his Impressionist landscapes he did not render light through spectral colors; atmospheric effects came to him quite naturally through the combination of his nervous brushwork and a palette heightened by heavy admixtures of white.

In 1911 Corinth suffered a stroke. After a long period of recuperation his style changed. Several critics maintain that the jagged rhythms of trembling, "windswept," diagonal brushstrokes, the discontinuous shapes and frequent clashes of color were caused by a tremor in his right hand. But Eberhard Ruhmer has refuted this theory on the grounds of contemporary testimony, which proves that those characteristics were due not to a lack of motor control but to willfully induced states of hypertension.[103] And in fact they are an intensification rather than a break with Corinth's previous style as it had evolved during the 1910s. With his ever-increasing concentration upon landscape, the landscape around his beloved Walchensee in Upper Bavaria (fig. 29), the slag was removed from his art. These broad and shimmering views of lake and mountain convey the same ardor and restlessness that inform Mahler's last symphonies; like these, they are an ecstatic "Farewell to Life"; their Impressionism is of a visionary kind. Similarly, Corinth's last

30. Max Slevogt. *Lions in Their Cage,* 1901. Oil on canvas, 52 x 59 cm (20½ x 23¼″). Städtische Galerie, Niedersächsisches Landesmuseum, Hannover

hand of liberated brushwork. He learned to model with light and to dissolve distant complexes in a multicolored haze, using complementaries but not a divided brushstroke (fig. 30). He also worked on illustrations for the *Thousand and One Nights,* a series of swift, vibrating pen drawings, executed with the same newly gained freedom.

In Berlin Slevogt discovered in portraiture a new field, especially actors' portraits. His *Francisco d'Andrade as Don Giovanni,* 1903 (Collection Francisco d'Andrade, Jr., Lisbon),[107] is deservedly famous for its seignorial attitude and its sparkle. The painting has its counterpart in *Marietta de Rigardo* (fig. 31), which depicts a Philippine dancer, enticing and impassive as she wheels slowly around the floor to the accompaniment of guitars and castanets. Slevogt's public was to be found among Berlin's upper bourgeoisie, a civilized breed, politically opposed to the Empire, that found in his paintings a reflection of its elegance and exuberance.[108] In *Nini at the Vine Trellis,* 1911 (no. 85), the artist portrayed his wife on her family's estate in Neukastel. He painted her as a *grande dame,* with a majestic sweep of composition. Were it not for Nini's wry and pessimistic expression,

portraits are visionary evocations of the sitters' spirituality, suffused with the artist's own awareness of death.[104]

The early development of the third German Impressionist, Max Slevogt (1868–1932), in some ways paralleled that of Corinth. Slevogt also studied in Paris at the Académie Julian, and experimented in Munich with Idealist Naturalism; like Corinth he met with opposition in Munich and with instant success in Berlin. As a painter of literary subjects Slevogt was closer to Corinth than to Liebermann. But they differed greatly in character. Corinth was a sturdy East Prussian, capable of occasional lapses into vulgarity. Slevogt had his roots in the southwest of Germany; he was civilized, balanced, and gifted with some of the Apollonian serenity of Mozart, his idol. Both artists worked intermittently in the graphic arts, but in Slevogt's career there were periods when the book illustrator outweighed the painter. As an illustrator he ranks second only to the Austrian Alfred Kubin.

Sheherezade, 1897 (no. 83), depicts the 1890s fashion of staging mythical subjects with contemporary models. For this painting friends posed for Slevogt in his studio. The relief composition creates an impression of physical closeness. The painting is similar stylistically to the earlier *Danaë,* 1895 (Städtische Galerie, Munich),[105] which created a scandal because of the ugliness of the models, and because Slevogt interpreted the subject as an allegory of procurement, the "nurse" catching most of the rain of gold in her apron. The triptych *The Return of the Prodigal Son,* 1898–99 (Staatsgalerie, Munich),[106] made Slevogt famous; here the human impact triumphs over the anachronistic treatment.

In his large series of oils, watercolors, and drawings of the Frankfurt zoo, done in 1901, Slevogt created a pictorial short-

31. Max Slevogt. *Marietta de Rigardo,* 1904. Oil on canvas, 230 x 180 cm (90½ x 70⅞″). Gemäldegalerie Neue Meister, Staatliche Kunstsammlungen Dresden

32. Max Slevogt. *Papageno*, detail, 1924. Fresco. Music Room, Neukastel

coherent form, and in the human figure a sharper characterization. Whether Slevogt paints the tombs of the caliphs near Cairo or the horse races in Aswān, a sandstorm in the Libyan desert or a palm garden in Luxor, he conveys each time the excitement of the sun-drenched Orient. *Entry into the Harbor at Syracuse*, 1914 (no. 86), is the last work in this series. The twenty-one paintings were purchased by the Dresden Gallery, where they were seen by Oskar Kokoschka, who then made his own series of travel pictures.

At the outbreak of World War I Slevogt, carried away by the general upsurge of patriotism, spent several weeks with the Sixth Bavarian Army in Belgium, painting at the front; he returned disenchanted. Toward the end of the war he created the finest of his illustrations: marginal designs for a facsimile edition of Mozart's score of *Magic Flute*. The years of the Weimar Republic, so rich in new cultural trends, brought for the artists of Slevogt's generation the disappointment of being considered old-fashioned. Slevogt therefore retired to his own home in Neukastel, where he painted the sum of his artistic experience on the ceilings of the music room (1924) and the library (1929). For the music room he chose scenes from *Magic Flute, Don Giovanni, Siegfried,* and *Faust.* As *Papageno* (fig. 32) shows, these frescoes, painted in the abbreviated manner of Slevogt's book illustrations, are nonetheless monumental in feeling.

In 1932, the year of his death, Slevogt received his last public commission: a fresco of Golgotha in the Church of the Peace in Ludwigshafen. In a style that is more realistic than in most of his other works Slevogt depicted the Passion of Christ as experienced by the industrial proletariat. Aware that "there was no tradition for the Protestant church mural," he nevertheless used a Romantic motif: the crucifix is situated on a rock symbolizing the Church. Throughout Slevogt's musically inspired oeuvre one finds such elements, which tie him to Romanticism; they made Slevogt the last German painter of the nineteenth century.

one could find here a kinship with Matisse. The same year brought Slevogt his first fresco commission. The frescoes were painted on the walls of a garden pavilion in Prussian Neu-Cladow, in a decorative framework based upon Pompeian wall painting, joyful allegories[109] that echo Runge.

On the eve of World War I artists tended to seek inspiration in exotic countries. As Pechstein traveled to Palau, Nolde to the South Seas, Klee, Macke, and Moilliet to North Africa, Slevogt went to Egypt. The paintings he brought home form a self-contained cycle, like the pictures from the Frankfurt zoo; they share with the earlier series a note of jubilation. But they display more breadth, a greater balance between sketchiness and

Notes

This essay endeavors to outline the history of nineteenth-century German painting in connection with the principal political and intellectual developments of the period. Limitations of space, however, have precluded lengthy discussion of any artist not represented in the exhibition. The reader who might miss such names as Reinhart, Preller, Wilhelm von Kobell, Fohr, Führich, Waldmüller, Stifter, Gärtner, Krüger, Richter, Rayski, Klinger, and Stuck is referred to Fritz Novotny, Painting and Sculpture in Europe 1780–1880, *3rd ed. (Harmondsworth, England/New York, 1978).*

1. Golo Mann, *Deutsche Geschichte des 19. und 20. Jahrhunderts,* 11th ed. (Frankfurt am Main, 1976), p. 27.
2. Herbert von Einem, *Deutsche Malerei des Klassizismus und der Romantik: 1760 bis 1840* (Munich, 1978), pp. 20–21.
3. Oskar Walzel, *Deutsche Romantik,* 4th ed., vol. 1 (Leipzig, 1918), p. 38, and passim.
4. Quoted ibid., p. 58. Unless otherwise stated, translations are those of the author.
5. For an excellent brief summary of this problem, see Hans Eichner, Introduction to Friedrich Schlegel, *Ansichten und Ideen von der christlichen Kunst: Kritische Friedrich Schlegel-Ausgabe,* vol. 4 (Munich, 1959), pp. xiv–xvii.
6. Quoted in Walzel, *Deutsche Romantik,* p. 83.
7. Novalis, *Werke, Tagebücher, Briefe,* vol. 2 (Munich, 1978), p. 750.
8. Von Einem, *Deutsche Malerei,* pp. 70–77.
9. Helmuth Plessner, *Die verspätete Nation,* 5th ed. (Stuttgart, 1969), pp. 58–64.
10. Werner Hofmann, in *Runge in seiner Zeit,* ed. Werner Hofman (exhibition catalogue; Hamburg, Hamburger Kunsthalle, 1977), pp. 31–45.
11. Jörg Traeger, *Philipp Otto Runge und sein Werk: Monographie und kritischer Katalog.* Studien zur Kunst des 19. Jahrhunderts. Special volume (Munich, 1975), pp. 46–52.
12. Victor H. Miesel, "Philipp Otto Runge, Caspar David Friedrich and Romantic Nationalism," *Correlations Between German and Non-German Art in the Nineteenth Century: A Symposium Held at Yale University, November 1970,* ed. Egbert Haverkamp-Begemann. Special issue of the *Yale University Art Gallery Bulletin* (Oct. 1972), p. 41, fig. 4 (hereafter cited as *Correlations*).
13. *Philipp Otto Runge, Hinterlassene Schriften,* ed. Johann Daniel Runge, vol. 1 (Göttingen, 1965), p. 17; quoted by Hanna Hohl in *Runge in seiner Zeit,* p. 189.
14. Sigrid Hinz, ed., *Caspar David Friedrich in Briefen und Bekenntnissen* (Berlin/Munich, 1968), p. 83.
15. Heinrich von Kleist, "Verschiedene Empfindungen vor einer Seelandschaft von Friedrich, worauf ein Kapuziner" (1810), reprinted ibid., p. 222.
16. *Caspar David Friedrich: 1774–1840,* ed. Werner Hofmann (exhibition catalogue; Hamburg, Hamburger Kunsthalle, 1974), no. 135.
17. Ibid., no. 137.
18. Hinz, *Caspar David Friedrich,* p. 156.
19. Ibid., pp. 142–48.
20. "Eternal Womanhood leads us above." Translation

by Philip Wayne in Goethe, *Faust Part Two* (Harmondsworth, England, 1977), p. 288.

21. Quoted by Hans Werner Grohn in *Caspar David Friedrich: 1774–1840,* no. 90.

22. Werner Hofmann, ibid., p. 62.

23. Ibid., p. 52.

24. Ibid., no. 106.

25. Ibid., no. 113.

26. Ibid., no. 181.

27. Miesel, "Philip Otto Runge, Caspar David Friedrich and Romantic Nationalism," *Correlations,* pp. 50–51.

28. For a summary, see *Caspar David Friedrich: 1774–1840,* p. 259.

29. Translation by William Vaughan, *Caspar David Friedrich 1774–1840: Romantic Landscape Painting in Dresden,* by William Vaughan, Helmut Börsch-Supan, and Hans Joachim Neidhardt (exhibition catalogue; London, Tate Gallery, 1972), pp. 16–17.

30. Hinz, *Caspar David Friedrich,* p. 133.

31. Hugh Honour, *Romanticism* (New York, 1979), p. 82.

32. Dagobert Frey, "Die Bildkomposition bei Joseph Anton Koch in ihrer Beziehung zur Dichtung," *Wiener Jahrbuch für Kunstgeschichte,* 14 (1950).

33. Marianne Prause, *Carl Gustav Carus: Leben und Werk* (Berlin, 1968), pp. 43–49.

34. Ibid., p. 42.

35. Georg Friedrich Koch, "Schinkels architektonische Entwürfe im gotischen Stil 1810–1815," *Zeitschrift für Kunstgeschichte,* vol. 32, no. 3/4 (1969), pp. 270–75.

36. Friedrich Schlegel, quoted in Von Einem, *Deutsche Malerei,* p. 102.

37. Peter Cornelius was ennobled in 1825, Wilhelm Schadow in 1845; their names became Peter von Cornelius and Wilhelm von Schadow.

38. Günter Metken, in *Die Nazarener,* ed. Klaus Gallwitz, with Hans Ziemke et al. (exhibition catalogue; Frankfurt am Main, Städelsches Kunstinstitut und Städtische Galerie, 1977), pp. 327–35.

39. Robert Rosenblum, *Ingres* (New York, 1967), p. 119.

40. Anton Merk, in *Die Nazarener,* p. 159.

41. Von Einem, *Deutsche Malerei,* p. 136; *Berthel Thorvaldsen* (exhibition catalogue; Cologne, Museen der Stadt Köln, 1977), no. 72.

42. The originals have been transferred to the Nationalgalerie, East Berlin.

43. For color reproductions of both the Casa Bartholdy and Casino Massimo frescoes, see *Die Nazarener,* pp. 83–109.

44. Fritz Novotny, *Painting and Sculpture in Europe 1780–1880,* 3rd ed., Pelican History of Art (Harmondsworth, England/New York, 1978), pp. 123–26; Heinrich Schwarz, "German Artists in Austria in the First Quarter of the 19th Century," *Correlations,* pp. 63–64.

45. See *Hagen Exhorts Brunhilde to Avenge Herself* (no. 76).

46. *The Artist's Children,* 1820 (no. 75), is another instance of Schadow's innate sense of what would appeal to the public. The painting is unrelated to the stylistic trends of its time; it has nothing in common with the archaizing linear asceticism of the Nazarenes, let alone with Runge's unsentimental conception of childhood. Rather, it harks back to the timeless idealization of the child in Neoclassical painting (for example, Gottlieb Schick, *Adelheid und Gabriele von Humboldt,* 1809, in Von Einem, *Deutsche Malerei,* pl. 53), while at the same time strangely anticipating Victorian portraits of children.

47. William Vaughan, *German Romanticism and English Art* (New Haven/London, 1979), passim.

48. Günter Metken, in *Die Nazarener,* p. 325; ibid., pp. 355–64.

49. Mann, *Deutsche Geschichte,* p. 114.

50. For further information on these busts, see Helmut R. Leppien, in *La Peinture allemande à l'époque du romantisme* (exhibition catalogue; Paris, Orangerie des Tuileries, 1976), p. 211, no. 242.

51. See *Departure by the Gray Light of Dawn,* 1859 (no. 82).

52. Novotny, *Painting and Sculpture in Europe,* pp. 195–219.

53. See *The Poor Poet,* 1839 (no. 87).

54. Jens Christian Jensen, *Carl Spitzweg* (Cologne, 1971), pp. 87–90.

55. The standard monograph on Blechen is Paul Ortwin Rave, *Karl Blechen: Leben, Würdigungen, Werk,* Denkmäler Deutscher Kunst (Berlin, 1940). A concise and useful introduction is Gertrud Heider, *Karl Blechen* (Leipzig, c. 1970); Heider provides reproductions of the two pictures, *Ruin of a Gothic Church,* 1826, pl. 5, and *Ravine in the Mountains in Winter,* 1825, pl. 2.

56. Waldemar Lessing, *Johann Georg von Dillis als Künstler und Museumsmann, 1759–1841* (Munich, 1951).

57. For a detailed discussion, see Erika Bierhaus-Rödiger et al., *Carl Rottmann 1797–1850: Monographie und kritischer Werkkatalog* (Munich, 1978), p. 267, no. 273.

58. Heider, *Karl Blechen,* pl. 67.

59. After the description by Hermann T. Beenken, *Das neunzehnte Jahrhundert in der deutschen Kunst: Aufgaben und Gehalte, Versuch einer Rechenschaft* (Munich, 1944), p. 174.

60. Heider, *Karl Blechen,* p. 25.

61. Letter of July 11, 1838, from Bettina von Arnim to M. A. von Bethmann-Hollweg, cited ibid., p. 131.

62. Ibid., pl. 58.

63. Ibid., pls. 54–57.

64. Michael Zeller, "Zur Rekonstruktion eines Mythos. Anselm Feuerbach in seinen Briefen und Aufzeichnungen," in *Anselm Feuerbach: Gemälde und Zeichnungen,* ed. Horst Vey, 2nd ed. (exhibition catalogue; Karlsruhe, Kunsthalle. Munich, 1976), pp. 51–63.

65. Hermann Uhde-Bernays, *Feuerbach: Des Meisters Gemälde in 200 Abbildungen* (Stuttgart, 1913), pls. 13, 14.

66. Edgar Wind, "Humanitätsidee und heroisiertes Porträt in der englischen Kultur des achtzehnten Jahrhunderts," *Vorträge der Bibliothek Warburg IX: England und die Antike,* vol. 9 (1930–31), pp. 156–229.

67. Heinrich Theissing, " 'Die Ewigkeit der Kunst.' Zu Anselm Feuerbachs Schaffen und Denken," in *Anselm Feuerbach: Gemälde und Zeichnungen,* pp. 78–84.

68. Ibid., pl. 144.

69. Ibid., pl. 155.

70. This interpretation was introduced by Konrad Fiedler in accordance with his own philosophy of art. For a refutation, see L. D. Ettlinger, "Hans von Marées and the Academic Tradition," *Correlations,* pp. 76–77.

71. Bernhard Degenhart, *Hans von Marées: Die Fresken in Neapel* (Munich, 1958).

72. Kurt Gerstenberg, *Die grossen Deutschrömer und der Geist der Antike* (Würzburg, 1954), pp. 28–29.

73. Ettlinger, "Hans von Marées and the Academic Tradition," pp. 76–77.

74. Julius Meier-Graefe, *Hans von Marées: Sein Leben und sein Werk,* vol. 1 (Munich, 1909), p. 434.

75. This paragraph is adapted from Gert Schiff, "Hans von Marées and His Place in Modern Painting," *Correlations,* p. 102.

76. Georg Schmidt, in *Arnold Böcklin: Die Gemälde,* by Rolf Andree et al., Schweizerisches Institut für Kunstwissenschaft, Zürich. Oeuvrekataloge

Schweizer Künstler, 6 (Basel/Munich, 1977), p. 57.

77. Jürgen Wissmann, in *Arnold Böcklin: 1827–1901,* comp. Rolf Andree (exhibition catalogue; Düsseldorf, Städtisches Kunstmuseum, 1974), p. 28.

78. Schmidt, in *Arnold Böcklin: Die Gemälde,* p. 57.

79. Andree, ibid., pp. 326–27, no. 227.

80. Gerstenberg, *Die grossen Deutschrömer,* pp. 21–22.

81. Andree, *Arnold Böcklin: Die Gemälde,* nos. 284, 294, colorplate 28; for an interpretation, see Schmidt, ibid., pp. 58–59.

82. Andree, ibid., no. 401.

83. Quoted in Beenken, *Das neunzehnte Jahrhundert in der deutschen Kunst,* p. 189.

84. For an excellent psychological interpretation, see Karl Scheffler, *Menzel* (Berlin, n.d.), pp. 21–97.

85. Françoise Forster-Hahn, "Adolph Menzel's 'Daguerreotypical' Image of Frederick the Great: A Liberal Bourgeois Interpretation of German History," *Art Bulletin* (June 1977), pp. 242–61.

86. Ibid., pls. 22, 29.

87. Scheffler, *Menzel,* pls. on pp. 51, 55.

88. Forster-Hahn, "Adolph Menzel's 'Daguerreotypical' Image," p. 247.

89. Rose-Marie and Rainer Hagen, "Majestät Unter den Linden," *Art* (Aug. 1980).

90. Scheffler, *Menzel,* pls. on pp. 203, 204, 207; *Max Liebermann in seiner Zeit,* by Sigrid Achenbach and Matthias Eberle (exhibition catalogue; Berlin, Nationalgalerie, Staatliche Museen Preussischer Kulturbesitz, 1979), colorplate 177.

91. Hans Wolff, ed., *Adolph von Menzels Briefe* (1914), p. 13; here translated from the quote in Beenken, *Das neunzehnte Jahrhundert in der deutschen Kunst,* pp. 103–4.

92. Siegfried Wichmann, *Franz von Lenbach und seine Zeit* (Cologne, 1973), pp. 213–26.

93. Now Städtische Galerie im Lenbachhaus, Munich.

94. Gerbert Frodl, *Hans Makart* (Salzburg, 1974).

95. Other Munich painters who used photographs in the same way include Franz von Stuck, Eduard Grützner, and Franz von Defregger; Wichmann, *Franz von Lenbach,* p. 184.

96. Alfred Langer, *Wilhelm Leibl* (Leipzig, 1961), p. 34.

97. *Courbet und Deutschland,* by Werner Hofmann, Helmut R. Leppien et al. (exhibition catalogue; Hamburg, Hamburger Kunsthalle, 1978).

98. Peter Krieger, "Max Liebermanns Impressionistensammlung und ihre Bedeutung für sein Werk," in *Max Liebermann in seiner Zeit,* pp. 60–71.

99. "Die Phantasie in der Malerei" is the title of an essay on theory by Max Liebermann, first published in 1903.

100. Matthias Eberle, "Max Liebermann zwischen Tradition und Opposition," in *Max Liebermann in seiner Zeit,* pp. 11–41.

101. Ibid., pls. 30, 72, 78, 89.

102. *Lovis Corinth 1858–1925: Gemälde und Druckgraphik,* comp. Armin Zweite (exhibition catalogue; Munich, Städtische Galerie im Lenbachhaus, 1975); for examples of Corinth's paintings of carcasses see pls. 11, 15, 23, 65; for examples of flower and still-life paintings see pls. 59, 60, colorplates 16, 19, 20; for examples of nudes and bacchants see pls. 20, 25, colorplate 7; for *The Blinding of Samson* see p. 89.

103. Eberhard Ruhmer, "Corinth als Schüler und Lehrer," in *Lovis Corinth 1858–1925,* p. 99.

104. Hans-Jürgen Imiela, "Lovis Corinth als Bildnismaler," ibid., pp. 67–68.

105. Hans-Jürgen Imiela, *Max Slevogt; Eine Monographie* (Karlsruhe, 1968), p. 36, colorplate 13.

106. Ibid., fig. 126, colorplate 19.

107. Ibid., colorplate 36.

108. Ibid., p. 79.

109. Ibid., pp. 168–72.

Artists and Society

Stephan Waetzoldt

Nineteenth-century German art, inconsistent in its development and eclectic in its expression, was more strongly under the influence of political, social, and economic forces than were its French and English counterparts. As late as the end of the eighteenth century the Holy Roman Empire was still comprised of hundreds of territories. No central authority existed, and the political arena was determined by the antagonism between the two superpowers, Austria and Prussia. Schiller had perceived correctly that: "The German empire and the German nation are two different entities . . . the more the political sphere totters, the more secure and united does the spiritual realm become." This discrepancy between the existence of a shared German culture and the longing for a political equivalent—a German national state—determined both the spiritual and the political climate in Germany throughout the nineteenth century.

Even the reorganization of the German territories following the French Revolution and the Napoleonic wars did little to alter permanently a fragmented political structure. Following the Congress of Vienna in 1815 a German Confederation consisting of thirty-nine sovereign states was established. Each state had its own cultural and political claims; the need for a binding constitution remained unfulfilled. What did change, however, was the social system, the relation of the individual to the state.

Until the end of the eighteenth century there existed throughout Europe a rigidly organized hierarchical social structure which did not afford the average citizen any role in the governmental decision-making process. The first and foremost duty of the state, centered around the monarch, was to preserve the status quo in favor of the ruling classes. When progressive forces in Germany began to agitate against this feudalistic system, they were aided in their endeavor not only by the overthrow of the monarchy in France during the Revolution, but also by the political, social, and educational reforms that swept Europe as a whole in the early nineteenth century. In Prussia the liberal changes introduced by Stein, Hardenberg, and Wilhelm von Humboldt gave higher-ranking civil servants—invariably belonging to the nobility—and the upper middle class a previously unknown degree of political power and individual freedom. It is true that many of the gains made in the era of reform were rescinded after the Congress of Vienna, when the new political establishment in Europe sought to restore order, and the forces of reaction were once again successful. Predictably, however, their very success fostered a more vehement demand by the middle classes that changes already set in motion be continued.

The one great aspiration, to achieve a politically unified as well as a culturally cohesive German state, remained unsatisfied. Restricted in their political life and under the control of the censor, reformers looked to the past to find their model for an ideal society. The language, literature, and art of earlier periods were rediscovered and researched anew. The romantically glorified image of a German nation, which extended back to the Middle Ages and to the Renaissance, the "age of Dürer," was

revived and transformed to meet their needs. The younger generation, particularly those belonging to university fraternities, openly voiced their demands for greater personal freedom, for a larger role in the political process, for more social equality, and for a united Germany—claims that became the leitmotifs of German political history. Although the German Reich was ultimately founded in 1871, these demands remained largely unfulfilled until the nation's reconstitution following World War I.

What is true of political history is also generally valid for the history of art. Not only were the decisive questions posed during the early years of the nineteenth century, but those concepts that would remain unquestioned for decades were also formulated. This process occurred under the direct influence of the science of history, a discipline that itself evolved during the Romantic era. The content and form of German nineteenth-century art are unthinkable without the existence of modern philology, historical research, archaeological knowledge, and art history. The recently formulated theory of the origin and course of historical epochs as well as the overestimation of their importance were among the chief prerequisites for the establishment of historicism, one of the most influential factors in nineteenth-century art, particularly that of Germany. Because the parameters of earlier artistic developments could now be known and because their historical character imparted an emblematic quality to the entire concept, historicism proved an eminently usable and influential tool in making available the techniques, themes, and motifs of earlier art forms. In the nineteenth century the pictorial arts drew a significant part of their inspiration from history rather than from contemporary life.

The destruction of the old social order in the wake of the French Revolution meant more to art than the mere passing from one epoch to another. Freed from traditional bondage to church and monarchy, artists were left on their own. Caspar David Friedrich elevated the new subjectivism of the age to a central tenet: "No one is the measure for all; each person is only his own measure and sets a standard only for himself." Friedrich's theory of the artist's special place in society evolved from the concept of genius propagated in the late eighteenth century, wherein genius, according to Herder, was the embodiment of man's creative energies expressed in one individual. In 1799 Friedrich Schlegel wrote: "What am I proud of, and about what can I be proud as an artist? About the decision that eternally segregates and isolates me from all common things; about the work that, divine in itself, transcends all conscious intentions of the artist, and whose true intentions can never be fully comprehended." Genius never wastes itself on profane goals: "To give the community of artists a specific purpose means to replace it with a shabby institution; it means the degradation of a holy company in accordance with the wishes of the state." The unique liberal-individualistic position of the artist within society, a position that continues to be held even today, ultimately derives from the Romantic cult of genius. This cult legitimized not only the artist's demand for creative freedom and respect, but also his material demands from state and society.

Goethe warned early in the century that an excessive reliance upon subjectivism could destroy the unity of the arts. In his work on color theory he criticized this contemporary trend: "Never have individuals been more encapsulated and isolated from one another than today. Each person wants to create the universe solely in accordance with his own ideas. But when one assimilates nature, one is also forced to accept what others have accomplished and what others have handed down through the ages."

The artist's reliance on his own perceptions on the one hand and his debt to tradition on the other created a polarity in nineteenth-century German art. Friedrich Schlegel, who wished to revive traditional values, counseled artists: "Instead of creating unusual works completely unique in character . . . follow the old masters . . . assiduously imitating what is truly just and naïve in their works, until it becomes second nature to the eye and to the mind." Philipp Otto Runge, inspired by the desire to create a personal symbolism of nature, asked precisely the opposite question: "For what purpose . . . would one use the old myths today? What is the use of anything that has already been said? When something has been said, it has been completed; what is said a second time is only of value for the library or the granary, and will never germinate in either kind of soil." Such profound dichotomies in the nineteenth century are known only in German art. Nor were they confined to the early part of the century; Romanticism and the Nazarene movement, Realism and Idealism, Impressionism and Symbolism, Art Nouveau and Expressionism are opposites that existed simultaneously, though their differences are perhaps more apparent than real. Herbert von Einem recently recognized a Protestant and a Catholic strain within the German Romantic movement, exemplified by Friedrich and Runge on one side and the Nazarenes on the other, but the issue of the unity of nineteenth-century German art is one that has yet to be fully explored.

Surely one of the reasons for the contradictory nature of German art was the absence of a cultural center such as Paris or London. Another reason was the conflict between the Protestant north and the Catholic south and west which, during the latter half of the century, exploded politically in the *Kulturkampf*. The division can be seen in the continuation of court patronage for the arts in the south under Ludwig I of Bavaria, and the development of upper middle-class patronage in the north and west. But more important was the freeing of the artist from his old connections to church and state and from a firmly established social order. Freed from a binding stylistic tradition he could experiment with a variety of pictorial formulas. The Nazarenes were the first to make use of their new possibilities. They chose freely from among the stylistic devices of the past; in this they were followed by other artists throughout the century. Attempts in theory and practice to create a contemporary style (*Zeitstil*) failed, as had the effort during the 1880s and 1890s

41

to develop an imperial style (*Reichsstil*) based on Hohenstaufen Romanesque architecture. The contemporary styles of the nineteenth century were historicism and pluralism.

German art has traditionally focused on content rather than on form and painterliness, and German artists have possessed an almost compulsive proclivity for mythological and philosophical subjects as well as for social and historical criticism. Nineteenth-century German artists were not alone in this—one need only think of contemporary Belgian painting—but they did pursue "intellectual art" (*Gedankenmalerei*) with particular intensity. The creative powers of the German artist were in fact generated by his study of cognitive philosophy and aesthetic theory, by his contemplation of the new scientific conception of the universe, and by his knowledge of history.

Goethe, himself a talented if amateur draftsman, was one of the first to foster a dialogue between the artist and the philosophical teacher, or critical thinker, a dialogue that was innovative and mutually productive. Through his Weimar competitions, held between 1799 and 1805, Goethe sought to have a direct and personal influence on the development of painting. With the aid of the art historian Heinrich Meyer he published important and lasting theoretical and critical treatises on art in his periodical *Propyläen* and in *Über Kunst und Altertum,* and had an extensive correspondence with Philipp Otto Runge about color theory. A classicist, Goethe was not, however, insensitive to the paintings of the Romantics. He was, for instance, deeply impressed by Runge's *Four Times of Day.* But more decisive than Goethe in their influence on the Romantics were Wackenroder, Tieck, and Novalis. Friedrich Schlegel became the theoretician of the Nazarenes, but their work was equally influenced by Joseph von Görres. The philosopher Friedrich Theodor Vischer paved the way for the Realist history painting of the Düsseldorf school. The art of Hans von Marées would have been very different had it not been for his intellectual exchanges with Konrad Fiedler. Schopenhauer, Nietzsche, Hegel, and Dilthey, among others—all exercised considerable influence on the development of art and art theory during this period.

The nineteenth century was a great age for philosophers, for historians, and for natural scientists. It was also a great age for commentators on art. Art criticism was no longer directed solely to the "initiated," as it had been in the eighteenth and early nineteenth centuries. It was read now by a rapidly growing public comprised of the affluent and the educated. The title of the journal *Kunst für Alle* ("Art for Everyone"), published after 1885, is indicative of this development. In addition to art-historical research in the universities and museums, the feuilleton, which dealt critically with contemporary events in the arts, was a popular and inexpensive way to reach the public. To be sure, the first widespread attempts to describe German art in the nineteenth century are strongly journalistic in character, as in the writings of Adolf Rosenberg, Richard Muther, and Cornelius Gurlitt in the eighties and nineties. It is interesting to note, however, that throughout the nineteenth century the work

of the two greatest Romantics, Friedrich and Runge, remained largely unknown. Only through the comprehensive Centenary Exhibition in Berlin in 1906 was their importance recognized. Runge's paintings were long held in the possession of the family, and Friedrich's symbolic landscapes were neither understood nor given critical consideration.

Popular literature on art, numerous exhibitions, and the reproduction of paintings through such techniques as etching, lithography, photogravure, and photography fueled public debate, which in turn could not help but influence the artists themselves. Well-known examples are Julius Meier-Graefe's sharp attack on Böcklin in 1905 and Karl Scheffler's defense of Impressionism against the officially sanctioned art of such painters as Anton von Werner in Berlin (see fig. 12, page 24). The so-called monumental arts, large-scale state commissions for the decoration of churches and public buildings, were debated in parliament and in the daily press.

The importance of graphic reproductions and illustrations during this period cannot be overestimated. In addition to having a significant impact upon the public, they also contributed to the development of art itself. Throughout the century numerous paintings were created with a view toward being marketed as reproductions. By 1900 there were few respectable middle-class families that did not own a lithograph of Böcklin's *Island of the Dead* (see nos. 9 and 10), though the painting itself had not been made specifically for reproduction. (Interestingly, the evocative title was coined not by the artist but by an art dealer.) Menzel's illustrations for Franz Kugler's *History of Frederick the Great* created the enduring image of the "old man of Sans Souci" as a symbol dear to the hearts of German nationalists; its impact continued to be felt in historical films and in election posters during the 1930s.

But in more ways than this Menzel typified German artistic behavior. Born into the lower middle class like Lenbach, Corinth, and even the Austrian "prince of painters," Hans Makart, Menzel rose to become a celebrated and officially honored painter of Prussian history and culture. Known as the Little Excellency, the brilliant though obstinate Menzel made a clear distinction between works he created to fulfill political or social needs and those he made for purely artistic reasons. His "official" and "private" works were produced simultaneously, and both were of equal value to him. The fact that we tend today to prefer his (pseudo)-Impressionistic works to his history paintings is due to an inappropriate application of French artistic standards.

Contemporary art critics evaluated the work of Menzel and other artists according to its subject matter and illustrative content. Critical discussion of style, color, and form occurred, if at all, almost exclusively within the context of a comparison with art of the past. Ruysdael and the Dutch masters were the measure of excellence in the area of landscape painting; Titian and the Venetians in portraiture; Perugino and Raphael, Dürer and the old German masters in religious themes; and Rubens in history painting.

Critical evaluation of the art of the past as a standard of quality played a decisive role also when it came to artistic training. Prototypes abounded either in the collections of local art academies or in public art museums, which by the middle of the century existed in every large city. But the academies, founded for the most part during the seventeenth and eighteenth centuries, were not prepared for the increasing number of people seeking to study art, nor were they capable of formulating concrete plans of study. The old academies existed not so much to teach but to add prestige to the local sovereign's court and to care for the needs of established artists. Reforms were required, and the academies therefore devised a stricter course of study, demanding more artistic specialization. The fact that the professors were state-appointed allowed the academy to be used as an active agent in cultural politics. The Düsseldorf regulations of 1831, issued by the Prussian Ministry of Culture in Berlin, were typical. The goal of their educational endeavors was "to instruct the novice in the rudiments of art, to instruct him in the direct and mature perception of whatever is capable of artistic representaton, to awaken the novice's creative gift of inspiration and develop and expand it so that upon leaving the Academy he is able to pursue his chosen specialization independently and, at the same time, to perfect it without further guidance from an instructor." Instruction at the academy was divided into four sections: painting, architecture, graphics for purposes of reproduction ("engraving school"), and sculpture. Students were given a battery of introductory courses. Those who chose to study painting could decide at the advanced level whether they wished to specialize in portraiture, history painting, genre, or landscape. In landscape still further specialization was possible, as, for instance, in the painting of animals or architecture.

The ultimate determinant of quality and stylistic direction within the academy was the teaching staff, headed by the director. Academies differed from each other in approach and in the form of painting they emphasized. In 1810 students from the Vienna Academy, in protest against the policies and teaching methods of that institution, moved to Rome and formed the Brotherhood of St. Luke. The Dresden Academy was at the beginning of the century the center of Romantic painting, although its role later diminished. In Düsseldorf, under the leadership of Wilhelm von Schadow, director from 1826 to 1859, the Academy was transformed—with the help of Lessing, Bendemann, Rethel, and Gebhardt—into a center for religious and secular history painting; later, under Schirmer and Achenbach, landscape painting was also cultivated. The stronghold of both Idealist and Realist painting, the Düsseldorf Academy claimed an international reputation, attracting students from all over the world, particularly the United States. By mid-century, however, it was replaced in importance by the Munich Academy, whose professors—Kaulbach, Piloty, and Dietz—were recognized masters of monumental history painting in the tradition of Cornelius and the Nazarenes. At Karlsruhe, on the other hand, emphasis was placed on realistic landscape painting.

Schirmer and Lessing—both later professors at Düsseldorf—trained there, and Hans Thoma, perhaps the greatest landscape painter in Germany after 1870, was its director.

The official art of the academies was propagated by exhibitions and marketed by art associations (Kunstvereine), which were closely allied to the art schools. Following the model of the French Academy, which had been holding yearly exhibitions at the Louvre from as early as 1737, the German academies held annual or biannual exhibitions which were open to professors, students, independent artists, and even amateurs. The scope and importance of these exhibitions throughout the nineteenth century cannot be overestimated. The Berlin Academy exhibition of 1800 contained 435 works; by 1836 the number had grown to 1,683, and these were seen by 111,945 visitors. (The total population of Berlin at this time was only about 300,000.) The mammoth Glass Palace in Munich, built in 1854 for an industrial fair, housed national and international art exhibitions. Throughout the nation museums with permanent collections and facilities for temporary exhibitions sprang up, becoming centers for debate and for the dissemination of information.

In 1869 Eduard Schleich, "father of South German mood painting," in the face of opposition from the Academy, invited several of the great French painters—Gustave Courbet, Camille Corot, Jules Elie Delaunay, and Edouard Manet—to participate in the Munich International Art Exhibition of 1869. Following his trip to Munich Courbet, in a letter to Castagnary, wrote: "Good painting in Germany is as good as nonexistent . . . one of the most important things . . . is perspective, everyone speaks about it all day long. Furthermore, the exact rendition of historical costume continues to play an important role. Painting has come very close to being pure anecdote. The walls of Munich bristle with frescoes, and one quickly comes to believe that they have covered everything with wallpaper . . . here is a king who makes a solemn pledge, there is one who abdicates, while still another signs a contract, one dies, and another marries . . . with all this, people like Cornelius, Kaulbach, Schwind, and so forth, have lived too long. . . . The younger generation in Munich is pretty good. . . . They are determined to overthrow all the antiquated traditions." The "younger generation" to which Courbet refers alludes to Wilhelm Leibl, whom he had met at the International Exhibition. Their meeting developed into a friendship that proved beneficial to both artists.

Associations with France—and they were by no means restricted to the International Exhibition nor did they occur only in Munich—encouraged the final split within the German community of artists, a community that until this time had been fairly homogeneous. In opposition to the artists who adhered to the traditional teachings of the academies, the more progressive artists left these institutions to form their own associations and to hold their own exhibitions. The Munich Secession was established in 1892 by, among others, Slevogt, Trübner, and Uhde. The same year, on the occasion of the closing by the Berlin Academy of an exhibition of the work of Edvard

Munch, Max Liebermann founded the Group of XI, which later was the nucleus of what eventually became the Berlin Secession, formally established in 1898.

In 1897 a secessionist group was formed in Vienna under the leadership of Gustav Klimt. With increasing regularity independent artists' groups organized their own exhibitions on the pattern of the Paris Salon des Refusés. Furthermore, the influence of the commercial galleries, which held one-man as well as group shows, continued to grow throughout the century. The monopoly of the academies was finally broken.

The selling of contemporary art by private dealers began rather late in Germany, during the last quarter of the century. Until then this function had been performed by the art associations. These associations—unique in Europe—were established in the twenties: 1818 in Karlsruhe, 1824 in Munich, 1825 in Berlin, 1828 in Dresden, 1829 in Düsseldorf. Each was a kind of joint-stock company whose shareholders were affluent lovers of art. Membership dues entitled members to a share in the works of art purchased at the academy, at art association exhibitions, or directly from the artist. The economic importance of the art associations was as significant as their influence on public taste and upon the academy with which they were often closely allied. In their financial dealings they were far in advance of state involvement in the arts. Between 1902 and 1912, for instance, the associations had nearly 1,900,000 marks per annum at their disposal for acquisitions. In contrast, the combined federal states during these years had slightly over 670,000 marks annually, and the cities only about 575,000 marks.

The policies of conservative groups within the academies and art associations, as well as within the court and government, were countered by the policies of museum directors such as Hugo von Tschudi in Berlin (and later in Munich) and by private collectors and patrons. Of the latter, Count Adolf Friedrich von Schack was the most influential. A somewhat cantankerous aristocrat from Mecklenburg, a Prussian diplomat, and an Orientalist, Count Schack settled in Munich in 1857. He did not buy from dealers or from artists' studios. Rather, he awarded commissions and involved himself directly with the creation of works he had ordered, often to the dismay of the artists. Schack encouraged Schwind during a time of personal difficulty and self-doubt; he supported promising young artists such as Len-

bach by commissioning them to copy old-master paintings; he helped Feuerbach from 1862 to 1866. He promoted the work of Marées and Böcklin, and with the latter he established a close friendship. In order to document the artistic origins of these contemporary painters, Schack also collected the work of earlier nineteenth-century artists—Dillis, Koch, Rottmann, Cornelius, Hess. His support did not extend to Leibl and his circle. At his death in 1894 his collection was bequeathed to Emperor William II.

In 1861 another collector, the Berlin businessman Heinrich Wilhelm Wagener, presented the Prussian state with his collection of 262 paintings. Most were by Berlin and Düsseldorf artists, but works by Friedrich, Ferdinand Georg Waldmüller, and a few French artists were included. Wagener's collection became the nucleus of the Berlin Nationalgalerie, which opened in 1876, and its donation led to the creation of a museum of modern art in the nation's capital—something artists had been trying to accomplish since the revolutionary year of 1848. Schack and similarly inspired patrons were a significant help to artists in the later nineteenth century, enabling them to develop their talents outside the control of the academy. Their role was later assumed by the art galleries, albeit in another fashion and with different intentions.

The contribution of nineteenth-century German artists, in the words of Jens Christian Jensen, "was the almost desperate but also magnificent attempt to affirm reality by and through visual perception." In other words, the artist took his experience of the visible world as the basis of his work. The art itself became a vehicle for those truths, despite the changes that may have taken place between what the artist saw and the painted image. What Friedrich sought to accomplish in his landscapes and what Runge embodied in his symbolic compositions and allegories was not the depiction of external reality but a creative response to "the eternal objects in nature" (Ferdinand Olivier). Others who chose as their subjects "the eternal objects in nature" were Thoma in his landscapes, Leibl and Lenbach in their portraits, Spitzweg in his Biedermeier genre scenes, and Menzel in his history paintings. Paradoxically, it is the same realistic perception of nature that characterizes the works of the Impressionists Liebermann, Slevogt, and Corinth as unmistakably German.

Bibliography

Beenken, Herman Theodor. *Das neunzehnte Jahrhundert in der deutschen Kunst: Aufgaben und Gehalte, Versuch einer Rechenschaft.* Munich, 1944.

Einem, Herbert von. *Deutsche Malerei des Klassizismus und der Romantik: 1760–1840.* Munich, 1978.

Hofmann, Werner. *The Earthly Paradise: Art in the Nineteenth Century.* Translated by Brian Battershaw. New York/London, 1961.

Novotny, Fritz. *Painting and Sculpture in Europe 1780–1800.* 3rd ed. Pelican History of Art. Harmondsworth, England/New York, 1978.

Pauli, Gustav. *Das neunzehnte Jahrhundert.* Geschichte der deutschen Kunst, 4, edited by Georg Gottfried Dehio. Berlin/Leipzig, 1934.

Exhibition catalogues

Düsseldorf, 1979. Kunstmuseum. *Die Düsseldorfer Malerschule.* Edited by Wend von Kalnein.

Frankfurt am Main, 1977. Städelsches Kunstinstitut und

Städtische Galerie. *Die Nazarener.* By Klaus Gallwitz, Hans Ziemke, and Henri Dorra.

Munich, 1979. Bayerische Staatsgemäldesammlungen and Ausstellungsleitung Haus der Kunst. *Die Münchner Schule: 1850–1914.* By Eberhard Ruhmer.

Nürnberg, 1977. Germanisches Nationalmuseum. *Sammlung Georg Schäfer, Schweinfurt: Deutsche Malerei im 19. Jahrhundert.* By Jörn Bohns. Forewords by Georg Schäfer and Arno Schönberger. Essays by Wulf Schadendorf and Jens Christian Jensen.

Paris, 1976. Orangerie des Tuileries. *La Peinture allemande à l'époque du romantisme.*

Paintings

In the Reference section that follows each painting and drawing entry, citations are keyed to the Bibliography.

1. Karl Blechen

Daybreak, 1824–27
(Morgendämmerung)

Oil on canvas, 96 x 72.5 cm (37¾ x 28½")
Westfälisches Landesmuseum für Kunst und Kulturgeschichte,
 Münster (property of the Federal Republic of Germany)

Daybreak was painted in 1824–27, when Blechen was working
as a set designer for the recently built Königstädtisches Theater
in Berlin. Karl Friedrich Schinkel had recommended him for
the position. A drawing by Schinkel, *Customs in Valais*, which
depicts the Romanesque fortification Mont Valère in the city
of Valais in the Rhone valley, may have provided Blechen with
a compositional prototype for the present painting. It has also
been suggested that this work is an amalgamation of motifs
from the three best-known operas of the time: the pair of figures
is from *Don Giovanni,* the serpent is from the *Magic Flute,* and
the owl is from Weber's *Der Freischütz*.

If a specific subject is depicted, it has never been identified.
The man appears to comfort the woman, but it is also possible
that they are struggling. The serpent is a symbol of evil and
temptation, and the owl could represent either Satan, the Prince
of Darkness, or wisdom. Blechen may have intended the pres-
ence of both the owl and the serpent to indicate an unresolved
conflict. The arrival of dawn, the symbol of Christ's triumph
over the darkness of sin, suggests that the couple will properly
resolve their plight.

The prosceniumlike quality of the composition reflects the
influence of set design on Blechen's painting. After Blechen's
trip to Italy, 1828–29, his style changed dramatically. He es-
chewed the Romantic Realist style seen here in favor of the more
painterly, plein-air landscape style that he undoubtedly encoun-
tered during his stay in Rome (see *View of Rooftops and Gardens,*
1828, no. 4).

References: Münster, 1975 [V], pp. 15–16, colorplate p. 15.

2. Karl Blechen

Forest Ravine with Red Deer, 1828
(Waldschlucht mit Rotwild)

Oil on canvas, 99.7 x 82 cm (39¼ x 32¼")
Niedersächsisches Landesmuseum, Hannover
 (property of the Federal Republic of Germany)

This work belongs to a series of dark, wild landscapes that Blechen painted before his trip to Italy in 1828–29. The painting is typical of a compositional format that he used both before and after the trip. He employs a vertical format in which an element or combination of elements in the immediate foreground rises to the full height of the canvas on one or both sides of the canvas. The wedgelike recession into space is blocked in the middle ground, but opens up again in the upper part of the composition to reveal the sky.

The sudden shifts from light to dark, the fluid paint handling, and the relatively broad treatment of form are also characteristic. While some of these pictorial mannerisms may be distantly related to sixteenth-century German landscape technique, Blechen's style developed at least in part as a response to his appointment by Karl Friedrich Schinkel in 1824 as a set designer for the Königstädtisches Theater. Gottfried Schadow credited him with being "one of the first to decorate that stage with landscapes."

Forest Ravine with Red Deer also reflects Blechen's interest in Friedrich and the quasi-religious veneration of nature that is a strong undercurrent in German Romantic painting. However, Blechen's depiction of the vast, overwhelming beauty of nature sometimes disturbed contemporary viewers, who used phrases such as "profoundly melancholy character," "a sense of nameless terror," and "dreadful" to describe the mood conveyed by the landscapes he exhibited in the Berlin Academy exhibitions.

References: Hannover, 1969 [V], pp. 110–11, colorplate p. 111; Hannover, 1973 [V], no. 71; Schrade, 1977 [II], p. 106.

48

3. Karl Blechen

Sans Souci Palace, 1830–32
(Schloss Sanssouci)

Oil on cardboard, 41 x 33 cm (16⅛ x 13")
Nationalgalerie, Staatliche Museen Preussischer Kulturbesitz, Berlin

Here Blechen depicts the uppermost terrace of Sans Souci Palace, Potsdam, built in the middle of a large park according to plans sketched by Frederick II, king of Prussia. The final plans were probably the collaborative effort of the king and several architects and critics, including the chief court architect, Georg Wenzeslaus von Knobelsdorff. Knobelsdorff laid the foundation stone in 1745 and finished the building in 1749. Sans Souci Palace is a masterpiece of the Rococo style in Germany and a key monument of eighteenth-century European architecture. Within the Sans Souci complex, which served as the royal summer residence, the palace is unquestionably the most important structure. However, in the present work Blechen's primary interest is not the palace itself but the approaching storm, the play of light in the landscape, the sky, and the fountains. Blechen showed a marked preference for such subjects after his trip to Italy, 1828–29, during which he perfected the watercolor technique that seems to have influenced the paint handling in the present work. There is a pencil drawing of the palace, done after 1830, in the Kupferstichkabinett, East Berlin.

References: Berlin, 1977 [V], pp. 54–56, illus. p. 55.

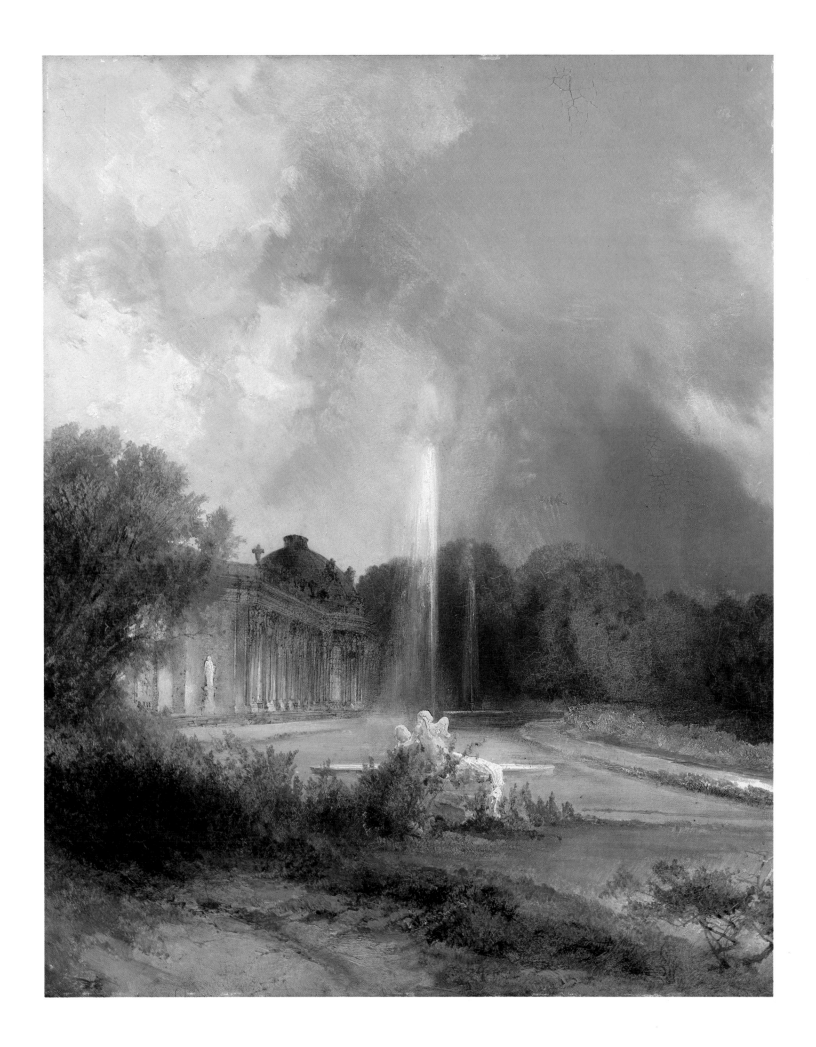

4. Karl Blechen

View of Rooftops and Gardens, c. 1835
(Blick auf Dächer und Gärten)

Oil on canvas, 20 x 26 cm (8 x 10¼″)
Nationalgalerie, Staatliche Museen Preussischer Kulturbesitz, Berlin

Blechen's belief that even the commonplace was worthy of the artist's attention was rare among German painters in the 1820s and 1830s. His attitude represents an important advance in the history of German Realism. He was one of the first German painters to record contemporary urban views such as this bold composition of roofs and backyards at the edge of a growing town, or the early industrial landscape depicted in *Rolling Mill near Neustadt-Eberswalde,* c. 1834 (Nationalgalerie, Berlin). Sometimes ascribed to the late twenties, *View of Rooftops and Gardens* was more probably painted about 1835 when Blechen was thirty-seven. It is a view of either Berlin or Potsdam which belongs to a group of five small pictures that, like Blechen's landscapes with factories and mills, were painted in the mid-thirties, toward the end of his relatively short career. Although the art-historical origins of such works may lie in seventeenth-century Dutch and late eighteenth-century English painting, Blechen was undoubtedly influenced by the school of plein-air landscapists working in Rome in the twenties. (When Blechen was in Italy, 1828–29, the best-known member of the group was Corot.) He was perhaps even more strongly influenced by such works as Georg von Dillis's *View of St. Peter's from the Villa Malta in Rome,* 1818 (no. 22). In terms of paint handling and composition, however, Blechen himself appears to have provided an important precedent for urban-industrial scenes such as those by Adolf von Menzel, which were painted more than ten years later (e.g., *The Berlin-Potsdam Railroad,* 1847, no. 62).

References: Paris, 1976 [III], pp. 6–8, no. 6, illus. p. 8; Berlin, 1977 [V], pp. 58, 60, illus. p. 61.

5. Arnold Böcklin

Murder at the Castle (Castle by the Sea;
 Attack by Pirates), 1859
(Mord im Schloss [Schloss am Meer;
 Überfall von Seeräubern])

Signed (lower left): A. Böcklin fec
Oil on canvas, 112 x 117.3 cm (44⅛ x 46⅛")
Museum Folkwang, Essen (property of the
 Federal Republic of Germany)

One of the titles by which this picture is known, *Castle by the Sea,* refers to a poem by the German Romantic poet Johann Ludwig Uhland. Uhland's poem is similar to the painting in mood, theme, and setting.

Murder at the Castle is one of the first of the so-called villa pictures. The motif of the villa, or castle, appears in Böcklin's work for more than thirty years and is often the setting for dramatic incidents such as the one depicted here. The oil sketch (Kunstmuseum, Düsseldorf) and the painting itself were begun in 1859, after Böcklin had recovered from typhus. They were completed that year in Weimar. Böcklin then sent the completed painting to Zürich where he hoped it would be purchased. However, the picture was criticized for being "too little studied," and the artist then sent it to Berlin where again it was exhibited. Upon the recommendation of the grand duke of Weimar, it was acquired by the grand duke of Oldenburg, from whom Hitler obtained it for his Linz Collection. *Murder at the Castle* was the third major work by Böcklin that he acquired for this collection, following *Fight of the Centaurs,* 1878 (location unknown) and *Island of the Dead,* 1883 (no. 10).

According to one of Böcklin's friends, the artist had difficulty placing the figures so that the drama did not dominate the scene but served rather to enhance the mood of the landscape. It is possible that the composition did not satisfy Böcklin, because in a later version the figures used in the present work were replaced by the single figure of Iphigenia.

The oil sketch in Düsseldorf differs from the painting in that it depicts a sunset instead of a clear, cool morning; it is one of the few preparatory works Böcklin made either for himself or for a purchaser in order to predetermine the composition. Here for the first time he realizes his characteristic compositional mode. These impressive, spare landscapes achieve their elegiac mood through the use of typical Romantic conceits: rocky cliffs, isolated beaches with breaking waves, and a villa silhouetted against an early morning sky.

References: Essen, 1971 [V], pp. 16–17, illus. p. 16; Basel, 1977 [IV], p. 168, no. 47.

6. Arnold Böcklin

unfinished [handwritten annotation]

The Birth of Venus (Blue Venus), 1868−69
(Die Geburt der Venus)

Oil on canvas, 135.5 x 79 cm (53⅜ x 31⅛")
Hessisches Landesmuseum, Darmstadt (property of the
 Federal Republic of Germany)

Böcklin worked on this painting from August 1868 until June
1869, when he decided to leave it unfinished. On January 18,
1869, his student Rudolf Schick noted: "When Jakob Burckhardt
visited Böcklin yesterday, he tried to persuade him to alter var-
ious aspects of the figure and gave him all kinds of advice about
it." On January 30, 1869, Burckhardt renewed his criticism.
Böcklin, however, wished to maintain the character of his com-
position, especially the concentric circles of waves which pro-
vided a foundation for the relatively unemphatic lower half of
the figure as well as a balance for the stronger upper part of the
composition. Burckhardt's repeated advice and criticism may
have caused Böcklin to leave the picture unfinished.

Böcklin's objective in *The Birth of Venus* was to translate
his own intellectual ideal of artistic harmony into a visible form.
In 1872 he again took up this theme in an oil study (Kunsthaus
Heylshof, Worms) which he then executed as a finished painting
(*Venus Anadyomene, 1872−73*, Private collection, Italy). In ac-
cordance with Burckhardt's advice, in the later version Venus
balances on a dolphin, and above her hovers a circle of putti,
one of whom holds a garland over her head.

The Birth of Venus is imbued with a rich shade of blue, with
only the colors of the flesh and hair to provide contrast. For
this reason it has sometimes been called *Blue Venus.*

References: Düsseldorf, 1974 [IV], no 227; Basel, 1977 [IV], no. 96,
colorplate 34; New Haven, 1970 [III], pp. 74−75, no. 6, pl. 57.

56

7. Arnold Böcklin

Springtime of Love, 1868–69
(Liebesfrühling)

Oil on canvas, 220 x 137 cm (85⅝ x 53⅞")
Hessisches Landesmuseum, Darmstadt (Heyl Foundation,
 property of the city of Darmstadt)

In 1859 Böcklin executed a grisaille titled *The Gods of Greece*
(Die Götter Griechenlands) for an edition of Schiller's poem of
the same name, which was published by Cotta in Stuttgart. In
the 1860s Count Adolf Friedrich von Schack commissioned him
to paint a large version of the composition. Böcklin first at-
tempted to create such a version in 1866 (formerly National-
galerie, Berlin; missing since 1945). It was based on the grisaille,
but changes were made in the figures and the disposition of the
water nymph. Schack rejected it, and it remained unfinished.

On August 8, 1868, Böcklin began work on a second large
treatment of the theme, the present painting. Evidently it posed
serious difficulties because it was painted over on February 17,
1868. Ultimately it was abandoned in its present state on January
3, 1869. The present composition is a fully reworked interpre-
tation of the lower right quadrant of the painting executed for
Schack. The Arcadian landscape depicted in the *The Gods of
Greece* has been almost completely subsumed by an allegorical
scene, the significance of which is not known. The naiad or
water nymph has become more prominent, and the spying
youth and putti are entirely new. It is tempting to think that
the composition may be indirectly related to the Grotto of Love
in Wagner's *Tannhäuser*.

As Rolf Andree has pointed out, the present painting results
from a process of elimination, reduction, and simplification;
indeed, the process continued in *The Dance of Spring,* 1869 (Staat-
liche Kunstsammlungen Dresden). Although Schack rejected
the first large version, the second attempt, the present painting,
was eventually acquired by the important Darmstadt collectors
Doris and Maximilian von Heyl.

References: For an illustration of the first large version, see Rave, 1945 [I],
p. 321, no. 164, pl. 164; Andree, 1962 [IV], p. 51; Basel, 1977 [IV], p. 180,
no. 87, illus.

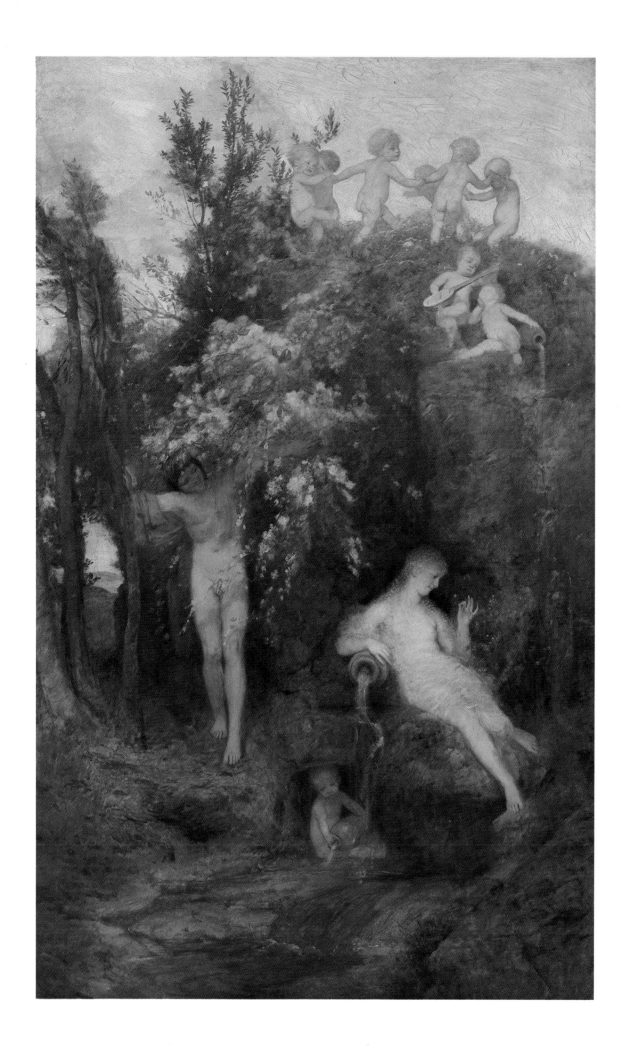

8. Arnold Böcklin

Self-Portrait with Death as Fiddler, 1872
(Selbstbildnis mit fiedelndem Tod)

Signed and dated (upper left): A. Böcklin pin. 1872
Oil on canvas, 75 x 61 cm (29½ x 24″)
Nationalgalerie, Staatliche Museen Preussischer Kulturbesitz, Berlin

This self-portrait from Böcklin's Munich period shows the artist with paintbrush and palette in hand, his face turned toward the viewer. His attention, however, is directed toward the figure of Death behind him. The artist wears a high-necked jacket and white shirt with collar similar to those in a work that he painted in 1863–64 in Rome depicting himself and his wife strolling past a high park wall (Nationalgalerie, Berlin). In contrast to the earlier work and to his self-portrait of 1878 (Hessisches Landesmuseum, Darmstadt), here Böcklin has a full beard, which also appears in the self-portrait in the Hamburger Kunsthalle, 1875–76, and again in the self-portrait of 1893 (Kunstmuseum, Basel).

The compositional model for the present picture was the portrait of Sir Bryan Tuke (Alte Pinakothek, Munich), which in the nineteenth century was attributed to Hans Holbein the Younger but is now recognized as a studio or school replica with seventeenth-century additions. The additions include a skeletal figure of Death with an hourglass, standing behind the sitter. Traditionally, death is often represented as a fiddler playing a single-stringed instrument. In addition to the *vanitas* theme, the picture has also been interpreted as depicting death as an attribute of the artist or as his muse.

Self-Portrait with Death as Fiddler was exhibited at the Munich Kunstverein in 1872 and established Böcklin's reputation in the artistic community. In addition, it undoubtedly inspired Hans Thoma's *Self-Portrait with Death*, 1875 (Staatliche Kunsthalle, Karlsruhe), and Lovis Corinth's *Self-Portrait with Skeleton*, 1896 (Städtische Galerie im Lenbachhaus, Munich). In *Self-Portrait in the Studio*, 1893 (Kunstmuseum, Basel), Böcklin portrays himself in a similar pose. It was commissioned by the Basel Art Commission and painted at San Terenzo, near La Spezia, Italy. Once again he depicts himself with his paintbrush and palette in his studio, but in the later work the recently begun self-portrait stands on an easel behind him, his figure in profile lightly sketched onto the canvas. The 1893 realistic portrait of the successful, well-dressed, older painter is in complete contrast to the image of the romantic young artist in the self-portrait of 1872. However, the theme of death, important throughout his career, soon reappeared in *Pestilence*, 1898 (Kunstmuseum, Basel), a painting in which Böcklin depicts Death riding a prehistoric bird through the streets of a city.

References: New Haven, 1970 [III], pp. 75–76, no. 7, pl. 59; Düsseldorf, 1974 [IV], no. 30; Basel, 1977 [IV], p. 188, no. 114; Berlin, 1977 [V], pp. 67–69, illus. p. 69.

9. Arnold Böcklin

Island of the Dead, 1880
(Toteninsel)

Signed (lower right): AB
Oil on canvas, 73.6 x 121.9 cm (29 x 48")
The Metropolitan Museum of Art, New York

Böcklin painted five versions of *Island of the Dead.* The versions in The Metropolitan Museum of Art (the present work) and in the Kunstmuseum, Basel, are dated 1880; the painting in the Nationalgalerie, Berlin (no. 10), was executed in 1883 (it once hung in the chancellery of the Third Reich, from which it disappeared in 1945, reappearing only recently); the example that was formerly in the Thyssen Collection (present location unknown) was painted in 1884; and the final version (Museum der bildenden Künste, Leipzig) is dated 1886. The five works are similarly composed variations on the same theme.

The first two versions were not well received by the critics, whose opinion, however, had little effect on Böcklin. When he returned to the theme again in 1883, the Berlin art dealer Fritz Gurlitt provided the title by which all five versions are now known: *Toteninsel,* or *Island of the Dead.* Böcklin himself referred to the painting as *A Still Place, A Silent Island,* and later, *Island of the Graves.*

In the foreground a boatman transports a white-cloaked, priestlike figure and a coffin draped with garlands. On the island itself there are funerary vaults built into the cliffs on both sides of the cypresses. A depiction of Charon (the mythical boatman who ferries the souls of the damned across the river Styx to the banks of hell) that Böcklin painted in 1876 (Georg Schäfer Collection, Schweinfurt) may be thematically related to *Island of the Dead.* However, the first version of the painting resulted from a request made by the recently widowed Marie Berna. In Florence in 1880 she asked Böcklin to paint a picture on the theme of her bereavement. In a letter dated April 29, 1880, Böcklin wrote to her: "You will be able to dream yourself into the world of dark shadows until you believe you can feel the soft and gentle breeze that ripples the sea, so that you shy from interrupting the stillness with any audible sound. . . ."

The inauspicious dark skies in the two versions of 1880 and the approaching storm and windblown treetops in the later, lighter versions threaten the stillness. Death is conceived as an ambiguous event, a journey into an unknown realm in which anonymous figures perform their silent duties in the rite of final passage. In the versions of 1884 and 1886 Böcklin depicts the figure in white praying over the coffin. The silent conversation suggests that death is not the end of existence; the artist appears to encourage a view of death as an impersonal phenomenon no more threatening than an event observed upon a stage.

Island of the Dead is probably Böcklin's most famous image. Max Klinger made an etching of the first version in 1885; Klinger's reproduction is still popular. Twentieth-century artists have also dealt with the theme, for example, Salvador Dali in *The True Picture of Arnold Böcklin's Island of the Dead at the Hour of the Angelus,* 1932 (Von der Heydt-Museum, Wuppertal), and Ernst Fuchs in an etching of 1971 titled *Island of the Dead.* In addition, the picture inspired Sergei Rachmaninoff's symphonic poem *The Isle of the Dead* (1907) and the third movement of Max Reger's *Böcklin Suite* (1913, Opus 128).

References: Düsseldorf, 1974 [IV], nos. 344, 345; Basel, 1977 [IV], nos. 154 (Kunstmuseum Basel version), 155 (Museum der bildende Künste zu Leipzig version).

10. Arnold Böcklin

Island of the Dead, 1883
(Toteninsel)

Signed (lower right, on rock): AB
Oil on canvas, 80 x 150 cm (31½ x 59″)
Nationalgalerie, Staatliche Museen Preussischer Kulturbesitz, Berlin

See entry for version in The Metropolitan Museum of Art, New York (no. 9).

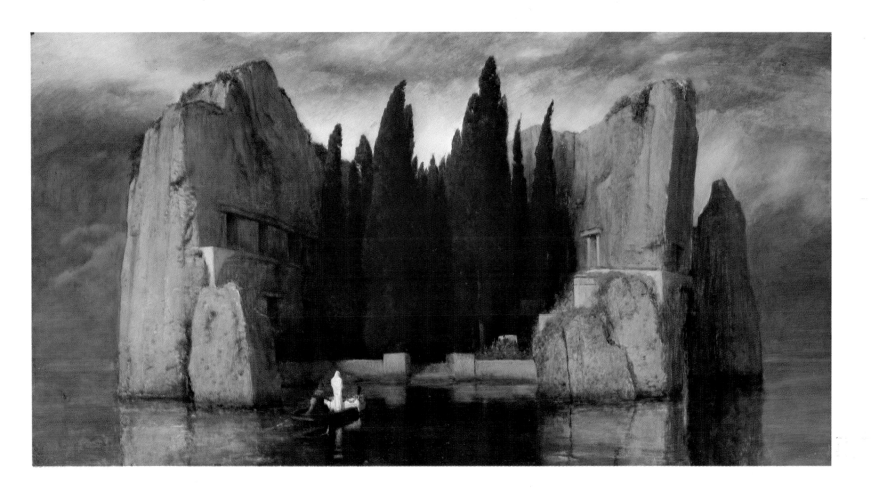

11. Carl Gustav Carus

Prehistoric Grave by Moonlight, 1820
(Hünengrab bei Mondschein)

Signed and dated (upper right): GC 1820
Oil on canvas, 33 x 44 cm (13 x 17⅜")
Kunsthalle Bremen

Prehistoric graves were a source of fascination for the circle of
Romantic artists in Dresden. In August 1819 Carus, prompted
by the travels of his friend Caspar David Friedrich, took his first
trip to Rügen, an area rich in prehistoric burial sites. Like Fried-
rich, Carus never tired of painting this motif. Shown here is
the grave between Silvitz and Keiserlitz, considered the most
impressive example in northern Germany. It is situated on the
road that runs from Mönschsgut to Bergen. The study for this
work (Nasjonalgalleriet, Oslo) is dated August 16. After re-
turning from Rügen, Carus painted several views of prehistoric
graves. In 1820 the present work was first exhibited in Dresden
with the title *Prehistoric Grave near Bergen.* Since we know that
Carus traveled by day, the moonlit interpretation was undoubt-
edly a creation of the artist's imagination.

References: Prause, 1968 [IV], p. 28, no. 312; Bremen, 1973 [V] (text vol.),
pp. 42–53; (plates vol.), pl. 5.

12. Carl Gustav Carus

*High Mountains: View of the Mont Blanc Group
 from Montenvers near Chamonix, 1821–24
(Hochgebirge: Ausblick vom Montanvert bei Chamonix
 auf die Montblanc-Gruppe)*

Oil on canvas, 136 x 171 cm (53½ x 67⅜")
Museum Folkwang, Essen

In August 1821 Carus traveled to Genoa. He returned through
Switzerland via the Simplon Pass and arrived in Chamonix the
night of September 11. The next day he climbed Montenvers
and from the summit could see the entire Mont Blanc Group.
Later he wrote in his diary: "The view over the sea of ice with
its bluish green coloration and eternally frozen contours was
marvelous. The snow and ice seemed to descend half from Mont
Dru and half from Mont Blanc to form one gigantic ice
field. . . . How charming is the play of colors of this enormous
mountain, how delicate and pure the gradations of its reddish,
ocher, and violet tones despite its colossal size." Upon his return
to Germany he began to work on a picture which was completed
in 1824 and included that year in the Dresden Academy exhi-
bition. However, recent research indicates that it was another
painting, not the picture in the Museum Folkwang, which was
shown in 1824. The picture shown in Dresden was probably
Carus's copy of a view from Montenvers that Friedrich painted
from a drawing supplied by Carus. The copy was formerly in
the Nationalgalerie, Berlin; it disappeared after 1945.

References: Prause, 1968 [IV], no. 139a; Essen, 1971 [V], pp. 22–23, illus.
p. 22.

13. Lovis Corinth

Slaughterhouse in Schäftlarn an der Isar, 1897
(Schlachterladen in Schäftlarn an der Isar)

Signed (upper right): Lovis Corinth/1897
Oil on canvas, 69 x 87 cm (27⅛ x 34¼")
Kunsthalle Bremen

Butcher shops were popular as subjects during the nineteenth century, but their interest for artists probably has its origins in seventeenth-century examples such as Rembrandt's *Slaughtered Ox*, 1655 (Louvre, Paris), and Annibale Carracci's *Butcher Shop*, 1582–83 (Christ Church, Oxford). Moreover, as Gabriel Weisberg indicates, "The theme of a carcass hanging in a butcher shop was not new in 1874 when François Bonvin completed *The Pig* [Musée St. Denis, Reims]. Ever since 1857, when the Louvre first exhibited Rembrandt's *Slaughtered Ox*, major painters such as Daumier, Decamps, and Delacroix had copied or interpreted the theme. . . . By the late 1860s, other painters were also using the theme."

As the son of a tanner from Tapiau, Corinth had undoubtedly experienced scenes like the one depicted here. The subject appears a number of times in his work between 1892 and 1921. The present example was painted in a slaughterhouse on the Isar near Munich. Although it is significant as a Naturalist-Realist treatment of a working-class subject, Corinth's interests transcend genre painting. The richness of the facture underscores the artist's fascination with the painterliness and the two-dimensional reality of the picture. Indeed, the ingested orchestration of shapes, brushwork, and pigment emphasizes qualities that bring to mind Maurice Denis's famous dictum of 1890: "Remember that a painting—before it is a battlehorse, a nude woman, or some anecdote—is essentially a flat surface covered with colors assembled in a certain order."

References: Berend-Corinth, 1958 [IV], p. 141, no. 147, illus. p. 357; Bremen, 1973 [V] (vol. 1), pp. 58–59; (vol. 2), pl. 349; Cologne,.1976 [IV], p. 52, no. 8, pl. 5; Gabriel P. Weisberg, *The Realist Tradition: French Painting and Drawing 1830–1900,* Cleveland, 1980, p. 224.

14. Lovis Corinth

Young Woman with Cats, 1904
(Junge Frau mit Katzen)

Signed (upper right): Lovis Corinth
Oil on canvas, 78.5 x 60 cm (30⅞ x 23⅝")
Staatsgalerie Stuttgart (Galerievereins, extended loan)

Young Woman with Cats was painted in 1904 during a summer vacation in the country at Waidlage-in-dem-Mark, near Berlin. The painting depicts Corinth's twenty-four-year-old wife, Charlotte Berend.

The subject, the point of view, and the paint handling bear a stylistic relationship to earlier French Impressionist pictures, but these similarities reflect shared affinities rather than direct influences. Although Corinth is sometimes called an Impressionist, this portrait of his young wife is more direct and more clearly articulated than French Impressionist works of similar subjects. The definition throughout is clearer, and there is an appealing immediacy that is absent from most Impressionist portraiture.

Corinth was forty-six, exactly twice Charlotte's age, when he married her the year before he painted this picture. He chose to paint her in a flowered dress and hat, in full summer light. The painting clearly celebrates the artist's love for his young wife, whose youth and innocence are reflected by the two kittens in her lap. Charlotte Berend was herself a painter, who worked in a style similar to Corinth's, but today she is best known as the author of the catalogue raisonné of his work.

References: Berend-Corinth, 1958 [IV], p. 431, no. 292; Stuttgart, 1968 [V], pp. 43–44.

15. Lovis Corinth

Young Otto with His Mother, 1905
(Ottchen mit seiner Mutter)

Signed (upper left): Lovis Corinth
Oil on canvas, 95 x 75 cm (37⅜ x 29½")
Niedersächsisches Landesmuseum, Hannover

In 1905 Corinth painted this work during a visit to Braunlage, in the Harz Mountains. The child, named Otto, is supported by his mother as he takes his first steps. *Young Otto with His Mother* depicts an intimate, private domain, and its composition has it origins in Renaissance and Baroque images of the Madonna and Child, such as Rubens's *Madonna with Standing Child*, 1616–18 (Niedersächsisches Landesmuseum, Hannover).

To assure the analogy between the present painting and those of the Madonna and Child, Corinth has placed an apple in the hand of Otto's mother. As George Ferguson has written, "When the apple appears in the hands of Adam it means sin, but when it is in the hands of Christ, it symbolizes the fruit of salvation. . . . As Christ is the new Adam, so, in tradition, the Virgin Mary is considered to be the new Eve and, for this reason, an apple placed in the hands of Mary is also considered an allusion to salvation." Although the composition and the iconography seem to allude to a specific Christian subject, Corinth himself associated the child with a kind of ideal German figure: "The child is the pure old German type. His curly blond hair is the kind which doesn't exist anymore, and the boy is very reminiscent of the ancient Germans."

This secularized, early twentieth-century treatment of a subject that was more or less confined to religious painting for centuries underscores the ongoing transformations that combined to create the foundations of modern art about 1900. Here we see Corinth combining a quasi-Impressionist style with proto-Expressionist tendencies, while painting an ostensibly bourgeois subject which alludes to both traditional compositional sources and contemporary nationalistic concerns. In such paintings we find the culmination of earlier currents, as well as the roots of one of the most important modernist movements, German Expressionism.

References: George Ferguson, *Signs and Symbols in Christian Art,* New York, 1954, p. 32; Hannover, 1973 [V], no. 175.

16. Lovis Corinth

Potiphar's Wife, 1914
(Potiphars Weib)

Signed and dated (upper right): Lovis Corinth/1914
Oil on canvas, 107 x 148 cm (42⅛ x 58¼″)
Hessisches Landesmuseum, Darmstadt

The title of this painting refers to the encounter between Joseph and Potiphar's wife described in Gen. 39:12: "And she caught him by his garment, saying, Lie with me: and he left his garment in her hand, and fled. . . ." It is one of numerous works by Corinth that depict a biblical or mythological subject in a fully modern idiom.

Potiphar's Wife was painted in Corinth's studio on the Klopstockstrasse in Berlin. It is apparently directly related to a small, loosely executed sketch done the same year (present location unknown; Berend-Corinth no. 608). There are three other paintings that also treat the theme: *Joseph and Potiphar's Wife, First Version,* 1914 (present location unknown; Berend-Corinth no. 606), *Joseph and Potiphar's Wife, Second Version*, 1914 (Städtische Museum, Krefeld; Berend-Corinth no. 607), and *Joseph and Potiphar's Wife, Third Version*, 1915 (present location unknown; Berend-Corinth no. 657). In these three paintings Joseph is actually visible, and Potiphar's wife is shown holding onto his garment as he escapes.

Eroticism is an important theme in Corinth's art, and the present painting is typical of the intensity with which the artist pursued its interlocking physical, psychological, and often unabashedly atavistic aspects. For some painters a subject such as Potiphar's wife merely provides a pretext for eroticism, but for Corinth eroticism is itself the undisguised subject. As he made clear in a journal entry, dated April 15, 1923, he believed that painting was particularly appropriate to his purpose: "Just as music in man and in the songs of birds is predicated upon sexual feelings, so too is painting a totally sensual expression. I can certainly say that eroticism is the most spiritual and . . . the most difficult to master as a strictly artistic concept. . . . Precisely because it . . . is purely an art of feeling, it must evoke lofty and sublime sentiments in every man. When, like ancient and medieval man, we have gained enough naïveté to regard every expression of feeling as an expression of art, then today's art will also be complete. Until that is achieved, all that we will have is a shabby fragment."

References: Corinth, 1926 [IV], pp. 165–66; Berend-Corinth, 1958 [IV], p. 132, no. 605, illus. p. 616.

17. Peter von Cornelius

Odysseus and Polyphemos, 1803
(Odysseus bei Polyphem)

Oil on canvas, 101 x 157 cm (39¾ x 61¾")
Schlossverwaltung Stolzenfels, Koblenz (Landesamt für
 Denkmalpflege Rheinland-Pfalz und Verwaltung der
 Staatlichen Schlösser)

This early work by Cornelius is one of his first oil paintings.
It was painted in 1803 and entered in the Weimar Open Com-
petition which was organized annually from 1799 to 1805 by
the Weimarer Kunstfreunde, a pseudonym for Johann Wolfgang
von Goethe and his friend Heinrich Meyer. Each year they chose
a theme from Greek literature or mythology to be addressed
by the entrants. The competitions fostered, albeit indirectly, the
Neoclassical ideas and theories promulgated by *Propyläen,* the
art review that Goethe and Meyer published from 1798 to 1800.

In 1803 the theme chosen was from Homer's *Odyssey;* artists
were to depict "Odysseus's use of wine to cunningly soothe the
Cyclops." In a preliminary version, about half the size of the
present painting (Kunstmuseum, Düsseldorf), Cornelius fo-
cused on the moment when Odysseus offers Polyphemos the
wine that will cause the one-eyed giant to sleep, thereby af-
fording Odysseus and his remaining men (Polyphemos has eaten
the others) the opportunity to blind the Cyclops and to escape.

In the finished painting, the present work, Cornelius chose
a slightly later moment in the story: "When the wine had got
into the brains of the Cyclops, then I spoke to him, and my
words were full of beguilement: 'Cyclops, you ask me for my
famous name. I will tell you then, but you must give me a guest
gift as you have promised. Nobody is my name. My father and
mother call me Nobody, as do all the others who are my com-
panions.' So I spoke, and he answered me in pitiless spirit: 'Then
I will eat Nobody after his friends, and the others I will eat first,
and that shall be my guest present to you.' He spoke and slumped
away and fell on his back, and lay there with his thick neck
crooked over on one side, and sleep who subdues all came on
and captured him, and the wine gurgled up from his gullet with
gobs of human meat." In addition to illustrating different lines
of the text, Cornelius also altered the location and/or posture
of virtually every figure, although he retained the fundamental
structure of the composition.

The relationship of this painting to Cornelius's later work
is significant; although these figures are comparatively stiff and
anatomically primitive, they are directly related to the dramatic,
gesticulating, quasi-Mannerist figures that later appear in more
refined form. *Odysseus and Polyphemos* illustrates several char-
acteristics of Cornelius's style, particularly a stagelike quality;
as Ulrich Finke has pointed out, "Cornelius is the most theatrical
of the Nazarenes: the way in which he places groups of figures
in front of architectural scenery, and also creates a pseudo-Ba-
roque or mannered world of forms out of gesture, is extremely
important." Moreover, the composition anticipates certain later
work in which he "stresses particularly the clarity of the figures.
. . . The area of the picture has become like a theatrical set on
which actors move about."

References: Markowitz, 1960 [IV], pp. 201–06; Düsseldorf, 1969 [V],
pp. 66–67; Finke, 1974 [I], p. 53; *The Odyssey of Homer,* translated and
with an introduction by Richard Lattimore, New York/London, 1975,
pp. 146–147 (9. 345–52, 362–74).

18. Peter von Cornelius

Athena Teaching the Women to Weave, 1807–8
(Athene lehrt die Weberei)

Signed and dated (lower left): P. Cornelius pinx[t]. 1809 (?)
Oil on canvas, 107 x 88 cm (42⅛ x 34⅝")
Kunstmuseum, Düsseldorf

Athena Teaching the Women to Weave is an early work by Cornelius, painted in the Neoclassical manner encouraged by the Düsseldorf Academy when Peter von Langer was director. The date of this painting as 1809 has been disputed since at least 1883. On stylistic grounds it is now believed to have been painted in 1807–8. The execution is closer to work Cornelius did at the Düsseldorf Academy than to pictures done after he moved to Frankfurt in 1809.

This painting was commissioned by a textile manufacturer from the town of Eupen, and Athena, patron goddess of the arts and crafts, especially spinning and weaving, was an appropriate subject. Standing in front of a Doric-columned portico, Athena is depicted in plumed helmet and peplos and holding a spear—attributes designating her also as goddess of war. She instructs a young woman in the art of weaving as three other women listen attentively. At the far left an elderly woman shears a sheepskin to make yarn.

The composition relates to earlier works by the artist in its use of classical buildings to enclose a figural scene, but it is distinguished by the more fully integrated relation between the figures and the architectural surrounding. The use of an architectural background to offset and articulate the poses and gestures of the figures in the foreground may be traced to works by Jacques Louis David, an artist greatly admired by the Langer-directed Academy (e.g., *Paris and Helen*, 1788, and *Lictors Returning to Brutus the Bodies of His Sons*, 1789; both in the Louvre, Paris). The delicate and restrained palette is also characteristic of teaching at the Academy during Langer's tenure as director, and the subject reflects the Neoclassical tenet that contemporary life should be interpreted through the mythology and subject matter of ancient Greek and Roman art.

In 1807–8, however, Cornelius's knowledge of anatomy and sense of proportion were not yet fully developed. Certain figural motifs are borrowed from works by, among others, Raphael, Giulio Romano, and Anton Schoonjans. Cornelius was able to familiarize himself with the work of these and other artists because of the extensive holdings of the print collection at the Düsseldorf Academy.

References: Düsseldorf, 1969 [V], pp. 68–69; Düsseldorf, 1979 [III], p. 286, no. 49a, illus.

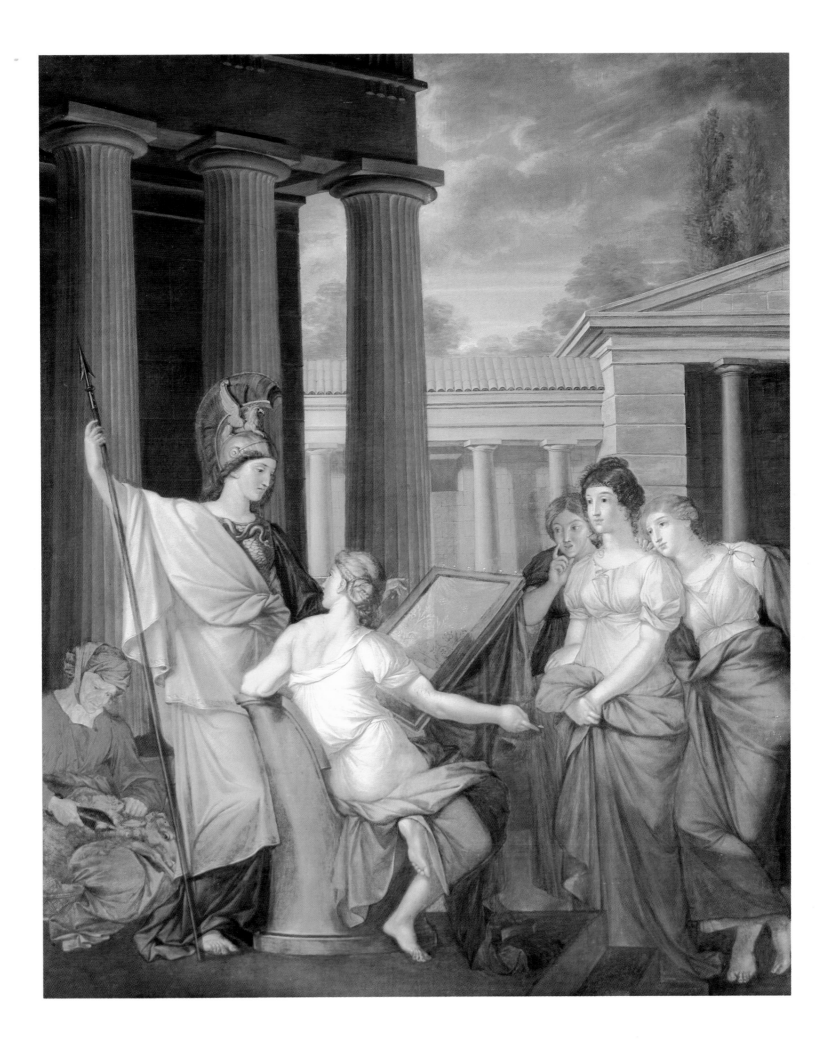

19. Peter von Cornelius

Theodor Glasmacher, c. 1808–9

Oil on canvas, 82.5 x 68.3 cm (32½ x 26⅞")
Quirinus-Gymnasium, Neuss

The educator Theodor Glasmacher is shown here seated in a heavy Renaissance chair shaded by a canopy of foliage in a wooded landscape. The book in his right hand and the antique bust, possibly of Plato, behind him are indications of his position as a man of learning. Glasmacher was originally ordained as a priest in the Benedictine abbey of St. Pantaleon in Cologne but subsequently left the order. He became a teacher in a girls' secondary school in Bonn and then director of a private school in Bad Godesberg. In 1806 he was appointed director of a secondary school in Neuss, the Quirinus-Gymnasium, a position he held until 1825.

This painting was rediscovered in 1978 by Wend van Kalnein, who identified it as an early portrait by Cornelius. It was probably painted during 1808–9, after Cornelius had finished his fresco paintings for the St. Quirinus Cathedral in Neuss. The style of the portrait perhaps reflects the influence of his father, Aloys Cornelius. The elder Cornelius worked in a Late Baroque manner and taught the elementary class at the Düsseldorf Academy. The present painting is typical of a kind of international portrait style common in the early nineteenth century; note, for example, Prud'hon's strikingly similar portrait of Count Gianbattista Sommariva, 1815 (Pinacoteca de Brera, Milan).

References: Wend von Kalnein, "Ein Frühwerk von Peter Cornelius," *Neusser Jahrbuch 1978,* pp. 38–42; Düsseldorf, 1979 [III], p. 286, no. 49, illus. p. 285.

20. Peter von Cornelius

The Wise and the Foolish Virgins, 1813–19
(Die klugen und die törichten Jungfrauen)

Oil on canvas, 116 x 155 cm (45⅝ x 61")
Kunstmuseum, Düsseldorf

The Wise and the Foolish Virgins is based on the parable of the Ten Virgins (Matt. 25:1–13). The subject was of special interest to Cornelius in the years 1813–15 because he planned to illustrate all the Christian parables in a graphic cycle intended as a counterpart to Overbeck's *Seven Acts of Mercy*.

The painting is a somewhat free interpretation in that Christ recounts the parable but does not actually play a role in it. He is shown here as the bridegroom who emerges on a cloud from the Doors of Paradise, surrounded by angels and Old and New Testament saints—all of which is a departure from the text. In the actual parable a bridegroom simply appears and departs with the Wise Virgins, leaving the Foolish Virgins behind. The five with the lighted oil lamps in the foreground are the Wise Virgins, who bring extra oil and are prepared for the bridegroom's delay. The Foolish Virgins are in the darkness in the background. Arriving without sufficient oil, they try to replenish their supply; meanwhile, the bridegroom arrives, and departs with the Wise Virgins. The parable illustrates the final line, "Watch, therefore; for ye know neither the day nor the hour in which the Son of man cometh."

In a letter of 1814 Cornelius referred to this painting as the best work he had yet done. Indeed, it is his most accomplished early attempt at monumental religious painting, and is a significant step in the development that culminated in his later large-scale frescoes. The first studies were made in Orvieto in 1813; work on the final canvas began in Florence in the fall of that year and continued into 1816. His interest in the painting declined in 1816 after he received the commission for the Casa Bartholdy frescoes (see no. 21). When Cornelius left Rome in 1819 the painting remained in Joseph Anton Koch's studio. The entire left side of the picture remains unfinished.

The Nazarenes' wish to revive German religious painting, which Cornelius sought to accomplish by emulating the monumental fresco art of the past, is here reflected in the large format, the compositional type, and the symbolic theme which, as Karl Förster noted in 1874, lends itself to the portrayal of beautiful and ideal figures. The present work is characteristic of the Nazarene belief that art could be revitalized by seeking inspiration from early Italian and German Gothic cultures. Indeed, the facial expressions and figural style of *The Wise and the Foolish Virgins* relate to the German Gothic manner of Cornelius's illustrations for Goethe's *Faust* and the *Nibelungenlied*, which he was also working on at about the same time as the painting. The profusion of motifs, the predominantly linear style, and the influence of Mannerism are traits that became integral elements of his mature style. Several of the saints and virgins are modeled on Raphael prototypes; for example, as Keith Andrews has noted, the Wise Virgins at the right derive from the Three Muses in *Parnassus,* and the Foolish Virgins in the background derive from figures in *Fire in the Borgo*. The ornamental frames and decorative panels of the Doors of Paradise relate to border motifs in Raphael's tapestries in the Vatican and Ghiberti's doors for the Baptistery in Florence. Also evident in the rendering of the figures and the composition is the influence of Signorelli's frescoes in the cathedral at Orvieto, which Cornelius had seen in the summer of 1813.

Cornelius's depiction of the bridegroom as Christ was at the time apparently unprecedented in illustrations of the parable of the Ten Virgins. The painting inspired both Thorvaldsen's full-length sculpture of Christ in the Frauenkirche, Copenhagen, and Schadow's *The Wise and the Foolish Virgins,* 1838–42 (Städelsches Kunstinstitut, Frankfurt am Main). It entered Thorvaldsen's collection in 1831 and was taken to Copenhagen, but was back in Rome by 1848.

In 1861 *The Wise and the Foolish Virgins* was included in the Second Universal Exhibition of German and Historic Art in Cologne, at which time it was acquired by the Kunstmuseum, Düsseldorf.

References: London, 1959 [III], p. 94, no. 76, pl. 79; Andrews, 1964 [II], p. 101, no. 21, pl. 21; Düsseldorf, 1969 [V], pp. 71–74, no. 4062, pl. 43; New Haven, 1970 [III], pp. 84–86, no. 18, pl. 20; London, 1972 [III], pp. 34–35, no. 56; Düsseldorf, 1979 [III], pp. 287–88, no. 51, illus. p. 288.

21. Peter von Cornelius,
Johann Friedrich Overbeck,
Wilhelm von Schadow, and Philipp Veit

Five Wall Paintings in the Casa Bartholdy, Rome, 1818
(Fünf Wandbilder in der Casa Bartholdy in Rom)

Watercolor on paper attached to canvas, 52 x 108 cm (20½ x 42½")
Nationalgalerie, Staatliche Museen Preussischer Kulturbesitz, Berlin

The five scenes depicted represent frescoes painted in 1816–17 by Cornelius, Overbeck, Schadow, and Veit that decorated the reception room of the apartment belonging to Jakob Salomon Bartholdy, the Prussian consul general in Rome. The apartment was in a building known then as the Palazzo Zuccari, which was later renamed the Casa Bartholdy and is now the Biblioteca Hertziana.

In 1814 Cornelius expressed the desire that "fresco painting be reintroduced as it had existed in Italy from the time of Giotto to the divine Raphael." In a letter to Johann Joseph von Görres, he explained that "a small number of German artists have begun to clear the overgrown path to the sacred temple of art; they are filled with awareness of the true nobility and divinity of their art, by divine revelation, as it were . . . this small band is waiting for a worthy opportunity, and burning with desire to show the world that art can magnificently come alive now, as it was once. . . . The strongest means . . . of giving German art the basis for a new direction would be no less than the reintroduction of fresco painting. . . . To insure a good start for this, nothing would be more desirable . . . than that those who have embraced the true meaning of art with courage in their hearts . . . should, according to their unanimous wish, be given a great, worthy, extended task in a public building in some German city." The Casa Bartholdy frescoes were the first realization of the kind of joint effort that Cornelius envisaged. The Casa Bartholdy frescoes and those for the Casino Massimo (1817–29) are the most important projects executed by the Nazarenes as a group during their early years in Rome.

The individual watercolors comprising the present work were painted by each artist after work that he himself had done in the Casa Bartholdy. They were then attached to canvas and unified with painted decorative architectural motifs for display in the 1818 autumn exhibition of the Berlin Academy; the arrangement of the watercolors does not correspond to the arrangement of the original frescoes. In this way the Nazarenes provided their German countrymen with an example of the kind of painting they had done in Rome and which they hoped also to execute in Germany.

The subjects for the frescoes illustrate scenes from the story of Joseph in the Book of Genesis. The scenes represented here, a selection from the Casa Bartholdy cycle, are as follows: *Jacob's Lament* by Schadow (left panel), *The Seven Years of Plenty* by Veit (left lunette), *Joseph Interprets the Pharaoh's Dreams* by Cornelius (right panel), *The Seven Lean Years* by Overbeck (right lunette), and *Joseph and Potiphar's Wife* by Veit (center).

In 1886–87 the original frescoes were removed from the Casa Bartholdy and sent to the Nationalgalerie, Berlin. They are now in the Nationalgalerie, East Berlin.

References: Andrews, 1964 [II], pp. 33–37; Berlin, 1977 [V], pp. 85–87, illus. pp. 86, 87 (detail); Frankfurt am Main, 1977 [III], pp. 64–65, no. B 22, illus. p. 79; Schrade, 1977 [II], p. 118.

22. Johann Georg von Dillis

View of St. Peter's from the Villa Malta, Rome, 1818
(Blick auf St. Peter von der Villa Malta, Rome)

Oil on paper mounted on canvas, 29.2 x 43.4 cm (11 ½ x 17 ⅛")
Schack-Galerie, Bayerische Staatsgemäldesammlungen, Munich

In 1817–18 Johann Georg von Dillis accompanied Crown Prince Ludwig of Bavaria on a trip through Italy. In the spring the crown prince rented the Villa Malta in Rome, which he purchased nine years later for use by German artists. During the trip Dillis made drawings of important sites that were to be used later for works painted in Bavaria. From the Villa Malta he made three drawings, now in Munich, depicting the same view as the present picture. In addition, he painted three oil studies from nature which were probably used for the same purpose as the drawings. The oil studies were, respectively, this view west toward St. Peter's, with the dome of San Carlo al Corso in the right background (the Castel Sant'Angelo is just out of sight farther to the right); a view of the Palazzo del Quirinale to the southeast; and a view of the capitol to the southwest. The three oil studies are all in the Schack-Galerie, Munich. They were purchased by Count Adolf Friedrich von Schack in 1869 for his collection as works by Carl Rottmann. However, on stylistic grounds and through comparison with Dillis's drawings in the Staatliche Graphische Sammlung and Stadtarchiv, Munich, they have since been attributed to Dillis.

As Helmut R. Leppien has pointed out (Paris, 1976), the three studies are among the most important oil sketches in the history of German painting. Their significance is attributable largely to the artist's eschewal of the classical tradition. A seemingly fortuitous composition has resulted, which anticipates effects that would be made commonplace by the invention of photography later in the century (see entry for Blechen's *View of Rooftops and Gardens,* c. 1835, no. 4).

Dillis never used the sketches and drawings made at the Villa Malta for finished landscapes painted after his return to Bavaria. However, another German artist, Johann Christian Reinhart, using a methodology similar to that of Dillis, did paint four detailed panoramic views of Rome from the Villa Malta (Neue Pinakothek, and Staatsgalerie, Munich). Ludwig commissioned the views in 1829, and Reinhart finished them in 1835.

References: Munich, 1969 [V] (vol. 1), pl. 3; (vol. 2), pp. 94–95, no. II 468; Paris, 1976 [III], pp. 34–35, no. 41, illus. p. 35.

23. Louis Eysen

Still Life with Shell, Glass of Water, and Spoon, 1869
(Stilleben mit Muschel, Wasserglas und Löffel)

Inscribed (upper left): II
Dated (lower right): 6/69
Oil on pasteboard, 23 x 48.2 cm (9 x 19″)
Städelsches Kunstinstitut und Städtische Galerie, Frankfurt am Main

According to Eysen this still life was his second painting, but Werner Zimmermann has identified it as the artist's first picture. It was done in Paris in June 1869 during Eysen's brief period of study with Otto Scholderer, a Frankfurt artist then living in Paris. Scholderer's own still lifes, which owed much to the work of Henri Fantin-Latour and the French tradition, probably provided the stimulus for this painting. Although the still life is clearly that of a beginner, the young painter's talent is evident; instead of concentrating on subtleties of surface and texture, which he could not master at the time, he focused on compositional elements such as the delicate pattern of repeating curves.

References: Zimmermann, 1963 [IV], no. 1, pl. 37; Frankfurt am Main, 1972 [V] (vol. 1), p. 100; (vol. 2), pl. 180.

24. Louis Eysen

Summer Landscape, 1875–77
(Sommerlandschaft)

Oil on canvas, 49.5 x 67.5 cm (19½ x 26⅝″)
Städelsches Kunstinstitut und Städtische Galerie, Frankfurt am Main

In 1873 Eysen moved from Frankfurt to Kronberg in the Taunus Mountains where he lived until 1878. *Summer Landscape* probably depicts a scene in the foothills and is one of many views of the area that Eysen painted during his years in Kronberg. The painterly brushwork and strong colors distinguish this picture from the artist's earlier landscapes; comparison with the tighter handling and darker palette of *Königstein in the Taunus Mountains* (Städelsches Kunstinstitut und Städtische Galerie, Frankfurt am Main), painted immediately after Eysen's arrival, suggests a slightly later date, 1875–77, for the present painting. The paint handling and interest in light may reflect the influence of early Impressionism, which Eysen undoubtedly encountered in 1869 during his stay in Paris. In addition, the artist had clearly benefited from exposure to the work of Wilhelm Leibl, whom he met in 1867, Gustave Courbet, whom he met in Paris in 1869, and Hans Thoma, a member of the Leibl circle, with whom he was in regular contact beginning about 1870.

References: Zimmermann, 1963 [IV], no. 42; Frankfurt am Main, 1972 [V] (vol. 1), p. 101; (vol. 2), pl. 184.

25. Anselm Feuerbach

The Storyteller at the Well (Hafiz), 1866
(Der Märchenerzähler am Brunnen [Hafis])

Signed (lower right): A. Feuerbach. 66.
Oil on canvas, 137 x 99 cm (54 x 39″)
Pfalzgalerie des Bezirksverbandes, Kaiserslautern

The fourteenth-century Persian poet Shams ud-din Mo-
hammed, known as Hafiz, had interested Feuerbach since his
youth. The work of Hafiz was accessible in translation through
the collection of oriental poems titled *Ghaselen,* which had been
published by G. F. Daumer. Although Feuerbach first depicted
the poet in *Hafiz Before the Inn,* 1852 (Kunsthalle Mannheim),
it was not until 1866 that he executed his major pictures devoted
to the theme.

The present work is the second and smaller version of *Hafiz
at the Well* (Schack-Galerie, Munich), which Feuerbach painted
earlier in 1866 for Count Adolf Friedrich von Schack. The artist
liked the picture and executed a variant. He changed the com-
position slightly, gave the poet a younger appearance, and re-
titled it *The Storyteller.* Two years later Privy Councilor Joseph
Benzino bought it for his collection, which was eventually be-
queathed to the Pfalzgalerie.

In Count Schack's comments about the first version, which
are equally applicable to the second, he noted that, "The picture
did not contain much in the way of oriental costumes except
for the caftan which Hafiz wears. With the exception of one
female figure who is supposed to be a nubian slave, one might
mistake the other extremely gracious women for Greeks. In the
depiction of this figural group, Feuerbach seems to revel in a
cult of beauty." Indeed, there is an anonymity of subject and
a sense of timelessness which suggest that Feuerbach hoped to
reach beyond the bounds of a specific anecdotal subject. The
composition has a proto-Symbolist quality that seems to antic-
ipate the work of Pierre Puvis de Chavannes.

References: Kaiserslautern, 1975 [V], illus. (unpaginated); Karlsruhe, 1976
[IV], p. 176, no. 45, illus. p. 255.

26. Anselm Feuerbach

Ricordo di Tivoli, 1867

Signed (lower left): A. Feuerbach 67
Oil on canvas, 194 x 131 cm (76⅜ x 51⅝")
Nationalgalerie, Staatliche Museen Preussischer Kulturbesitz, Berlin

Feuerbach must have visited Tivoli often while living in Rome, 1856–72. The area, famous for its classical, medieval, and Renaissance archaeological sites and buildings, as well as for its gardens and waterfall, is situated east of Rome on the western slopes of the Sabine Mountains. In 1864 Feuerbach included the famous waterfall in two versions of *Nymph Eavesdropping on Children Playing Music* (Schack-Galerie, Munich, and Kunstmuseum Basel). The composition and subjects of both anticipate those of the present painting.

Feuerbach began *Ricordo di Tivoli* early in 1866. He finished it on December 31, but dated it 1867; the title is his own. The painting was purchased by the Munich collector Konrad Fiedler, but the artist did not deliver it for another year. Fiedler also owned Feuerbach's *Idyll of Tivoli,* 1867 (formerly Nationalgalerie, Berlin; missing since 1945), which showed only the peasant girl seated in a landscape and turned toward the viewer. The delayed delivery of the present painting was probably necessitated by the artist's having agreed to paint a replica for Count Adolf Friedrich von Schack, another important Munich collector. The replica took longer than anticipated and was only sent to Munich in 1868. It was Schack's last commission for Feuerbach; his order for a *Medea* was subsequently withdrawn, bringing an end to the count's support of the artist.

Feuerbach himself was very satisfied with the composition and wrote: "In terms of content, this work along with *Hafiz* [see no. 25] and *Family Scene* comprise a kind of spiritual triad." The painting attempts a glorification of music and landscape. Although its focus is the idyllic landscape that occurs in German painting throughout the nineteenth century, today's audience is more likely to interpret the picture as a slightly stilted idealization of peasant children in a bucolic setting. It does in fact reflect Feuerbach's academic training in Düsseldorf and Paris, and provides an interesting comparison with contemporary paintings of peasants by Adolphe William Bouguereau.

There are three drawings of the peasant children in various poses (Nationalgalerie, East Berlin), which suggests that the composition of *Ricordo di Tivoli* resulted from careful study.

References: Berlin, 1977 [V], pp. 114–16, illus. p. 115.

27. Anselm Feuerbach

By the Sea (Iphigenia), 1875
(Am Meer [Iphigenie])

Monogrammed and dated (at left): AF. 75
Oil on canvas, 197 x 113.5 cm (77½ x 44⅝")
Kunstmuseum, Düsseldorf

Although Iphigenia is not mentioned by Homer she is identified in Greek mythology as the daughter of Agamemnon, leader of the Greeks in the war against Troy. Artemis, goddess of the hunt, demanded the sacrifice of Iphigenia either because Agamemnon had insulted her or because he had vowed to sacrifice to her the most beautiful thing, presumably an animal, born in a certain year; but in that year Iphigenia was born. To assure her demand, Artemis prevented the departure of the Greek fleet at Aulis on its way to Troy. Iphigenia was sent for on the pretext of marrying her to Achilles, but instead of the intended sacrifice Artemis substituted an animal for her and took her to the land of the Tauri (Crimea). There the young woman served as priestess, overseeing the sacrifice of shipwrecked strangers. Later, when Iphigenia discovered that her brother Orestes and Pylades were among the prisoners, she permitted their escape and fled with them.

Feuerbach's first painting of Iphigenia, for which his mistress Nanna Risi was model, was executed in 1862 (Hessisches Landesmuseum, Darmstadt). In 1871 Lucia Brunacci, Nanna's successor, posed for Feuerbach's second treatment of the subject (Staatsgalerie Stuttgart). Four years later she also served as model for the present painting, the third and last of the artist's Iphigenia pictures. In the two earlier versions Iphigenia is seated; in the present example she stands. In 1872, after the painting had been started, Feuerbach decided to title it *By the Sea,* a change which suggests that he intended a broader, timeless appeal in lieu of a specific, anecdotal subject; it is clear, however, that the subject is Iphigenia. In all three paintings she is seen from behind looking out to sea. In the second and third examples the same promontory is visible in the far distance, suggesting that the same coastline is depicted, presumably the shore of the land of the Tauri.

It is impossible to determine which literary source or sources, if any, Feuerbach may have used. However, in Kermit Champa's discussion of the differences between the first and second versions (New Haven, 1970), which is also applicable to the differences between the first and third versions, he suggests that Goethe's interpretation of the myth of Iphigenia may have been influential: "The first version depends upon Feuerbach's ability to render his personal passion for Nanna into some poetically generalized aesthetic form; the second depends on his ability to move from a position of great aesthetic self-certainty

to an individual embodiment of that certainty. In both instances he succeeds and, in doing so, he manages to express the two-part character that Iphigenia assumed for Goethe in his re-creation of the myth, which Feuerbach read in 1860. For Goethe, Iphigenia was both an intensely real woman and an impersonal tool of mythical fate. She was as seductive in one guise as she was a poetically abstract, sublime, and finally classical female archetype in the other."

The early 1870s are rich in Feuerbach's descriptions of figures from antiquity. In addition to the Iphigenia paintings, he twice illustrated Medea, who played a prominent role in the story of Jason and the Argonauts. Those paintings, similar to the Iphigenia pictures in size and composition, were painted in 1870 and 1873 (Kunsthalle Mannheim, and Kunsthistorisches Museum, Vienna).

References: Düsseldorf, 1968 [V], pp. 30–31, no. 4126, pl. 27; New Haven, 1970 [III], pp. 91–92, no. 28, frontispiece; Berlin, 1980 [V], pp. 337 ff.

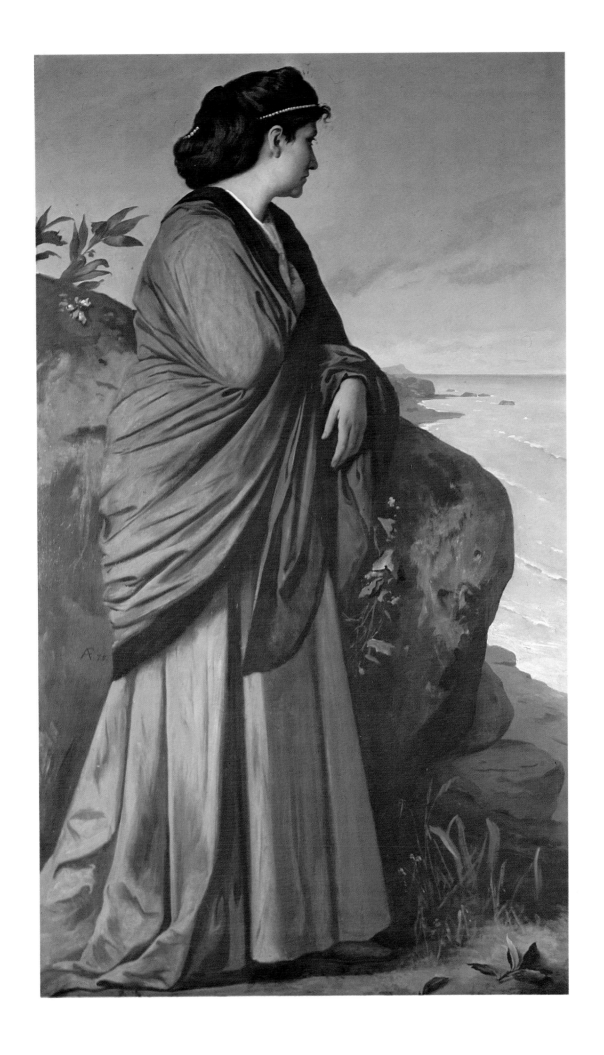

28. Anselm Feuerbach

Portrait of the Artist's Stepmother, Frau Henriette Feuerbach, 1878

(Porträt der Stiefmutter des Künstlers, Frau Henriette Feuerbach)

Monogrammed and dated (upper right): AF s.M. / 78
Oil on canvas, 86.5 x 69.8 cm (43 x 27½")
Nationalgalerie, Staatliche Museen Preussischer Kulturbesitz, Berlin

Henriette Heydenreich married Feuerbach's father in 1834 when the artist was five years old. Her husband died in 1851, and subsequently she maintained a close relationship with her step-son. She encouraged his career and acted as agent for his work; occasionally she also assisted him financially. In 1882, two years after he died, she published a two-volume collection of his letters to her which attests to the importance of their relationship.

This painting is the last of three portraits of his stepmother. The first, dated 1867, is in the Kurpfälzisches Museum, Heidelberg, and the second, dated 1871, is in the Österreichische Galerie, Vienna. Each was apparently done with the help of a photograph. The present example is a more fully developed painting than the portrait of 1871, but it seems based on that version.

Each time Feuerbach painted Henriette he also executed a self-portrait, but the pairs should not necessarily be construed as pendants. Nevertheless, both the present work and the self-portrait of 1878 (Kunsthalle, Karlsruhe) are of nearly identical dimensions and were left unfinished, suggesting that they were related projects. However, they are not executed in the traditional manner of paintings of couples, where the man and woman usually face each other. In the present instance one figure would be sitting with his or her back to the other if the pictures were hung together.

The Berlin version is a straightforward, realistic treatment, enlivened by the rich orchestration of dark colors and the sensitivity with which the artist depicts his sixty-six-year-old step-mother. The youthfulness of her appearance may relate to the artist's quasi-oedipal feelings about her, and it has been noted that there is at least an indirect connection between the portraits of Henriette and those of Nanna Risi, Feuerbach's muse, model, and mistress for nearly seven years. As Kermit Champa has observed (New Haven, 1970), "Feuerbach worshipped [Henriette], partly, one feels, out of guilt and partly out of real affection; but, as with Nanna—the other female object of his adulation—affection, a certain coefficient of terror and a longing for a simpler, more direct relationship went hand in hand. Granting the generally similar and comparably problematic emotional bonds that held Feuerbach to Nanna and to his stepmother, it is not surprising to find a disconcertingly direct connection between his successive paintings of the two of them."

References: New Haven, 1970 [III], p. 91, no. 27 (the example of 1867); Karlsruhe, 1976 [IV] p. 193, no. 65; illus., p. 270, Berlin, 1977 [V], pp. 118-19, illus. p. 118.

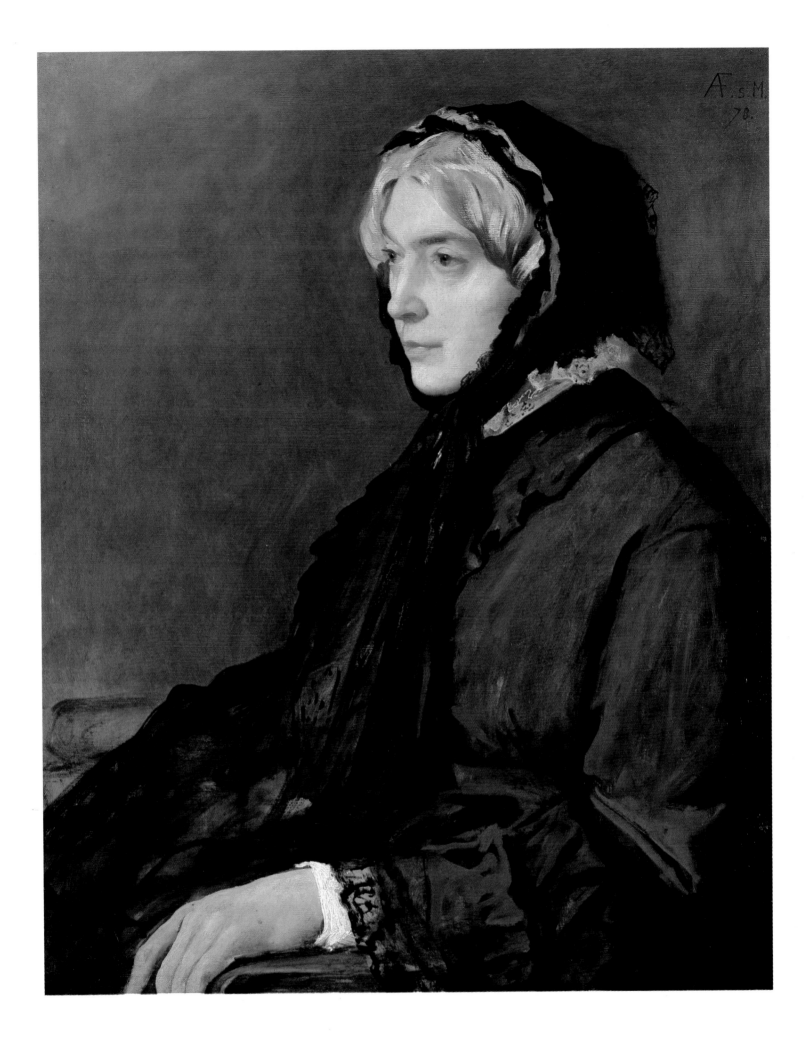

29. Caspar David Friedrich

Portrait of the Artist's Brother, Christian Friedrich,
 1803 or 1808
(Bildnis des Bruders Christian Friedrich)

Oil on canvas, 71.5 x 55.5 cm (28⅛ x 21⅞")
Gemäldegalerie der Stiftung Pommern, Kiel

In 1937 this painting was bought by the Stettin Museum, now the Stiftung Pommern, Kiel. It was purchased from the granddaughter of Christian Friedrich, Fräulein Fuhrmann, who lived in Greifswald. According to family tradition the painting is by Caspar David Friedrich and depicts the artist's brother. Christian Friedrich, born in 1799, was a cabinetmaker and executed several woodcuts based on drawings by his brother.

Contemporary scholarship is divided about the attribution to Friedrich. Helmut Börsch-Supan and Karl Wilhelm Jähnig ascribe the painting to a routine portrait painter who may have relied on one of Friedrich's portrait drawings. Moreover, the attitude of the sitter is not as introspective as that of the figures generally encountered in Friedrich's portrait drawings. To further complicate the matter of attribution, there are no other painted portraits by Friedrich to which the present painting might be compared.

The age of the sitter, if it is Friedrich's brother, suggests that this work was painted either in 1803, during one of Christian's trips to Dresden, or in 1808 when they were both in Paris.

References: Keil, 1971 [V], no. 33; Börsch-Supan and Jähnig, 1973 [IV], p. 486, no. 23.

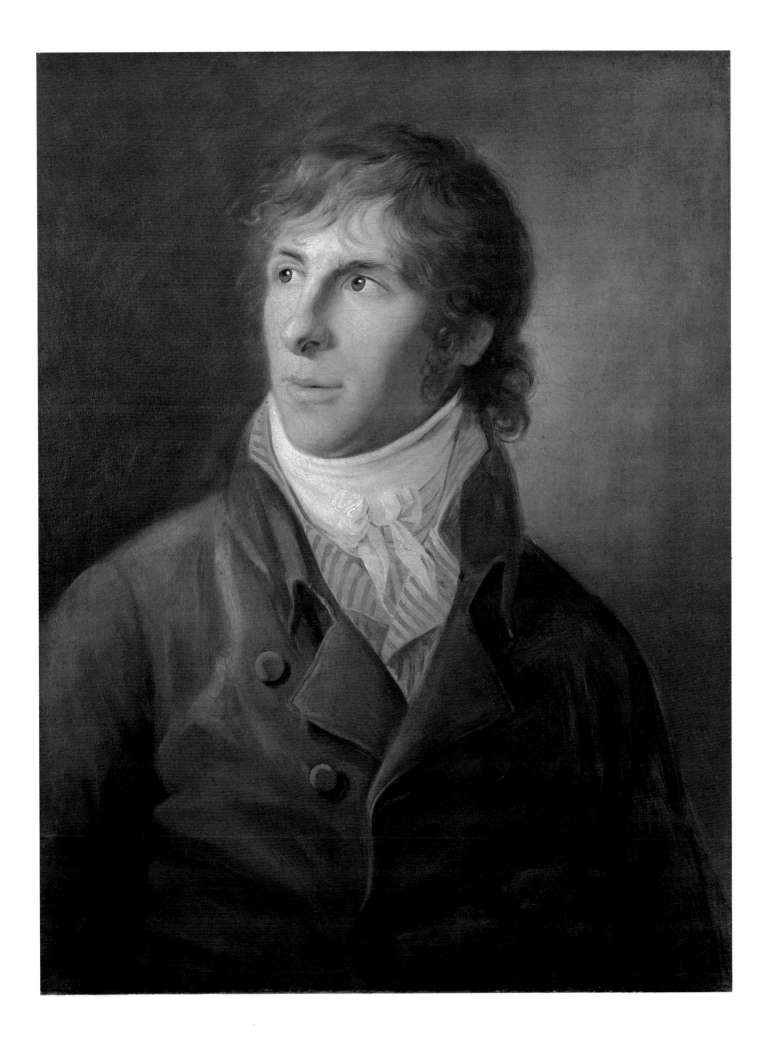

30. Caspar David Friedrich

Mountain Landscape with Rainbow, 1810

(Gebirgslandschaft mit Regenbogen)

Oil on canvas, 70 x 102 cm (27½ x 40⅛″)
Museum Folkwang, Essen

Mountain Landscape with Rainbow is a view of the Rosenberg in Saxonian Switzerland. The figure in the foreground is a self-portrait. Friedrich began the painting as a night scene and then added the rainbow, which resulted in contradictory sources of illumination. The light shining through the clouds must come from the moon, but a rainbow would be visible only if there were another source of light, presumably the sun, behind the viewer. Evidently the artist added the rainbow to emphasize the symbolism of the painting. As Börsch-Supan and Jähnig have suggested, the moonlight symbolizes the illumination of the world through Christ, and the rainbow represents the reconciliation of man with God. The deep, fog-enshrouded valley in the middle ground is a metaphor for the inchoate obscurity of life, which can only be overcome by the light of God. The abyss itself represents the ubiquity of death, the imminence of destruction at the edge of life. The hat on the ground—a motif used frequently by Friedrich—refers to the figure's humility before nature and before death. The rock is his support, the faith on which he leans.

Because the figure is a self-portrait, the painting can be interpreted as a statement of the artist's religious convictions. In a somewhat earlier painting, *Landscape with Rainbow*, 1808–10 (formerly Staatliche Kunstsammlungen, Weimar; missing since 1945), Friedrich attempted to realize pictorially the vision of nature set forth in Goethe's poem "The Shepherd's Lament" ("Schäfers Klagelied"), 1802. Despite differing dimensions, the present painting and the work formerly in Weimar are pendants; in them Friedrich contrasts his own deeply religious understanding of the world with Goethe's view of nature.

References: London, 1959 [III], p. 131, no. 147; Essen, 1971 [V], pp. 35–36, illus. p. 35; Börsch-Supan and Jähnig, 1973 [IV], pp. 308–9, illus. p. 309; Paris, 1976 [III], pp. 49–50, no. 57, illus. p. 49.

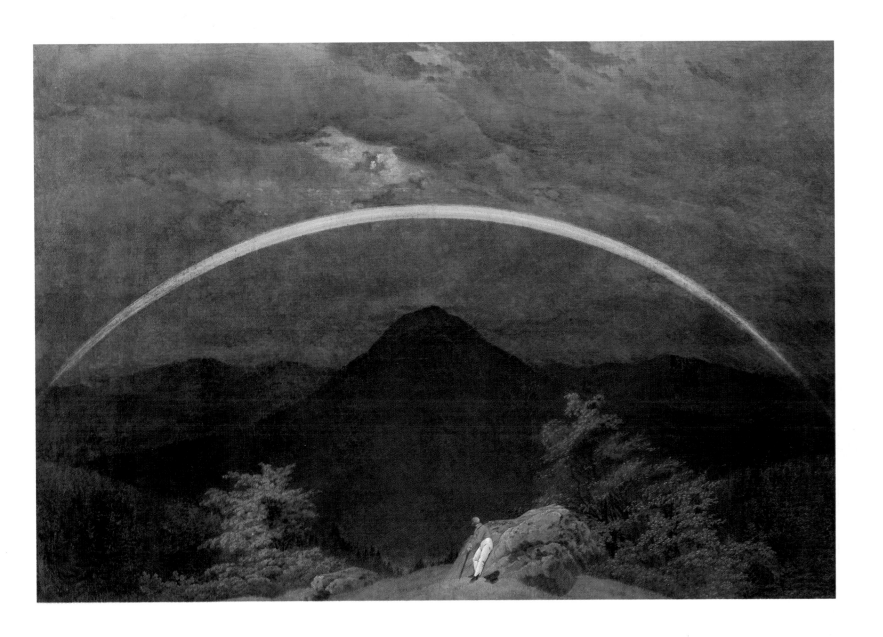

31. Caspar David Friedrich

Morning in the Riesengebirge (The Cross on the Peak; Landscape with Morning Fog and a Crucifix), 1810–11

(Morgen im Riesengebirge [Das Kreuz auf der Felsenspitze; Gegend im Morgennebel mit einem Kruzifix])

Oil on canvas, 108 x 170 cm (42½ x 66⅞")
Staatliche Schlösser und Gärten, Schloss Charlottenburg, Berlin

The Riesengebirge or Giant Mountains are situated on the border between Prussian Silesia and Bohemia; they continue southeast into Czechoslovakia. *Morning in the Riesengebirge* was probably begun in July 1810 after Friedrich and fellow artist Georg Friedrich Kersting returned from a trip to the area. For the composition Friedrich used studies made during the trip as well as drawings dated as early as 1799 from other notebooks. The painting was completed in March 1811 and was included belatedly in the Dresden Academy exhibition shortly before it closed that year. In 1811 it was also exhibited in Weimar, and the next year it was shown in the Berlin Academy exhibition from which Frederick William III purchased it for 200 talers (600 marks). Thereafter it hung in various royal residences; after 1930 it was in the Berlin Palace.

Contemporary accounts inform us that Kersting painted the figures and that the figure being helped to the top of the mountain is Friedrich himself. The *staffage* is, in fact, weaker and clearly different from figures by Friedrich in other paintings. *Morning in the Riesengebirge* is the pendant to an evening scene, *Mountain Landscape with Waterfall* (location unknown); the two were exhibited together in Weimar in 1812. Friedrich often painted pairs of pictures with interlocking iconographical programs, such as *Moonrise on the Sea,* 1822 (no. 33), and *The Solitary Tree,* 1822 (no. 32).

In the present work the woman who clasps the cross is probably intended as an allegorical figure of faith. As in *Mountain Landscape with Rainbow,* also painted in 1810 (no. 30), the omnipresent fog-enshrouded valleys symbolize the dark obscurity of life and the constant danger of death. As Helmut Börsch-Supan wrote (London, 1972): "The cross, as the only object to break the line of the horizon, connects the near with the distant: thus, as in *The Cross in the Mountains* [see fig. 3, page 14], it comes to represent Christ as the intercessor between heaven and earth. The rising sun, which lies to the left of the composition, counterbalances the cross on the right. When exhibited at Weimar in 1812 the work was shown with a companion piece. . . .

In the latter picture, one also saw a ship navigating a river in the background, and a man helping a woman to cross a ravine. In contrast to *Morning in the Riesengebirge,* this picture symbolized the unrest of earthly existence, and the guidance given by the man in the mastery of practical existence."

References: London, 1972 [IV], pp. 64–65, no. 38, illus. p. 64; Börsch-Supan and Jähnig, 1973 [IV], pp. 315–16, no. 190, illus. p. 315; Paris, 1976 [III], pp. 50–52, no. 59, illus. p. 51.

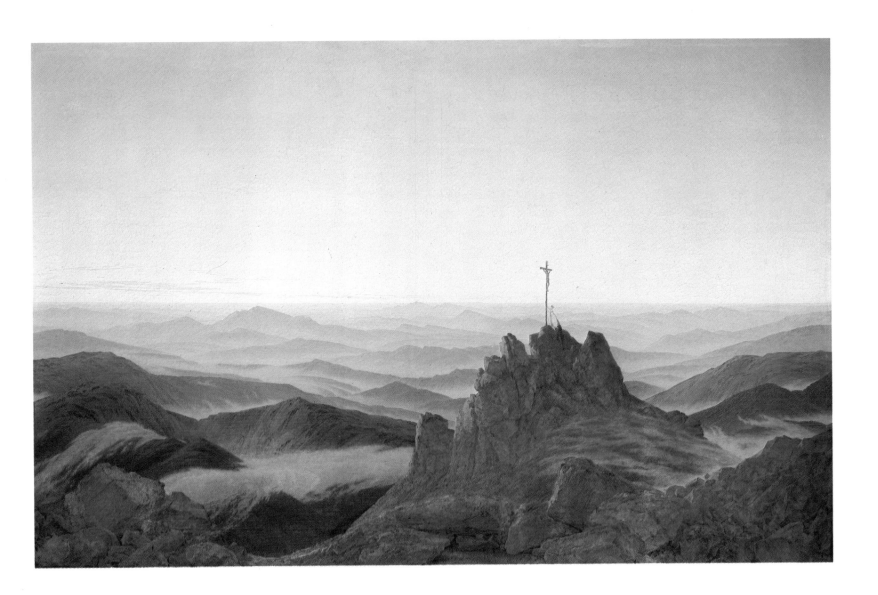

32. Caspar David Friedrich

The Solitary Tree (Village Landscape in the Morning Light; Harz Mountain Landscape), 1822
(Der Einsame Baum [Dorflandschaft bei Morgenbeleuchtung; Harzlandschaft])

Oil on canvas, 55 x 71 cm (21⅝ x 28")
Nationalgalerie, Staatliche Museen Preussischer Kulturbesitz, Berlin

The Solitary Tree is the pendant to *Moonrise on the Sea,* 1822 (no. 33). Both were commissioned by the Berlin consul and merchant, Joachim Heinrich Wilhelm Wagener; in a letter to him dated November 1, 1822, Friedrich said that he had completed the two pictures.

The present painting depicts a landscape in the Riesengebirge or Giant Mountains, a range on the boundary between Prussian Silesia and Bohemia. Between 1806 and 1810 Friedrich made six drawings, nature studies executed in the Riesengebirge and the area around Neubrandenburg, that he used for this painting.

The iconography of *The Solitary Tree* and its pendant are discussed in the entry for the latter. Trees often play an important role in Friedrich's paintings, but the oak in the present work is especially significant. It rises above the silhouette of the mountains and unites heaven and earth. At an earlier time it was apparently struck by lightning, but new shoots have begun to grow from the old trunk. It becomes, therefore, a symbol of the Resurrection, the link between earthly existence and the spiritual afterlife. Moreover, as George Ferguson has noted, "Long before the Christian era, the ancient Celtic cult of the Druids worshipped the oak. As was often the case with pagan superstitions, the veneration of the oak tree was absorbed into Christian symbolism and its meaning changed into a symbol of Christ or the Virgin Mary. The oak was one of several species of trees that were looked upon as the tree from which the Cross was made. . . . Because of its solidity and endurance, the oak is also a symbol of the strength of faith and virtue, and of the endurance of the Christian against adversity."

The Solitary Tree and *Moonrise on the Sea* entered Wagener's collection in 1823. In 1861 the entire collection was bequeathed to the king of Prussia; it became the basis for the founding of the Nationalgalerie, which was first housed in the Orangerie of Schloss Charlottenburg.

References: George Ferguson, *Signs and Symbols in Christian Art,* New York, 1954, p. 43; New Haven, 1970 [III], pp. 94–95, no. 31, pl. 7; Börsch-Supan and Jähnig, 1973 [IV], p. 378, no. 298, colorplate 23 p. 100, illus. p. 378; Hamburg, 1974 [IV], p. 252, no. 162, illus. p. 253; Berlin, 1977 [V], pp. 128–29, colorplate p. 11, illus. p. 128; Schrade, 1977 [II], p. 76, colorplate p. 77.

33. Caspar David Friedrich

Moonrise on the Sea, 1822
(Mondaufgang am Meer)

Oil on canvas, 55 x 71 cm (21⅝ x 28″)
Nationalgalerie, Staatliche Museen Preussischer Kulturbesitz, Berlin

Moonrise on the Sea was commissioned and purchased in 1822 by the Berlin collector Joachim Heinrich Wilhelm Wagener as a companion piece to *The Solitary Tree,* 1822 (no. 32).

In *The Solitary Tree* the shepherd and his flock, man and animal, are integrated with nature. Friedrich presents an image of pastoral harmony that differs markedly in theme from its pendant. In *Moonrise on the Sea* three unmistakably urban individuals view the scene before them as a phenomenon separate from their own world. Friedrich's use of antithetical but complementary subjects in pairs of paintings is typical; commonly used interlocking dualities include land and sea, peasants and city dwellers, mountains and valleys, morning and evening, and day and night.

The iconography of the present work is characteristic of the kind of symbolic program often described by Börsch-Supan and Jähnig. The moon, symbolic of Christ, lights the journey of life, which is represented by the ships. The first ship, with some of its sails already furled, underscores the brevity of life; the voyage draws to an end. The rock upon which the figures sit is symbolic of faith, and the scene before them is illuminated by the light of Christ. In contrast to *The Solitary Tree* the figures are isolated from the environment. Moreover, the land is separated from the sea, the ships from one another, and the man from the two women. Friedrich appears to suggest that only through Christ can the three spectators overcome their solipsistic state and rediscover the journey that has already begun to end.

Finally, as Helmut Börsch-Supan pointed out (London, 1972), "The strong, abstract composition is in keeping with a spiritualized conception of nature, which is quite different from that in [*The Solitary Tree*]. Evidence provided by Ludwig Richter leads one to believe that the strange blue-violet is an expression of melancholy."

References: New Haven, 1970 [III], p. 95, no. 32, pl. 8; London, 1972 [IV], p. 79, no. 67, illus. p. 31; Börsch-Supan and Jähnig, 1973 [IV], p. 379, no. 299, illus. p. 299; Paris, 1976 [III], p. 62, no. 70, illus. p. 62 and colorplate 51; Berlin, 1977 [V], pp. 126–28, illus. p. 27.

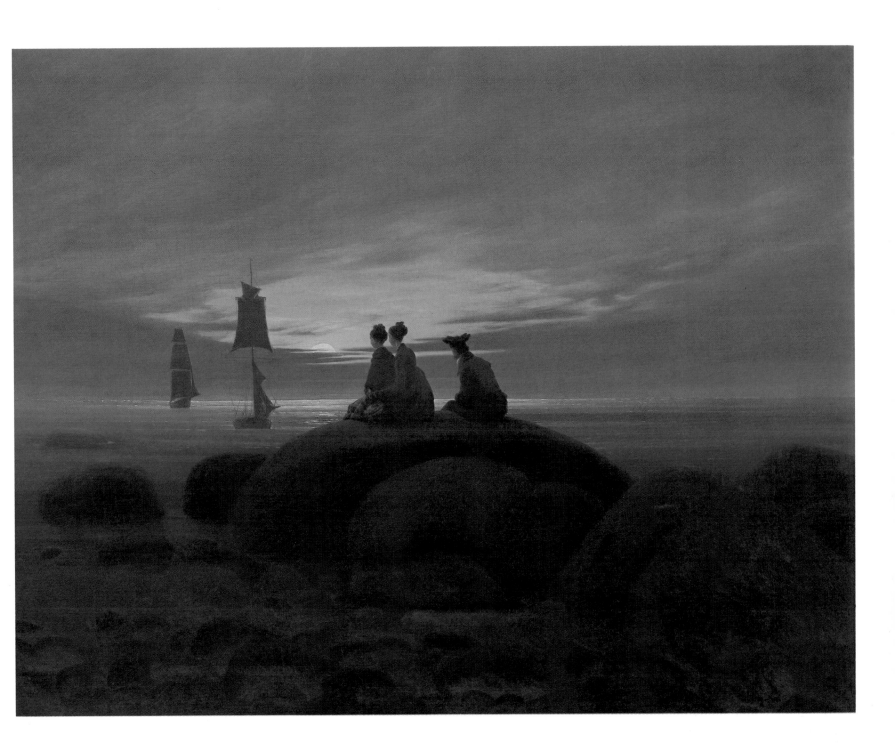

34. Caspar David Friedrich

The Sea of Ice (The Failed North Pole Expedition;
* The Wrecked "Hope"), 1823–24*
(Das Eismeer [Die verunglückte Nordpolexpedition;
* Die verunglückte Hoffnung])*

Oil on canvas, 97.7 x 126.9 cm (38⅛ x 50″)
Hamburger Kunsthalle, Hamburg

In 1843 Friedrich's friend and fellow painter Johann Christian Clausen Dahl purchased *The Sea of Ice* from the artist's estate. At that time it was known as *The Failed North Pole Expedition*. In 1905 the Hamburger Kunsthalle acquired the painting from Dahl's widow. It was subsequently known as *The Wrecked "Hope,"* or *The Wreck of the "Hope,"* because it was confused with a lost painting that Alexandra Feodorovna (later empress of Russia) ordered from Friedrich in 1821.

The Sea of Ice was painted in 1823–24 and exhibited in Prague and Dresden in 1824. The wrecked ship is thought to be the *Griper,* which participated in expeditions to the North Pole in 1819–20 and 1824. Friedrich may have been inspired by an account of the earlier trip, *Journal of the Voyage for the Discovery of a North-West Passage from the Atlantic to the Pacific,* which was published in 1821. He could also have learned about the trip from newspaper accounts. In addition, he may have known Antonio Sacchetti's hemicycloramic painting, *North Pole Expedition,* which was exhibited in Prague in 1821, and Johann Carl Enslen's panorama, *Winter Sojourn of the North Pole Expedition,* which was exhibited in Dresden in 1822.

Although the present work has been confused with Alexandra Feodorovna's painting, its meaning differs markedly from the allegorical program conveyed by the apocryphal title (the actual title of the work ordered in 1821 is *A Wrecked Ship off the Coast of Greenland*). As Werner Hofmann has indicated (Paris, 1976), two interpretations of *The Sea of Ice* seem most plausible. The first is Helmut Börsch-Supan's belief that the painting's symbolism is predominantly religious: the blocks of ice turned skyward are an expression of the divinity of nature, and the debris of the boat represents the vulnerability of man and his inevitable failure to attain godliness; the wrecked ship itself represents the end of the "navagatio vitae." The second is an understanding of the painting as a historical–political metaphor: the frozen wasteland is an allusion to the paralysis that characterized German politics under the despotic administration of Metternich, and the ship is the coffin of liberty.

The blocks of ice in the right foreground are based on one of three sketches that Friedrich made during the winter of 1820–21 (Hamburger Kunsthalle) when the Elbe froze over. Friedrich's amalgamation of details carefully studied from nature into a largely invented composition is typical of his working method. A similar process can be observed in *Morning in the Riesengebirge,* 1810–11 (no. 31). The artist himself once wrote: "Observe forms exactly, the smallest as well as the largest; do not separate the small from the great, but carefully distinguish the details from the whole."

References: Hamburg, 1969. Kunsthalle. *Katalog der Meister des 19. Jahrhunderts* [V], pp. 73–74, no. 1051, illus. p. 73; Börsch-Supan and Jähnig, 1973 [IV], pp. 386–87, no. 311, colorplate p. 109, illus. p. 387; Hamburg, 1974 [IV], pp. 258–59, no. 167, colorplate 12, illus. p. 258; Paris, 1976 [III], pp. 64–65, no. 73, illus. p. 64 and colorplate 45.

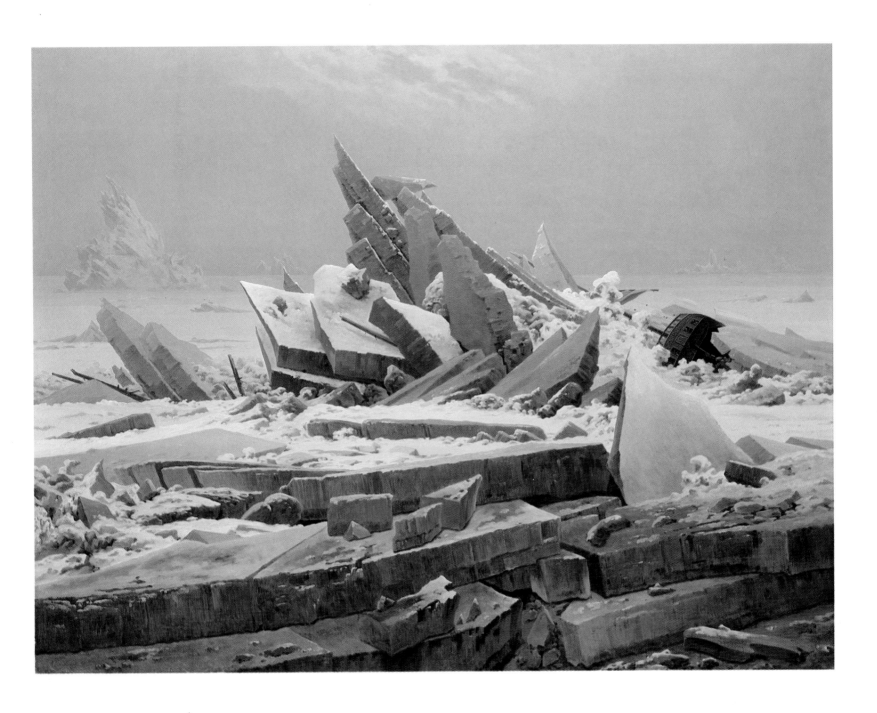

35. Caspar David Friedrich

The Temple of Juno at Agrigento, 1828–30
(Junotempel in Agrigent)

Oil on canvas, 53.5 x 71.5 cm (21 x 28⅛")
Museum für Kunst und Kulturgeschichte der Stadt Dortmund,
 Schloss Cappenberg, Dortmund

Unknown until 1943, *The Temple of Juno at Agrigento* was acquired by the Museum für Kunst und Kulturgeschichte der Stadt Dortmund in 1951. On stylistic grounds this work is dated about 1828–30. It is probably based on an aquatint by Franz Hegi from Carl Ludwig Frommel's book, *Voyage pittoresque en Sicile,* which was published in Paris in 1826. Friedrich altered Hegi's composition by omitting the figures and by removing the olive trees and aloes that surrounded the temple. In their place he added a group of trees, a characteristic compositional device, and fragments of ruins reminiscent of the sandstone mountains of the Elbe near Dresden. The mountain range in the background has also been changed, and instead of daylight Friedrich has chosen the light of the full moon. The temple in a barren landscape symbolizes the demise of ancient religion, the moonlight is a metaphor for Christianity, and the sea denotes Christian eternity. This is Friedrich's only known work with an Italian subject.

References: London, 1972 [IV], p. 86, no. 95, illus. p. 87; Börsch-Supan and Jähnig, 1973 [IV], pp. 419–20, no. 381, illus. p. 419.

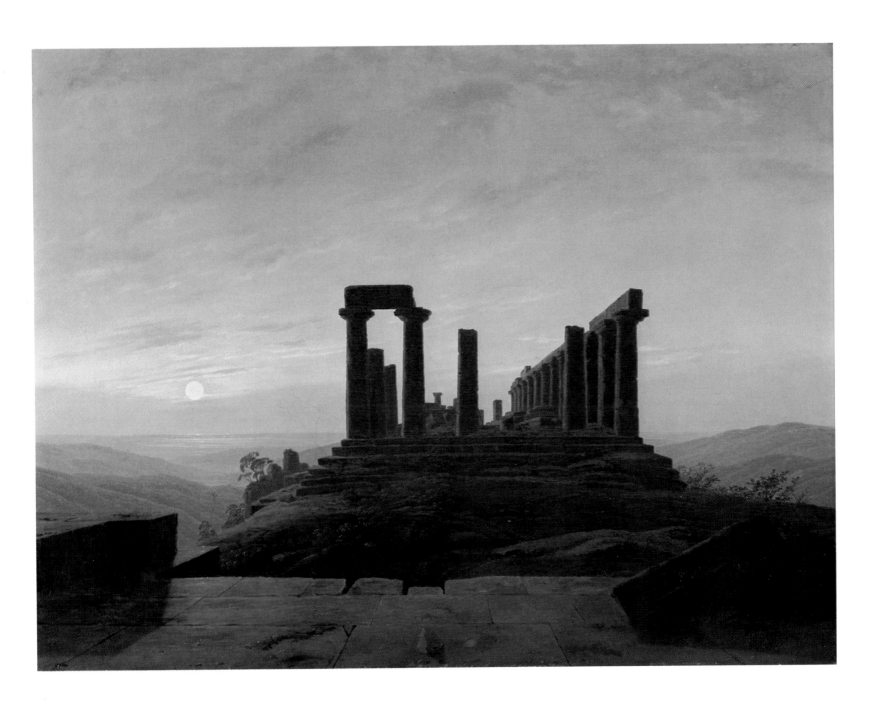

36. Caspar David Friedrich

Evening Star (View of Dresden), 1830–35
(Der Abendstern [Blick auf Dresden])

Oil on canvas, 32.5 x 45 cm (12⅞ x 17¾")
Freies Deutsches Hochstift, Frankfurter Goethemuseum,
 Frankfurt am Main

The Kreuzkirche (Church of the Holy Cross), Frauenkirche (Church of Our Lady), Schlossturm (Castle Tower), and Hofkirche (High Church) identify the scene as a view from the east of the city of Dresden. The tower of the Schlossturm and the church spires have since been modified; the lantern on the dome of the Frauenkirche was destroyed during the Napoleonic wars.

The figures are probably the artist's wife, Caroline, one of their two daughters, and their son, Gustav Adolf, born in 1824. Although the composition is similar to that of *Hill and Ploughed Field near Dresden,* about 1824 (Hamburger Kunsthalle), the enamellike quality of the paint surface and the intense color distinguish it as a work of about 1830–35. Indeed, if the figures are in fact members of the artist's family, the apparent age of his son suggests a date of about 1835.

Evening Star, as Börsch-Supan and Jähnig have indicated, is an allegory of life, death, and hope for mankind through the Resurrection. The evening star, Venus, which is also the morning star, shines brightly in the cloud-scattered sky. The star, then, is both harbinger of evening (death) and of morning (hope and resurrection). The city of Dresden, visible only as a group of ecclesiastical edifices, beckons the figures as a spiritual haven rising from the darkness of worldly existence.

This painting was probably once titled *Recollection of Dresden* and offered as the first prize in a lottery (July 23, 1835) sponsored by the Kunstverein (art association) of Pommern-Stettin. The winner was the municipal and higher regional court justice Calow. The price paid by the Kunstverein, 50 talers (150 marks), would have been appropriate for a work of this size.

References: London, 1972 [IV], pp. 86–87, no. 97, illus. p. 87; Börsch-Supan and Jähnig, 1973 [IV], pp. 423–25, no. 389, illus. p. 424.

37. Georg Friedrich Kersting

Caspar David Friedrich in His Studio, 1812 (?)
(Caspar David Friedrich in seinem Atelier)

Signed (lower left): G. Kersting 1812 (?)
Oil on canvas, 51 x 40 cm (20⅛ x 15¾")
Nationalgalerie, Staatliche Museen Preussischer Kulturbesitz, Berlin

Kersting first portrayed his friend Caspar David Friedrich in 1811 in Friedrich's studio in Pirna, a suburb of Dresden, where he worked until 1820 (Hamburger Kunsthalle). In 1812 Kersting painted the present work. Seven years later he executed a replica of the 1811 picture (Kunsthalle, Mannheim). In the Hamburg and Mannheim versions Friedrich is positioned farther from the viewer than in the Berlin example; in both these paintings he is seated and actively working on a painting; beside his easel there is a table for his painting materials. In the version of 1812 there are important differences. Friedrich stands behind his chair and contemplates a painting that we cannot see. The table has been positioned behind his easel, just out of his line of sight. Because we are closer to the artist, the austerity of the studio is emphasized by the bold geometry of the architectural elements and the easel. There is virtually nothing to interfere with the artist's concentration on his work and his own creative process. Friedrich himself once wrote: "An artist should not just paint what he sees before him, but also what he sees within himself. And when he sees nothing within, then he should also refrain from painting what he sees without."

Indeed, the present painting is nearly an illustration of the description of Friedrich's studio provided by the painter Wilhelm von Kügelen: "Friedrich's studio was absolutely bare . . . there was nothing in it except an easel, a chair, and a table. A solitary ruler was the only wall decoration. No one could figure out how it had attained that honor. Even the necessary paint box with its oil bottles and paint rags was banished to the next room, for Friedrich felt that all extraneous objects disturbed his interior pictorial world." The intellectual aspect of Friedrich's work is powerfully underscored by Kügelen's description and Kersting's painting. Nothing is left to accident, as the ruler and the triangle suggest; their purposefulness is unquestionable. Friedrich's one extravagance is a view of the cloud-filled sky, necessary in order to allow light to enter the room (the lower part of the window is shuttered to block distracting imagery). The clouds are, however, appropriate to Friedrich and are probably not merely a fortuitous detail. In Friedrich's work the presence of God as reflected in natural phenomena is often a theme; as George Ferguson has pointed out, clouds are the natural veil of the blue sky and are used to symbolize the unseen God.

References: George Ferguson, *Signs and Symbols in Christian Art*, New York, 1954, p. 53; Berlin, 1977 [V], pp. 192–94, illus. p. 193; Schrade, 1977 [II], pp. 30–33, 80–81, colorplate p. 81; see also Paris, 1976 [III], pp. 99–101 (largely a discussion of the Hamburg version).

38. Joseph Anton Koch

Waterfall near Subiaco, 1813
(Wasserfälle bei Subiaco)

Signed and dated (lower left): G. Koch fece 1813
Oil on canvas, 58 x 68 cm (22⅞ x 26¾")
Nationalgalerie, Staatliche Museen Preussischer Kulturbesitz, Berlin

Koch was as important to the development of nineteenth-century German landscape painting in Rome as Friedrich was to its development in the north. He created a new type of heroic landscape that combined the classical tradition of Claude and Poussin with an intensive study of nature. The artist wished, in his own words, to evoke in landscape "an elemental character such as one may imagine when reading the Bible or Homer"; he once called his paintings "great Greek landscapes." Like Friedrich and Runge, he sought an ideal objectivity that would embody the essence of nature and reflect a universal significance. However, instead of developing a variation of the symbolic realism of his two northern contemporaries, he chose to emulate the classical tradition, especially as manifested in seventeenth-century French landscape painting. His work is characterized by clear planar construction reflecting the influence of Nicolas Poussin and Gaspard Dughet, but the precise rendering of detail probably derives from Italian High Renaissance painting.

In *Waterfall near Subiaco* Koch depicts a site in the Sabine Mountains near Rome which was popular with both Romantic and Nazarene painters. Koch was one of the first painters to discover the beauty of the area. He first depicted the subject of the present painting in two drawings dated 1805–6 (Akademie der bildenden Künste, Vienna) and a third drawing that is now lost. In 1811 he painted the waterfall near Subiaco for the first time but from a vantage point opposite that of the present work (Museum der bildenden Künste, Leipzig). Because of the Napoleonic wars, Koch lived in Vienna from July 1812 to October 1815. In 1813 he painted the view of the waterfall that is now in the Nationalgalerie, Berlin. The painting was ordered by Koch's dealer and friend, Robert von Langer, as a present for his father. In a letter to Langer that Koch wrote in October 1820, he described the picture: "It is of the area around Subiaco with a waterfall, the same one that appears in Herr von Asbeck's picture [Museum der bildenden Künste, Leipzig] but seen from the other side. The view is completely in the taste of Gaspard Poussin [Dughet] but more vibrantly colored."

The figures in the foreground suggest the theme of the Flight into Egypt, but the woman on a donkey carries a basket of fruit, not a child. The *staffage* in Koch's landscapes often seems to allude to a historical or narrative subject. A figure group similar to that of the present painting appears in *Landscape near Ronciglione,* 1815 (Hamburger Kunsthalle).

References: Lutterotti, 1940 [IV], p. 206, no. 25, fig. 26; New Haven, 1970 [III], pp. 105–6, no. 46, pl. 14; London, 1972 [III], p. 112, no. 171; Berlin, 1977 [V], pp. 204, 206, illus. p. 205.

39. Joseph Anton Koch

Landscape After a Thunderstorm, c. 1830
(Landschaft nach einem Gewitter)

Signed (lower right): I.K.
Oil on canvas, 75.7 x 103 cm (29¾ x 40½″)
Staatsgalerie Stuttgart

The composition, subject, and vantage point of this late work by Koch reflect the influences of seventeenth-century French and late sixteenth-century Netherlandish landscape painting. The scene depicted is a view toward the Gulf of Salerno on the southwest coast of Italy. However, the painting transcends a specific time and place; as such it is typical of the so-called heroic landscapes which the artist had been painting since just before the turn of the century. *Landscape with Rainbow,* 1805 (Staatliche Kunsthalle, Karlsruhe), provides an early example of Koch's treatment of the theme of the present work.

In this picture Koch has emphasized the timeless grandeur of nature. The figures and antique buildings are harmonious elements within the landscape, but the broken sapling in the left foreground and the toppled tree in the middle ground underscore the brutal indifference of natural forces. The rainbow suggests that the travelers in the landscape and the city in the distance endure by the grace of God. As George Ferguson has observed, "The rainbow is a symbol of union and, because it appeared after the Flood, it is also a symbol of pardon and of the reconciliation given to the human race by God."

The style of the figures differs from Koch's characteristic treatment. They have been attributed to Baron Karl Wilhelm von Heidick. In 1829 Heidick returned to Rome from Greece and stayed for about a year, at the time *Landscape After a Thunderstorm* was painted. The picture was in Heidick's collection in Munich when he died in 1861, and was acquired by the Staatsgalerie Stuttgart the following year. Evidently Koch was in the habit of occasionally asking colleagues to contribute to his paintings, as Adrian Ludwig Richter once reported: "Since he asked me to, I painted in a piece of foreground for him. 'I can't paint those little plants,' he said. 'I've got a damned heavy paw and it needs something light and delicate here.' So I painted in the little plants."

There are related drawings, with different figures and without the rainbow, in Munich, Berlin, and Dresden (see Lutterotti nos. Z 556, Z 98, and Z 187, respectively).

The present picture is also known as *Gulf of Salerno, Stormy Landscape with Homeward-Bound Rider,* and *Rider Returning in a Thunderstorm.*

For a comparative treatment of the theme by a contemporary, see Friedrich's *Mountain Landscape with Rainbow,* 1810 (no. 30).

References: Lutterotti, 1940 [IV], pp. 221–22, no. 74, pl. 74; George Ferguson, *Signs and Symbols in Christian Art,* New York, 1954, p. 57; London, 1959 [III], pp. 170–71, no. 235; Stuttgart, 1968 [V], pp. 99–100; Schrade, 1977 [II], p. 56.

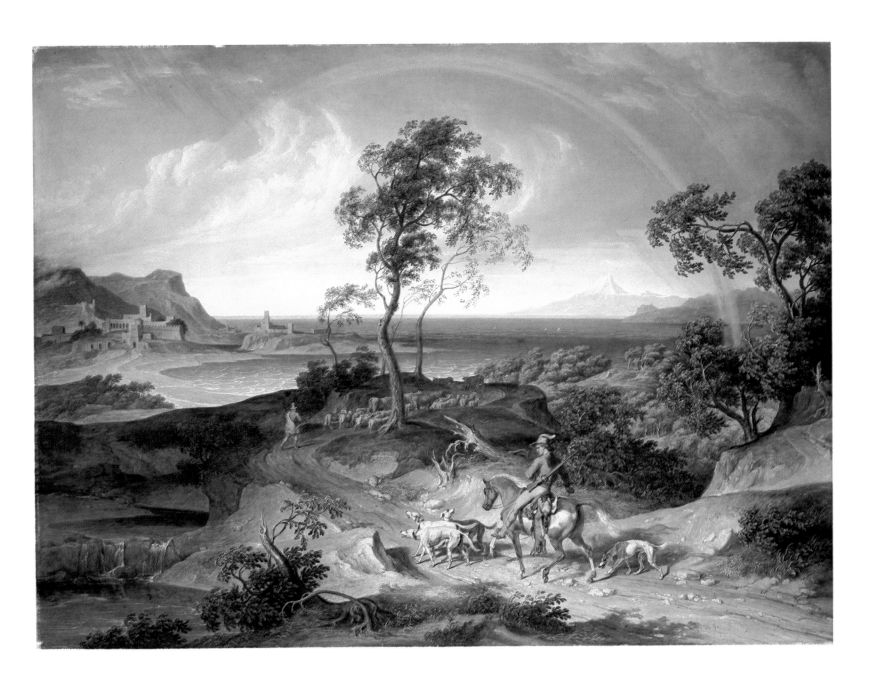

40. Joseph Anton Koch

Grotta Ferrata, 1835–36

Signed (lower left): J.K.
Oil on wood, 29 x 44.5 cm (11⅜ x 17⅞")
Niedersächsisches Landesmuseum, Hannover

Grotta Ferrata is situated southeast of Rome in the Alban Hills between Frascati and Marino. Its name derives from a grotto sanctuary where early Christians worshipped a painting of the Virgin. There in 1002 the Greek hermit Nilus established a Basilian monastery to which the image of the Madonna was moved. Under Pope Julius II (1503–13) the monastery was fortified; that structure is the building in the right background of the present painting. Grotta Ferrata became the most important holy place in the Alban Hills. Interestingly, Monte Cavo, an important site of pagan worship and the location of the temple of Jupiter Latiaris, is nearby. It is faintly visible in the left background.

The inclusion of both sites in *Grotta Ferrata* is not without significance. Although Koch was interested in the connection between the modern and the classical world, the Christian element is preeminent. Unlike Monte Cavo, Grotta Ferrata has survived the ravages of time, and Koch purposefully relates the monastery to the idyllic character of the surrounding landscape. He credits a spiritual force with the peace and tranquillity of the scene, much as he did in *Landscape After a Thunderstorm*, c. 1830 (no. 39). In *Serpentara Landscape with Shepherd and Cattle at the Source*, c. 1834 (Hamburger Kunsthalle), the companion piece to another version of *Grotta Ferrata*, Koch's theme is the pagan era before the advent of Christianity.

The present painting is Koch's third version of the subject. The first, dated 1834, is in the Stiftung Pommern, Kiel; the second, dated 1834–35, and the third are both in the Niedersächsisches Landesmuseum, Hannover. The compositions of the example in Kiel and the present painting are nearly identical; the former differs in being smaller and on wood. In the second version Koch added a sixth figure to the group around the well, and the woman to the right of the well holds up a child for the individual approaching from the far right to see; there are also swans in the pond in the foreground and three cows in the right middle ground. In all three versions the figure grouping is reminiscent of the story of Jacob and Rachel at the well (Gen. 29:1–12).

Kermit Champa's stylistic analysis (New Haven, 1970) of the second version is equally applicable to the present example: "*Grotta Ferrata* represents one aspect of Koch's late style—that aspect which continues to refine French-Italianate elements and gradually surrenders the more vigorously personal characteristics of Koch's earlier modes of landscape expression. Gone almost completely is the surface excitement of the *Mountain Landscape* [1796, Wallraf-Richartz-Museum, Cologne] and the *Waterfall* [1813, no. 38]. Koch's viewpoint is lowered and his horizon drops correspondingly, so that pictorial space expands at the expense of two-dimensional cogency. Bright, slightly brittle, Nazarene color appears both in figures and in the landscape, echoing the lucid hardness of the landscape prospect in general. In his friezelike arrangement of the figures around the well and in the swirling rhythms of the tree shapes above them, one can feel Koch trying to hold on to at least some of the planimetric energy of his earlier landscapes." One of the reasons for the change in Koch's style was apparently his increasing interest in the work of Claude Lorrain.

There are related drawings in Darmstadt, Weimar, and Vienna (Lutterotti nos. Z 152, Z 650, and Z 686, respectively).

References: Lutterotti, 1940 [IV], p. 224, no. 86, pl. 91; Hannover, 1973 [V] (vol. 1), p. 254, no. 530; (vol. 2), illus. p. 268; New Haven, 1970 [III], pp. 106–7.

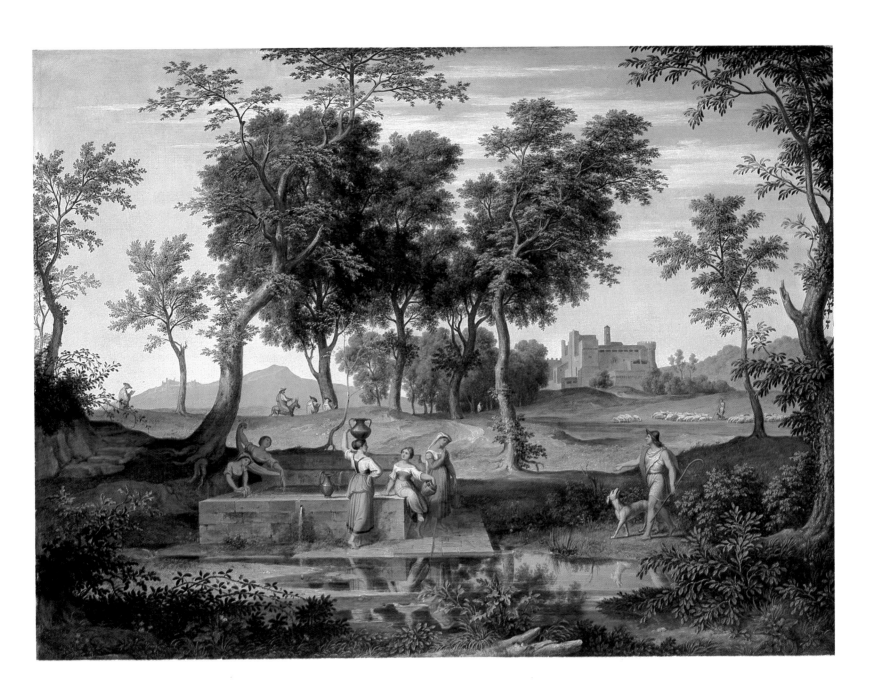

41. Wilhelm Leibl

Countess Rosine Treuberg, 1877
(Gräfin Rosine Treuberg)

Oil on canvas, 104.1 x 82.2 cm (41 x 32⅜")
Signed and dated in pencil (lower left): Leibl 1878
Hamburger Kunsthalle, Hamburg

At the invitation of his patron and friend, Count Ferdinand Fischler von Treuberg, Leibl spent from July to October 1877 at Schloss Holzen. The count asked Leibl to paint a portrait of his wife, twenty-eight-year-old Rosine Treuberg. Before beginning the present work Leibl executed a smaller, darker, and less ambitious portrait in tempera (Kunsthistorisches Museum, Vienna).

Although the portrait now in Hamburg was never finished, it provides an insight into the technique that Leibl used during his so-called Holbein period or "hard style." He began by sketching in the figure with thinned oil paint. Then, instead of gradually resolving the image as a whole, he concentrated on individual passages, such as the head in the present painting. According to Kermit Champa (New Haven, 1970) the technique was related to the light tones that Leibl was using at the time: "Leibl's desire to handle comparatively light tones, delicately modulated in their values, developed simultaneously with his 'hard style' and seems directly, if not totally, responsible for it. The Treuberg portrait demonstrates a variety and delicacy of coloration which Leibl was never able to achieve (and, in fact, never really pursued) in the more painterly style of his earlier and later years."

It is not clear why the unfinished painting is signed and dated. Leibl may have been satisfied with it aesthetically, but, as Champa has indicated, it is more likely that the composition itself presented formal difficulties which the artist was notoriously slow to resolve: "The situation was complicated largely as a result of the off-center, three-quarter profile pose. The somewhat compressed and unresolved contour of the left side of the subject's face seems, for example, to fight the overall shape of the figure in order to respond to the curves of the black neckband. Working out difficulties of this sort took Leibl an incredibly long time—in the case of *Three Women in Church* [see fig. 24, page 34], nearly four years."

References: Waldmann, 1930 [IV], no. 161; Hamburg, 1969. Kunsthalle. *Katalog der Meister des 19. Jahrhunderts* [V], pp. 173–74, no. 1535, illus. p. 173; New Haven, 1970 [III], pp. 108–9, no. 50, pl. 69; Cologne, 1971 [III], p. 37, no. 50, pl. 47.

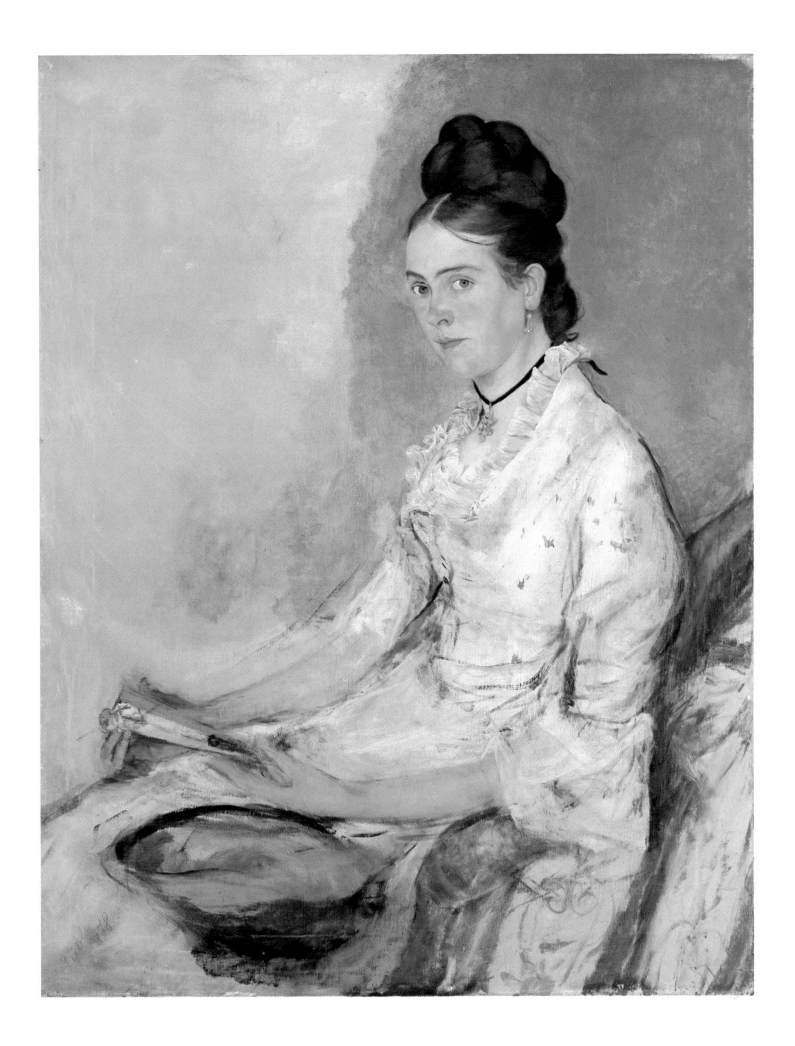

42. Wilhelm Leibl and Johann Sperl

Orchard in Kutterling, 1888
(Obstgarten in Kutterling)

Signed and dated (lower right): W. Leibl/Sperl/Kutterling 1888
Oil on canvas, 61 x 82.5 cm (24 x 32½")
Wallraf-Richartz-Museum, Cologne

Orchard in Kutterling is one of nine paintings that Leibl and Sperl made in cooperation during their later years. Sperl painted the landscape, and Leibl contributed the figures. The procedure suited Sperl's interest in plein-air landscape painting and Leibl's primarily figurative focus.

Leibl and Sperl met when they were students, but a strong friendship developed only in 1873. Leibl left Munich that year and lived in a succession of Bavarian villages. After joint painting campaigns in 1875 and 1878 they lived and worked in Bad Aibling from 1881 to 1892. Although the present work was painted during the Bad Aibling period, it depicts a scene in Kutterling, the village near Munich to which they moved in 1892.

The landscape style is, not surprisingly, recognizably that of the Leibl circle. The palette and the combination of sharp- and soft-focus effects are particularly characteristic and can also be found in the work of Thoma and Eysen. The well-rendered, solid figures are typical of Leibl before his brushstroke loosened in the early nineties. However, they bear a similarity to the work of certain French academic painters with a strong interest in peasant life, such as Jules Bastien-Lepage. Although Courbet is often cited as the source of inspiration for members of the Leibl circle, it appears that more orthodox realists were also influential.

References: Cologne, 1964 [V], pp. 75–76, no. 1164, illus. p. 230.

43. Wilhelm Leibl

Young Woman at the Window, 1899
(Mädchen am Fenster)

Signed and dated (lower left): W. Leibl / 1899
Oil on canvas, 109 x 72.5 cm (42⅞ x 28½″)
Wallraf-Richartz-Museum, Cologne

In this portrait of eighteen-year-old Babette Maurer, née Jordan, Leibl has used a simple, shallow space and strong chiaroscuro to direct our attention to the face and hand of this sympathetic young woman. In his figure paintings Leibl often emphasized the expressiveness of hands and preserved them from the painterly effects characteristic of his compositions. In the present work the young woman's right hand serves a dual purpose: the hand itself reflects her delicacy and sensitivity, but it also acts as a barrier between the figure and the viewer. Her slightly inclined head and fidgeting fingers contribute significantly to the mood of the painting, adding a winsome quality that contradicts her self-consciousness and the cramped, dark setting. Her situation finds poignant echo in that of the flower on the windowsill, unnaturally confined yet radiant.

Leibl's interest in Babette Jordan continued after the painting was finished. The next year, during the illness that preceded his death, he thought of her hands and feared that farmwork would coarsen and disfigure them.

The Wallraf-Richartz-Museum acquired *Young Woman at the Window* in 1911 from the Seeger Collection in Berlin. Ernst Seeger, a privy councilor who was also an art dealer and collector, became Leibl's patron after his success at the International Art Exhibition of 1895 in Berlin. In 1898 he persuaded Leibl to accompany him on a trip to Holland and Belgium. During the trip Leibl was impressed by the Dutch masters, including Rembrandt and, above all, Frans Hals: "There was never a greater artist than Hals and there never will be." These artists provided the impetus for the looser brushwork in Leibl's late work as well as the continuing concern for humanity exemplified by the present painting.

References: Waldmann, 1930 [IV], p. 149, no. 256, pl. 256; Cologne, 1964 [V], p. 74, no. 1161, illus. p. 228; Munich, 1974 [IV], no. 41, colorplate viii.

44. Franz von Lenbach

Two Shepherd Boys on a Grassy Incline, 1858 or 1860
(Zwei Hirtenknaben an einem Grashang)

Oil on canvas, 90 x 65 cm (35½ x 25⅝")
Städtische Galerie im Lenbachhaus, Munich

In 1857, at the age of twenty-one, Lenbach became a pupil of
the history painter Karl Theodor von Piloty. In the summer of
the following year they traveled together from Munich to Italy.
Lenbach spent the fall there as well, based primarily in Rome.
In Italy he drew extensively from nature; his work was strongly
influenced by the southern light and landscape, as can be seen
in his work of 1858–60, especially his major project, *The Arch*
of Titus in Rome, c. 1860 (see fig. 19, page 31). *Two Shepherd*
Boys on a Grassy Incline is, in fact, a fully finished study for the
lower right quadrant of that picture. Not surprisingly, Lenbach's
style at that time reflects a strong awareness of the contemporary
Macchiaioli painters, especially Cristiano Banti and Giovanni
Fattori.

In addition to working on *Two Shepherd Boys on a Grassy*
Incline while in Italy, Lenbach went to Aresing, a village near
his birthplace, Schrobenhausen, to paint figures from nature.
Two young peasant boys posed for him, and he wrote that he
painted them again and again, "standing, in the middle of a herd
of sheep, kneeling, sitting, lying, or leaning on a shepherd's
spade." From these studies Lenbach developed the final com-
position for the present work. The precise date of execution is
unknown; the painting is neither signed nor dated and remained
in Lenbach's possession until his death. There is, however, a
virtually identical version which is dated 1859 (Staatliche Kunst-
sammlungen, Weimar). In 1860 Lenbach painted one of the
shepherd boys alone lying on top of a grassy embankment
(Schack-Galerie, Munich).

References: Mehl, 1980 [IV], p. 73, no. 53, colorplate 3.

45. Franz von Lenbach

Portrait of Richard Wagner, 1874–75
(Porträt Richard Wagner)

Inscribed on the reverse: F. v. Lenbach bestätigt, dass diese Skizze R.
 Wagners von seiner Hand ist. München [F. v. Lenbach verifies that
 this sketch of R. Wagner is by his hand. Munich]
Oil on canvas, 55 x 38 cm (21⅝ x 15″)
Nationalgalerie, Staatliche Museen Preussischer Kulturbesitz, Berlin

Richard Wagner, the leading German composer of the later
nineteenth century, maintained that he was also a musical dram-
atist and that his stage works had profound symbolic signifi-
cance. He was already tremendously successful when Lenbach
met him in June 1868 in Munich, upon the occasion of the first
performance of *Die Meistersinger von Nürnberg*. A friendly re-
lationship developed, and during the next fifteen years Lenbach
executed numerous portraits of the composer.

Lenbach often used photographs as a source for his portraits
of famous German contemporaries. The present painting seems
to be based upon a photograph of Wagner and his wife, Cosima,
taken in either 1873 or 1874 by Adolph von Gross. There is a
closely related chalk drawing executed in 1880 (Winifred Wagner
Collection, Bayreuth), and similar portraits of Wagner with his
beret, but turned to either side, are dated as early as 1871 and
as late as 1881 (Lenbachhaus, Munich; Winifred Wagner Col-
lection, Bayreuth). The Nationalgalerie, Berlin, ascribes the
present work to about 1870, but if it is in fact based on Gross's
photograph, it was probably painted 1874–75. However, be-
cause this work is a sketch (see the inscription on the reverse),
because Lenbach's style changed very slowly, and because he
used the same photographs over and over again, it is impossible
to date this portrait with certainty.

References: Geck, 1970 [II], p. 150, no. 28c; Berlin, 1977 [V], p. 226, illus.

46. Franz von Lenbach

Pope Leo XIII, 1885
(Papst Leo XIII)

Oil on wood, 65.5 x 53.5 cm (25¾ x 21")
Städtische Galerie im Lenbachhaus, Munich

Gioacchino Vincenzo Pecci ruled the Roman Catholic church as Pope Leo XIII from 1878 until his death in 1903. In the decades prior to becoming pope he was in the diplomatic service of the Papal States and served in London, Paris, Brussels, and Cologne; between 1846 and 1878 he was bishop of Perugia. In assuming the pontificate he succeeded the conservative Pope Pius IX. Leo XIII differed from him in adopting a less rigid attitude toward civil governments, and he was able to restore good relations with contemporary European powers. Furthermore, he chose not to oppose scientific progress, and favored a strong role in combating modern social problems.

Lenbach's portrait of the pope was painted 1884–85. A church association in Munich commissioned the painting in order to raise money for the construction of a new church. The artist portrayed the pope, then in his mid-seventies, in a seated position with his head turned toward the viewer. The pontiff had asked to be shown as "young, upright, and blessed." Lenbach wrote, however, that he found him "already a dying man . . . pallid, shriveled, nothing but a shadow."

The artist met the pope once, during an audience in 1884, but the photographic studies he commissioned were probably of more help in painting the portrait. The composition is clearly indebted to Titian's *Portrait of Pope Paul III* in the Palazzo di Capodimonte, Naples, and an even more similar prototype, Velázquez's *Portrait of Pope Innocent X,* in the Doria-Pamphili Collection, Rome. Lenbach made drawings after both works (Städtische Galerie im Lenbachhaus, Munich).

Several versions of this composition exist; they differ only in the position of the sitter's head and his angle of vision. The example in the Lenbachhaus was painted in Rome and was still in the artist's possession when he died in 1904; apparently it served as model for the others. The version commissioned by a church in Munich was executed in that city and is dated 1885 (Neue Pinakothek, Munich). There are other versions in the Museo d'Arte Moderna, Ca' Pesaro, Venice, the Kaiser Wilhelm Museum, Krefeld, and a private collection in Switzerland. In addition, there is also a portrait of Leo XIII in profile, dated 1885 (Städtische Galerie im Lenbachhaus, Munich).

References: Mehl, 1980 [IV], pp. 180–81, illus.

47. Franz von Lenbach

Otto, Prince Bismarck, 1890
(Otto Fürst Bismarck)

Signed and dated (upper left): F. Lenbach/Friedrichruh 1890
Oil on canvas, 119 x 96 cm (46⅞ x 37¾")
Städtische Galerie im Lenbachhaus, Munich

Otto Eduard Leopold von Bismarck (1815–1898) was one of the most influential statesmen in Europe during the nineteenth century. Born into a wealthy family, he showed an early interest in politics. In 1851 he began his political career as Prussian minister to the German Diet in Frankfurt. In 1859 he was appointed ambassador to Russia and three years later was briefly ambassador to France before William I named him premier and foreign minister. In this capacity he extended Prussia's hegemony through military force and in 1871 proclaimed a united Germany. The same year he was made a prince and was appointed the first chancellor of the German Empire, a position he held for twenty years. Though respected and revered, he was a controversial figure whose domestic policies were less inspired than his ideas concerning foreign policy. On March 18, 1890, two years after William II became emperor, Bismarck was forced to resign.

The present painting was executed shortly after the chancellor's resignation. It is one of eighty portraits of Bismarck painted by Lenbach. The two had known each other since meeting in Bad Gastein in 1878. A relationship characterized by mutual respect and reserved friendship developed, and Bismarck often introduced the artist to important figures in German social circles. In late March 1890 Lenbach made several visits to Friedrichruh, the estate to which Bismarck had retired to write his memoirs, *Gedanken und Erinnerungen* (1898). In the portrait that resulted, Bismarck is depicted as a Halberstädt cuirassier in the uniform he had worn at the time of many of his greatest political triumphs. Lenbach shows us a man who is still described today as "a political genius of the highest rank," but one who had nevertheless just been forced to surrender his power. For three decades one of the most effective leaders in the world, here he sits listlessly with hands folded, no longer an active force in the course of history.

References: Mehl, 1980 [IV], pp. 123–24, no. 233, colorplate 12 p. 28.

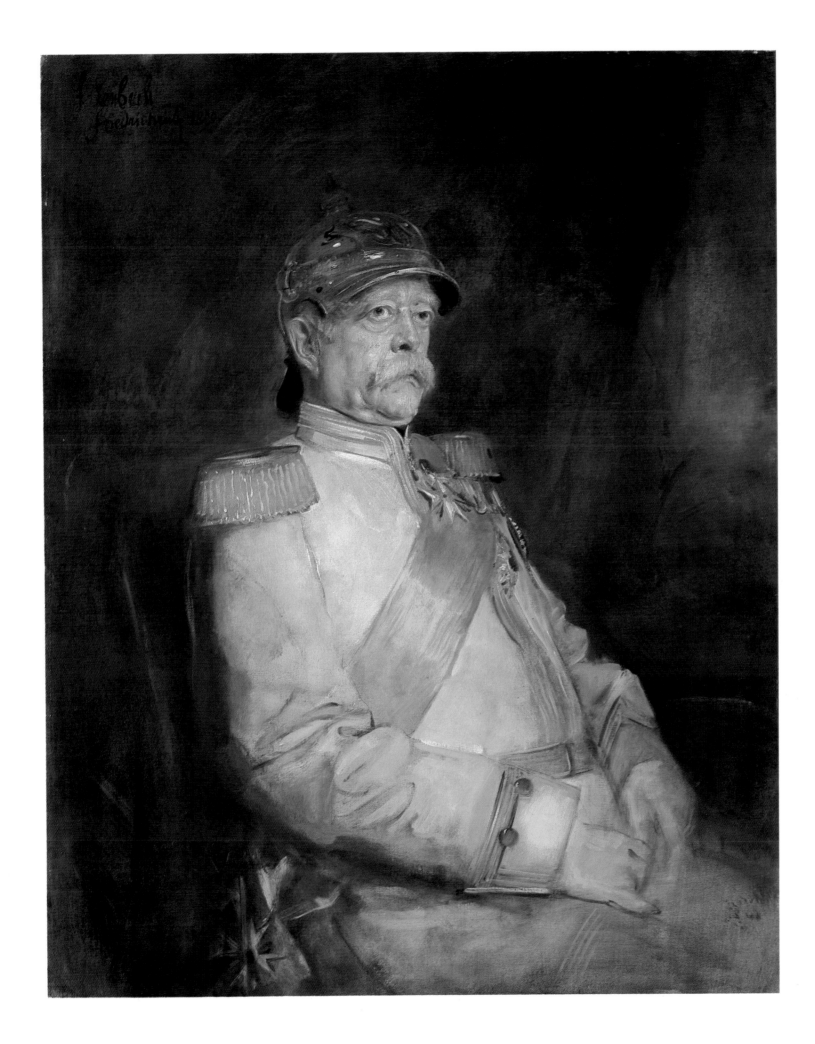

48. Franz von Lenbach

Marion Lenbach, Daughter of the Artist, 1900
(Marion Lenbach, Tochter des Künstlers)

Signed and dated (lower right): Lenbach 1900
Oil on canvas, 149.5 x 105.4 cm (58⅞ x 41½")
The Metropolitan Museum of Art, New York

Lenbach painted many portraits of his daughter Marion about 1900. She appears with her mother, in family portraits, and alone. The present example depicts her at the age of eight, but her appearance and facial expression suggest those of an adolescent.

This formally posed portrait is loosely based on a conventional compositional type that has its origins in the seventeenth century. In all other respects it is a thoroughly modern statement. The contemporaneity of the image is emphasized by Marion's clothing and demeanor, but the intensity of her expression and the disheveled curly blond hair, slightly covering one eye, combine to give the impression of an eight-year-old *femme fatale*. In a broader context this work can be seen in a tradition of children's portraits in which the sitters appear to have the emotional capacities of adults (e.g., Reynolds, Géricault). However, because Marion Lenbach is included in a photograph her father made in connection with *Franz Lenbach with Wife and Daughters,* 1903 (Städtische Galerie im Lenbachhaus, Munich), we know that the present picture exaggerates and modifies her appearance. This work is typical of Lenbach's portraits in its emphasis on the tenebrous aspects of the sitter's psyche.

The present portrait may be related to the figure of Marion in the unfinished family portrait of 1902–3, *Franz von Lenbach with Wife, Daughters, Parrot, and Spitz* (Städtische Galerie im Lenbachhaus, Munich). Her position on the corner of the carpet is approximately the same, but in the later picture her posture is slightly changed and the dress is different.

References: Rosenberg, 1903 [IV], p. 113, pl. 63; for comparative material relating to the present painting, see Mehl, 1980 [IV], pp. 176–79.

49. Franz von Lenbach

Franz von Lenbach's Last (?) Self-Portrait, 1902–3
(Franz von Lenbachs letztes [?] Selbstporträt)

Oil on cardboard (oval image), 98 x 78 cm (38⅝ x 30¾″)
Städtische Galerie im Lenbachhaus, Munich

Lenbach painted self-portraits throughout his career. In this example he presents himself full-face, standing, and leaning on a console to his left. The penetrating gaze that seems directed at the viewer was, of course, directed at his own image in a mirror. The intense, perhaps even slightly deranged look is characteristic of the self-portraits and the portraits of the artist's family (e.g., *Marion Lenbach, Daughter of the Artist*, 1900, no. 48).

The present work belongs to a series of self-portraits with a palette, which Lenbach began about 1895. According to his wife, Lolo, the empty palette that the artist points to is evidence that this is the last of his self-portraits. However, it is difficult to determine whether the artist intentionally stopped depicting himself or if the stroke that he suffered in the fall of 1902 and the illnesses that followed were not the reason. In any case, Lenbach did portray himself again at least twice, both times in unfinished group portraits of his family painted in 1902–3 and 1903 (both in the Städtische Galerie im Lenbachhaus, Munich).

As Sonja Mehl has pointed out, Lenbach may have used a photograph or a lantern slide in connection with this work. Beginning in 1880 he often made photographic studies preliminary to his paintings.

References: Mehl, 1980 [IV], p. 176, no. 360.

50. Max Liebermann

Old-Age Home for Men in Amsterdam
(Altmännerhaus in Amsterdam)

Signed and dated (lower right): Amsterdam/M. Liebermañ 82.
Oil on canvas, 53.5 x 71.5 cm (21⅛ x 28⅛")
Private collection

During the period that Liebermann lived in Paris (1873–78), he made several trips to Holland where the work of two of the foremost members of the Hague school, Jozef Israels and Anton Mauve, made a strong impression on him. He had already evolved a style reflecting the influences of Leibl, Thoma, and the painters of the Barbizon school, but his contact with pictures by the two Dutch artists led him to further develop his technique. His penchant for working-class and peasant subjects made a strong interest in the Barbizon and Hague schools almost inevitable.

This painting, one of the most important of Liebermann's Dutch works, depicts the garden of a Catholic old-age home for men in Amsterdam. The residents of the home wear the uniformlike clothes provided for them. The picture is often described as a study, but it is more accurately a first version. A more finished example was painted in Munich in 1881 and exhibited at the Paris Salon the same year (Georg Schäfer Collection, Schweinfurt); that version, close in composition and color to the present painting, was acclaimed by the critics and public in France, but was greeted initially with little enthusiasm in Germany.

Old-Age Home for Men in Amsterdam is inscribed "82," but it was in fact painted in the summer of 1880. In 1880 Liebermann also painted another, different view of the old-age home which is incorrectly inscribed "75" (Staatsgalerie, Stuttgart).

References: Berlin, 1979 [IV], pp. 214–15, no. 38, illus.

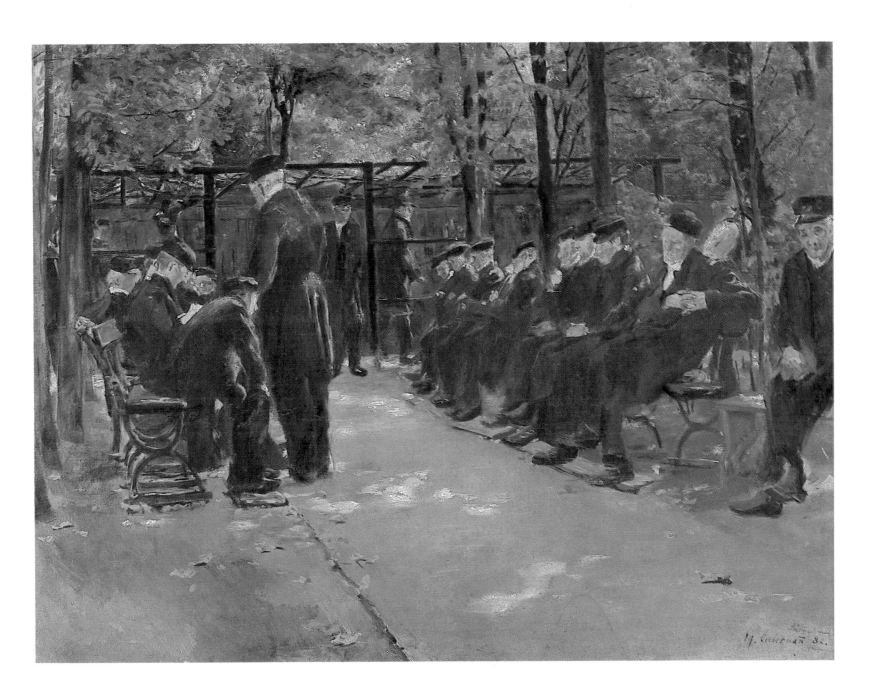

51. Max Liebermann

Stevenstift in Leiden, 1889

Signed and dated (lower right): M. Liebermann 1889
Oil on canvas, 70 x 100 cm (27½ x 39⅜")
Nationalgalerie, Staatliche Museen Preussischer Kulturbesitz, Berlin
 (Collection, Association of the Friends of the Nationalgalerie)

Liebermann spent the summer of 1889 in Katwijk, Holland, and during a trip to nearby Leiden he painted this work. The Steven Charitable Foundation was one of several homes supported by municipalities for the care of elderly and needy citizens. *Stevenstift in Leiden* belongs to a series of paintings of old-age homes and orphanages in which the artist expresses his admiration both for the Dutch social welfare system and the unity in Holland of architecture, social life, and nature.

Stevenstift in Leiden, like *Old-Age Home for Men in Amsterdam,* 1880 (no. 50), is typical of what Kermit Champa (New Haven, 1970) has called Liebermann's "accommodation of late Barbizon (cf. Jules Breton) social realist subjects and a diluted, essentially academic, form of Impressionism, based generally . . . on the contemporary paintings of French artists such as Bastien-Lepage, but containing a strong admixture of effects from contemporary realist painting in Holland." Furthermore, the relatively tightly painted figures and carefully defined space are characteristic of the reaction away from Impressionism during the eighties. Although Liebermann often uses paths and trees to define space—devices that provide inherent compositional structure—the present work is perhaps as tightly painted as any that the artist executed in the eighties. Indeed, it seems to represent the culmination of a current in Liebermann's work which Champa points out vis-à-vis *The Bleaching Ground,* 1882 (Wallraf-Richartz-Museum, Cologne): "The painting . . . presents an interesting sidelight to contemporary developments in France where, between 1882 and 1885, the young neo-Impressionists, Seurat in particular, had begun, in a way not unrelated to Liebermann's, to stress firmness and regularity in the drawing of figures . . . and greater breadth and clarity in the construction of pictorial space than one finds in the art of Manet or in the French Impressionism of the 1870s. Liebermann's manner of designing space is a good deal more perspectival (in the sense of traditional linear perspective) and more literally vacant in the effects it produces than Seurat's and his drawing less systematic in its construction of hierarchical units of rhythm; but a similar impulse toward a greater pictorial definiteness than Impressionism featured is evident." Interest-

ingly, in the nineties Liebermann's brushwork loosened considerably, and he developed the style that is today practically synonymous with the misleading term "German Impressionism."

References: New Haven, 1970 [III], pp. 112–13; Berlin, 1979 [IV], pp. 256–57, no. 61, illus.

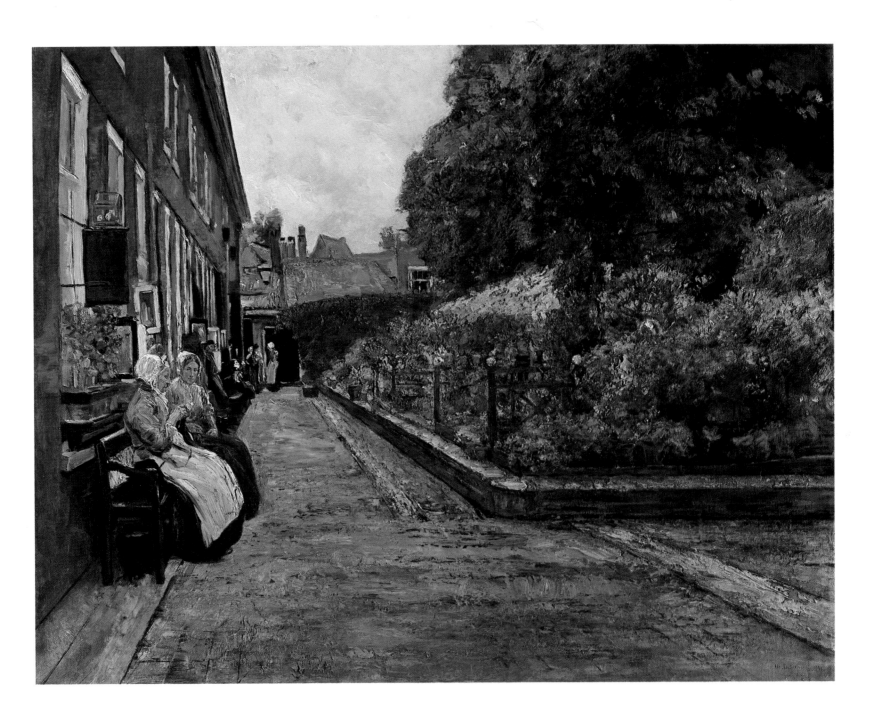

52. Max Liebermann

Man and Woman Riding on the Beach, 1903
(Reiter und Reiterin am Strand)

Signed (lower right): M. Liebermann
Oil on canvas, 72 x 101 cm (28⅜ x 39¾")
Wallraf-Richartz-Museum, Cologne

In the late 1890s Liebermann began to include upper-class sub-
jects in his work. Previously he had concentrated on working-
class themes. He was himself from an affluent Berlin family
(his father had a successful textile business), and during the
summer months he often visited fashionable Dutch resorts in
Scheveningen and Nordwijk. Although he continued to depict
laborers, he increasingly chose subjects from the life of his own
class: bathers and people at leisure on the beach, tennis matches,
people riding for pleasure, and outdoor cafés. In addition to the
subject matter, the brightness of the palette and the paint han-
dling suggest the influence of French Impressionism, especially
the art of Manet. His work also reflects a strong awareness of
Jozef Israels, Isaac Israels, and Anton Mauve, whose *Morning
Ride on the Beach,* 1876 (Rijksmuseum, Amsterdam), provides
an art-historical precedent for the present painting.

Liebermann himself was an enthusiastic horseman and was
undoubtedly familiar with the scene depicted here. Although
the subject reflects his increased interest in movement, it is not
without social comment. The woman in the sidesaddle looks
stiff and uncomfortable, and the gentleman does not appear to
be in complete control of his mount. Moreover, the riders' facial
expressions seem to reflect personal concerns that further
alienate them from the environment. Comparison to one of
Liebermann's peasant paintings indicates a less than sympathetic
point of view.

References: Cologne, 1964 [V], p. 81, no. 2819, illus. p. 240; Berlin, 1979
[IV], p. 304, no. 88, colorplate p. 305; The Hague, 1980 [IV], p. 71, no.
46a.

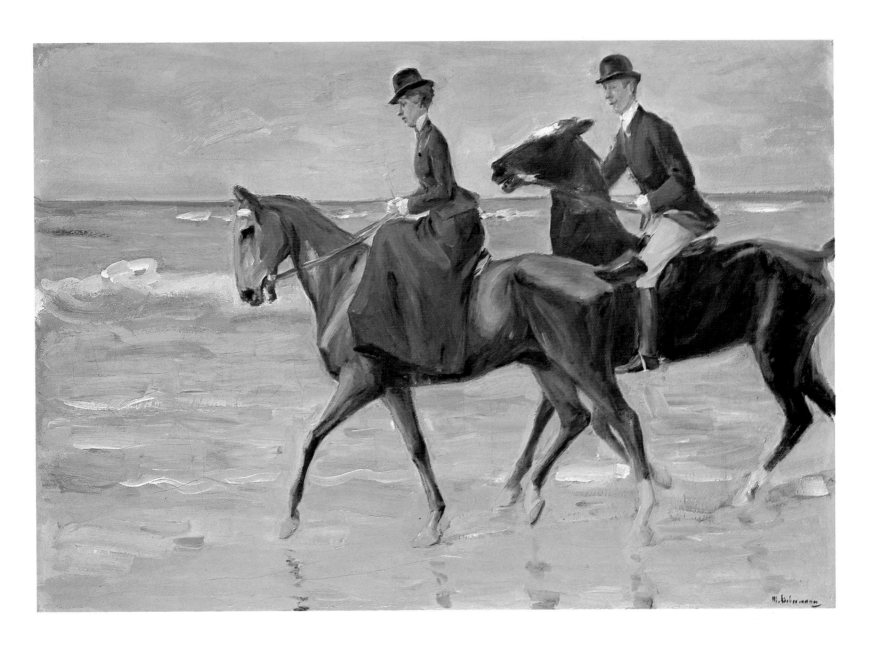

53. Max Liebermann

Ropewalk in Edam, 1904
(Seilerbahn in Edam)

Signed and dated (lower left): M Liebermañ 1904.
Oil on canvas, 101 x 71.1 cm (39¾ x 28″)
The Metropolitan Museum of Art, New York

Liebermann painted *Ropewalk in Edam* in 1904, during a visit to the small Dutch town of Edam, about thirteen miles northeast of Amsterdam near the Zuider Zee. The town remains famous for its locally produced cheese. The present work illustrates a lesser-known industry, the manufacture of rope. Laborers stand along a path known as the ropewalk and intertwine strands of fiber to fashion lengths of rope. In the background is the canal that links Edam to the Zuider Zee. The composition incorporates one of Liebermann's favorite devices, a tree-lined path along which he arranges figures.

Liebermann is one of the most important of the so-called German Impressionists. *Ropewalk in Edam* is typical of the palette-knife technique that he developed as a vehicle for his fascination with color and light. Its link to orthodox Impressionism is less important than its influence on such German Expressionists as Emil Nolde. Indeed, it is probably less confusing if we think of Liebermann, like Slevogt and Corinth, as the key figures of the Berlin Secession, rather than continuing to describe them as Impressionists, which invites a generally unproductive comparison to French painting.

The subject of this picture surpasses mere genre painting. Other paintings by Liebermann in this exhibition (nos. 50 and 51) underscore the artist's strong interest in social themes. He himself came from a wealthy Berlin family, and his motives for painting working-class subjects remain a matter that requires further investigation. Although this painting appears to be only a picturesque record of a minor local industry, Liebermann seems to have been intrigued by the harmony of landscape, laborers, and work. The ropemakers do not seem consumed by their labor, but, as in earlier works, the artist focuses on a tedious occupation that dehumanizes the worker. Moreover, it is difficult to ignore the prominent sabots, or wooden shoes, worn by the ropemakers; Millet and van Gogh had earlier emphasized the wooden shoes as a symbol of the dignified simplicity and decency of impoverished peasant life. "Sabot" is, of course, the root word for "sabotage," the term originally applied to the actions taken by discontented laborers who threw wooden shoes into machinery to protest unfair labor practices.

There is a chalk study for this painting in the Wallraf-Richartz-Museum, Cologne. In addition, there is another, smaller painting titled *Ropewalk in Edam,* and dated 1904 (formerly Collection Max Bauman, Cologne; present location unknown.)

References: Hancke, 1914 [IV], pp. 415, 541, illus. p. 416.

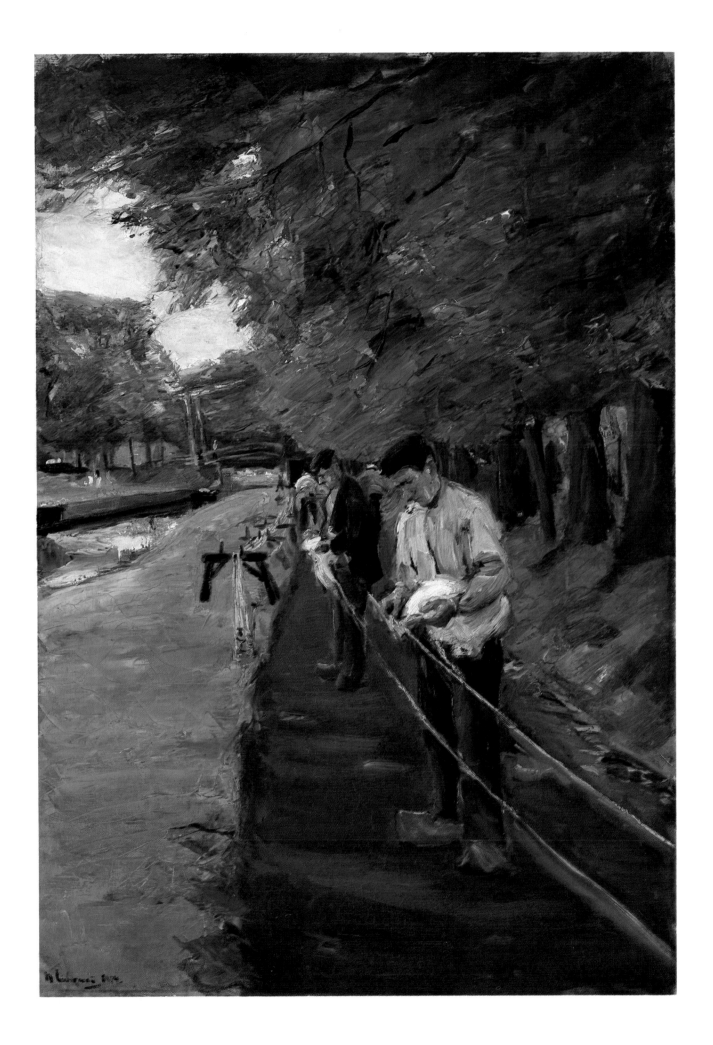

54. Max Liebermann

Self-Portrait, 1908
(Selbstbildnis)

Signed and dated (upper right): M. Liebermañ 1908
Oil on canvas, 97 x 76 cm (38⅛ x 30¼″)
Saarland-Museum, Saarbrücken

Today Liebermann's reputation rests on his early genre pictures and his later so-called Impressionist depictions of outdoor cafés, beach scenes, and upper-class life. Nevertheless, at the turn of the century he was one of the most popular and significant portraitists in Germany. His work appealed especially to the well educated; many artists and literati sat for him. Furthermore, he was a prominent figure in upper-bourgeois society and courageously defended his own views about art against those represented by official court painting. A long period of struggle preceded his success.

Liebermann, like Lenbach, painted many self-portraits, especially during the later part of his career. A large number of these paintings survive, but unlike Lenbach's self-portraits they are less theatrical and more sympathetic. In the present work he has painted himself simply and directly; he wears everyday clothes and stands full-face before a loosely articulated background. The two paintings leaning against the back wall identify the space as his studio. The painting is a straightforward view of the self, devoid of the dark seriousness of the nearly contemporary self-portrait by Lenbach included in the exhibition (see no. 49).

At least four other self-portraits were painted at about the same time as the present picture. In three the artist is also at his easel but is more in profile (1908, Uffizi, Florence; 1908, Wallraf-Richartz-Museum, Cologne; 1908, formerly Claas Collection, Königsberg); in the fourth he smokes a cigarette instead of holding his brushes and palette (1909, Hamburger Kunsthalle). Despite the artist's entirely ordinary appearance, the composition of this painting is based on one of the best-known self-portraits in the history of art, Nicolas Poussin's *Self-Portrait* of 1650 in the Louvre.

References: Frankfurt am Main, 1978 [III], pp. 26 ff.

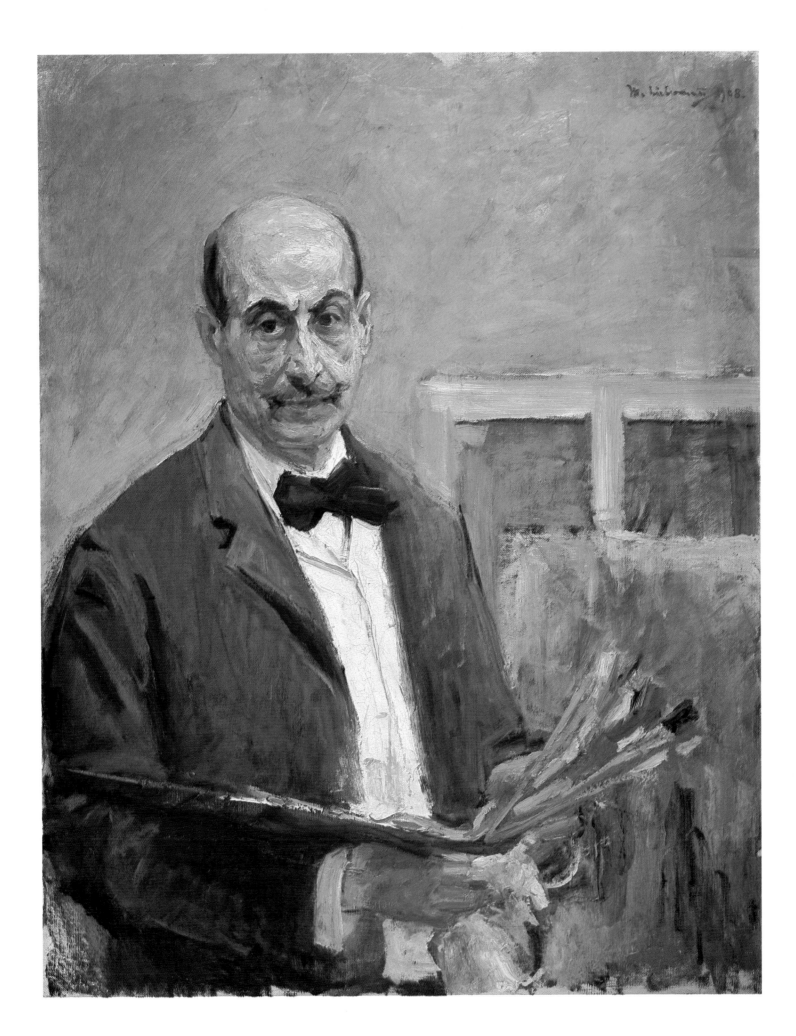

55. Max Liebermann

Beer Garden by the Water, 1915
(Gartenlokal am Wasser)

Signed and dated (lower left): M. Liebermann 1915
Oil on canvas, 69.5 x 86 cm (27⅜ x 33⅞″)
Gemäldegalerie der Stiftung Pommern, Kiel

After the outbreak of World War I in August 1914, Liebermann no longer traveled to Holland, which had adopted a position of neutrality. Except for trips to Wiesbaden in 1915 and 1917, he remained in Berlin during the war, painting scenes from his immediate surroundings. Since he did not work from memory, the riverside sites depicted during the war must be in Berlin. Liebermann was especially attracted to the popular beer gardens, cafés, and restaurants along the Havel and Wannsee rivers in the southwest section of the city. In all probability the present work depicts a beer garden on the Wannsee or farther south along the Havel, possibly the terrace at Nikolskoe.

Liebermann had long been painting outdoor cafés and restaurants in Germany and Holland (e.g., *Beer Garden in Brannenburg,* 1893, Palais de Tokyo, Paris). However, in the present work he treats the subject in a looser, softer style than previously; his paint handling results in a pastellike effect. In both subject and style he is clearly indebted to the French Impressionists; Liebermann had undoubtedly seen paintings of café scenes during his visits to Paris as well as in private collections in Berlin, which included examples of Monet's and Renoir's paintings of the river café La Grenouillère. Furthermore, in 1912 the Galerie Paul Cassirer in Berlin held a Renoir exhibition that may have reacquainted Liebermann with that artist's treatment of similar scenes.

References: Kiel, 1971 [V], no. 183: Berlin, 1979 [IV], p. 244, no. 111, colorplate p. 345.

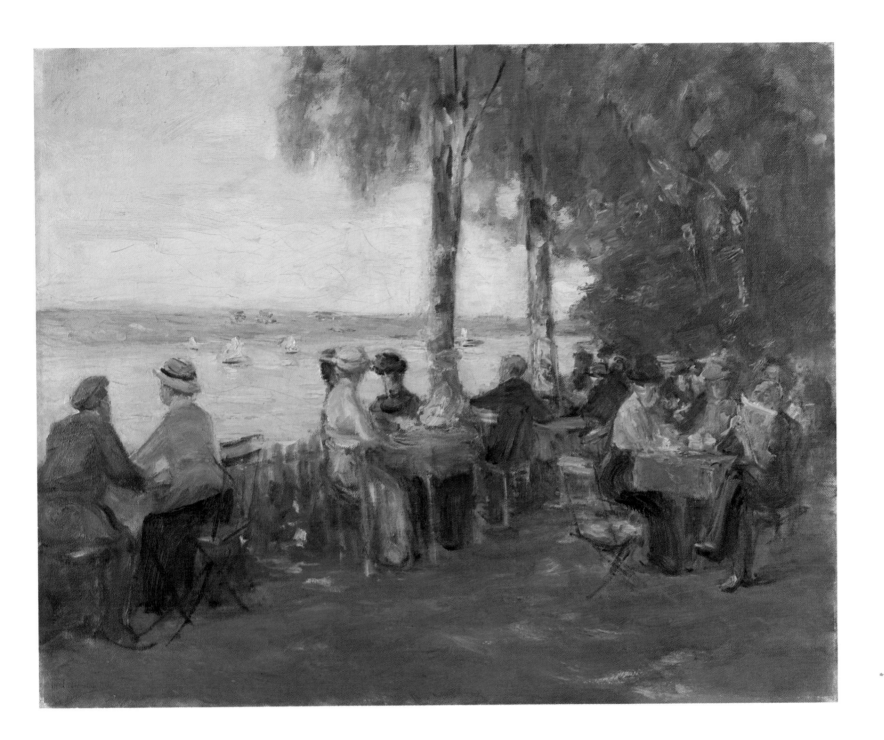

56. Hans von Marées

The Oarsmen, 1873 *[handwritten: final study for the oarsmen]*
(Die Ruderer)

Oil on canvas, 137 x 167 cm (54 x 65¾")
Nationalgalerie, Staatliche Museen Preussischer Kulturbesitz, Berlin

Hans von Marées's most significant achievement was his cycle
of frescoes that decorates the library of the German Marine
Zoological Station in Naples. In this commission Marées first
realized his goal of reconciling Realist depiction with classical
tranquillity and timelessness. The Zoological Station was
founded in 1872 by the German zoologist Anton Dohrn, and
the initial idea for the frescoes originated from meetings between
Dohrn, the artist, and his friend and patron Konrad Fiedler in
January 1873 in Munich and Dresden. The room contains five
main pictures separated by friezes and pilasters. These illusion-
istic architectural elements were painted by Marées's intimate
friend, Adolf von Hildebrand. The two artists collaborated on
this project from the beginning; together they decided to avoid
the traditional historical, mythological, and biblical scenes com-
mon to such enterprises and instead chose to depict in panoramic
views and allegory the daily life of the Bay of Naples.
 The north wall contains the largest of these frescoes; it
depicts oarsmen rowing across the bay. The painting in this
exhibition is the final study for the rowers. The muscular figures
are graphically portrayed, almost silhouetted against the late
afternoon sky. The palette is restricted to a cool range of grays,
blues, and sepias accented by the bright red belt of the foremost
oarsman. While these figures are evidently studied from life,
the symmetry of the composition imbues the scene with a clas-
sical order. The painting owes much of its impact to the cropped,
close-up view of the figures. (In the fresco, however, this group
makes up only a quadrant of the vast panorama of the bay.) At
the same time, Marées preserved the immediacy of a cropped
view by having the boat itself divided by the architectural ele-
ment designed by Hildebrand; the passengers, a young woman
and a boy, and the head oarsman appear on the other side of
the pilaster, thus achieving the illusion of a boat gliding by an
open window.

References: Meier-Graefe, 1909 [IV] (vol. 2), p. 172, no. 200, illus. p. 173;
Degenhart, 1958 [IV], passim, colorplate 19; Finke, 1974 [I], pp. 142–43;
Berlin, 1977 [V], pp. 244–46, illus. p. 245.

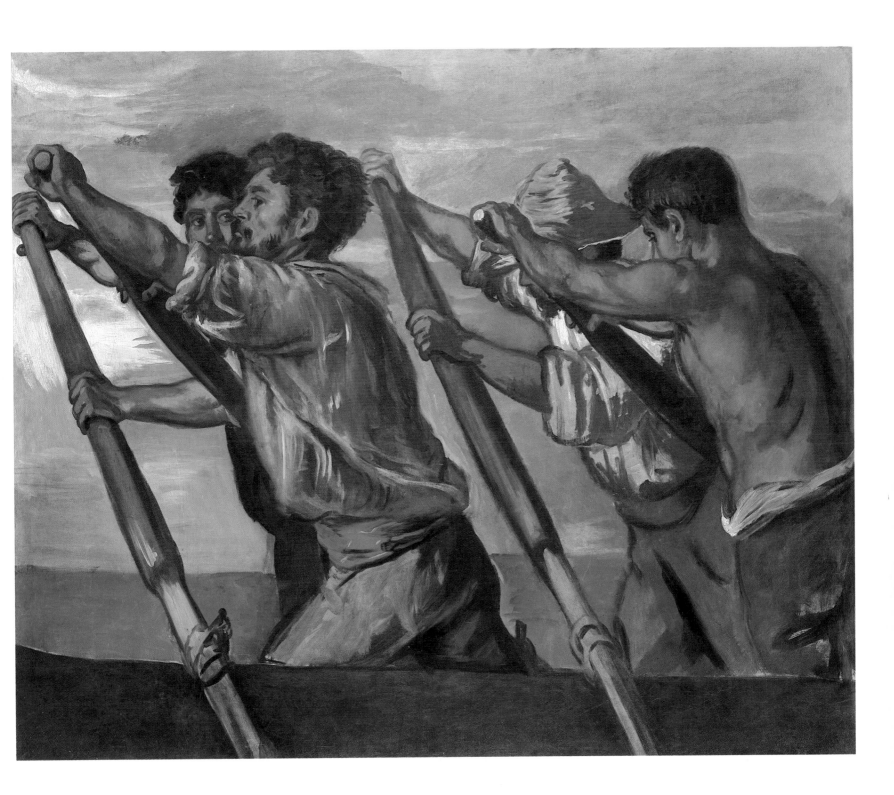

57. Hans von Marées

Study for the Mural *Pergola*, 1873
(Skizze zu dem Waldbild der *Pergola*)

Oil on canvas, 73.5 x 63 cm (28¾ x 24¾")
Von der Heydt-Museum, Wuppertal

The last of the German Marine Zoological Station frescoes painted by Marées is on the east wall, and depicts Marées and his friends grouped under a pergola; the site is a popular trattoria in Posilipo, on the Bay of Naples, where the artists gathered in the evenings. The painting in Wuppertal is a study for the major part of the composition and focuses on the group of the artist and his friends. The figures, left to right, have been identified as the zoologist Anton Dohrn, another zoologist Nikolaus Kleinenberg, and the artists Adolf von Hildebrand, Marées himself, and Charles Grant. Seated on the balustrade above is the innkeeper, nursing a small child.

Unlike *The Oarsmen*, 1873 (no. 56), this study differs in several important details from the final version. In the fresco the poses of the figures have been subordinated to a more rigorous composition; their interaction is far less casual than in the Wuppertal sketch. The image of the woman nursing her child has been changed; the child is omitted, and the woman's posture is frontal and more formal. The overall point of view shifts slightly in the final version, so that the figures of Marées and Grant are not cropped so abruptly. This sketch also omits the far-right portion of the fresco, where the architecture is extended and the foreground is occupied by an old beggar woman.

Marées executed further studies for parts of the composition. The Von der Heydt-Museum also owns a study of the three artists at the table; there was a study of the innkeeper as well (formerly Nationalgalerie, Berlin; present location unknown). The rest of the scene can be broken into similar units. As can be seen in this study, the overall composition is divided into distinct spaces by the architecture of the pergola and by the ancient palazzo of Donna Anna, which houses the trattoria. In this fashion Marées imposed a classical serenity on a scene that is traditionally depicted as a site of bustling activity.

References: Meier-Graefe, 1909 [IV] (vol. 2), p. 194, no. 217, illus. p. 195; Degenhart, 1958 [IV], passim, pl. 23; New Haven, 1970 [III], pp. 117–18; Finke, 1974 [I], pp. 142–43.

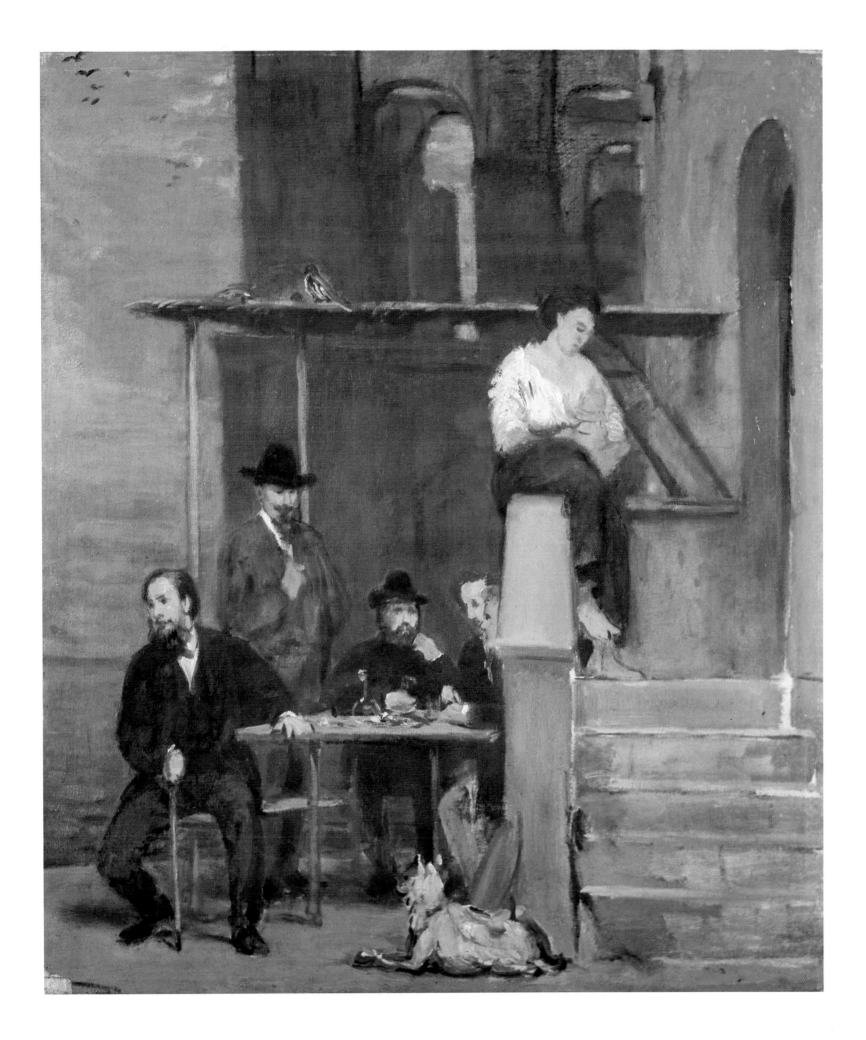

58. Hans von Marées

The Ages of Man, 1873–78
(Die Lebensalter)

Oil and egg tempera on wood, 98 x 87 cm (38⅝ x 37¼")
Nationalgalerie, Staatliche Museen Preussischer Kulturbesitz, Berlin

This painting represents Hans von Marées's mature resolution of the problem of the idealized nude in a landscape first explored in *The Orange Grove,* 1873 (German Marine Zoological Station, Naples), and studied in works such as *Men by the Sea,* c. 1874 (see no. 59). He began the painting in Florence in 1873 and completed it in Rome the winter of 1877–78. He presented it as a belated wedding gift to his patron Konrad Fiedler, who had married in 1876. Marées described in a letter to his brother George, dated May 1, 1879, how pleased Fiedler was with the painting and how both Adolf von Hildebrand and Arnold Böcklin admired it. Indeed, Hildebrand copied the work, and certain paintings by Böcklin show a striking affinity to this scene of idyllic nature (e.g., *The Awakening Spring,* 1880, Kunsthaus Zürich).

The Ages of Man belongs to a long tradition in art, and thematically Marées does not diverge from this tradition. The six figures form an easily read circle from the infant children, to the young lovers, to the mature man, to the old man, each representing a stage of life. Pictorially, however, Marées's achievement is unique and radical: he combines the cool classicism of such artists as Poussin with the exaggerated and mannered figures of Late Renaissance Italian artists. He dispenses with all perspectival illusion, presenting the figures and landscape in a series of flattened planes. Thus, while he adheres to an ostensibly classical canon, Marées infuses it with compositional tension. This effect is further heightened by his color and his technique of laying down each tone in a series of glazes so that the surface takes on a luminous quality. Iconographically Marées has chosen to amplify the theme of the Ages of Man by placing the figures in the sacred grove of the Hesperides, a theme he returned to in his 1884–87 triptych, *The Hesperides* (see fig. 15, page 28).

References: Meier-Graefe, 1909 [IV] (vol. 2), p. 226, no. 280, illus. p. 227; Finke, 1974 [I], p. 144; Berlin, 1977 [V], pp. 147–49, illus. p. 148.

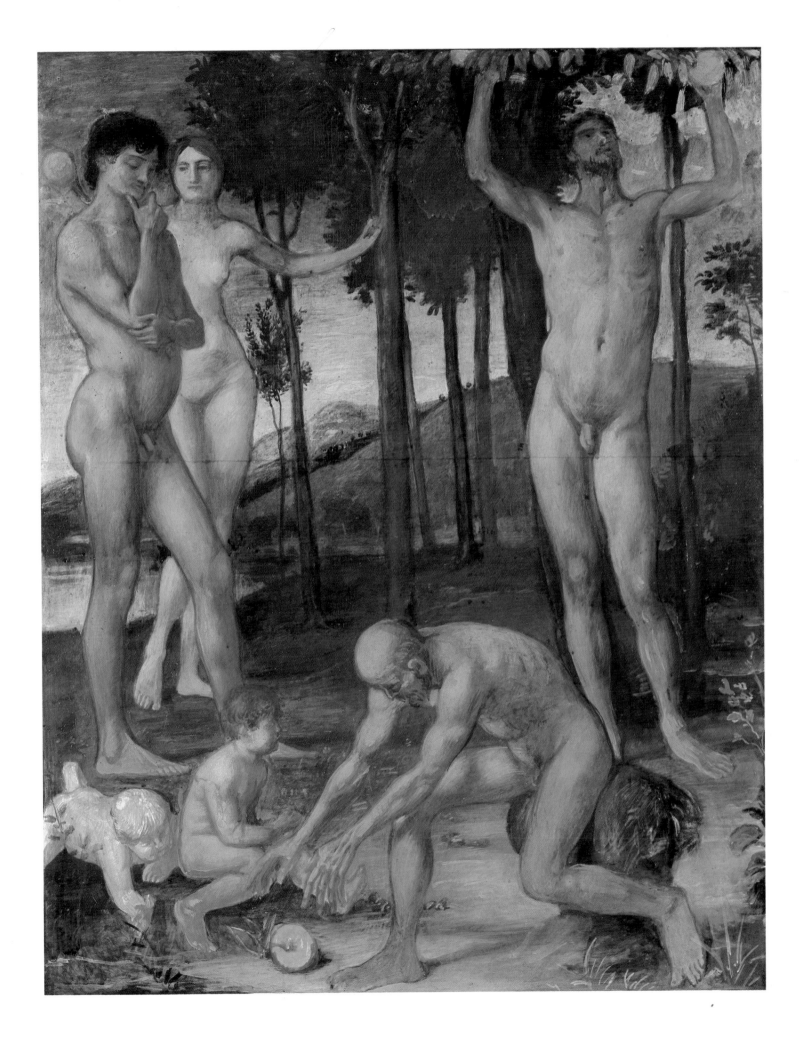

59. Hans von Marées

Men by the Sea, c. 1874
(Männer am Meer)

Oil on canvas, 75 x 99.5 cm (29½ x 37⅝")
Von der Heydt-Museum, Wuppertal

Men by the Sea is representative of a tentative experimental period
in Marées's work, a period in which he strove to give a new
direction to his art. Shortly after completing the Naples frescoes
(see nos. 56 and 57), he approached the problem of resolving
the image of the nude in a landscape. On the south wall of the
Naples library Marées had painted a scene of an orange grove.
In this fresco he turned away from the depiction of everyday
life to paint a vision of the Golden Age; the figures are nude,
and the grove of fruit trees is a realm beyond reality, the magic
grove of the Hesperides.

It was to this theme that Marées devoted the rest of his
career. While *Men by the Sea* must be regarded as a study, with
its unfinished portion on the right of the canvas, it provides an
important insight into how Marées developed his compositions
from nature into idyllic and classical views. As Marées wrote
to his friend Konrad Fiedler on April 10, 1871, "I long for
nothing more than the moment in which conception and rep-
resentation will flow together to form a unity." In *Men by the
Sea* Marées has yet to find the conception that can unify the
scene; the nudes appear to be studio models arbitrarily placed
against a landscape backdrop rather than being fully integrated
into the scene. The figure second from the right was uncovered
during restoration in 1948; it had formerly been partially ob-
scured by a tree trunk.

In orienting himself firmly in nature, Marées stands apart
from the Deutsch-Römer with whom he is frequently associ-
ated, Arnold Böcklin and Anselm Feuerbach. As had these art-
ists, Marées sought inspiration in classical Italy rather than his
native Germany, but he avoided their distinctly historical stance.
Instead, he evolved a uniquely classical vision, combining geo-
metricized compositions with figure groupings that express at
once the transient and the eternal, the mundane and the ideal.

References: Meier-Graefe, 1909 [IV] (vol. 1), p. 236, no. 291, illus. p. 237.

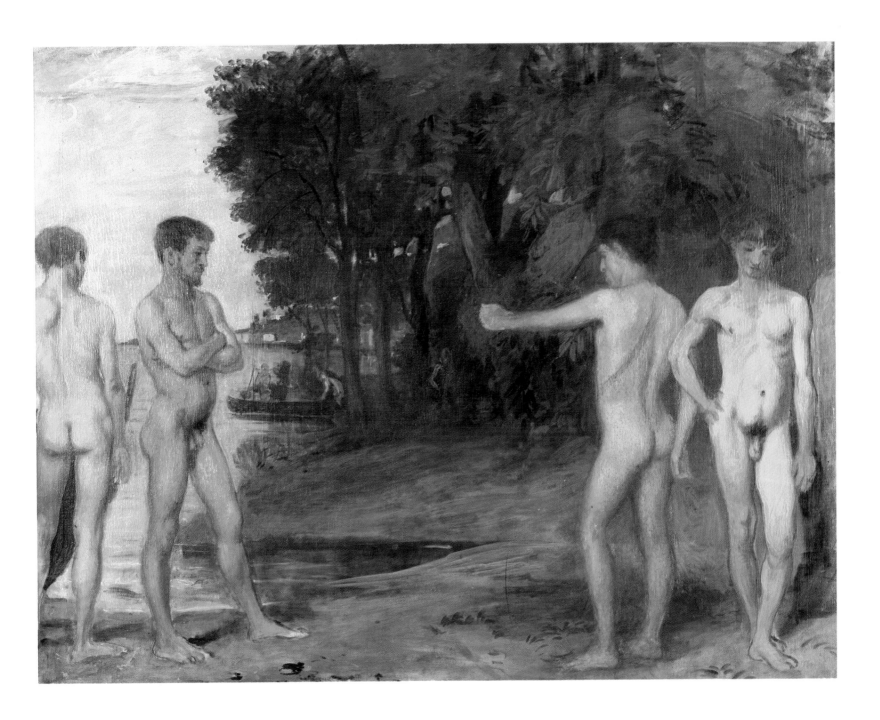

60. Adolph von Menzel

The Interruption, 1846
(Die Störung)

Signed and dated (at left, on side of piano): Adolph Menzel 1846
Oil on canvas, 111.5 x 90 cm (43⅞ x 35⅜")
Staatliche Kunsthalle, Karlsruhe

This painting, like *Théâtre du Gymnase,* 1856 (no. 63), reflects Menzel's fascination with the tonal richness of an artificially lit interior. The skillful rendering and orchestration of light effects are in themselves sufficient to hold our interest, but it is the dramatic situation that first arrests our attention. The figures entering at the rear of the room have evidently interrupted the young pianist whose companion rises and turns. Their expressions indicate that the visitors are unexpected. There is a cinematic or "stop-action" quality to the realism which anticipates the development of instantaneous photography and the studies in motion by Eadweard Muybridge.

The architecture appears to be late eighteenth century, but the interior is furnished in a manner that suggests the 1820s and 1830s. Indeed, the style of decoration suggests the taste of the generation of the woman coming through the door. Menzel's 400 illustrations for Franz Kugler's *History of Frederick the Great* had immersed him in the study of the eighteenth century and provided him with a broad knowledge of the decorative arts; indeed, for his *Frederick the Great's Flute Concert,* 1850–52 (Nationalgalerie, Berlin), he designed his own "rococo" frame for which there is a watercolor in the Hessisches Landesmuseum, Darmstadt. It is possible that the interior depicted in *The Interruption* is entirely invented. Menzel's experience as an illustrator may account for the anecdotal character of the painting, but it is equally possible that the work depicts a scene from literature or from history. In any case, like Degas's *The Interior (The Rape),* 1868–69 (Collection Henry P. McIlhenny, Philadelphia), which is apparently a distillation of passages from Zola's novels *Thérèse Raquin* (1867) and *Madeleine Férat* (1868), the present painting seems to describe a specific time, place, and event. However, the unexplained ambiguity of both *The Interior* and *The Interruption* contributes to the success of each painting, because, as Degas once told a friend, "A painting demands a certain mystery, vagueness, fantasy. When one dots all the i's, one ends by being boring."

References: Tschudi, 1905 [IV], p. 20, no. 29, illus.; Theodore Reff, *Degas: The Artist's Mind,* New York, 1976, pp. 200–38.

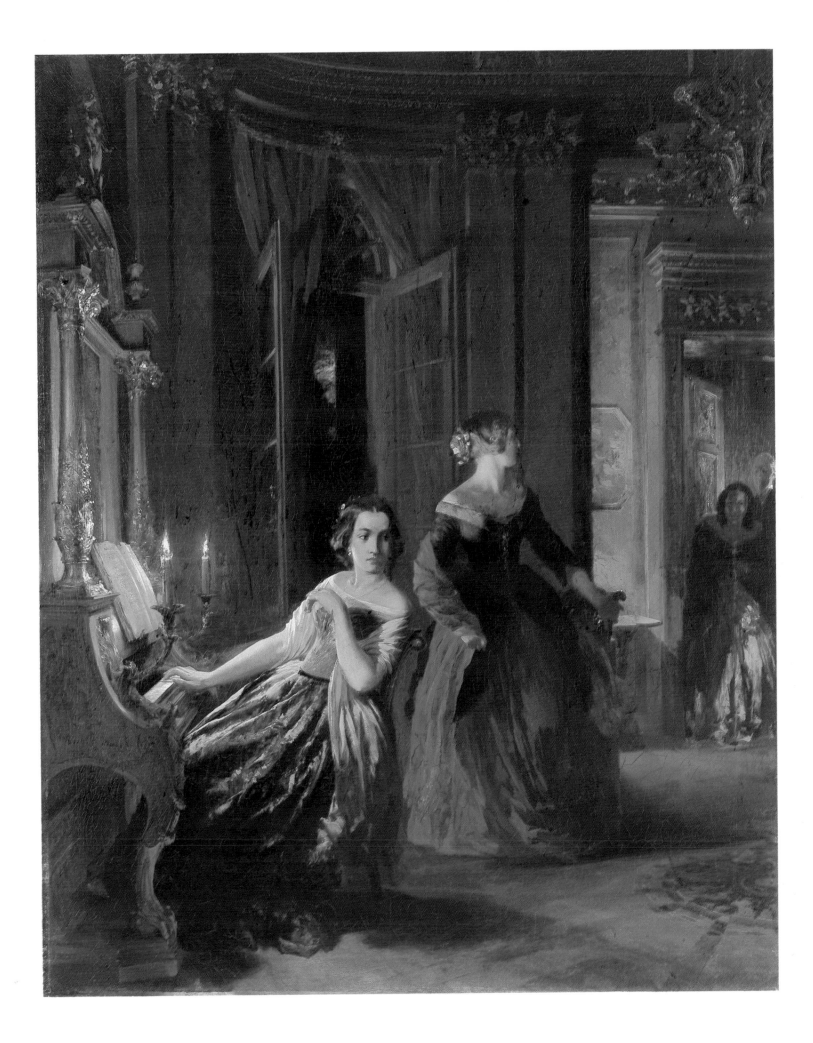

61. Adolph von Menzel

Prince Albert's Palace Garden, 1846 and 1876
(Palaisgarten des Prinzen Albrecht)

Signed and dated (lower left): Ad. Menzel 46
Oil on canvas, 68 x 86 cm (26¾ x 33⅞")
Nationalgalerie, Staatliche Museen Preussischer Kulturbesitz, Berlin

This is a view from Menzel's apartment on the Schöneberger Strasse toward the Palais Vernezobre, the upper floors of which are visible behind the trees. The palace was built in 1740 in the middle of Berlin, but it was later substantially modified in a classicizing manner by Karl Friedrich Schinkel. In 1832 it became the residence of Prince Albert of Prussia, son of Frederick William I, and his wife, Princess Marianne.

Although it has been suggested that Menzel painted *Prince Albert's Palace Garden* from the residence of friends, on the Anhalter Strasse, the artist himself assured the first owner of the painting, the banker Hermann Frenkel, that it was painted from the balcony of his own apartment. He also stated that he had worked from nature, but that the scene with the resting workers in the left foreground was fictionalized. In addition, the artist indicated that in 1876 he repainted the sky, because he had not been satisfied with it. In other words, the picture began as a plein-air landscape, but the artist adjusted and modified it in the studio.

The raised vantage point, the execution from nature, and the unconventional composition, especially the fragmented and cropped buildings, are characteristics that this work shares with later, more advanced painting, especially Impressionism. However, despite its art-historical precocity, the painting is a logical development from such works as Blechen's *View of Rooftops and Gardens,* c. 1835 (no. 4), which was itself probably influenced by the school of plein-air landscape painting that flourished in Rome in the 1820s and 1830s. Perhaps only coincidentally, the most direct compositional prototype seems to be Jacques Louis David's *View of the Luxembourg Gardens,* 1794 (Louvre, Paris).

An interesting contrast to Menzel's view of the palace garden is provided by another work he painted the same year, *Back of Building and Backyard,* 1846 (Nationalgalerie, Berlin). Although it is compositionally quite similar, it is an example of a kind of urban realism that was exceedingly rare at that time.

There is a study for the palace roof and the treetops in the Nationalgalerie, East Berlin.

References: Berlin, 1977 [V], pp. 258–60, illus. p. 259.

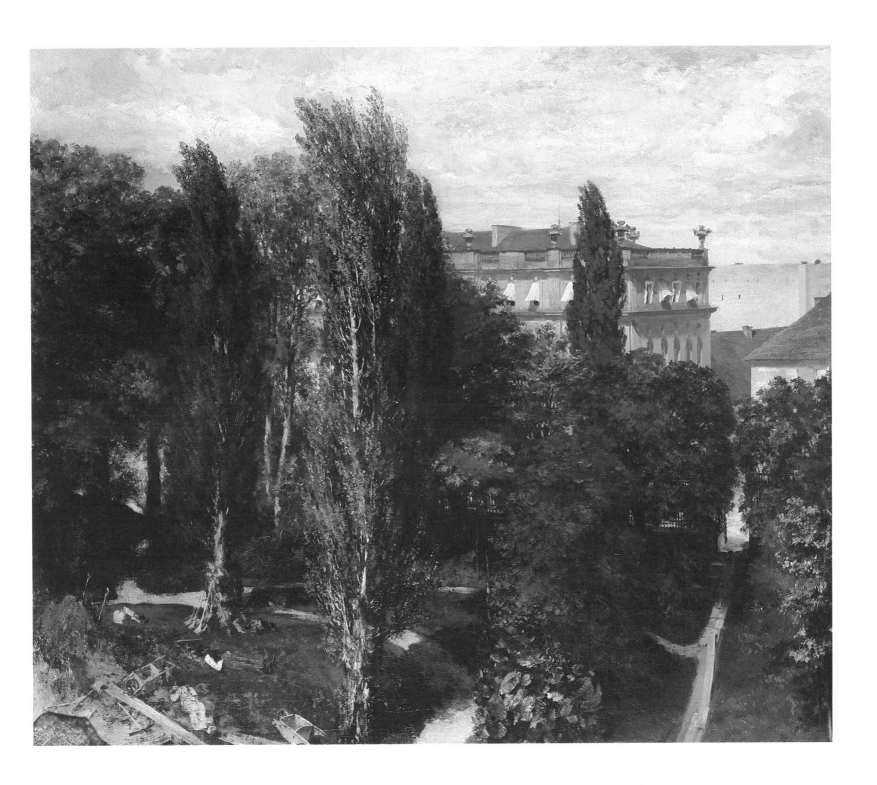

62. Adolph von Menzel

The Berlin-Potsdam Railroad, 1847
(Die Berlin-Potsdamer Eisenbahn)

Initialed and dated (lower right): A.M. 1847
Oil on canvas, 42 x 52 cm (16½ x 20½")
Nationalgalerie, Staatliche Museen Preussischer Kulturbesitz, Berlin

This early work by Menzel shows a freight train traveling from Berlin to Potsdam on the first Prussian railroad, which had opened in 1838. The skyline of Berlin is visible in the left background. With only Turner's *Rain, Steam, and Speed* of 1844 (National Gallery, London) as a precedent, *The Berlin-Potsdam Railroad* is the second painting in the history of art to depict a moving train.

In this pioneering work Menzel neither applauds nor deplores this new phenomenon of industry and transportation. The dynamism of the speeding train, its contours partly obscured by billowing steam, is emphasized by the taut curve of the tracks which contrasts with the more irregular elements of the landscape. The red highlights of the locomotive may allude to a potentially sinister aspect of the arrival of the railroad age, but the artist's criticism—if there is any—is as characteristically understated here as it would be later in one of his most famous paintings, *The Iron Rolling Mill,* 1875 (Nationalgalerie, East Berlin).

In 1845 Menzel made a detailed drawing of the scene which does not include the train but was probably done from nature (Kupferstichkabinett und Sammlungen der Zeichnungen, East Berlin). In the drawing grass obscures the tracks at the edge of the composition, but in the painting this is rejected in favor of more open, outwardly directed space. In the painting the tonal values accomplish the overall harmony and balance. The palette owes much to John Constable, whose influence is visible in the browns in the foreground and the misty silhouette of the city in the background. The liveliness of the brushwork may also reflect the influence of Constable, whose works Menzel later remembered studying at an exhibition at the Hôtel de Russie in Berlin in 1839.

The Berlin-Potsdam Railroad is one of several landscapes and interiors of the late 1840s, including *Prince Albert's Palace Garden,* 1846 and 1876 (no. 61), that seem limited to a straightforward representation of the visible world. They are, however, often extremely advanced compositionally and contrast strongly with such "official" works as *Departure of King William I for the Army on July 31, 1870,* 1871 (no. 64). They were private works, finished but not intended for exhibition, and only became known toward the end of Menzel's long career. They have since been admired as among his finest paintings.

The brushwork, surface, tonal character, and even the composition of this painting are remarkably similar to effects that Degas achieved many years later in his landscape monotypes.

References: Tschudi, 1905 [IV], p. 26, no. 33, illus. p. 27; Weinhold, 1955–56 [IV], pp. 191–99, esp. pp. 191–92; Berlin, 1977 [V], pp. 264–66, illus. p. 265.

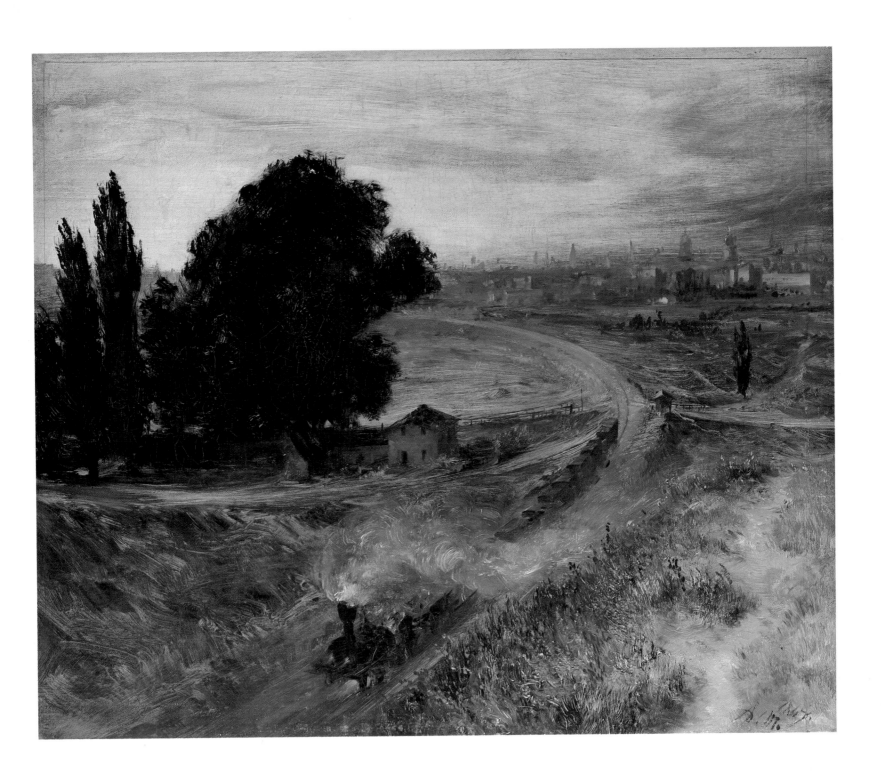

63. Adolph von Menzel

Théâtre du Gymnase, 1856

Signed (lower left): Menzel. 1856
Oil on canvas, 46 x 62 cm (18⅜ x 24¾")
Nationalgalerie, Staatliche Museen Preussischer Kulturbesitz, Berlin

Menzel made three trips to Paris: 1855 (two weeks), 1867 (four weeks), and 1868 (four weeks). The present work depicts a theater in Paris which Menzel became acquainted with during his first trip in September 1855. However, the painting was executed from memory, with the help of a sketchbook, in the artist's studio in Berlin in 1856. It is the kind of subject from modern life that Daumier had already begun to explore and that would soon be more fully exploited by Manet and Degas.

Like Degas, Menzel seems to have been fascinated by the spectacle, the artifice, the light effects, and the phenomena of the theater. However, unlike Degas, who was more interested in the technical aspects of the theater and the repertory of repeated gestures of musicians, dancers, and audience, Menzel was primarily interested in a specific event and a specific moment in time. *Théâtre du Gymnase* is, like *Departure of King William I for the Army on July 31, 1870,* 1871 (no. 64), a Realist statement. Ironically, Kermit Champa (New Haven, 1970) has criticized it for its literalness, although he also notes interesting visual qualities: "Because of the bold division of the image into areas of contrasting shape and tone, much of the pictorial conciseness of earlier pictures is maintained, but within each zone the kind of literally descriptive busyness of Menzel's later style begins to emerge. Yet considerable vitality of a truly visual sort exists as well, particularly in Menzel's brilliant development of silhouettes jutting upward from the orchestra into other areas of the picture and in the consistent and effective warmth of the color." Interestingly, the heads in the orchestra, which are important both rhythmically and compositionally, were added to the once dark foreground shortly before the artist's death. Menzel did not hesitate to make changes years after having finished a picture, as in *Prince Albert's Palace Garden,* 1846 and 1876 (no. 61).

The Théâtre du Gymnase first opened in 1820 as the Théâtre de Madame. It was given its present name in 1830. Between about 1835 and 1865 its repertory company was well known. The theater was renovated in 1972.

References: New Haven, 1970 [III], p. 121, pl. 49; Berlin, 1977 [V], pp. 274–76, illus. p. 275.

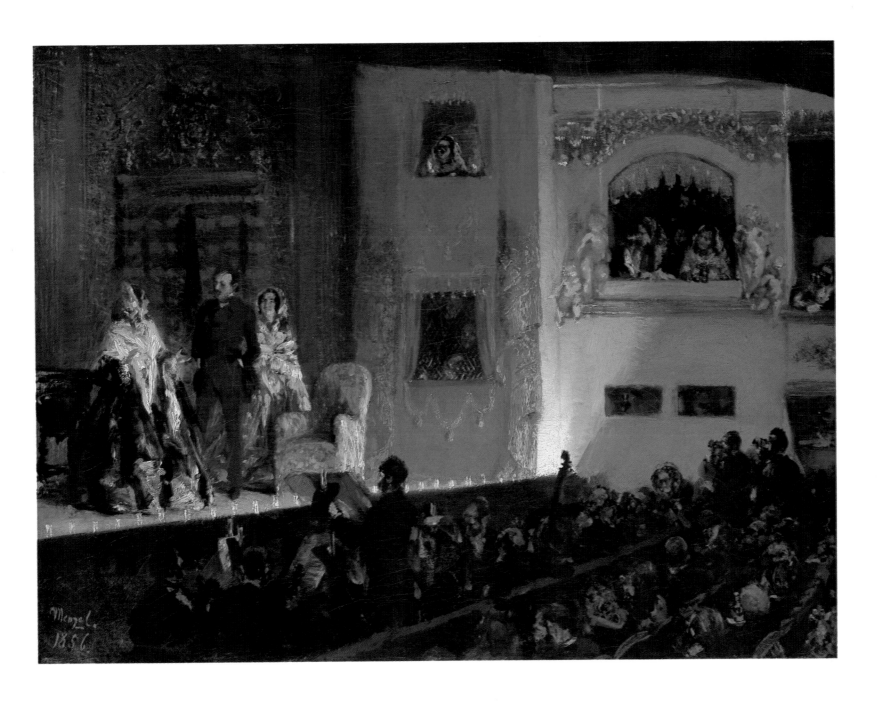

64. Adolph von Menzel

*Departure of King William I for the Army
 on July 31, 1870, 1871
(Abreise König Wilhelms I. zur Armee
 am 31. Juli 1870)*

Signed and dated (lower right): Ad. Menzel 1871
Oil on canvas, 63 x 78 cm (24¾ x 30¾")
Nationalgalerie, Staatliche Museen Preussischer Kulturbesitz, Berlin

On July 19, 1870, France declared war on Prussia following a dispute about the accession of a Hohenzollern prince to the Spanish throne. Prussia responded by invading France. The present painting depicts the departure of King William I for the front on July 31, 1870. Ultimately the Prussians were victorious, and an armistice was signed January 28, 1871.

This painting was commissioned by the Berlin collector Magnus Herrmann. It depicts the king and queen in an open carriage on the south side of the Unter den Linden, the most impressive boulevard in Berlin. The royal couple has left the imperial castle and travels in the direction of the Brandenburg Gate. The rows of trees and houses along the way are decorated with black and white (Prussian) and black, white, and red (German) flags. The combination of flags is of particular importance in that the unification of southern states with Prussia in the war effort brought about the national political consolidation that resulted in modern Germany.

Menzel's attention to detail is extraordinary; each individual in the crowd is treated separately. The realism is underscored by such seemingly insignificant details as the newsboy in the foreground, who sells a special edition of the paper. Standing on the balcony in the upper right corner are Magnus Herrmann's daughter and son-in-law, Albert Hertel, a landscape painter and one of the artist's friends. Menzel's emphasis on carefully rendered reportage lends the painting nearly photojournalistic credibility. Indeed, such depictions of actual events were immensely popular and firmly established Menzel's reputation during his lifetime.

Nevertheless, Menzel's achievement is not without its critics. Kermit Champa, for example, has objected to the present painting as an indiscriminately orchestrated, albeit technically proficient assemblage of facts (New Haven, 1970): "The wealth of bright color and the undeniable energy of Menzel's drawing make the image impressive, but the descriptive complications are finally so extreme and so small in scale that genuine expressiveness is dissipated into an exercise in craft. . . . By the time of this painting Menzel has lost the ability to be guided by what he sees. Instead he manufactures an elaborate product from visual raw materials which are important because of what

they are, rather than how they appear." Although Menzel's drawing and execution may be more analogous to that of Ernest Meissonier than to that of an Impressionist, it is nonetheless important to see him in the context of the advanced tendencies that Edmond Duranty described in his essay "The New Painting: Concerning the Group of Artists Exhibiting at the Durand-Ruel Galleries" (1876). Duranty wrote that "it was necessary to make the painter leave his sky-lighted cell, his cloister where he was in contact with the sky alone, and to bring him out among men, into the world," and that "they [the Impressionists] have tried to render the walk, the movement, the tremor, the intermingling of passersby just as they have tried to render the trembling of leaves, the shivering of water, the vibration of air inundated with light. . . ." In paintings such as the present one, what is perhaps more important than the artist's execution is his choice of subject matter, his willingness to treat subjects from modern life, even if in the guise of history painting.

There are preliminary drawings for this painting in the Kupferstichkabinett, Staatliche Museen, East Berlin.

References: Edmond Duranty, cited in Linda Nochlin, ed., *Impressionism and Post-Impressionism, 1874–1904, Sources and Documents,* Sources and Documents in the History of Art, Englewood Cliffs, N. J., 1966, p. 5; New Haven, 1970 [III], pp. 121–22, no. 70, pl. 48; Berlin, 1977 [V], p. 281, illus. p. 282.

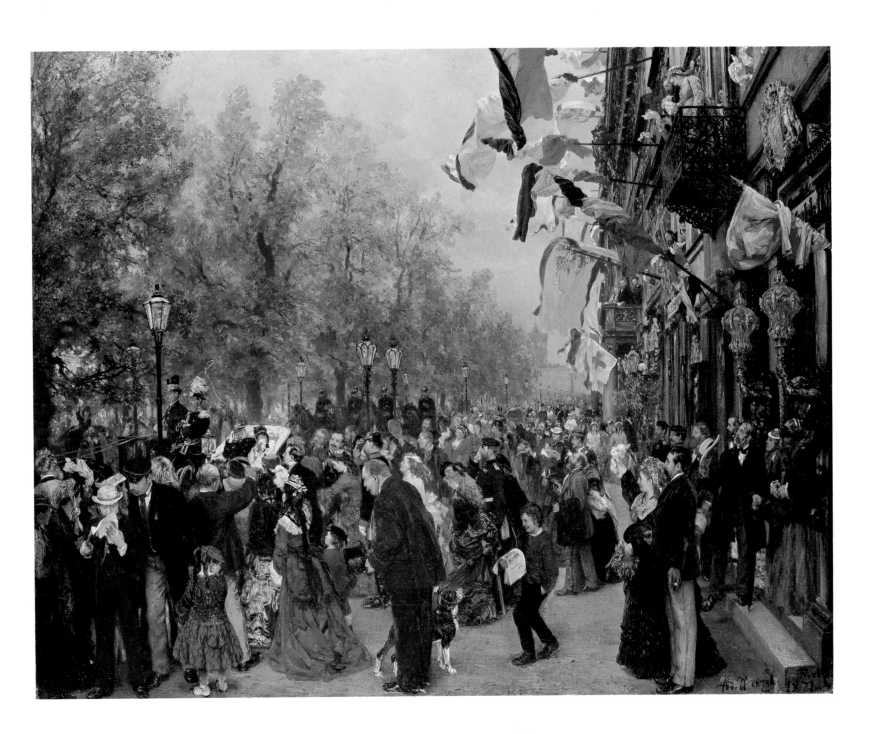

65. Ferdinand Olivier

Forest Landscape with a Cardinal on Horseback, 1839
(Waldlandschaft mit reitendem Kardinal)

Oil on canvas, 79 x 61.5 cm (31⅛ x 24¼″)
Gemäldegalerie der Stiftung Pommern, Kiel

Following the recommendation of Peter von Cornelius and Julius Schnorr von Carolsfeld, Olivier was appointed secretary and professor of art history at the Munich Academy in 1832. His duties seem to have interfered with his art, and about seven years later, three years before he died, he resigned as secretary. He resumed painting and again showed work in the exhibitions of the Munich Kunstverein. The present picture is considered one of the best works of his late period.

The handling of the trees on the left reflects the influence of seventeenth-century French painting, especially the landscapes of Claude Lorrain. The seventeenth-century classical landscape tradition is also apparent in Olivier's spatial construction, which depends on receding parallel planes. The subject and composition of this work are also at least indirectly related to landscapes by Joseph Anton Koch, such as *Grotta Ferrata,* 1835–36 (see no. 40). Koch's landscape style had strongly influenced Olivier's work since the two first met in Vienna in 1812, and it was probably through Koch that Olivier became aware of earlier French landscape painting.

A rudimentary version of the present work first appears in a drawing that Olivier made about 1833, *Ideal Landscape with Riders in Italy* (Graphische Sammlung, Munich).

References: Grote, 1938 [IV], pp. 344, 350 (drawing of about 1830, illus. no. 227), and illus. p. 351 (no. 228); Kiel, 1971 [V], no. 97.

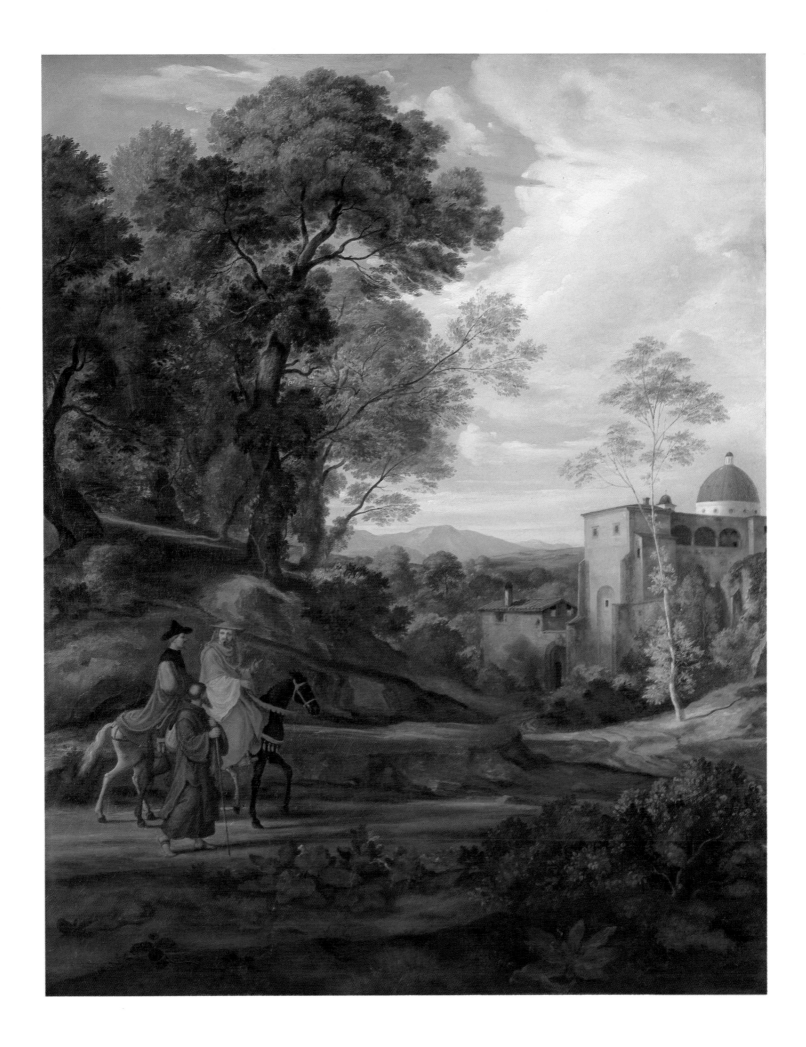

66. Johann Friedrich Overbeck

The Painter Franz Pforr, 1810
(Der Maler Franz Pforr)

Inscribed (lower right, indistinct): Pforr
Oil on canvas, 62 x 47 cm (24⅜ x 18½″)
Nationalgalerie, Staatliche Museen Preussischer Kulturbesitz, Berlin

Overbeck's portrait of Pforr was painted in Rome in 1810, shortly after they arrived with other members of the newly formed Brotherhood of St. Luke. The group was founded in Berlin in 1809 and constituted the original association of Nazarene painters. *The Painter Franz Pforr* represents the idealized image of a Nazarene artist in addition to functioning as a Nazarene "friendship picture," a portrait painting or drawing reciprocally executed and exchanged as proof of affection or loyalty. Overbeck's intention, as he explained in a letter of October 10, 1810, to Joseph Johann Sutter, was to portray Pforr "in a surrounding in which he would perhaps feel happiest." Overbeck had been inspired largely by a letter that Pforr had written to him and the other *Lukasbrüder* in which he described what he considered an ideal existence of himself as a medieval *Schlachtenmaler,* a painter of battle scenes, living in peaceful domesticity with his Madonna-like young wife.

Overbeck has modeled the painting on fifteenth- and early sixteenth-century German and Italian portraits of artists. He shows his friend in elegant old German dress at the window of an open Gothic loggia which is surrounded by a grapevine and a carved decorative border that incorporates Pforr's emblem, a skull in profile surmounted by a cross. In the background Pforr's imagined wife sews quietly while reading a religious book. A vase of lilies on the nearby table relates her to the Virgin; indeed, the cat beside Pforr may refer to the cat of the Madonna ("gatta della Madonna"). The domestic falcon above Pforr's "wife" is a symbol of the holy man, or the Christian convert; it also appears in Pforr's *Goetz* illustrations. In the distance is a German Gothic town in a Mediterranean coastal setting. It is an imaginary landscape characteristic of the Nazarene belief in the need to assimilate both early German and Italian art in order to create a new art for the present.

In response to Overbeck's portrait Pforr painted a diptych, *Shulamit and Maria,* 1811 (Georg Schäfer Collection, Schweinfurt). As Kermit Champa has explained (New Haven, 1970), Shulamit, "traditionally a symbol for the Old Testament—was the personification of what Italy and her art meant to Overbeck, fully formed, chaste but passionate—the beauty and clarity of Raphael's art. Maria belonged to the North, with its Germanic heritage of folk wandering, of Gothic Christianity, of legend— the forces which informed Pforr's art. Each woman was to be symbolically the bride of the painter who embraced her ideals;

together the two brides celebrated the union of the two dominant forces of Nazarene art."

Pforr died in 1812. Overbeck's portrait of Pforr was not entirely finished until 1865. Pforr's reciprocal tribute to their friendship remained in his possession throughout his life. The portrait of Pforr hung in Overbeck's entrance hall until he died in Rome in 1869.

References: London, 1959 [III], p. 187, no. 274; Andrews, 1964 [II], p. 98, no. 16a, pl. 16a; New Haven, 1970 [III], pp. 123–25; Berlin, 1977 [V], pp. 297–98, illus. p. 297; Frankfurt am Main, 1977 [III], p. 158, no. D 15, colorplate p. 165.

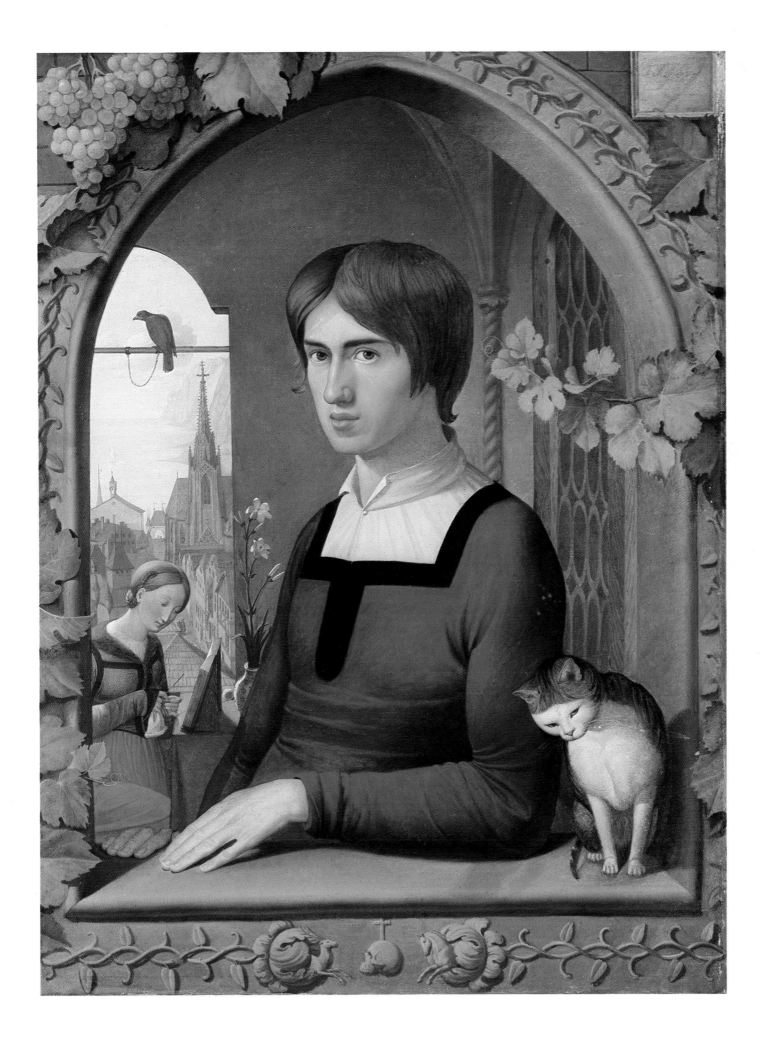

67. Johann Friedrich Overbeck

Christ with Mary and Martha, 1812–16
(Christus bei Maria und Martha)

Monogrammed and dated (lower left): FO 1815
Oil on canvas, 103 x 85.5 cm (40½ x 33⅝″)
Nationalgalerie, Staatliche Museen Preussischer Kulturbesitz, Berlin

The subject is taken from Luke 10:38–42 which recounts the story of Christ's visit to the house of Mary and Martha in Bethany. Martha criticizes Mary for sitting and listening to Christ instead of helping to serve the guests. The moment depicted is Christ's retort: "Martha, Martha, you are anxious and troubled about many things. But one thing is needful, and Mary has chosen that good part, which shall not be taken away from her." The framed inscription on the wall behind transcribes and identifies the passage.

The painting was commissioned by David Vogel of Zürich, the father of the artist Ludwig Vogel, who, like Overbeck, was a founding member of the Brotherhood of St. Luke, the group that later became known as the Nazarenes. The incident portrayed concerns the distinction between faith (represented by Mary) and the performance of good deeds (represented by Martha), about which the artist and the patron disagreed. Overbeck, an ardent Catholic convert, supported Mary's position, and Vogel, a Protestant, espoused that of Martha.

The paint handling, figural style, and facial types reflect the influence of the early work of Raphael, one of the artists most revered by the Nazarenes. Each of the apostles resembles a historical or contemporary personality. The face of the first apostle on the left, Peter, resembles Raphael's presumed portrait of Michelangelo as Heraclitus in *The School of Athens*. It is also similar to Dürer's portrayal of Peter in *The Four Apostles,* 1526 (Alte Pinakothek, Munich). The second apostle from the left, James, has the face of Raphael's presumed self-portrait in *The School of Athens.* The face of the next apostle, John, is that of a youth identified as Xaverio, who often modeled for the Nazarenes; the countenance of John is also reminiscent of one of the figures bending over Euclid on the right side of *The School of Athens.* Lazarus, the figure to the right of Christ in the present work, is thought to be a portrait of Ludwig Vogel.

Although Overbeck depicts an especially lively moment in the account, there is little evidence of activity. The figures are static, which clearly distinguishes the work of Overbeck from that of Raphael and Dürer, artists whom the Nazarenes consciously emulated. He has produced a somewhat didactic illustration rather than a dramatic representation of the episode. The artist seems more concerned with the precise arrangement of figures in a compositional whole than with the portrayal of the event itself.

A book by Thomas à Kempis, the medieval monk whose work Overbeck admired greatly, lies in the niche of the wall at the right. Through the open window on the left, a scene from the parable of the Good Samaritan is illustrated. The parable (Luke 10:29–37) immediately precedes the account of Christ's visit to the house of Mary and Martha.

References: Berlin, 1977 [V], p. 299, illus. p. 299; Frankfurt am Main, 1977 [III], p. 122, no. C 17, illus. p. 135.

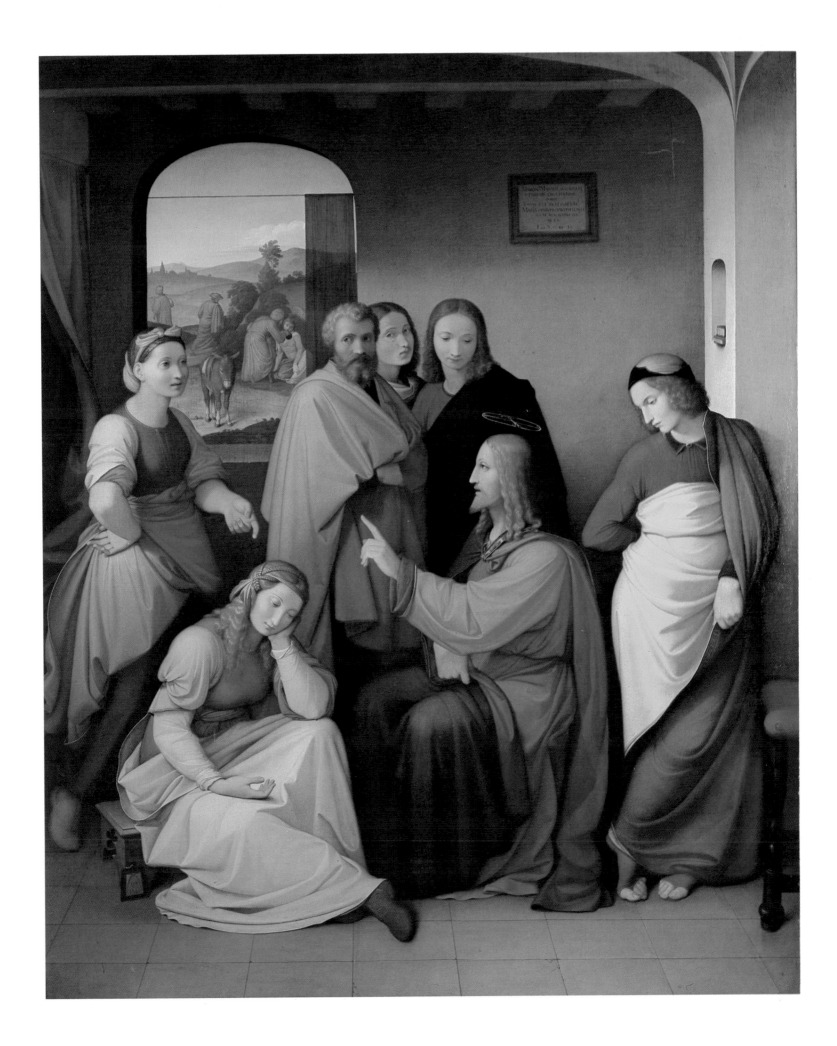

68. Johann Friedrich Overbeck

Vittoria Caldoni, 1820–21

Oil on canvas, 52 x 37 cm (20½ x 14½")
Von der Heydt-Museum, Wuppertal

The model for this painting is Vittoria Caldoni, the fifteen-year-old daughter of a vintner from Albano, a village in the Alban Hills south of Rome. August Kestner, secretary of the Hannoverian embassy in Rome, discovered her while visiting the Hannoverian ambassador during the summer of 1820. Kestner introduced her to his hosts, the von Redens, who subsequently invited her to Rome. She soon became popular as an artist's model, and von Reden provided a room in the embassy, the Villa Malta (see no. 22), where Vittoria posed several hours each day. Kestner recounts having seen forty-four portraits of her, among which were sculptures by Bertel Thorvaldsen and Rudolf Schadow, and paintings by Franz Ludwig Catel, Julius Schnorr von Carolsfeld, and Horace Vernet. Her popularity is perhaps best explained by the following passage written by Margaret Howitt in 1886: "She was the daughter of poor vintners, brought up according to the very strict customs of the countryside. Only rarely did she cross beyond the threshold of her parents' house, except to go to church or to work in the vineyard . . . the von Reden women were struck by her marvelous beauty, but were even more conquered . . . by her unusual wisdom and her childlike frankness. . . . Thorvaldsen and Rudolf Schadow rushed [to the Villa Malta] with their sculpting paraphernalia; the painters came in turn, each one of them enthusiastic about the idea of reproducing the innocent young woman's unique beauty."

Overbeck depicts Vittoria as a weary young peasant woman. Her pose suggests the theme of Melancholy (e.g., Dürer's etching *Melancolia I,* 1514), but the wheat fields, gourds, sickle, and the sack on which she sits indicate that the subject is an allegory of late summer or early autumn. Her expression probably signifies weariness as well as a recognition that another cycle of the seasons has come to an end. In a more general way the painting seems to address the question that is one of the underlying themes of Eccles. 1:3–4: "What profit has a man of all his labor which he taketh under the sun? One generation passeth away, and another generation cometh, but the earth abideth forever."

There are two other versions of the present painting. The example in the Neue Pinakothek, Munich, is evidently the first, because it was commissioned and paid for by Crown Prince Ludwig of Bavaria. The second (formerly Ellison Collection; present location unknown) is thought to be a study for the painting in Munich. The present example, which is smaller and less lively in execution than the other two, was in the artist's estate and later in the Rodolfi Collection in Rome. The artist apparently painted it for himself.

References: Howitt, 1886 [IV] (vol. 1), p. 480 ff.; Wuppertal, 1974 [V], pp. 163–64, no. 504, illus. p. 163; Paris, 1976 [III], pp. 143–44, no. 165, illus. p. 143 and colorplate 48; Frankfurt am Main, 1977 [III], p. 159, no. D 18, illus. p. 178.

69. Carl Rottmann

Cefalù, 1829

Signed and inscribed on reverse: Cap Cefalu. / mit zwei der Aeolischen
 Inseln: Aticuri et / Telicuri. / C. Rottmann 1839. [*C* and *R* are
 a ligature]
Oil on canvas, 63 x 79 cm (23¾ x 31⅛")
Wallraf-Richartz-Museum, Cologne

This painting was first exhibited in 1829 at the Munich Kunst-
verein as *Cape Cefalù in Sicily with the Islands Aticuri and Tilicuri.*
Details from studies made during Rottmann's first (1826–27)
and second (1829–30) trips to Italy, such as *Alicudi-Filicudi* (Pri-
vate collection, Munich), *Cefalù* (Private collection, Cologne),
and various sketches of the Lipari Islands, were carefully in-
corporated into the composition of the present painting. How-
ever, in the finished work the artist made changes in the sites
he had sketched *in situ*; for example, he replaced a group of tall
trees which blocked the view on the left with a young boy and
a knoll dotted with agave (a species of amaryllis), and added
a ford to the riverbed. The completed picture is a realistic land-
scape which has been edited to create a view that is awesome
and breathtaking; as Hubert Schrade has written, "Rottmann's
contemporaries extolled his vivid imagination. But while he
was rich in inner visions, he took fire from what he actually
saw. That visionary talent came into play even when he was
supposed to paint a 'view.' "

He returned to this subject in 1830–32 when he painted
a cycle of frescoes for the Hofgarten at the Residenz in Munich.
"The biggest commission of his life," as Schrade has pointed
out, "was a series of landscapes for the arcades of the residential
palace in Munich. Begun in 1830, it was a daring project, both
technically and thematically. The pictures were to be frescoes.
But Rottmann's knowledge of the fresco technique was rather
vague, and so he used a mixture of techniques. As for the subject
matter of these pictures, they were to be a refutation of Cor-
nelius, who had declared that landscape painting was merely
the 'moss and lichen' of art. Rottmann wanted to bring landscape
art into its own by giving it a monumental quality."

References: Decker, 1957 [IV], p. 79, no. 432; Cologne, 1964 [V],
pp. 105–6, no. 1107, illus. p. 272; Schrade, 1977 [II], p. 98; Bierhaus-
Rödiger et al., 1978 [IV], pp. 221–22, no. 184, illus. p. 222.

70. Philipp Otto Runge

Portrait of Otto Sigismund in a Folding Chair, 1805
(Bildnis Otto Sigismund im Klappstuhl)

Inscribed (on back of chair): P. O. Runge
Oil on canvas, 40 x 35.5 cm (15¾ x 14")
Lent by the Runge family

This portrait by Runge of his son is the third in a series of portraits of children done in 1805. The other two, *The Little Perthes* (Staatliche Kunsthalle, Weimar) and *The Hülsenbeck Children* (Hamburger Kunsthalle), were commissioned works. In all three portraits the artist observes the subjects without condescension; the viewer is brought to the same level as the children, literally and figuratively. They are presented as solemn and independent, in their own world. Furthermore, Runge refrains from effecting a saccharine cuteness, thus breaking with the tradition that dominated children's portraiture throughout the eighteenth and early nineteenth centuries.

Otto Sigismund was born April 30, 1805. Runge painted this portrait at the end of that year and sent it, with a portrait of his wife, Pauline, as a Christmas gift to Pauline's parents. Otto Sigismund could have been no more than eight months old when the painting was executed. Unlike the somewhat formal commissioned portraits of his friends' children, Runge's depiction of his son is particularly intimate and natural. The artist's devotion to his son is documented in his many letters to friends and relatives, and apparently he paid rapt attention to the child's development. Such attention is indicated by the carefully observed nuances of the portrait: the child's expression is one of observant curiosity, and his posture is characteristic of the unsteady balance of small infants.

While portraiture is a secondary concern in Runge's oeuvre, the portraits of 1805 mark a turning point in his career. Previous to these works his paintings were notable for their almost Neoclassical formality. In portraiture Runge discovered a means by which he could introduce a more relaxed approach to his compositions. It is this ability to capture observable phenomena that gives Runge's later, more ambitious and complex works their resonance; in this more personal painting it serves to bring Runge's son to life.

References: Traeger, 1975 [IV], pp. 379–80, no. 313, illus. p. 380; Hamburg, 1977 [IV], no. 239, colorplate 14; Traeger, 1977 [IV], p. 106, colorplate 16.

71. Philipp Otto Runge

Rest on the Flight into Egypt, 1805–6
(Ruhe auf der Flucht nach Ägypten)

Oil on canvas, 96.5 x 129.5 cm (38 x 51″)
Hamburger Kunsthalle, Hamburg

This painting is the first successful realization of Philipp Otto Runge's ambition to unite Christian orthodoxy with Romantic mysticism and his own personal cosmology. Runge was brought up in a strictly Protestant household in northern Germany, and his family allowed him to study painting only after he had demonstrated that art could convey spiritual and religious significance. His first teacher, the novelist and poet Ludwig Theobul Kosegarten, communicated his pietism and almost pantheistic love of nature to his pupil, who continued to explore this duality throughout his career.

The Rest on the Flight into Egypt is a theme common to German art. Woodcuts of this episode by Martin Schongauer and Lucas van Leyden would have been accessible to Runge, and in painting this scene he allied himself with the northern tradition. The composition does not at first appear remarkable, and the figure types of Joseph, Mary, and the Christ Child accord with established forms. Within this context, however, Runge has made several radical departures which distinguish this work from all prototypes.

Runge first sketched *Rest on the Flight into Egypt* in 1797 in an informal drawing (Hamburger Kunsthalle). In 1805 he returned to this theme in the hope that it would be accepted as an altarpiece for the Marienkirche of Greifswald. He sent numerous preparatory drawings (almost all of which have been preserved in the Hamburger Kunsthalle) to his friend Karl Schildener in Greifswald, who in turn presented them to Johann Friedrich Quistorp. Ultimately, the commission was not offered to Runge, but he did complete a large part of the final painting.

The painting can be divided into three zones: the dark, immediate foreground with Joseph tending the fire; the highlighted middle ground of Christ and Mary; and the twilight background of a vast landscape dotted with palaces, a pyramid, and the winding Nile. (That this landscape looks more German than Egyptian is probably due to Runge's nationalistic bias.) In this fashion Runge captures the uncertain light of early dawn and ties it symbolically to the composition. The linking of Christ with the dawn—the Child raises his arms to the first rays—is a hallowed tenet of Christian doctrine, but Runge invests this tradition with an immediate significance in his masterful depiction of natural light. Indeed, Runge made this connection explicit in his subtitle to the work, *Morning of the Orient,* referring to the new light of Christ, which rises in the East.

Runge also introduced his theory of color (published in 1810 but already developed by 1805) into this painting. Runge

had rejected Newton's optics and instead adopted the absolute, Aristotelian notion that color properties are local and are made visible only by the effect of light. Furthermore, he believed that each hue could be invested with a specific meaning. He allied the three primary colors with the Trinity, blue representing God the Father, red the color of the Passion, and yellow/gold the Holy Ghost. Elaborating on this scheme, the red of Christ coupled with the golden light of morning in *Rest on the Flight into Egypt* reads as a signal of birth and hope.

The miraculous tulip tree, populated by small angels and left unfinished, can be interpreted several ways. The angel on the left blows his horn to greet the dawn; the angel on the right looks down in adoration at the Child. The lily this angel holds may refer to Christ's sacrifice, or, more likely, within Runge's personal iconography, to the font of light (see no. 73). Traeger reads the tree as a promise of salvation, a manifestation of paradise on earth. He goes on to suggest that the tree should be regarded as a symbol of the divine spirit of nature. Vaughan places the tree in a Christian context, suggesting that it represents "the miracle of the palm tree bending down at daybreak to offer its fruit to the fugitive family." Whichever interpretation is correct, Runge clearly employed this motif to underline the essential harmony between religious and natural events, the coming of Christ and the dawn.

Like much of Runge's oeuvre this work has a companion piece which acts as a counterpart to its theme. *The Poet at the Source,* 1805 (Hamburger Kunsthalle), subtitled *Evening of the Occident,* is a drawing that was submitted along with compositional studies for *Rest on the Flight in Egypt* for the Marienkirche commission. Although no painted version was ever made of this work, its theme is developed with the same degree of sophistication as *Rest on the Flight into Egypt.* The relationship between these works is complementary; *The Poet at the Source* depicts the evening of the old, Nordic, pre-Christian world. A bard in ancient dress is seated in a wood by a spring, the source of his inspiration. The general tonality and composition of this scene are dark and enclosed, as opposed to the light and openness of *Rest on the Flight into Egypt.* Taken together, these two works, representing a spiritual dawn and twilight, can be seen as a facet of the great concern of Runge's career, *Four Times of Day.*

References: Traeger, 1975 [IV], pp. 382–86, no. 322, colorplate 10; Paris, 1976 [III], pp. 181–82, no. 209, illus. p. 181 and colorplate 46; Hamburg, 1977 [IV], no. 151, colorplate 11; Traeger, 1977 [IV], pp. 108–10, colorplates 17–18; Vaughan, 1980 [II], pp. 56–58, pl. 36.

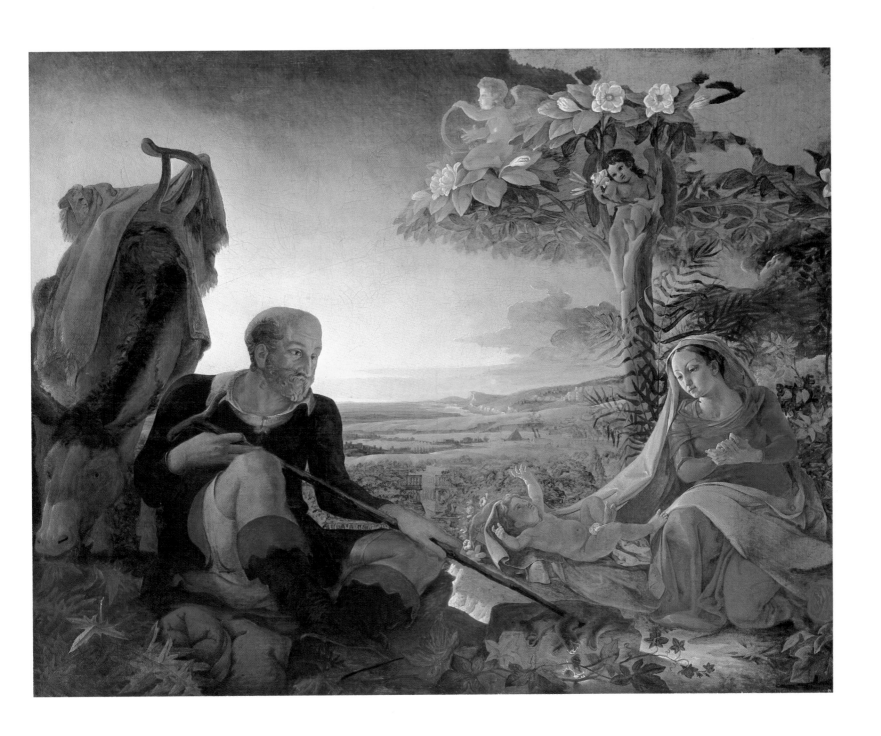

72. Philipp Otto Runge

Wife and Son of the Artist, 1807
(Frau und Söhnchen des Künstlers)

Oil on canvas, 97 x 73 cm (38⅛ x 28¾")
Nationalgalerie, Staatliche Museen Preussischer Kulturbesitz, Berlin

Like Caspar David Friedrich, Runge sought a new pictorial language to express his modern understanding of the world. Through theoretical and technical endeavors he wished to bring about a fundamental rejuvenation of art that would result in a synthesis of the arts. Significant aspects of his objective depended upon the analogy of art to music and of art to geometry. Pictorial realizations of these intellectual constructs can be found in his paintings of his family and friends, among which, despite the casual circumstances of their creation, are some of the most important German portraits of the nineteenth century. They are carefully interwoven combinations of straightforward observation and Romantic conceit.

Here Runge has painted his wife, Pauline Bassenge, and his two-year-old son, Otto Sigismund. Nearly equal parts of sky and forest frame the heads of mother and son respectively. A drawing, now lost, showed that Runge initially conceived the child closer to his mother and with his left arm raised. The faces of both have been rendered realistically, but the composition recalls depictions of Mary and the Christ Child. Such a correlation is unquestionably intentional, because at the time this portrait was painted Runge was especially interested in the compositional formats of German old-master painting.

Wife and Son of the Artist was painted in Wolgast shortly after *The Artist's Parents,* 1806 (Hamburger Kunsthalle). It was never completed; the heads of Pauline and Otto Sigismund are nearly finished, and the drapery is fairly well rendered, but the background and idealized landscape have only been sketched in with brown underpaint.

References: Traeger, 1975 [IV], pp. 413–14, colorplate 18 p. 125; Hamburg, 1977 [IV], p. 240, no. 237.

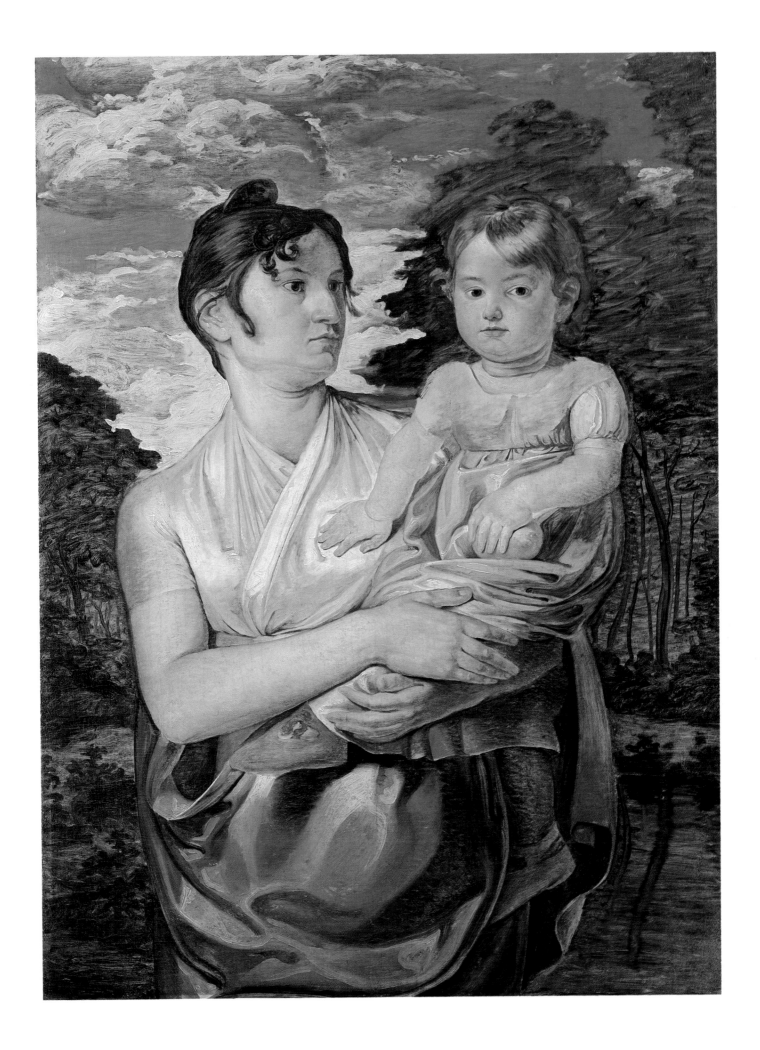

73. Philipp Otto Runge

Morning (Large Version), 1809
(Der Grosse Morgen)

Oil on canvas, 152 x 113 cm (60⅞ x 45⅛″)
Hamburger Kunsthalle, Hamburg

Philipp Otto Runge in his brief career was almost constantly devoted to one project, *Four Times of Day*. He divided the day into two complementary parts: morning/evening and day/night. He first outlined the cycle in four drawings, 1802–3 (Hamburger Kunsthalle; the preparatory drawings and versions cited here are all in this collection). These drawings received wider notice when they were published in 1806 and 1807 in a portfolio of etchings (executed in 1805). He painted the central portion, *Day*, in 1803; after he made numerous studies he painted *Morning (Small Version)* in 1808, and the more monumental *Morning (Large Version)* the following year. These fragmentary examples are all that Runge managed to complete of this grand cycle; not one of the murals he envisioned was ever begun. On his deathbed he is supposed to have requested that his brother Daniel destroy *Morning (Large Version)*, since it was still incomplete and lacked its decorative border. Daniel did not comply with this request; however, probably about 1890 the work was cut into nine incomplete segments. These were presented to the Hamburger Kunsthalle in 1894. The pieces were reassembled in 1927 and mounted on a neutral gray ground.

Despite this heavy damage, it is still possible to see that *Morning* is unquestionably one of Runge's greatest achievements. As the artist returned to the theme year after year he continued to enrich his vision. He intended to complete the cycle on a vast scale and mount it as a *Gesamtkunstwerk* (total work of art). As early as 1803 his letters describe the four canvases as symphonic in scope; he writes of their being exhibited in a building designed in the Gothic style. The murals were to be accompanied by music and poetry.

Runge frequently discussed *Four Times of Day*, and in one of his detailed annotations (cited by Novotny) he wrote: "Morning is the boundless illumination of the Universe. Day is the boundless figuration of the creatures which fill the Universe. Evening is the boundless annihilation of existence into the origin of the Universe. Night is the boundless depth of the knowledge of the indestructible existence in God. These are the four dimensions of the created spirit."

Runge's first drawing for *Morning* is executed with an almost Neoclassical formalism, reflecting the economical linearity of John Flaxman. Enclosed by a decorative border, the central portion depicts what might be called the cosmic lily of light. It divides the composition vertically, and from the flower emerge little genii. The lower stem divides to sprout four roses, symbol of Christ. Four genii playing musical instruments sit on the rose stems. The background is barely defined by clouds and an arched horizon line. The border decoration elaborates on the cosmic and Christian symbolism of the scene; at the top, amid a nebula of seraphim, shines the word "Jehovah," written in Hebraic script.

Compared to this highly formal and conceptual scheme, the 1809 *Morning* has gone through a series of naturalistic transformations, many of which can be noted in the earlier, small version. The figures are more corporeal. The landscape background is more fully developed. The genii are more individualized. The image of the lily of light is clarified as its stem is replaced by Aurora, goddess of the dawn. Apparently Runge arrived at this figure through two major sources: Raphael's *Sistine Madonna*, then in the Dresden Gallery, which shows a heavenly vision of the Virgin buoyed by clouds, and the Dresden Venus, a classical statue also in the Dresden Gallery. Thus, the personification of dawn implicitly combines two aspects of woman, as the Virgin Mary and as Venus. She becomes at once the divine and earthly bringer of light and knowledge, the generative force of matter and of pure understanding.

A similar layering of meaning can be applied to the other elements of the composition. The child lying in the meadow, joyfully reaching toward the warmth of the light, is a reworking of the Christ Child as he appears in the earlier *Rest on the Flight into Egypt* (see no. 71). More generally, this child represents the new day, spring, the dawn of understanding, the beginning of creation.

The colors of this composition can also be interpreted with Christian and cosmic references, much in the same manner as *Rest on the Flight into Egypt*. The most remarkable aspect of this canvas, however, is Runge's brilliant handling of the effects of light. Light finds a wide range of expression, from the gold of Aurora's hair, to the reflected gold on the dewy meadow, to the cool silver of the morning star, which crowns the composition. Indeed, few artists have made light in itself such an important aspect of a composition. In his depiction of light, simultaneously earthly and divine, Runge makes explicit the theme of *Morning*; he has found a pictorial as well as philosophical equivalent for the first burst of light from the rising sun. (For preliminary studies see d39, d40, and d41.)

References: Finke, 1974 [I], pp. 20–22, 236; Traeger, 1975 [IV], pp. 455–72, no. 497, colorplate 27; Paris, 1976 [III], p. 190, no. 217, illus. p. 189; Hamburg, 1977 [IV], no. 200, colorplate 19; Traeger, 1977 [IV], pp. 154–60, colorplates 38–41; Novotny, 1978 [I], pp. 106–12, fig. 65; Vaughan, 1980 [II], pp. 43, 49–52, 59–63, pl. 24, colorplate 5.

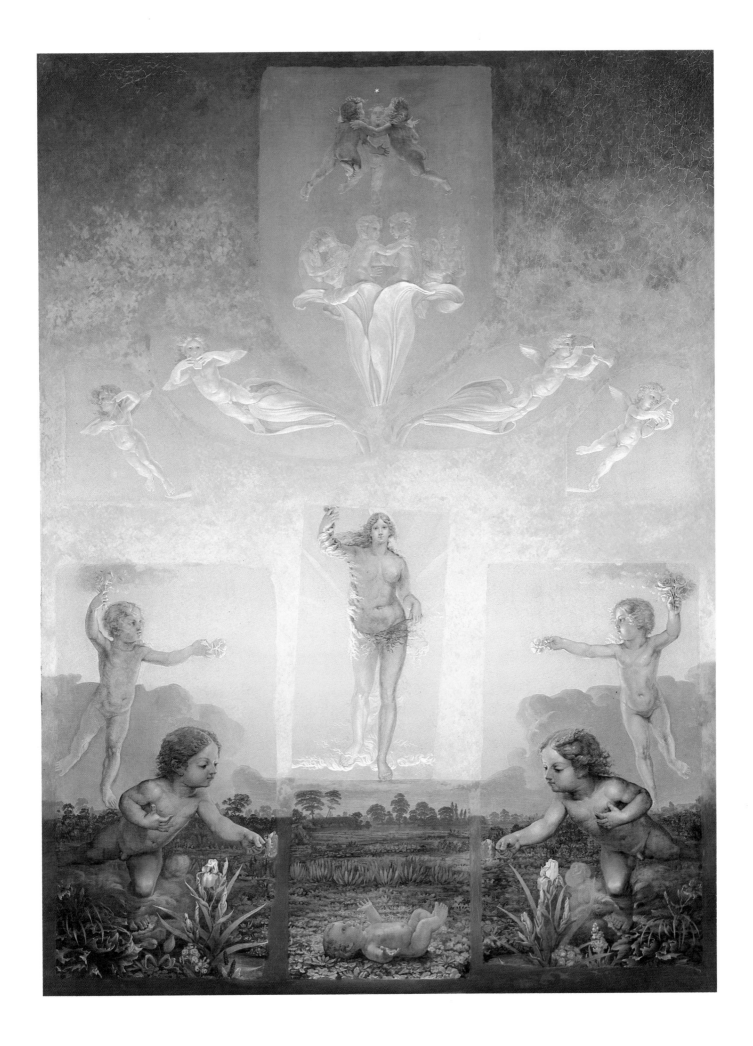

74. Wilhelm von Schadow

The Genius of Poetry, 1826
(Genius der Poesie)

Signed and dated (on reverse): WS 1826
Oil on canvas, diameter 101 cm (29¾")
Staatliche Schlösser und Gärten, Schloss Charlottenburg, Berlin

The Genius of Poetry is an idealized portrait of Elise (Elisabeth Concordia) Fraenkel, the daughter of a Berlin banker. She was herself a painter, and was married to the landscapist Georg Heinrich Crola. As the Genius of Poetry she looks toward heaven, pen in hand, in the classic pose of inspiration. In her hair she wears a laurel wreath, symbol of the art of poetry. The tablet she holds is inscribed with the names of the great poets: Horaz (Horace), Shakespeare, Dante, Calderon, Camoens (Camões), Goethe, and Schiller. She adds the name of the contemporary German Romantic poet Ludwig Tieck, an indication of the esteem accorded him in Berlin circles.

This painting is a half-length version of an earlier, full-length example painted the same year (Staatliche Schlösser und Gärten, Potsdam). The composition has been influenced by Raphael's fresco *Poetry*, also a tondo, in the Vatican. As such, it reflects the artist's involvement in the Nazarene circle and the group's interest in Italian High Renaissance painting. Furthermore, as a celebration of the importance of particular poets, the present work underscores the Nazarenes' admiration for the classical tradition, but with a strong Romantic undercurrent.

The Genius of Poetry was painted in 1826, the year Schadow became director of the Düsseldorf Academy. He had already moved beyond a strict adherence to Nazarene principles, and had begun to evolve the anecdotal realism that is characteristic of his late work. Although this image succeeds in its combining of an actual portrait with an ideal image, the Nazarenes' wish to rejuvenate the spirit, style, and goals of the High Renaissance was relatively short-lived, in large part because of the strong realist element that virtually all members of the group were unable to expunge.

Preliminary studies, including a chalk drawing of Elise Fraenkel's head, are in the Kunstmuseum, Düsseldorf.

References: Börsch-Supan, 1975 [VI], pp. 55–56, no. 62, illus. p. 56; Düsseldorf, 1979 [III], pp. 450, no. 215, illus. p. 451.

75. Wilhelm von Schadow

The Artist's Children, 1830
(Die Kinder des Künstlers)

Oil on canvas, 138 x 110 cm (54⅜ x 43⅜″)
Kunstmuseum, Düsseldorf

Schadow portrays his children in an Edenic world. On the left is his daughter Sophie von Schadow-Godenhaus, who later became well known as the translator of Michelangelo's sonnets and Dante's *Divine Comedy*. Beside her is her younger brother, Rudolf Johann Gottfried von Schadow-Godenhaus, later a distinguished army officer. Sophie is dressed in white, the symbol of innocence and holiness. One foot is in the water, which signifies the sacrament of the baptism, the washing away of sin.

Rudolf is also given attributes of traditional Christian iconography. The rabbit on his lap is the symbol of those who have put their hope of salvation in Christ. He is dressed in blue which is, according to George Ferguson, "the symbol of heaven and heavenly truth, because blue always appears in the sky after the clouds are dispelled, suggesting the unveiling of truth." Furthermore, he holds what appear to be violets and daisies, two attributes of Christ. The daisy symbolizes the innocence of the Christ Child, and the violet "denotes the humility of the son of God assuming human form."

The Artist's Children was painted in 1830, four years after Schadow became director of the Düsseldorf Academy. There he evolved a style combining the Romantic, archaizing principles of the Nazarenes with the tenets of academic realism.

References: George Ferguson, *Signs and Symbols in Christian Art,* New York, 1954, pp. 36, 52, 60–61, 272, 274; Düsseldorf, 1976. Kunstmuseum. *Düsseldorf und der Norden,* no. 31, illus. p. 66; Irene Markowitz and Rolf Andree, *Die Düsseldorf Malerschule, Bildheft des Kunstmuseums Düsseldorf,* Düsseldorf, 1977, no. 29; Düsseldorf, 1979 [III], pp. 453-54, no. 217, p. 237, colorplate 21.

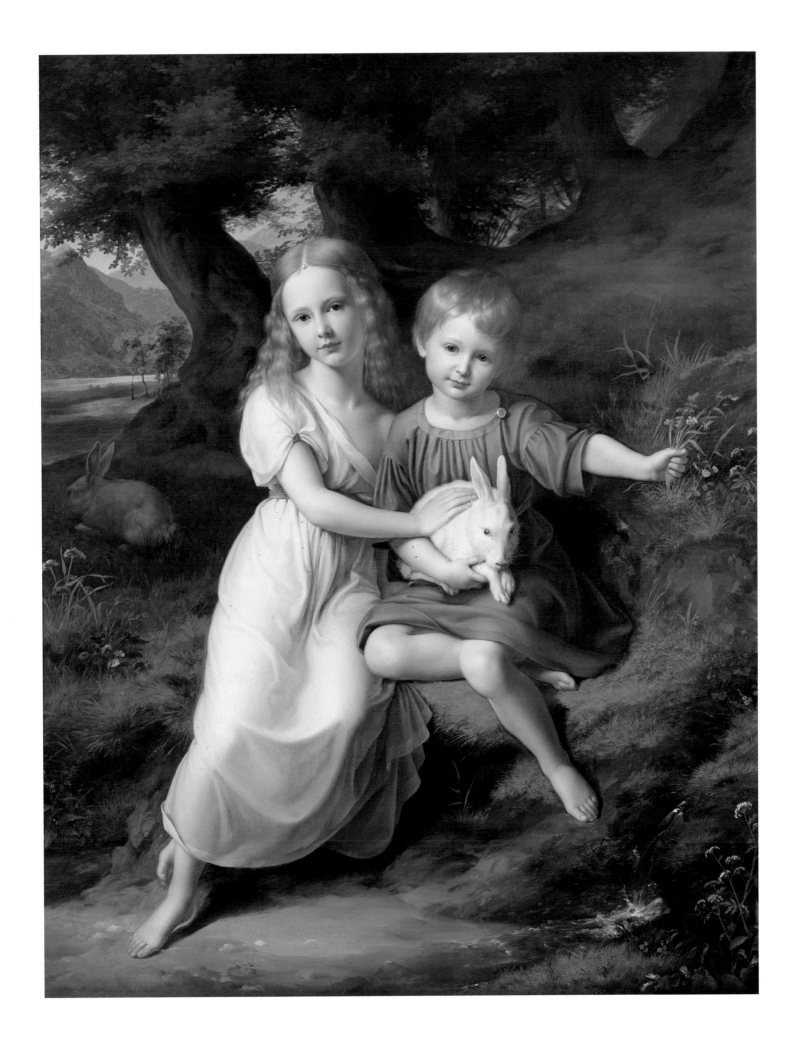

76. Julius Schnorr von Carolsfeld

Hagen Exhorts Brunhilde to Avenge Herself
(Hagen gelobt Brunhilde, sie zu rächen)

Oil on canvas, 74.5 x 100 cm (29⅜ x 39⅜")
Collection Georg Schäfer, Schweinfurt

In 1825 Lugwig I of Bavaria commissioned Schnorr to decorate his living quarters in the newly constructed wing of the royal Residenz in Munich. The paintings were to be frescoes depicting seven scenes from the *Nibelungenlied,* the medieval German heroic epic that was rediscovered in 1755. Strongly nationalistic, the saga became immensely popular during the 1813–14 War of Liberation against Napoleon. In 1817 seven drawings by Peter von Cornelius depicting scenes from the Nibelung saga were engraved by the artist and printed by G. A. Reimer in Berlin.

The *Nibelungenlied* is chiefly a history of King Siegfried—the possessor of the Nibelung treasure—and his courtship of Kriemhilde, the sister of Gunther, king of Burgundy. Other tales are interwoven, such as the story of Gêrnot and Giselhêr; Hagen's murder of Siegfried for having dishonored Gunther's wife, Brunhilde; and Kriemhilde's revenge on her brothers, the Burgundian kings. For forty years Schnorr and many assistants worked on the frescoes in the Residenz. He also illustrated two editions of the *Nibelungenlied* (1843 and 1867). Although the composition of the present painting is not incorporated into the frescoes for the Residenz or the illustrations for either edition, it does describe a particularly dramatic moment in the story. The central scene depicts Brunhilde and Hagen; Brunhilde has just learned, during the dispute of the queens, that Siegfried, not her husband Gunther, had seduced her while made invisible by the *tarnkappe*, or cape of darkness. Hagen, one of Gunther's retainers, persuades her to allow him to avenge the act. Later he kills Siegfried while the two are hunting.

The present work is typical of Schnorr's decorations for the Residenz. The paintings were especially important in that they influenced contemporary artists as well as artists of the next generation, including Anselm Feuerbach. The encompassing architectural decoration used in the composition of this painting is closely related to similarly articulated compositional devices in the frescoes. Moreover, as in some works by Cornelius and Fohr, Schnorr's use of the triptych format reflects the Nazarene interest in German and Italian Renaissance painting. His interest in Renaissance painting is also indicated by the figure style used in the present work: the central figure on the pedestal in the right foreground is similar to that of Joseph in Raphael's *Holy Family with St. Elizabeth and the Infant St. John,* 1507 (Alte Pinakothek, Munich), and the figure seated at the left on the same pedestal appears to be based on the youth at the lower right of Christ in Raphael's *Transfiguration,* 1518–20.

In addition to the somewhat hackneyed Mannerist treatment of the figures, the illustration of heroic epics was not an entirely successful undertaking. As Fritz Novotny has pointed out, "Cornelius's painted heroic epics were a stirring example for a number of painters at a time when the creative impulse of Nazarene religiousness was on the decline, an example which induced them to take the history and legends of their country, classical mythology, and allegories as subjects for mural paintings. Instances are the pictures painted by Julius Schnorr von Carolsfeld after his return from Rome in 1827, and by Bonaventura Genelli. But even here no fulfilment was found. Schnorr's frescoes of the legend of the Nibelungs . . . are lacking in inner cohesion with the architecture. . . ."

References: Nürnberg, 1966 [III], p. 93, no. 163 W 25, illus. no. 163; Novotny, 1978 [I], p. 120.

77. Julius Schnorr von Carolsfeld

Annunciation, 1820
(Verkündigung)

Signed and dated (lower right): 18 JS 20
Oil on canvas, 120 x 92 cm (47¼ x 36¼")
Nationalgalerie, Staatliche Museen Preussischer Kulturbesitz, Berlin

This painting is a classic treatment of the Annunciation: the angel Gabriel holds lilies, symbolic of the purity of the Virgin, as he approaches from the left. A dove, symbol of the Holy Ghost, descends toward the Virgin in a ray of light at the moment of the Immaculate Conception. The composition has been influenced by Renaissance examples, especially Annunciations by Fra Angelico, whom Schnorr admired. Indeed, the quattrocento painter embodied for him a spiritual view of the world, as opposed to the rational view espoused by nineteenth-century German academies. Arches serving to separate and enframe the angel and the Virgin were also used by Fra Angelico, and Schnorr may have loosely adapted his composition from a work such as the *Annunciation*, c. 1449, at the top of the stairs in the convent of San Marco, Florence.

The illusionistically rendered arch in the foreground that frames the scene is a compositional device often encountered in fifteenth-century Netherlandish paintings. Here, however, the arch is decorated with roundels alternating with stylized lilies. The roundel at the top repeats the Annunciation, but the figures are reversed. The other roundels contain as yet unidentified coats of arms which appear to be of eighteenth- and/or nineteenth-century design. The roundel in the lower right corner of the painting on the column depicts a pelican. According to legend, the pelican pricked its breast to feed its young; it has become, therefore, a symbol of Christ's having given his own blood to save mankind.

The open loggia is an imaginative compositional device which permits Schnorr to include a vine, symbol of the new relation between God and man made possible through Christ (see entry for *Mary with the Christ Child*, 1820, no. 78). Furthermore, St. Peter's is visible in the far distance; the structure is symbolic of the Christian church as a whole, having been built on the site where Christ said, "Thou art Peter, and upon this rock I will build my church; and the gates of hell shall not prevail against it" (Matt. 16:18). The present painting then can be interpreted both as the annunciation of the birth of Christ and of Christianity.

Schnorr's *Annunciation* was executed for Cardinal von Ampach, who later presented it to the Wurzen Foundation near Leipzig. It was exhibited at Wurzen cathedral in 1821.

References: Berlin, 1977 [V], illus. p. 366.

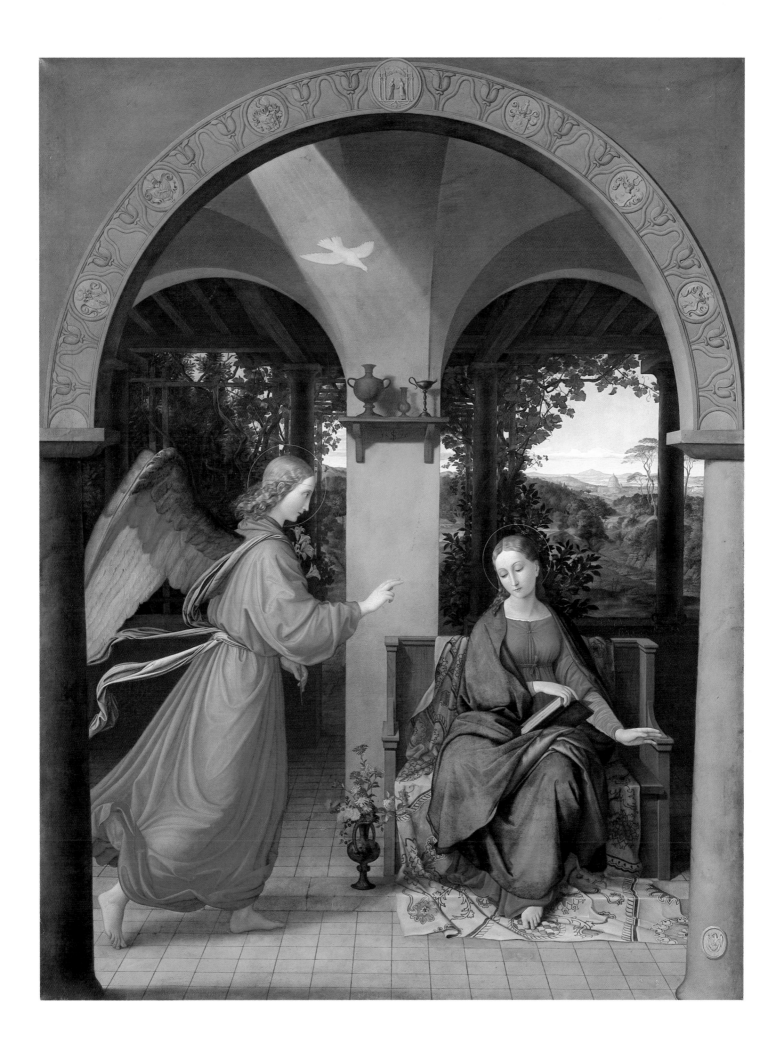

78. Julius Schnorr von Carolsfeld

Mary with the Christ Child, 1820
(Maria mit dem Kinde)

Signed and dated (lower left): 18 JS 20
Oil on canvas, 74 x 62 cm (29⅛ x 24⅜″)
Wallraf-Richartz-Museum, Cologne

The treatment of the Madonna and Child motif is based on Renaissance prototypes, but the figure of the Madonna seems to be an idealization of Clara Bianca von Quandt (see d44). Both the present work and a portrait of Frau von Quandt were commissioned in the fall of 1819 by the Dresden collector Johann Gottlob von Quandt, who had recently arrived in Rome with his bride and renewed his friendship with Schnorr.

Correspondence between Frau von Quandt and the artist is in the tradition of medieval courtly love and indicates an especially close relationship. Nevertheless, Schnorr's position was that of a devoted admirer who kept his distance. *Mary with the Christ Child* was to have been completed by Christmas 1819, but it was not delivered until the following year; indeed, on January 1, 1820, Schnorr wrote to his father, "I have received the most beautiful commission in the world. First I will execute the portrait of Frau von Quandt and then I will complete the Madonna painting for her."

In *Mary with the Christ Child* the Madonna sits in approximately the same position as Clara Bianca in the portrait (Nationalgalerie, Berlin), except that she faces left instead of right. The compositional arrangement of the figures seems to have been influenced by Fra Filippo Lippi's *Madonna and Child,* 1437 (Palazzo Barberini, Rome), as well as by a compositional type used by Botticelli and his studio in the 1480s.

The Hebraic text being read by the Virgin appears to be a book of the New Testament which Schnorr has transcribed from a medieval manuscript. It is probably one of the prophets, possibly the Book of Isaiah. It is virtually impossible to identify because Schnorr has copied the passages with varying degrees of precision.

The vine is a symbol of the new relation that exists between God and man through Christ, as indicated in John 15:1, 5, 8: "I am the true vine, and my Father is the husbandman. . . . I am the vine, ye are the branches: He that abideth in me, and I in him, the same bringeth forth much fruit: for without me ye can do nothing. . . . Herein is my Father glorified, that ye bear much fruit; so shall ye be my disciples."

Preliminary studies for the present painting are in the Kupferstichkabinett, Wallraf-Richartz-Museum, Cologne; the Kupferstichkabinett, Nationalgalerie, Berlin; and the Ashmolean Museum, Oxford.

References: George Ferguson, *Signs and Symbols in Christian Art,* New York, 1954, pp. 51–52; Cologne, 1964 [V], p. 110, no. 1112.

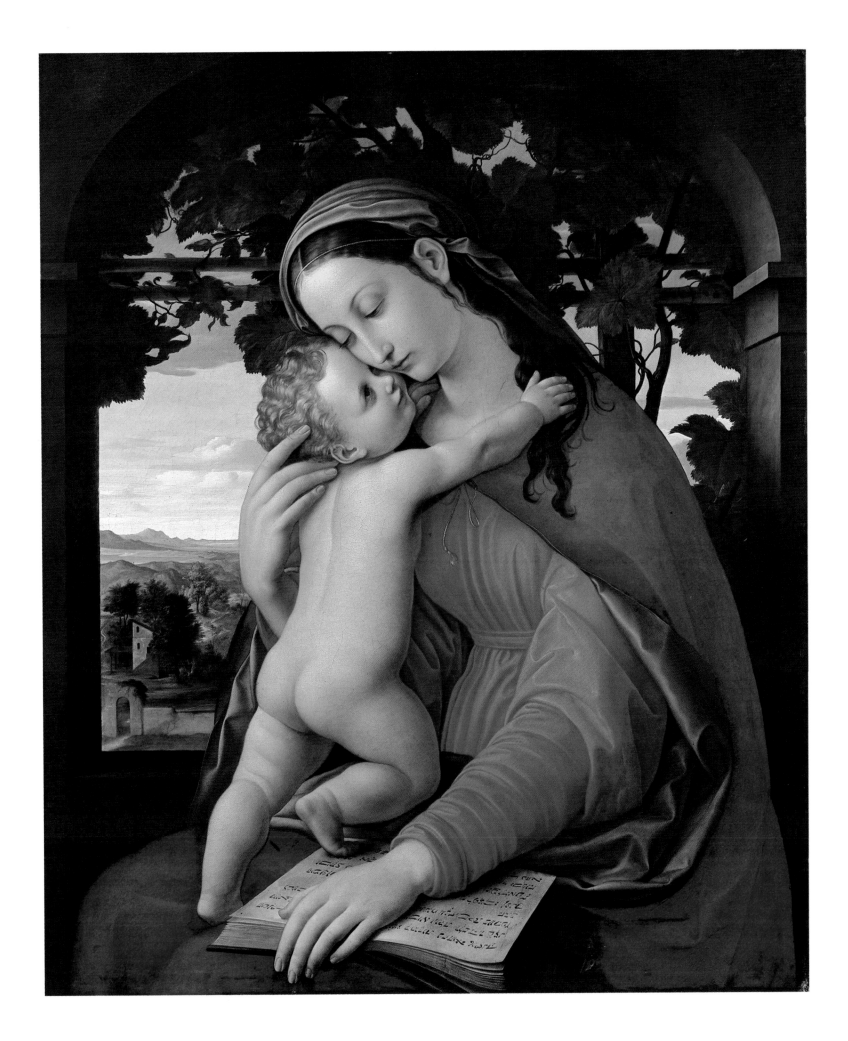

79. Moritz von Schwind

Portrait of the Singer Caroline Hetzenecker, 1848
(Porträt der Sängerin Caroline Hetzenecker)

Dated (middle right): Munich 1848
Oil on canvas, 120 x 95 cm (49⅛ x 38″)
Germanisches Nationalmuseum, Nürnberg (on loan from the
City of Nürnberg)

Moritz von Schwind is known primarily for his paintings of
scenes from legends and for his many illustrations of popular
folktales; however, he did execute a number of portraits of his
friends and fellow artists. This painting celebrates the singer
Caroline Hetzenecker, the widely acclaimed soprano of the
Munich Opera.

Schwind was particularly drawn to music. He formed a
lasting friendship with Franz Schubert, and was himself an am-
ateur violinist. His correspondence is filled with references to
the possibility of establishing a link between musical harmony
and the harmony of painterly composition. Caroline Hetze-
necker was for Schwind the embodiment of an ideal combination
of an artist at the highest level of achievement and a woman
of drama and mystery. He painted several portraits of her. In
a series of eight drawings and watercolors executed in 1848 he
depicted her in various leading roles, including Iphigenia (Staat-
liche Museen, East Berlin) and Donna Elvira (Kunst-
sammlungen, Weimar). A more fanciful tribute to the singer
is the drawing *Homage Rendered to the Opera Singer Caroline
Hetzenecker* (formerly Königliche Graphische Sammlung, Mu-
nich), where the luminaries of Munich society kneel at her feet
while the spirits of Mozart, Gluck, and Handel bless her.

The present portrait shows the singer in a simpler context.
She is about to give a recital and stands beside a piano, music
in hand; behind her are busts of Beethoven and Gluck. The
concert hall has been identified as the Odeon, and the setting
may be that of her farewell recital, since she left the stage in
1848 when she married. Indeed, the measured intimacy of the
scene suggests a domestic interior; the singer has shed her dra-
matic persona for the semblance of a *haute bourgeois* matron.

Schwind painted Caroline Hetzenecker for the last time in
Symphony, 1852 (Neue Pinakothek, Munich). Divided into com-
partments resembling a devotional polyptych, this panel is a
fantasy inspired by Beethoven. In the lowest range Caroline
Hetzenecker, in a stance identical to that in the present portrait,
leads a chorus. Her music is depicted as the font of the elaborate
imagery of the rest of the panel; the painting is an allegorical
representation of the creative force generated by music.

References: Weigmann, 1906 [IV], p. 279, illus. p. 279; New Haven, 1970
[III], pp. 134–35, no. 82, pl. 24; Pommeranz-Liedtke, 1974 [IV], p. 23;
Paris, 1976 [III], pp. 211–14, no. 242, illus. p. 212.

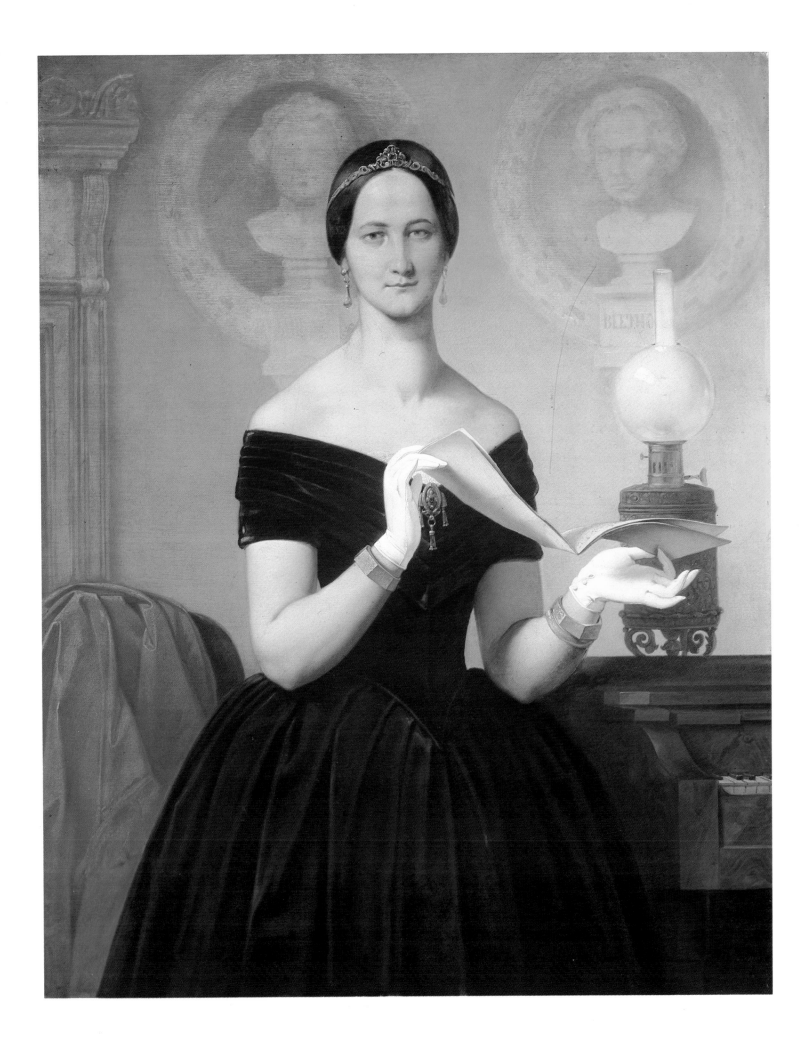

80. Moritz von Schwind

*In the Forest (The Youth's Magic Horn), c. 1848
(Im Walde [Des Knaben Wunderhorn])*

Oil on canvas, 49.5 x 39.4 cm (19½ x 15½")
Schack-Galerie, Bayerische Staatsgemäldesammlungen, Munich

This painting of a boy in the forest displays, as does *Rübezahl,*
1851–59 (no. 81), one of the most typical aspects of Schwind's
oeuvre; it concentrates on a shallow space with a close-up view
of a figure in the woods. However, this work must be considered
as distinct from Schwind's depictions of gnomes, wood sprites,
and fairies in that it is an illustration for a specific poem, Wolf-
gang Müller's "In the Forest" ("Im Walde"), which was pub-
lished in *German Poems with Marginal Sketches by German Artists
(Deutsche Dichtungen mit Randzeichnungen deutscher Künstler,*
1846–47).

The painting was acquired by Count Adolf Friedrich von
Schack in 1869, along with many other works by Schwind.
Schack described it as "a boy, only lightly clad, lying on the
ground, and, with a horn to his mouth, he gives expression to
the jubilation of his heart." Schwind was careful to follow the
poem by Müller. The composition echoes the poem's description
of sylvan solitude: the tawny light and rustling sounds of the
forest glade. This woodland symphony inspires the youth to
respond with his own music; man and nature are shown to be
in sympathetic harmony.

The original drawing of *In the Forest* (location unknown),
which served as the basis for the illustration published with the
poem etched by Constantin Müller, is referred to in a letter of
January 13, 1843, from Schwind to the editor of *Deutsche Dich-
tungen,* J. Buddeus. Schwind drew a variant, dated 1850 (for-
merly Schlesisches Museum der bildenden Künste, Breslau). In
his catalogue raisonné Weigmann dates the Munich work after
1860, but in the Schack-Galerie catalogue (Munich, 1969) it is
dated c. 1848. The earlier date would accord with Schwind's
concerns of the late 1840s and 1850s; later in his career he tended
to take a more formal view of nature, sacrificing the fresh nat-
uralism that gives *In the Forest* its intimate charm.

References: Weigmann, 1906 [IV], illus. p. 430; Munich, 1969 [V],
pp. 338–40, pl. 32; Pommeranz-Liedtke, 1974 [IV], colorplate 88; Paris,
1976 [III], p. 214, no. 243, illus. p. 213.

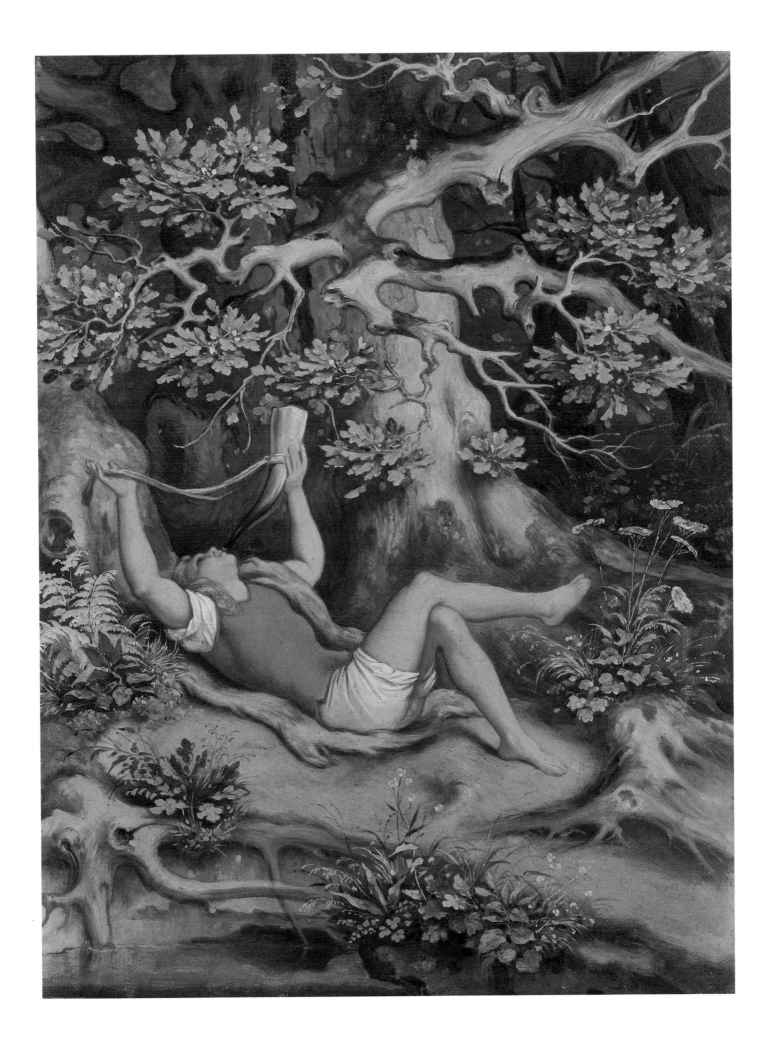

81. Moritz von Schwind

Rübezahl, 1851–59

Oil on canvas, 64.4 x 39.9 cm (25⅜ x 15¾")
Schack-Galerie, Bayerische Staatsgemäldesammlungen, Munich

This depiction of the folkloric figure Rübezahl is one of Moritz von Schwind's most characteristic works. At a time when the Brothers Grimm were collecting and codifying German folklore, Schwind drew inspiration from similar traditional legends and tales. This painting is not an illustration to a specific book or story; rather, it is a character portrait of a gnome who inhabits the woods, living on mushrooms, perpetually in search of a wife. To the uninformed viewer, however, this scene could easily read as the depiction of a rather eccentrically dressed peasant, for Schwind combined a carefully observed realism with even his most fantastic scenes.

This figure appears several times in Schwind's oeuvre. The first drawing of Rübezahl dates as early as 1831 (Stiftung Oskar Reinhart, Winterthur). Closer to the Munich version is an 1836 drawing in which the comic aspect of the figure is emphasized (Albertina, Vienna). An undated compositional sketch for the Munich painting is in the Kunsthaus Zürich, and there are two other versions to be found in Vienna and Cologne (Österreichische Galerie, and Wallraf-Richartz-Museum). The latter is unfinished, and none of the painted versions has been securely dated. In a more general context this painting can be linked to other works by Schwind—his caricatures of Father Winter published in the Munich journal *Fliegende Blätter* (1847), *In the Forest,* c. 1860 (see no. 80), his cycle of watercolors illustrating *The Tale of the Seven Ravens,* 1857 (Kunstsammlungen, Weimar)— all of which humorously depict familiar characters from popular legends. Indeed, among these works *Rübezahl* is one of the strongest.

Schwind added a personal touch to the Munich version of *Rübezahl.* The features of the gnome belong to Konrad Eberhard, a Munich painter (see d5). Since it is unlikely that Schwind would have painted such a caricature as a posthumous portrait, this painting must antedate Eberhard's death in 1859.

References: Haack, 1898 [IV], p. 91, illus. p. 91; Weigmann, 1906 [IV], p. 302, illus. p. 302; Kalkschmidt, 1943 [IV], colorplate 7; Munich, 1969 [V], pp. 341–43, pl. 33; Pommeranz-Liedtke, 1974 [IV], colorplate 40.

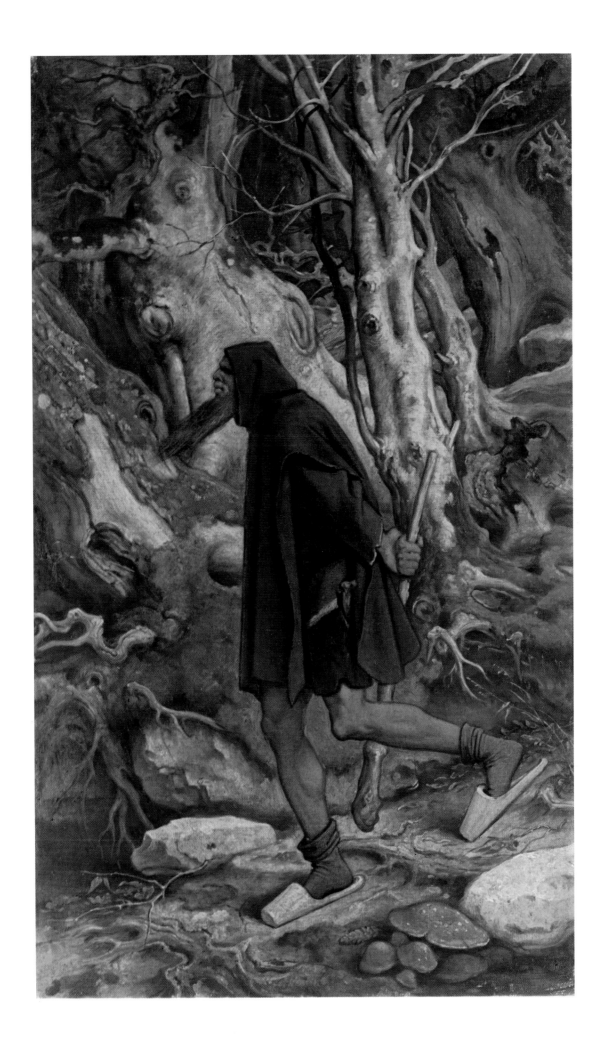

82. Moritz von Schwind

Departure by the Gray Light of Dawn, 1859
(Abschied im Morgengrauen)

Oil on pasteboard, 36 x 24 cm (14⅛ x 9½″)
Nationalgalerie, Staatliche Museen Preussischer Kulturbesitz, Berlin

One of the most cherished images of Romanticism was the artist as wanderer. In 1798 the poet Ludwig Tieck published *Franz Sternbald's Travels (Franz Sternbalds Wanderungen),* which describes the adventures of a young pupil of Dürer's who learns to become a mature artist through various encounters on his journey from Nürnberg to Rome. The story immediately provided a prototype emulated by German artists throughout the nineteenth century.

Schwind was no exception, and this scene is a retrospective self-portrait of his departure in 1828 from his home in Vienna. In actuality his destination was fixed; he was leaving to study in Munich. However, the poetic, half-lit atmosphere of the scene removes it from a specific time or place; the artist's journey, illuminated by the waning moon, seems charged with mystery and portent. The small figure hesitates on the threshold of the familiar before stepping out into the dark, forbidding forest.

The easily read narrative of this painting explains Schwind's popularity during his lifetime. Schwind himself identified such scenes as "spur-of-the-moment poetry, comedies, lyrical ballads or pictures." He made approximately forty similarly small works of this genre between 1857 and 1862, many of which were acquired by Count Adolf Friedrich von Schack. The painting *On the Journey,* c. 1860 (Schack-Galerie, Munich), is possibly a companion piece to the Berlin painting. Both works have almost identical dimensions, and the Munich piece shows the same young artist contemplating a mountain landscape. There are several drawings from the late 1820s that can be related to the Berlin painting, and it is evident that Schwind was to some extent returning nostalgically to his youth for inspiration. At the same time, the genre quality of the narrative and the careful depiction of the domestic courtyard reflect the popular current of Munich Biedermeier painting, seen also in the work of such artists as Carl Spitzweg.

References: Haack, 1898 [IV], p. 101, illus. p. 101; Weigmann, 1906 [IV], p. 396, illus. p. 396; Löffler, 1931 [IV], p. 211, illus. p. 211; Pommeranz-Liedtke, 1974 [IV], colorplate 90; Berlin, 1977 [V], p. 379, illus. p. 380.

83. Max Slevogt

Scheherezade, 1897

Signed (lower left): M. Slevogt 1897
Oil on canvas, 137 x 192 cm (53⅞ x 75⅝")
Pfalzgalerie des Bezirksverbandes, Kaiserslautern

Scheherezade was painted toward the end of Slevogt's Munich period (1890–99). The subject and the painterly execution reflect the influence of Wilhelm von Diez, his professor at the Munich Academy. The broad brushstrokes, the palette, and the non-idealized treatment of the female figures, however, signal a departure from the conservative manner promulgated by the Academy. Indeed, the paint handling exhibits the potential for the so-called Impressionist manner that soon emerged as the dominant element of Slevogt's style.

A painting the size of the present work was an important undertaking for the twenty-nine-year-old artist. Significantly, it represents the culmination of one phase of his work rather than the beginning of another. It is worth noting that *Scheherezade* was painted during the same year as the stylistically more advanced *Red Arbor with Dog* (no. 84). Furthermore, *Scheherezade* embodies few of the proto-Expressionist characteristics that emerged markedly in the triptych titled *The Return of the Prodigal Son, 1898–99* (Staatsgalerie Stuttgart).

The subject derives from the *Thousand and One Nights*, a collection of anonymous oriental tales in Arabic. The vehicle for the stories is Scheherezade, the daughter of a vizier, who each night must entertain her husband, Schariar, legendary king of Samarkand, by telling him a tale. Among the best known are "Ali Baba," "Sinbad the Sailor," and "Aladdin." If she fails to keep her husband's attention, she will be executed—the fate of unsuccessful predecessors. Each night ends with the same sentence: "Scheherezade observed that the morning had come, and she discontinued the story she had been permitted to begin." Slevogt's painting depicts Scheherezade weaving one of her suspenseful tales as the reposing king listens and a servant in the background adjusts a lamp. Three of Slevogt's friends posed for the painting in his studio: the actress Clothilde Schwarz (Scheherezade), her sister, and the sculptor Matthias Streicher.

References: Imiela, 1968 [IV], p. 294; Kaiserslautern, 1968. Pfalzgalerie. *Max Slevogt: Zum 100. Geburstag* [IV], no. 21.

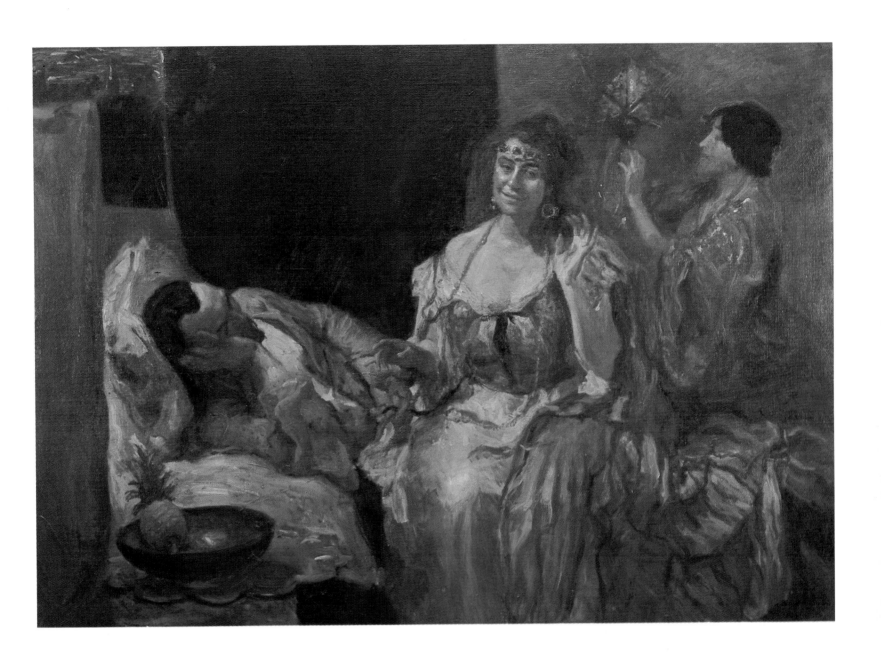

84. Max Slevogt

Red Arbor with Dog, 1897
(Rote Laube mit Hund)

Signed (lower right): Slevogt/1897
Oil on paper, mounted on wood, 57.5 x 84 cm (22⅝ x 33⅛″)
Mittelrheinisches Landesmuseum Mainz

Several times during Slevogt's career he painted compositions in which arbors play an important role. *Red Arbor with Dog,* 1897, *Nini at the Vine Trellis,* 1911 (no. 85), and *Slevogt's Children in a Vine Arbor at Neukastel,* 1917 (Wallraf-Richartz-Museum, Cologne) are three of the best-known examples.

The present work was painted near Neukastel, to the west of Landau in the Palatinate. Although it was painted from nature, it is dark in tonality despite the vibrancy of its colors. The darkness of Slevogt's palette is probably evidence of the lingering influence of Wilhelm von Diez, under whom he had studied at the Munich Academy. The relatively simple composition (five bands of color disposed horizontally across the picture plane) and the limited range of color (green, red, and a blue-gray shade of white) reflect Slevogt's fascination with the formal or abstract aspects of painting. However, the advanced character of this picture is especially important as the prelude to a new direction in his work; the following year he adopted the ideals of Impressionism and fully embraced the principles of plein-air painting.

Although there is probably no direct relation, the painting bears a resemblance to certain of Degas's highly simplified landscape monotypes. In 1889 Slevogt had in fact studied in Paris at the Académie Julian, and at that time saw the work of the Impressionists and the avant-garde. It was not, however, until he went to Berlin in 1899 at the invitation of Max Liebermann, and subsequently settled there in 1901 that he took an active interest in the work of Manet, Monet, Pissarro, and Degas.

This painting was once in the collection of the Finkler family, distant relatives whom Slevogt had known since his youth. The year after it was painted Slevogt married the Finklers' daughter, Antonie, or "Nini," who is depicted in *Nini at the Vine Trellis.*

References: Imiela, 1968 [IV], pp. 42, 360 n. 5; Frankfurt am Main, 1978 [III], no. 31.

85. Max Slevogt

Nini at the Vine Trellis, 1911
(Nini am Weinspalier)

Signed (lower right): Slevogt/1911
Oil on canvas, 200 x 106 cm (78¾ x 41¾")
Mittelrheinisches Landesmuseum Mainz

The figure standing at the grape arbor is Slevogt's wife, Nini. The origins of the picture probably lie in the work of the French Impressionists, artists whom Slevogt admired; indeed, *Nini at the Vine Trellis* is in the tradition described by French critic Edmond Duranty in 1876 in his essay "The New Painting: Concerning the Group of Artists Exhibiting at the Durand-Ruel Galleries": "What we need is the particular note of the modern individual in his clothing, in the midst of his social habits, at home or in the street."

Nevertheless, it is clear that Slevogt has transcended the influence of the French Impressionists, even artists whom he especially liked such as Manet and Degas. The firm, authoritative brushwork, the emphasis on the figure, and the particular expressiveness of the painting characterize a different focus. Moreover, the trace of a smile and the slightly raised eyebrows reflect a human interest that is rare in French Impressionism, except perhaps in the work of Degas, who wrote in 1869: "Make portraits of people in familiar and typical positions, above all, give their faces the same choice of expression one gives their bodies."

The verticality of the composition creates a larger-than-life quality; Nini's presence literally and figuratively fills the canvas. The compressed picture space and the rising ground plane further serve to emphasize the figure. The orchestration of the light-soaked colors is almost musical in effect; the muted, tinted whites of the dress, the subtly shifting pattern of the foliage, and the pinks of the path combine to surround Nini with a vision of form and color that connotes a very special *joie de vivre*.

This painting is one of several portraits of Nini, but it is particularly significant as a transitional work in Slevogt's *oeuvre*. *Nini at the Vine Trellis* achieves a degree of success that is rare in later portraits, especially because of its skillful articulation of subjective feeling.

References: Edmond Duranty, cited in Linda Nochlin, ed., *Impressionism and Post-Impressionism, 1874–1904, Sources and Documents,* Sources and Documents in the History of Art, Englewood Cliffs, N. J., 1966, pp. 5, 62; Imiela, 1968 [IV], pp. 134–35, colorplate p. 133.

86. Max Slevogt

Entry into the Harbor at Syracuse, 1914
(Einfahrt in den Hafen von Syrakus)

Signed (lower left): Slevogt/1914
Oil on canvas, 73 x 95.5 cm (28¾ x 37⅝")
Pfalzgalerie des Bezirksverbandes, Kaiserslautern

Between February 16 and March 22, 1914, Slevogt was in Egypt
with his companions Johannes Guthmann, Joachim Zimmer-
mann, and the art and cultural historian Eduard Fuchs. They
returned to Germany via Italy and on March 24 arrived in Syr-
acuse, the first stop on their homeward journey. The present
work was painted there ten days later, on April 3 between 1:30
and 6:00 P.M.

Earlier during their stay in Syracuse they had visited Fort
Euryelus, the famous local quarries, and the papyrus fields of
the Anapo River. Slevogt had in fact painted the papyrus fields
on April 1. On April 3 Fuchs rented a boat, and they spent the
day on the water. From the open sea Slevogt painted the harbor
entrance and the city behind it. Guthmann later described the
circumstances under which Slevogt painted the present work:
"One time as Slevogt was working from an anchored trawler
on a painting of the magnificent old city of Syracuse, which
seems to rise out of the blue sea, an angry storm suddenly
approached. The storm was so violent that only with great
difficulty could one climb down a rope in the wave-tossed row-
boat. Just as the painter was about to sacrifice his still-wet picture
to the ravages of the wind, Fuchs, the last to descend the rope
ladder, took the stretched canvas . . . between his teeth—his
hands were already full—and determinedly brought it safely
aboard the rocking rowboat. I don't know if I would have done
that, but I certainly was amazed by it."

The simplicity of this composition has its origins in earlier
works, such as *Red Arbor with Dog*, 1897 (no. 84). The three
horizontally arranged rectangles that comprise the composition,
and the limited range of the palette reflect the increasing pop-
ularity of the reductionist aesthetic. Monet's paintings of Antibes
(e.g., *Antibes, Afternoon Effect*, 1888, Museum of Fine Arts,
Boston) may have provided Slevogt with an important stylistic
precedent.

References: Imiela, 1968 [IV], p. 410 n. 5.

87. Carl Spitzweg

The Poor Poet, 1839
(Der arme Poet)

Signed and dated (lower right): Spitzweg/München 1839
Oil on canvas, 36.3 x 44.7 cm (14¼ x 17⅝")
Nationalgalerie, Staatliche Museen Preussischer Kulturbesitz, Berlin

It has been suggested that Spitzweg modeled the eccentric figure in this painting after the eighteenth-century Munich poet Entenhuber. The poet is working in bed, apparently to keep warm; the open umbrella over the bed is to protect him from leaks in the roof; and on the wall to the right there is a measuring device. The bundle of manuscripts in the left foreground is labeled "operum meor. facs. III," and the spine of one of the books near the bed bears the title *Gradus ad parnassum.* Spitzweg clearly intends him to be understood as a poet in the classical tradition, perhaps caught up in the enthusiasm for Greek and Roman art engendered by Johann Joachim Winckelmann.

The artist considered this work, with its clear construction and emphasis on descriptive detail, to be his first successful genre painting. When it was exhibited at the Munich Kunstverein in 1839, however, the painting was interpreted as ridiculing the art of poetry. The public rejected it, and as a result Spitzweg stopped participating in public exhibitions for a prolonged period. The element of parody or caricature remains a problematic aspect of Spitzweg's work, and modern audiences too have difficulty accepting these paintings as straightforward genre. Nevertheless, the artist remains one of the most popular nineteenth-century painters in Germany.

Spitzweg himself described the present work as a copy of the picture that is now in the Neue Pinakothek, Munich. The two are nearly identical, but, although both are signed and dated 1839, the first version was exhibited in 1837. A pencil sketch for the compostion is dated 1837 (Staatliche Graphische Sammlung, Munich); there is a later oil sketch in a private collection.

References: Roennefahrt, 1960 [IV], p. 288, no. 1362, illus. p. 126; Berlin, 1977 [V], p. 386–88, illus. p. 387.

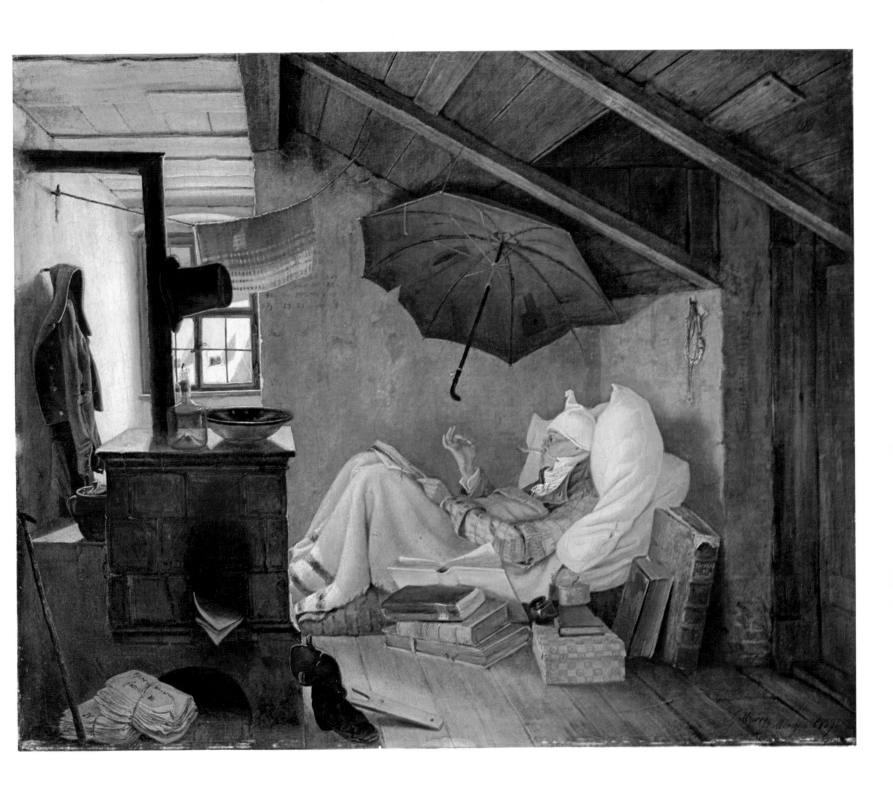

88. Carl Spitzweg

English Tourists in the Campagna (English Tourists Looking at Ruins), c. 1845
(Engländer in der Campagna [Engländer, Ruinen betrachtend])

Oil on paper attached to cardboard, 40 x 50 cm (15¾ x 19⅝")
Nationalgalerie, Staatliche Museen Preussischer Kulturbesitz, Berlin

Spitzweg here depicts a group of English tourists observing ruins in the Roman countryside. The Englishman in the foreground consults his guidebook, apparently failing to look beyond the pages. The woman at his side listens intently to the fatuities uttered by the guide. In the background another woman sketches. At the right a yawning servant stands holding coats and umbrellas; undoubtedly he has often watched as tourists attempt to fathom the complexities of classical antiquity.

The figures are the focus of the artist's attention; they are far more carefully rendered than the surrounding landscape. Moreover, they are perfectly suited to Spitzweg's humor; he often depicted people who took themselves too seriously or were forced by circumstance to assume roles of unsuitable authority. In the mid-nineteenth century the British Empire was moving inexorably toward its zenith, and Spitzweg clearly found the imperious English tourists appropriate targets for his wit.

The oil-on-paper technique used in the present work is similar in effect to watercolor. Indeed, there is a related watercolor with additional figures (formerly Galerie Heinemann, Munich) and a related pen drawing, also with additional figures (Albertina, Vienna).

References: Roennefahrt, 1960 [IV], p. 198, no. 621, illus.; Berlin, 1977 [V], pp. 388–90, illus. p. 389.

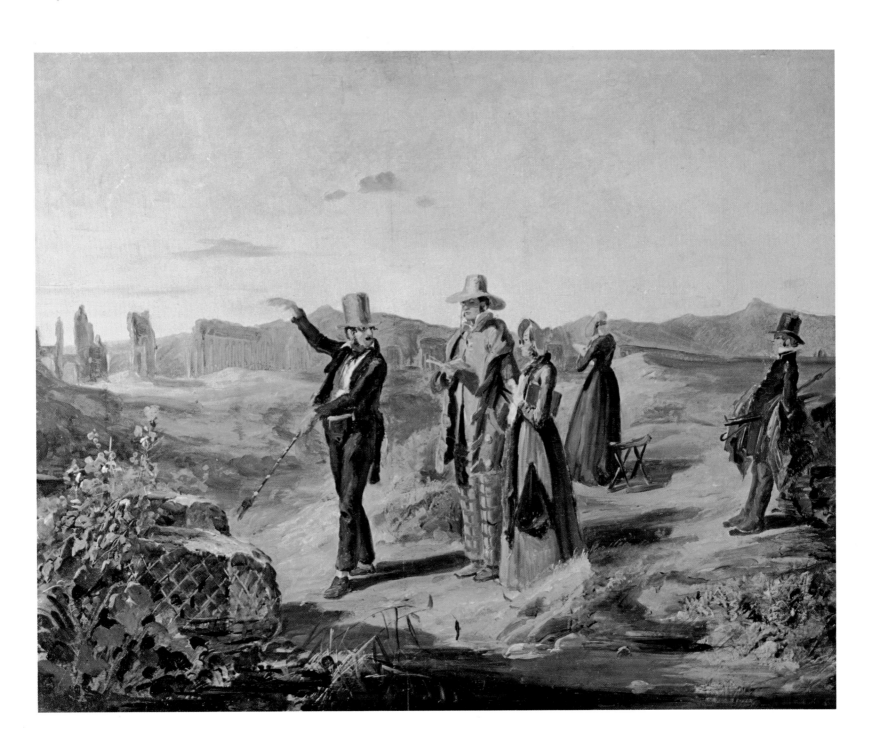

89. Carl Spitzweg

The Professor, 1868
(Der Herr Professor)

Monogrammed (lower right, in rhombus): CS
Oil on wood, 21.3 x 15.5 cm (8½ x 6⅛")
Pfalzgalerie des Bezirksverbandes, Kaiserslautern

Spitzweg painted many small pictures of a middle-aged or el-
derly figure reading a book or manuscript. As with the theme
of the night watchman (see no. 90), the artist frequently repeated
his subject, changing small details but always focusing on an
individual absorbed in a literary work. In addition to the nu-
merous examples depicting the professor in the garden, Spitz-
weg often shows him standing on a ladder in a study or a library.
 As is often the case in Spitzweg's work, there is a careful
balance between caricature and straightforward genre painting.
Despite the histrionic quality of the silhouette and the pompous
pose, the picture is neither serious nor mock-serious, neither
heroic nor mock-heroic. Like many of Daumier's subjects, the
professor is an exaggerated example of a type; nevertheless, the
artist's image is closer to reality than to caricature.
 This painting once belonged to Joseph Benzino, the Munich
privy councilor who bequeathed nearly his entire collection to
the Pfalzgalerie des Bezirksverbandes, Kaiserslautern.

References: Kaiserslautern, 1975 [V], colorplate (unpaginated).

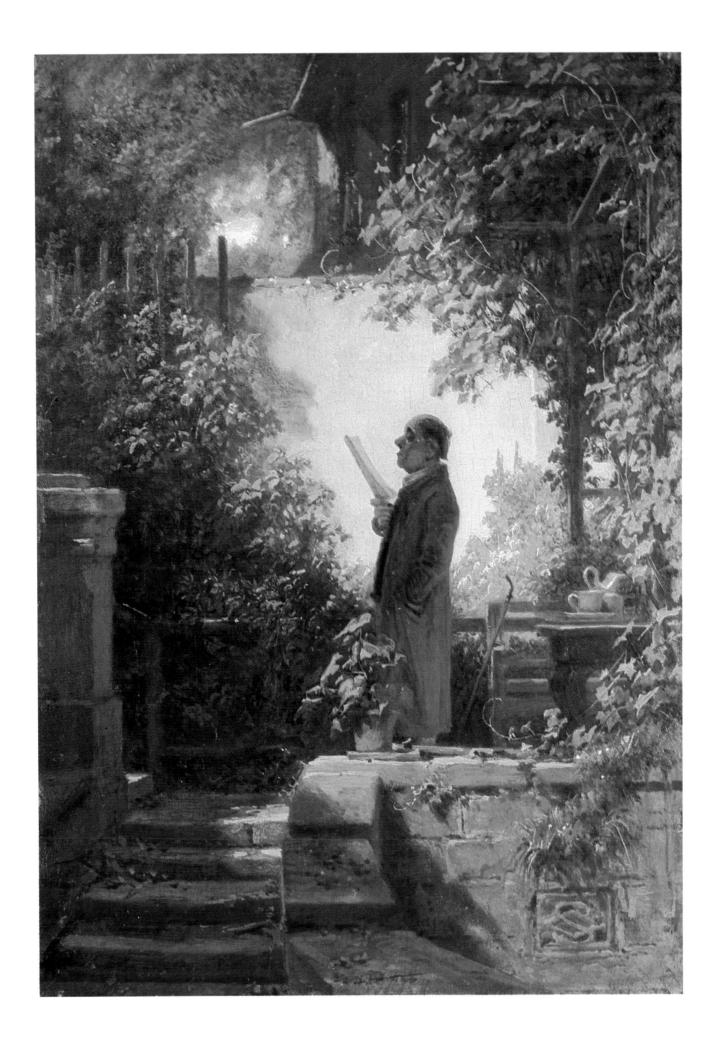

90. Carl Spitzweg

The Sleeping Night Watchman, c. 1875
(Der eingeschlafene Nachtwächter)

Monogrammed (lower right, in rhombus): CS
Oil on cardboard, image 29 x 18.5 cm (11⅜ x 7¼″);
 cardboard 54 x 32 cm (21¼ x 12⅝″)
Kurpfälzisches Museum, Heidelberg

Spitzweg often treated the theme of an isolated figure or figures in the moonlit streets of a town. Within this category the night watchman is one of his most often repeated subjects. These works are a combination of Romanticism and genre painting, in which the latter always predominates. Usually they approach caricature, but unlike the work of Spitzweg's French contemporary Honoré Daumier, his images are not concerned with biting political and social commentary. In the present work, for example, the sleeping figure is neither threatening nor humorous. He seems to have fallen asleep because the town is safe; the security of the town does not depend on the watchman's vigilance. There is no pomp and circumstance here, only a peaceful Bavarian community free of the need for an alert constabulary. Moreover, there is none of the religious or political symbolism associated with Friedrich's paintings of isolated figures in moonlit landscapes. Spitzweg's work is clearly intended for a nonintellectual, bourgeois middle class that could both appreciate and identify with the artist's subjects.

References: Roennefahrt, 1960 [IV], p. 209, no. 722, illus.

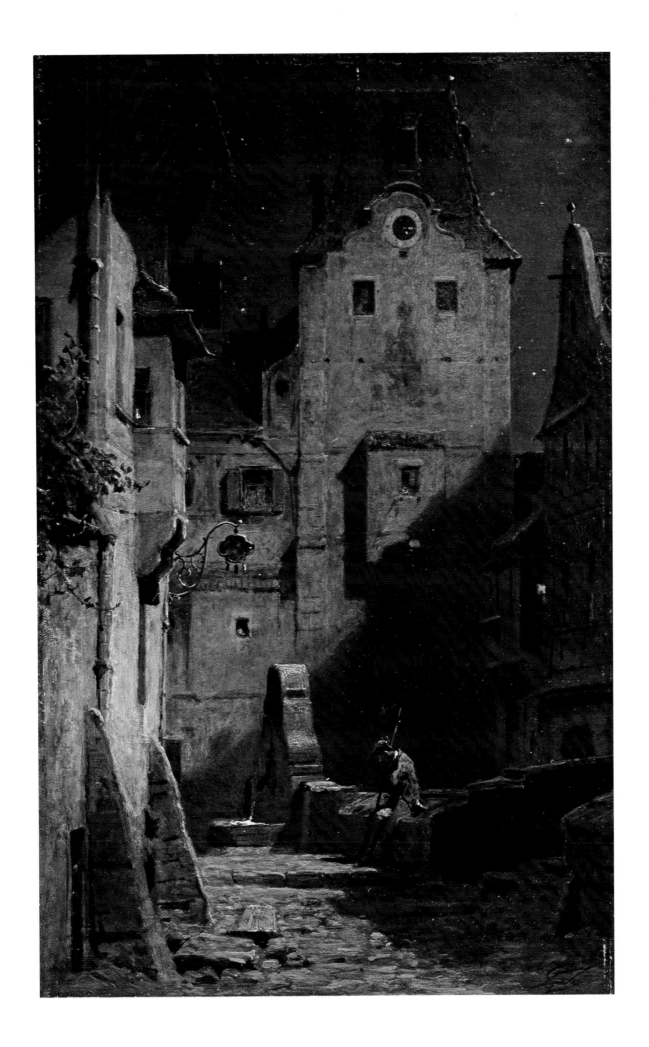

91. Hans Thoma

Bouquet of Wild Flowers, 1872
(Feldblumenstrauss)

Signed and dated (upper right): HThoma 1872
Oil on canvas, 77 x 55 cm (30¼ x 21⅝″)
Nationalgalerie, Staatliche Museen Preussischer Kulturbesitz, Berlin

Between 1868 and 1887 Thoma painted at least twenty-two flower pieces. The paint handling of the present work reflects the influence of Gustave Courbet, whom the artist met in Paris in 1868 and whose flower paintings of 1862–63 he may have become aware of during his stay. In addition, the compositional format and the disposition of objects on the table seem indebted to Henri Fantin-Latour's still lifes with flowers of the mid-sixties.

The picture is a celebration of common, ordinary pleasures: a stoneware jug, a cup of coffee or tea, a glass of water, and wild flowers. Instead of depicting objects associated with wealth and refinement, as would have been done in the seventeenth and eighteenth centuries, Thoma portrays everyday items, objects of popular culture in nineteenth-century Germany. The following passage from Edmond Duranty's "The New Painting: Concerning the Group of Artists Exhibiting at the Durand-Ruel Galleries," an essay published in 1876 about avant-garde painting in Paris, could easily have been written about Thoma and other artists associated with the Leibl circle: "The idea, the first idea, was to take away the partition separating the studio from everyday life. . . . It was necessary to make the painter leave his sky-lighted cell, his cloister where he was in contact with the sky alone, and to bring him out among men, into the world. . . ."

X-ray examination has revealed a self-portrait under this painting. Probably executed 1871–72, it shows Thoma in three-quarter profile facing left.

References: Thode, 1909 [IV], illus. p. 46; Edmond Duranty, cited in Linda Nochlin, ed., *Impressionism and Post-Impressionism, 1874–1904, Sources and Documents,* Sources and Documents in the History of Art, Englewood Cliffs, N. J., 1966, p. 5; Berlin, 1977 [V], pp. 407, illus. p. 408.

92. Hans Thoma

The Rhine near Säckingen, 1873
(Der Rhein bei Säckingen)

Signed and dated (lower right): Hans Thoma 1873
Oil on canvas, 63.5 x 112.5 cm (25⅞ x 45″)
Nationalgalerie, Staatliche Museen Preussischer Kulturbesitz, Berlin

This panoramic landscape is a view across the Rhine toward the village of Nieder-Mumpf, with the Jura Mountains of Switzerland on the horizon. Thoma and his mother spent many summers in nearby Säckingen, and this idyllic scene reflects the tranquillity of those visits. In contrast to his earlier, tighter work, *The Rhine near Laufenberg,* 1870 (Nationalgalerie, Berlin), the overall effect in the present painting is softer and more atmospheric. Thoma appears to have benefited from the example of the French Impressionists. The subject—a field scattered with flowers leading toward a river—is one that Monet often used, but the paint handling is entirely different. The palette-knife technique used in the foreground probably derives from Courbet. The figures in the field lend to the picture an anecdotal quality; indeed, it has been noted that the peasant family in the foreground suggests the scene of the Flight into Egypt. In any case, the painting shares in a northern European tradition of peasants in fields or along roadsides before panoramic landscapes which began in the sixteenth century with Pieter Brueghel the Elder and Joos de Momper and flourished in seventeenth-century Dutch painting in the work of, among others, Jan van Goyen and Philips Koninck.

In 1889 Thoma painted a variation of this composition (Staatliche Kunsthalle, Karlsruhe); in the intervening years he had occasionally painted similar subjects: *Summer Day* (Thode, p. 104), *Cornfield,* 1883 (Thode, p. 203), and *Uphill,* 1886 (Thode, p. 260). *The Rhine near Säckingen* is, however, the first example of this type of picture in Thoma's oeuvre; moreover, it is the most tonally balanced and unified. As such it is reminiscent of the many landscapes that Courbet painted in a primarily green palette; as Champa has suggested (New Haven, 1970), the horizontal format, soft brushwork, and accents of primary color may also reflect the influence of Daubigny.

References: Thode, 1909 [IV], illus. p. 62; New Haven, 1970 [III], p. 143, no. 94, pl. 76; Cologne, 1971 [III], pp. 55–56, no. 94, pl. 40; Berlin, 1977 [V], pp. 407, illus. p. 409.

93. Hans Thoma

Self-Portrait in Munich, 1873
(Selbstbildnis aus München)

Monogrammed and dated (upper left): HTh/1873/München 15. Januar
Oil on canvas, 54.3 x 44.5 cm (21⅜ x 17½")
Städelsches Kunstinstitut und Städtische Galerie, Frankfurt am Main

This confidently rendered Realist painting is the second of seven self-portraits by Thoma and the only one without a landscape background. By presenting himself against a dark ground, in dark clothes, and with a strong sidelight illuminating the three-quarter profile, Thoma seems consciously to adopt a portrait form common to the artists in Munich known as the Leibl circle. Indeed, the inscription in the upper left corner draws attention to the place of execution. Furthermore, the style of the inscription acknowledges indebtedness to earlier German art; the date is rendered in Gothic numerals, and the monogram is executed in a manner that first became popular in the late fifteenth century. Although the composition is reminiscent of a sixteenth-century prototype (e.g., Dürer's *Portrait of Hieronymus Holzschuher,* 1526, Gemäldegalerie, Berlin-Dahlem), the paint handling and portrait style have also been influenced by Courbet, whom Thoma met in Paris in 1868. This self-portrait is an example of the care and control with which Thoma and other members of the Leibl circle drew on both German and non-German (especially French Realist) sources to create a style that was characteristically German as well as in the mainstream of contemporary European modernism.

References: Thode, 1909 [IV], p. 57, illus.; Frankfurt am Main, 1972 [V] (vol. 1), p. 411; (vol. 2), pl. 160; Hamburg, 1978 [III], pp. 440, no. 374, illus.

94. Hans Thoma

In the Forest Meadow (In the Valley Meadow), 1876
(Auf der Waldwiese [Im Wiesengrund])

Monogrammed and dated (lower right): HTh 76.
Oil on canvas, 47.2 x 37.5 cm (18½ x 14¾")
Städelsches Kunstinstitut und Städtische Galerie, Frankfurt am Main

Painted three years after *The Rhine near Säckingen* (no. 92), this work also underscores Thoma's predilection for idyllic landscapes. The model for the woman picking flowers is Thoma's future wife, Bonicella (Cella) Berteneder, whom he married the following year. Because she was herself a flower painter, the gathering of flowers is in all probability of more than passing significance.

In the Forest Meadow is a Realist's interpretation of a subject that would not have been attempted a few years earlier. A woman with her face in shadow and bending at the waist like a field hand would have had little appeal; it is the kind of subject from modern life that had only recently become acceptable. Indeed, the present work might be used as a German example of the kind of painting that Edmond Duranty described in 1876 in his essay "The New Painting: Concerning the Group of Artists Exhibiting at the Durand-Ruel Galleries": "In some of their canvases we can feel the light and the heat vibrate and palpitate. We feel an intoxication of light, which, for painters educated outside of and in opposition to nature, is a thing without merit, without importance, much too bright, too clear, too crude, and too explicit. . . ."

Two other versions of this composition are known. One, also dated 1876, is now in the Hamburger Kunsthalle. The other, dated 1879, appeared at auction in 1912, but its present location is unknown. The composition was also used for an aluminographic print in 1900.

This painting was originally in the collection of Eduard and Elise Kuchler, who befriended Thoma during his first stay in Frankfurt in 1873.

References: Thode, 1909 [IV], illus. p. 63; George Ferguson, *Signs and Symbols in Christian Art*, New York, 1954, p. 55; Edmond Duranty, cited in Linda Nochlin, ed., *Impressionism and Post-Impressionism, 1874–1904, Sources and Documents*, Sources and Documents in the History of Art, Englewood Cliffs, N. J., 1966, pp. 4–5; Frankfurt am Main, 1972 [V] (vol. 1), p. 414, no. SG 910.

95. Hans Thoma

Christ and the Woman of Samaria, 1881
(Christus und die Samariterin)

Mongrammed and dated (lower left): HTh 1881
Oil on canvas, 79 x 107 cm (31⅛ x 42⅛")
Staatliche Kunsthalle, Karlsruhe

As recounted in John 4:3–26, Jesus stops at a well on his way from Judea to Galilee. There he speaks to a Samaritan woman who has come for water. He asks her for water, and she is surprised because, in her words, "The Jews have no dealings with the Samaritans." During the course of their conversation, Christ proclaims to her: "Whosoever drinketh of this water shall thirst again. But whosoever drinketh of the water that I shall give him shall never thirst." In reply to the woman's questions, he reveals his identity as the Messiah. Thoma seems not to have depicted a specific moment during the encounter but rather the event as a whole. He concentrates on the general significance of the scene as one of both revelation and reconciliation, for Christ addresses an individual of a people with whom the Jews traditionally had poor relations.

As his career progressed Thoma turned increasingly to religious and mythological subjects. Concurrently his style became slightly decorative. In this painting, for example, the two naturalistically rendered figures are presented close to the picture plane in nearly symmetrical halves of the composition; trailing branches form a delicately curving arch over their heads. Thoma aims for a monumental effect not unlike that sought by the Nazarenes earlier in the century; compare, for example, Overbeck's *Italy and Germany*, 1811–15–28 (see fig. 4, page 16).

The artist has introduced a personal note by using his wife as model for the woman of Samaria. He later used his own features for the figure of the Pharisee in a similarly composed painting, *Christ and Nicodemus*, 1878 (Städelsches Kunstinstitut und Städtische Galerie, Frankfurt am Main), in which Christ again gestures to his pensive interlocutor, bringing a similar message of Christian rebirth. In 1903 both compositions were published as aluminographic prints.

References: Thode, 1909 [IV], illus. p. 171; Karlsruhe, 1971 [V] (vol. 1), p. 262, no. 2191; (vol. 2), illus. p. 458.

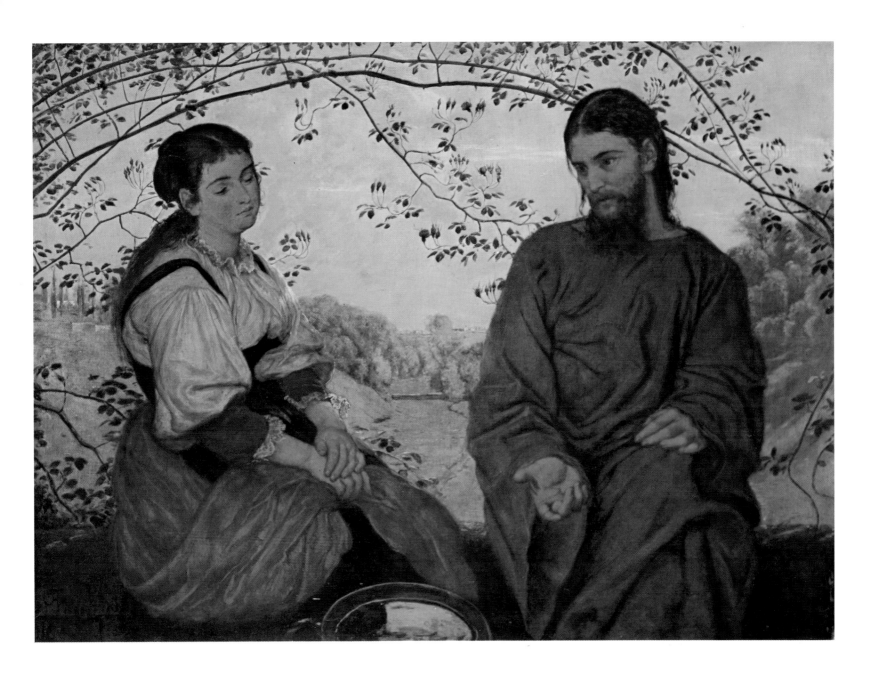

96. Wilhelm Trübner

Portrait of Fräulein von W., 1898
(Bildnis Fräulein von W.)

Signed (upper right): W. Trübner.
Oil on canvas, 64 x 51 cm (25¼ x 20⅛")
Museum Wiesbaden

From 1872 until 1895 Trübner lived in Munich, where he was associated with the group of artists that included Leibl, Thoma, and Schuch. In 1895 he was appointed professor at the Städelsches Kunstinstitut in Frankfurt, where he remained until 1903, when he moved to Karlsruhe. While in Frankfurt he produced numerous portraits of affluent, socially prominent individuals, such as the present painting. Many of these works from the turn of the century have a background of stylized foliage, share the same light palette, and are executed with his characteristic broad brushstroke. Trübner's early style is indebted to that of Gustave Courbet and other Realists—especially the Leibl group—but in *Portrait of Fräulein von W.* we see the strong influence of the so-called German Impressionists. Indeed, after a period of decline in the eighties, it was the example of Max Liebermann that rejuvenated Trübner's work; as Ulrich Finke points out, "Not until Max Liebermann began the new painting in Berlin did Trübner rediscover his own true talent: his palette became brighter, and in his old age he painted radiant landscapes in beautiful colours, fine horse pictures and strong portraits."

References: Karlsruhe, 1951 [IV], no. 92; Wiesbaden, 1967 [V] (unpaginated); Finke, 1974 [I], p. 154.

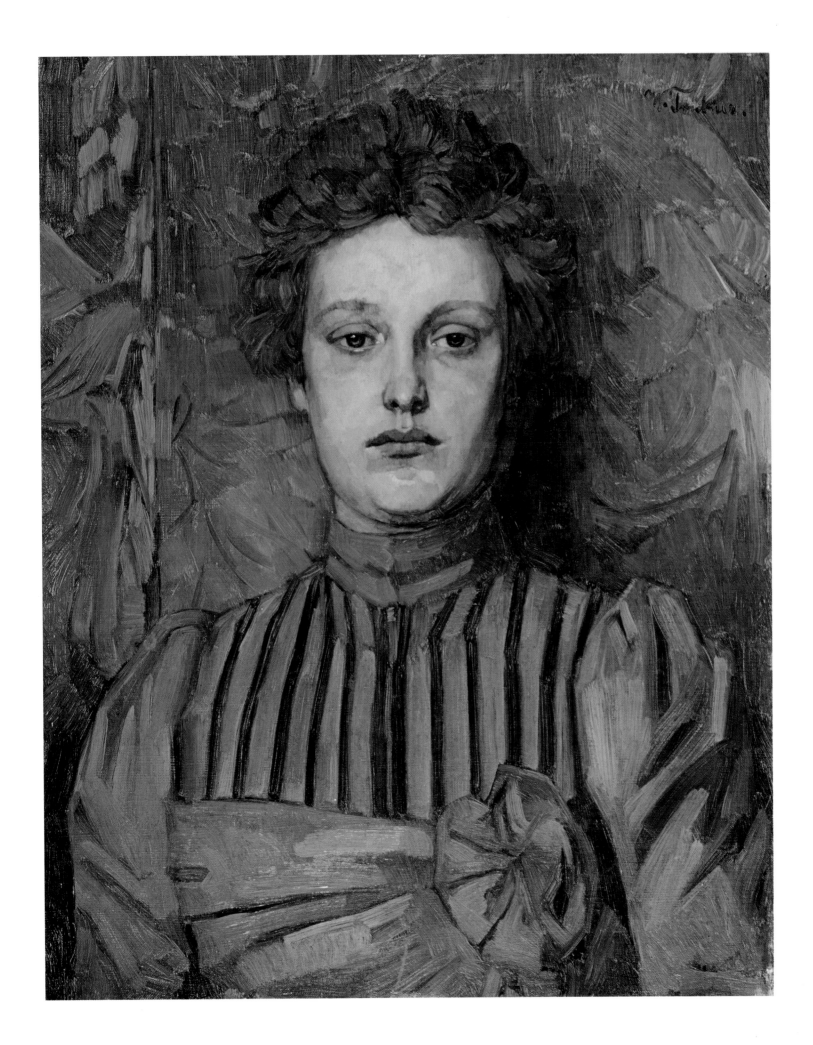

Drawings

d1. Karl Blechen

Sailboats in the Harbor, 1828
(Segelboote im Hafen)

Pencil, 17.2 x 25.7 cm (6¾ x 10⅛″)
Inscribed (upper right): Ans Land ["Toward land"]
Gemäldegalerie der Stiftung Pommern, Kiel

According to Rave this drawing depicts the area around
Ziegenort, north of Stettin, and is one of a series of
sketches, many of them pencil drawings of approximately
the same dimensions, executed during Blechen's trip to the
Ostsee in 1828. With delicate spareness, Blechen describes
the view from the harbor toward the shore: the low line of
the horizon is rhythmically punctuated by the extended ver-
ticals of masts and trees, reflected in the water.

On the reverse is a summary sketch of a beach.

References: Rave, 1940 [IV], p. 245, no. 668, pl. p. 247; Kiel, 1975
[IV; under Friedrich], no. 6; Berlin, 1978 [III], p. 25, no. 20.

d2. Karl Blechen

Stormy Weather in the Roman Campagna, 1829
(Unwetter in der römischen Campagna)

Oil on cardboard, 27.5 x 44.5 cm (10¾ x 17½″)
Nationalgalerie, Staatliche Museen Preussischer
 Kulturbesitz, Berlin (property of the Federal
 Republic of Germany)

This oil sketch belongs to a series of views by Blechen of
aqueducts in the Roman campagna. Most of them are pano-
ramic views emphasizing the longitudinal expanse of land-
scape and architecture. The free execution of transitory
atmospheric effects is typical of Blechen's plein-air
nature studies.

References: Rave, 1940 [IV], see p. 270, nos. 833–37, pls.
pp. 272–73; Berlin, 1977 [V], p. 47.

d3. Karl Blechen

Passage out of the Bodetal, 1833
(Partie aus dem Bodetal)

Pencil and watercolor, 22.7 x 33.3 cm (9 x 13⅛")
Inscribed (upper right): Bode Thal
Gemäldegalerie der Stiftung Pommern, Kiel

Between September 12 and September 22, 1833, Blechen traveled and
sketched in the Bodetal region in the Harz Mountains. Forty-nine oil
sketches, watercolors, and drawings are known from this ten-day period.
Twenty other Harz sketches have approximately the same dimensions,
which suggests that all come from the same sketchbook. The unfinished
portions on the right side of the composition indicate that the present
drawing is an impression rather than a completed work.

 Sketched on the reverse are the head of a man and a rear view of a
figure.

References: Rave, 1940 [IV], p. 454, no. 1852; Kiel, 1975 [IV; under Friedrich],
no. 11; Berlin, 1978 [III], pp. 28–29, no. 25.

d4. Karl Blechen

Lake with Wooded Shores
(See mit waldigen Ufern)

Pencil and watercolor, 10.5 x 16.5 cm (4⅛ x 6½")
Inscribed in pencil (in another hand): Slg Donop
Kupferstichkabinett der Kunstsammlungen Veste Coburg

A narrow lake or inlet is shown here, surrounded by thick
forest. On the far shore a low hill rises in the middle
ground; on the near shore stands a lone figure, sketched in
pencil. No specific date has been suggested for this work.

 On the reverse is a pencil study of a man from the
chest down, with boots and a weapon.

References: Rave, 1940 [IV], p. 500, no. 1985, pl. p. 497; Coburg,
1970 [V], no. 125, pl. 113.

Konrad Eberhard

Pencil, 19.3 x 13.5 cm (7⅝ x 5⅜")
Signed (lower right): P. Cornelius. fec.
Inscribed (by another hand?): C. Eberhart
Staatliche Graphische Sammlung, Munich

According to the precepts of the Schlegel brothers, artists should accept portrait commissions only if, after intense study, they remain drawn to their subject; they should also seek truth and objectivity in their description. As Ulrich Christoffel has observed, this portrait of the Munich painter and sculptor Konrad Eberhard fulfills these Romantic ideals: "In this face with its energetic forehead, soft and sensitive eyes, and supple mouth, one can clearly perceive how close [Eberhard] was to the circle of Nazarene artists. The Nazarene ideal of humanity itself has taken living form in this head."

References: Christoffel, 1920 [II], pp. 25–26.

d6. Peter von Cornelius

The Greeting of the Queens, 1812–17
(Der Königinnen Gruss)

Estate stamp (lower right): P. Cornelius
Inscribed (lower right): R.28/IV
Pen over pencil on brown paper, 48.5 x 69.9 cm (19⅛ x 27½")
Private collection, Munich

Inspired by the evening readings of the *Nibelungenlied* by his friend Christian Schlosser, Cornelius in 1812 began a group of six drawings illustrating scenes from the epic tale. The present example depicts the arrival of Queen Brunhilde in Worms. In the center Queen Kriemhilde greets Brunhilde; their embrace is reminiscent of that of Mary and Elizabeth often used for depictions of the Visitation. Siegfried on his horse in the foreground greets Kriemhilde, while the Burgundian kings Gunther, Giselhêr, and Gêrnot look on from the right. Queen Ute on horseback watches at the far left. The composition is based on a work by Raphael and assistants, *The Repulse of Attila,* 1511–14, in the Vatican.

The present drawing is preliminary to a more finished version in the Städelsches Kunstinstitut, Frankfurt. In 1817 six etchings and a title page based on Cornelius's finished drawings were published by the bookdealer G. A. Reimer in Berlin.

References: Kuhn, 1921 [IV], pp. 90–93, esp. p. 92; Munich, 1958 [III], p. 21, no. 9; Lübeck, 1969 [III], p. 20, no. 10; Frankfurt am Main, 1977 [III], pp. 209–10, nos. E 92, E 93.

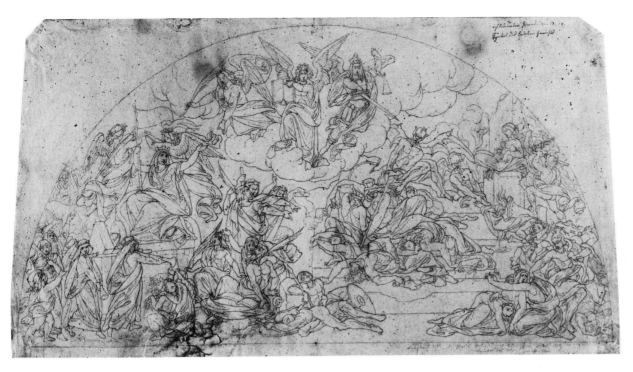

d7. Peter von Cornelius

The Last Judgment, c. 1836
(Das jüngste Gericht)

Pencil, 24.7 x 47 cm (9¾ x 18½")
Inscribed (upper right and lower right)
Hessisches Landesmuseum, Darmstadt

This drawing, together with d8, is related to Cornelius's monumental fresco *The Last Judgment,* 1836–40, in the Ludwigskirche, Munich. In a semicircular field, the angel of judgment presides over the division of the blessed from the damned. An outline drawing with no internal modeling, this work relies on fluidity of contour and the activity of the figures to suggest three-dimensional form.

References: Andrews, 1964 [II], see pp. 122–23, no. 61a; Frankfurt am Main, 1977 [III], p. 273, see also p. 273, no. F 34, pl. p. 293.

d8. Peter von Cornelius

The Last Judgment, c. 1836
(Das jüngste Gericht)

Pen and India ink and pencil on transparent paper, 51.4 x 32.7 cm (21¼ x 12⅞")
Kunsthalle Bremen

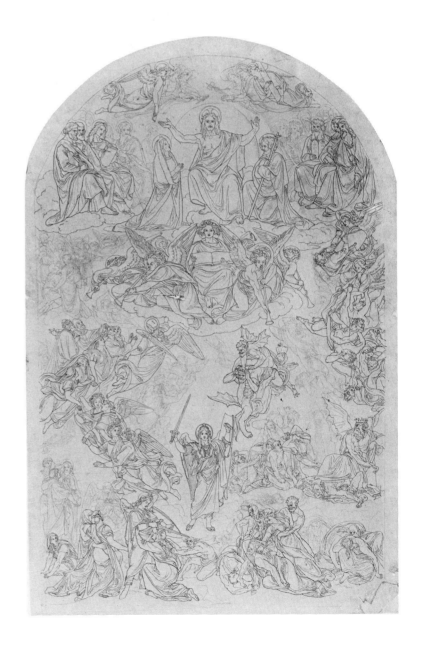

This drawing is nearly identical to Cornelius's fresco *The Last Judgment* in the Ludwigskirche, Munich, which suggests that it was executed later than d7. Although Cornelius was probably influenced by Michelangelo's fresco of the same subject in the Sistine Chapel, Keith Andrews notes that even Cornelius's contemporaries recognized that the painting bears a greater resemblance to earlier works, such as the middle panel of Fra Angelico's mid-fifteenth-century triptych *The Last Judgment, the Ascension, and Pentecost* (Galleria Nazionale d'Arte Antica, Rome). Like those by Fra Angelico and Michelangelo, Cornelius's composition has three horizontal and three vertical divisions.

The cartoon for the fresco is in the Kunstmuseum Basel, and a pen, watercolor, and gouache drawing is in the Städelsches Kunstinstitut, Frankfurt.

As in d7, the forms of this drawing are defined through fluent contours and active figures; spatial recession is here suggested also by a lighter line for background figures. The transparent paper on which the study is drawn and the absence of modeling indicate that it may be a tracing from another drawing.

References: Andrews, 1964 [II], see pp. 122–23, no. 61a; Frankfurt am Main, 1977 [III], p. 273, see also p. 273, no. F 34, pl. p. 293.

d9. Carl Philipp Fohr

Heidelberg Castle with Figural Staffage, 1813–14
(Heidelberger Schloss mit figürlicher Staffage)

Pen and watercolor, 45.1 x 56.6 cm (17¾ x 22¼″)
Hessisches Landesmuseum, Darmstadt

Fohr's native Heidelberg, on the Neckar River, was popular among poets, painters, and students for its picturesque castle ruins and bustling university life. Early in 1814 Fohr presented to his patron, Crown Princess Luise, grand duchess of Hesse, an album of thirty watercolor studies of the Neckar region. The present sketch and a very similar one titled *Heidelberg Castle from the East with White Cow* (Hessisches Landesmuseum, Darmstadt), which shows the castle from slightly farther away with animals in addition to people, probably date from this early period of Fohr's career.

References: Jensen, 1968 [IV], see pp. 15–28; Frankfurt am Main, 1968 [IV], see pp. 6, 18, no. 14; Kurpfälzisches Museum, *Carl Philipp Fohr 1795–1818: Skizzenbuch der Neckargegend, Badisches Skizzenbuch,* Heidelberg, 1968, see pp. 26–38; Darmstadt, 1979 [III], see pp. 286–87, 289.

d10. Carl Philipp Fohr

Gathering of Fohr's Heidelberg Friends as Knights of the Round Table, c. 1816
(Versammlung von Heidelberger Freunden Fohrs als ritterliche Tafelrunde)

Pen and gray ink over pencil on white paper, 17 x 23.1 cm (6¾ x 9″)
Hessisches Landesmuseum, Darmstadt

Between May and October 1816 Fohr returned to his native Heidelberg. He joined a circle of idealistic young students under the leadership of Adolf August Ludwig Follen, who had organized a highly nationalistic literary society and encouraged members to don medieval dress. In this quick pen sketch Fohr depicts the members of the group as Knights of the Round Table: Follen, dressed in armor, stands left of center, while Ludwig Simon and Fohr himself sit in the middle, with Simon leaning against Fohr. The identities of the other figures are disputed.

On the reverse are pencil sketches of two riders.

References: Jensen, 1968 [IV], p. 113, no. 55, pl. p 79, see also pp. 30–45; Frankfurt am Main, 1968 [IV], pp. 45–46, no. 98, pl. 32, see also p. 8; Bernhard, 1974 [II] (vol. 1), p. 298.

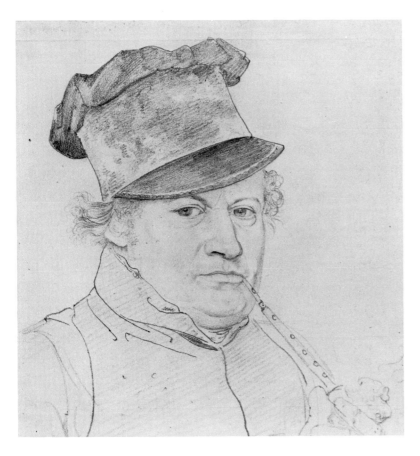

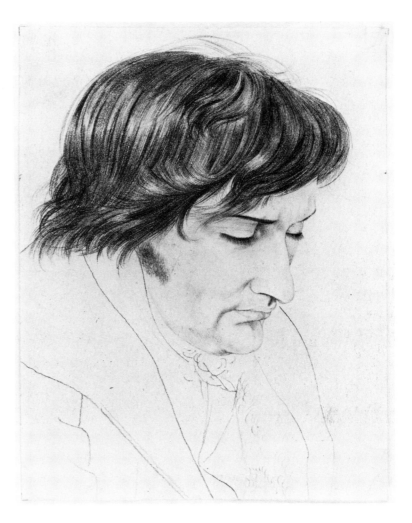

d11. Carl Philipp Fohr

Portrait of Joseph Anton Koch, 1817–18
(Bildnis von Joseph Anton Koch)

Pencil on white paper, 13 x 12.2 cm (5⅛ x 4⅞″)
Kurpfälzisches Museum, Heidelberg

When Fohr arrived in Rome in autumn 1814 he joined a large group of
expatriate German artists, among them Koch and the Nazarenes Over-
beck, Cornelius, Pforr, Veit, Schnorr, and Schadow. In 1817 Fohr be-
gan a series of studies for an engraving of a group portrait of his
friends, many of whom frequented the Caffè Greco near the Spanish
Steps. The project was still unfinished in 1818 when Fohr died at the
age of twenty-three, but three compositional studies (Städelsches Kunst-
institut, Frankfurt am Main) and numerous individual portrait drawings
(most of them in the Kurpfälzisches Museum, Heidelberg) are pre-
served. The portrait drawing of Joseph Anton Koch, whose landscape
compositions had strongly influenced Fohr, is one of his most subtle
and penetrating. This likeness of Koch appears in both the second and
third compositional sketches for the final group work.

On the reverse is a portrait of the painter and art historian Karl
Joseph Ignatius Mosler.

References: Frankfurt am Main, 1968 [IV], pp. 63–64, no. 137, pl. 55, see also
p. 8, pp. 59–77, nos. 127–77; Bernhard, 1974 [II] (vol. 1), p. 312; Darmstadt,
1979 [III], p. 316, no. 52.

d12. Carl Philipp Fohr

Portrait of the Painter Wilhelm von Schadow, 1817–18
(Bildnis des Malers Wilhelm von Schadow)

Pencil on white paper, 13.2 x 10.4 cm (5¼ x 4⅛″)
Kurpfälzisches Museum, Heidelberg

This portrait of the painter Wilhelm von Schadow, like Fohr's drawings
of Koch (d11) and Veit (d13), is a preparatory study for the Caffè Greco
group portrait. Schadow, however, cannot be identified in any of the
compositional sketches for the final work.

References: Frankfurt am Main, 1968 [IV], pp. 69–70, no. 154; Bernhard, 1974
[II] (vol. 2), p. 1583; Paris, 1976 [III], p. 38, no. 45; Darmstadt, 1979 [III],
p. 319, no. 53.

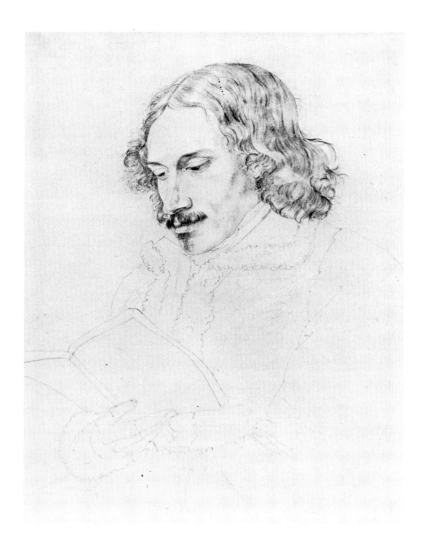

d13. Carl Philipp Fohr

Portrait of the Painter Philipp Veit, c. 1817–18
(Bildnis des Malers Philipp Veit)

Pencil on yellow paper, gilt on upper margin, 20.1 x 16.1 cm (7⅞ x 6¼″)
Kurpfälzisches Museum, Heidelberg

Like the studies of Koch (d11) and Schadow (d12), this one of Philipp
Veit was also intended for the Caffè Greco group portrait. This likeness
of Veit was used in the second and third studies for the final work
(Städelsches Kunstinstitut, Frankfurt am Main).

References: Frankfurt am Main, 1968 [IV], p. 62, no. 132, see also pp. 60–61;
Bernhard, 1974 [II] (vol. 1), p. 309.

d14. Caspar David Friedrich

Catharina Dorothea Sponholz, 1798–1802

Black crayon, 20.9 x 17 cm (8¼ x 6¾″)
Staatsgalerie Stuttgart

Based on family resemblance, the subject of this portrait has been iden-
tified as Catharina Dorothea Sponholz, the eldest sister of the artist.
There are stylistic similarities to other family portraits ascribed to the
late 1790s, although the exact year is disputed (Stiftung Pommern, Kiel;
Stiftung Oskar Reinhart, Winterthur; Collection Alfred Winterstein,
Munich; Nationalgalerie, Berlin). According to Helmut Börsch-Supan
and Karl Wilhelm Jähnig, the emphatic striated patterns in this and other
portraits of the period derive from Friedrich's training at the
Copenhagen Academy.

References: Börsch-Supan and Jähnig, 1973 [IV], p. 260, no. 66, see also
pp. 259–61, nos. 63–68, pp. 287–88, nos. 135–39; Bernhard, 1974 [II] (vol. I),
p. 337; Stuttgart, 1976 [V], p. 51, no. 266.

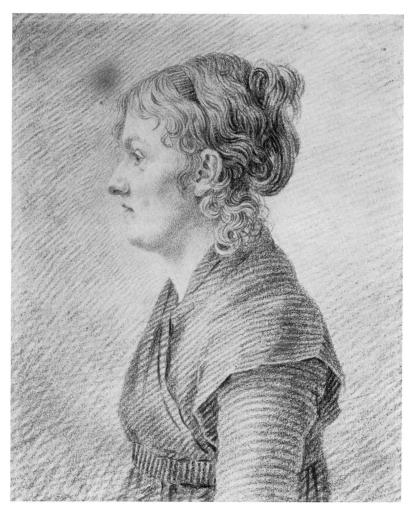

d15. Caspar David Friedrich

Woman Sitting Outdoors (Melancholy), 1801
(Sitzendes Mädchen im Freien [Melancholie])

Pen and ink wash, 18.5 x 12 cm (7¼ x 4¾")
Upper part dated (lower left, on rock): den 29t August 1801
Lower part dated (at left): den 25t September 1801
Städtische Kunsthalle Mannheim

Woman Sitting Outdoors (Melancholy) was once part of the now disassembled
Mannheim Sketchbook. Friedrich made another drawing of the same
model on the same day (Nationalgalerie, East Berlin). The present drawing
is also related thematically to a number of other drawings from the same
period (Georg Schäfer Collection, Schweinfurt, and Kupferstich-Kabinett,
Staatliche Kunstsammlungen Dresden). Börsch-Supan and Jähnig interpret
the dead tree as a symbol of death, the rock on which the woman sits as
faith, and the scythes on the lower part of the page as additional symbols
of death, meant to be read in conjunction with the scene above.

On the reverse is a sketch of another scythe, dated September 30, 1801.

References: Börsch-Supan and Jähnig, 1973 [IV], p. 254, no. 50; see also
pp. 254–55, nos. 51–52; Bernhard, 1974 [II] (vol. I), p. 346.

d16. Caspar David Friedrich

Hut with Bucket Well on Rügen, 1802
(Hütte mit Ziehbrunnen auf Rügen)

Gouache, 12.8 x 19.9 cm (5 x 7⅞")
Hamburger Kunsthalle, Hamburg

This gouache is one of many sketches executed by Friedrich between
May 16 and May 19, 1802, on a trip from Greifswald to Rügen. The land-
scape is that of Mittelrügen, and the peak of Jasmunder Boddens appears
on the horizon. A pen and brown wash drawing of the same subject (Stif-
tung Pommern, Kiel) is squared for transfer. The compositional mode is
apparently indebted to seventeenth-century Dutch examples, notably early
works by Jan van Goyen and Pieter Molijn. There is, however, a forebod-
ing quality in the looming hillside, which results from Friedrich's particular
expressiveness.

References: Cambridge, 1972 [III], see no. 28; Börsch-Supan and Jähnig, 1973 [IV],
p. 66, no. 79; Berlin, 1978 [III], see pp. 62–63, no. 57.

d17. Caspar David Friedrich

Bohemian Landscape, 1828
(Böhmische Landschaft)

Pen and watercolor, 12.7 x 20.5 cm (5 x 8")
Signed (upper left, in margin): Töplitz den 10t [?] May 1828
Gemäldegalerie der Stiftung Pommern, Kiel

In May 1828 Friedrich traveled to Bohemia, where he stayed in the vicinity of Teplitz. *Bohemian Landscape* is one of five known watercolors executed at this time, all of the same size and dated between May 9 and May 16 (Kupferstich-Kabinett, Staatliche Kunstsammlungen Dresden; two in the Nasjonalgalleriet, Oslo; location unknown, formerly Collection Frederick Augustus II).

References: Cambridge, 1972 [III], no. 30; Börsch-Supan and Jähnig, 1973 [IV], p. 50 n. 196; Kiel, 1975 [IV], no. 33; Berlin, 1978 [III], p. 65, no. 59.

d18. Johann Wolfgang von Goethe

Hilly Landscape with River at Sunset, c. 1780
*(Hügelige Landschaft mit Fluss bei
 Sonnenuntergang)*

Signed (lower right): Goethe
Pen and India ink with wash, 21.1 x 34.8 cm (8¼ x 13¾")
Kupferstichkabinett, Staatliche Museen Preussischer
 Kulturbesitz, Berlin

Stylistically the present work is closely related to a landscape drawing titled *Men at the Fire*, 1776 (Goethe-Nationalmuseum, Weimar), whose dimensions are nearly identical. Femmel notes that the motif of a bridge with trees is also used in two drawings of 1797 (Goethe-Nationalmuseum, Weimar) that were influenced by Claude Lorrain's etching *Departure for the Fields*, 1635–36. Although he remarks that Goethe "obviously knew Claude's works very early," there is no evidence that Goethe was familiar with Claude's work as early as 1780.

References: Gerhard Femmel, ed., *Corpus der Goethezeich-nungen,* Leipzig, 1971 (vol. 6B), p. 21, no. 42.

d19. Johann Wolfgang von Goethe

River Landscape on the Saale, 1806
(Flusslandschaft an der Saale)

Inscribed (lower left, by Johanna Schopenhauer): Goethe
Inscribed on reverse (see below)
Pen, brush and ink on gray paper, 27.8 x 33 cm (11 x 13″)
Kupferstichkabinett, Kunstsammlungen der Veste Coburg

This work belongs to a group of drawings of sites in the Saale valley below the Dornburg castles near Weimar. Several are dated 1806, and on the basis of stylistic similarities the present example has been given the same date. An inscription on the reverse records the origin of the drawing: "Drawn by Goethe at one of the evening gatherings of Frau Johanna Schopenhauer, where a table always stood for him to draw on. Probably executed in 1807. The name 'Goethe' on the drawing was written by Privy Councilor [Johanna] Schopenhauer, who carefully preserved the sketch. Jena 3/11 48 OLB Wolff."

References: Coburg, 1970 [V], pp. 60–61, no. 129, pl. 110; Gerhard Femmel, ed., *Corpus der Goethezeichnungen*, Leipzig, 1971 (vol. 6B), p. 43, no. 114.

d20. Johann Wolfgang von Goethe

River Landscape with Setting Sun (Fantasy Landscape),
 c. 1810
(Flusslandschaft mit untergehender Sonne [Phantasie-
 Landschaft])

Signed (lower right, by the artist, at a later date): Goethe
Pen and India ink over red chalk, 23.8 x 29.6 cm (9⅜ x 11⅝″)
Kupferstichkabinett, Staatliche Museen Preussischer
 Kulturbesitz, Berlin

This drawing is apparently a recollection of a site that Goethe saw while traveling in southern Italy and Sicily, 1786–88. The execution seems to have been influenced by the drawings of Kobell, a sketchbook of whose work Goethe owned. The composition reflects a strong awareness of the landscapes of Claude Lorrain. The date, c. 1810, has been ascribed to the present work on the basis of its similarity to a cursory sketch, *Temple Beside the Sea,* 1810 (Goethe-Nationalmuseum, Weimar).

References: Munich, 1956 [III], pp. 57-58, no. 149; Gerhard Femmel, ed., *Corpus der Goethezeichnungen*, Leipzig, 1971 (vol. 6B), p. 45, no. 122.

d21. Joseph Anton Koch

Swiss Mountain Landscape, 1792–94
(Schweizer Gebirgslandschaft)

Pen and watercolor, 31.2 x 45 cm (11⅞ x 17¾")
Städtische Kunsthalle Mannheim

Executed during Koch's first travels through Switzerland, this drawing depicts an alpine pasture at the foot of the Jungfrau and Silberhorn peaks. Despite its early date the sketch exhibits numerous similarities to Koch's mature landscapes: a high vantage point, a finite space created not by orthogonal recession but by a progression of horizontal planes parallel to the picture surface, and small, incidental *staffage*—in this case, a painter, two shepherds, and alpine cows and sheep.

References: Lutterotti, 1940 [IV], pp. 268–69, no. 542, pl. 104; Munich, 1956 [III], p. 59, no. 154; Bernhard, 1974 [II] (vol. I), p. 759.

d22. Joseph Anton Koch

Landscape with Hercules at the Crossroads, 1805–10
(Landschaft mit Hercules am Scheidewege)

Pen and watercolor, highlighted with white, 27.5 x 41.7 cm
 (10⅞ x 16⅜")
Signed (lower left): Coch Tyrolese
Museum Folkwang, Essen

While the young Hercules was meditating in solitude about his future, two women appeared before him, one personifying Pleasure, the other Virtue. This drawing shows Hercules seated in the foreground, literally and figuratively at the crossroads; at his left the nude Pleasure appeals seductively, while a more aloof, gowned Virtue beckons at the right. The general disposition of the figures, their asymmetrical placement at the left, and the recession back toward the right suggest that the present drawing is related to and possibly derived from a 1797 rendition of the same subject (Staatsgalerie Stuttgart).

References: Lutterotti, 1940 [IV], p. 251, no. 243, pl. 126; Bernhard, 1974 [II] (vol. 1), p. 784, see also p. 763.

d23. Joseph Anton Koch

San Stefano Rotondo in Rome, c. 1810
(San Stefano Rotondo in Rom)

Pen and sepia over pencil, 15 x 21.1 cm (5⅞ x 8¼″)
Freies Deutsches Hochstift, Frankfurter Goethemuseum,
 Frankfurt am Main

This simplified line drawing is a preparatory study for one
of twenty engraved *Roman Views* executed by Koch in 1810.

References: Darmstadt, 1977 [III], no. 44.

d24. Joseph Anton Koch

Landscape near Civitella with Hunter, c. 1820
(Landschaft bei Civitella mit Jäger)

Pencil, 22.9 x 35.6 cm (9 x 14″)
Wallraf-Richartz-Museum, Cologne

Koch often spent his summers in the Sabine Mountains near
Rome, in the vicinity of the villages of Civitella, Subiaco,
and Olevano. He frequently depicted local views, as in
Waterfall near Subiaco, 1813 (no. 38). In this drawing Koch
portrays the small mountaintop village of Civitella from the
oak grove of Serpentara. Despite a technique limited princi-
pally to line, the artist creates the impression of the remote-
ness of the village through a diminution of detail and a
lightening of touch.

References: Lutterotti, 1940 [IV], p. 263, no. 429; Darmstadt, 1977
[III], no. 82.

d25. Ferdinand Olivier

Hohensalzburg Citadel, c. 1818
(Die Festung Hohensalzburg)

Pencil heightened with white, 17.4 x 26.6 cm (6⅞ x 10½")
Monogrammed (lower left): FO
Private collection, Munich

Hohensalzburg Citadel is related to Olivier's series of lithographs *Seven Views of Salzburg and Berchtesgaden,* 1818–22 (see d26). The present drawing was presumably executed during either the 1815 or the 1817 trip to the Salzburg region. Together with a related drawing in Munich (Staatliche Graphische Sammlung), it is a preparatory study for the lithograph *Tuesday.* In the lithograph the citadel is depicted from a vantage point farther to the right, and figures and animals have been added.

References: Grote, 1938 [IV], p. 236, pl. 144; see also pp. 212–36; Munich, 1958. Staatliche Graphische Sammlung [III], p. 43, no. 113, pl. 21; Lübeck, 1969 [III], p. 63, no. 112; Bernhard, 1974 [II] (vol. 1), p. 995; Frankfurt am Main, 1977 [III], see pp. 194–95, nos. E 25, E 25d, pl. p. 225.

d26. Ferdinand Olivier

Wednesday (Footpath on the Mönchsberg near Salzburg).
 From the series *Seven Views of Salzburg and Berchtesgaden,* 1818–22
(Mittwoch [Fusspfad auf dem Mönchsberge bey Salzburg].
 Aus der Folge *Sieben Gegenden aus Salzburg und Berchtesgaden)*

Lithograph, 19.9 x 27.4 cm (7⅞ x 10¾")
Kupferstichkabinett, Staatliche Museen Preussischer Kulturbesitz, Berlin

Olivier traveled to Salzburg in 1815 and 1817; many of the drawings he made on these trips (including *Hohensalzburg Citadel,* c. 1818, d25) served as the basis for later works. The series *Seven Views of Salzburg and Berchtesgaden* is based on drawings from the second trip. The lithographs were made between 1818 and 1822, and the cycle was published in 1823 by Kunke in Vienna.

In these works, nature is made the vehicle of Christian iconography. *Wednesday,* which represents the virtue of charity, depicts the meeting of a clergyman with a blind beggar and his young companion. In the drawing for this work (Germanisches Nationalmuseum, Nürnberg), the landscape background is essentially the same. There are, however, two figures rather than three; as is suggested in the Frankfurt catalogue (1977), they probably represent St. Martin and the Beggar.

References: *Olivier Gedachtnis—Ausstellung,* Dessau, 1930, p. 33, nos. 246, 250; Grote, 1938 [IV], pp. 212–36; Frankfurt am Main, 1977 [III], pp. 194–95, nos. E 25, E 25e, pls. p. 225; see also p. 64, no. B 19, pl. p. 78, pp. 195–96, no. E 26, pl. p. 226.

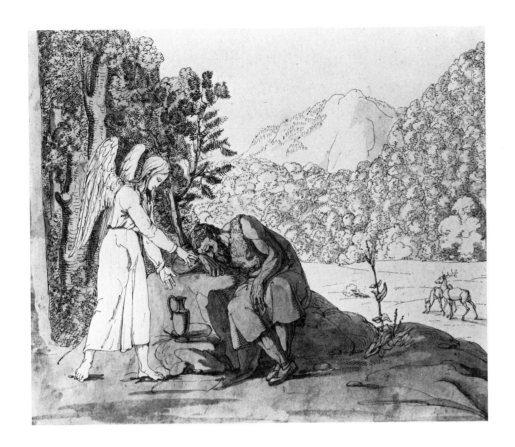

d27. Johann Friedrich Overbeck

Elijah with the Angel Under the Juniper Bush, c, 1810
(Elias mit dem Engel unter dem Ginsterstrauch)

Pen and ink wash on paper, 24.8 x 30 cm (9¾ x 11¾")
Nationalgalerie, Staatliche Museen Preussischer Kulturbesitz, Berlin

This drawing illustrates 1 Kings 19:5, in which the angel
appears in the wilderness before the Prophet Elijah: "And as
he lay and slept under a juniper tree, behold, then an angel
touched him, and said unto him 'Arise and eat.'" On the
basis of an old inscription, this work was formerly attri-
buted to Overbeck's fellow Nazarene, Franz Pforr. William
J. Hennessey, however, places it with Overbeck's numerous
treatments of related themes, the closest of which is a draw-
ing, c. 1807, of the same subject (Museen für Kunst und
Kulturgeschichte, Lübeck). In the present work, dating
from the year of Overbeck's arrival in Rome, the figures,
fully integrated into the landscape, replace the bolder,
Michelangelesque examples in the earlier work.

References: Bernhard, 1974 [II] (vol. 2), p. 1124 (attributed to Franz
Pforr); William J. Hennessey, "Friedrich Overbeck's Drawing of
Elijah Casting His Mantle over Elisha," *The Register of the Museum
of Art, The University of Kansas, Lawrence,* vol. 5, no. 4, Spring
1977, pp. 36–49.

d28. Johann Friedrich Overbeck

Abraham and the Three Angels, 1822–24
(Abraham und die drei Engel)

Pen and wash over pencil, 56.5 x 67 cm (22¼ x 26⅜")
Museum für Kunst und Kulturgeschichte, Lübeck

This highly finished drawing depicts the story of the three
angels who appear before Abraham disguised as men. Un-
suspecting, Abraham kneels, and with his wife, Sarah, gra-
ciously offers them hospitality and food (Gen. 18:1–22).
Jens Christian Jensen dates this drawing by comparing it
stylistically to a cartoon of the early 1820s (Kunstmuseum
Basel) for the *Finding of Moses* (Kunsthalle Bremen).

References: Jensen, 1969 [IV], p. 32, no. 128, pl. p. 41; Bernhard,
1974 [II] (vol. 2), p. 1098.

d29. Johann Friedrich Overbeck

The Miracle of the Prophet Elisha, c. 1827
(Das Wunder des Propheten Elisäus)

Black chalk on paper, 25.8 x 29.2 cm (10⅛ x 11½″)
Monogrammed in pencil (lower right): FO
Private collection, Munich

Like *Elijah with the Angel Under the Juniper Bush,* c. 1810 (d27), this draw-
ing represents a scene from the life of an Old Testament Prophet. Elisha
astounds his followers by making an ax head, which has fallen into the

river Jordan, float to the water's surface (2 Kings 6:1–7). William J. Hen-
nessey relates the present drawing thematically to the 1810 work, as well as
thematically and stylistically to two more clearly contemporaneous draw-
ings, *The Prophet Elijah Casting His Mantle over Elisha,* 1835 (Museum of
Art of the University of Kansas, Lawrence), and *The Ascension of Elijah in
the Fiery Chariot,* 1827 (Kestner-Museum, Hannover).

References: Howitt, 1886 [IV] (vol. 2), p. 411; Lübeck, 1969 [III], p. 66, no. 121, pl.
p. 67; Bernhard, 1974 [II] (vol. 2), p. 1102; William J. Hennessey, "Friedrich Over-
beck's Drawing of Elijah Casting His Mantle over Elisha," *The Register of the
Museum of Art, The University of Kansas, Lawrence,* vol. 5, no. 4, Spring 1977,
pp. 36–49.

d30. Johann Friedrich Overbeck

The Twelve-Year-Old Jesus in the Temple, 1830
(Der zwölfjährige Jesus im Tempel)

Pencil on yellow paper, 34.3 x 35.2 cm (13½ x 13⅞")
Monogrammed and dated (at right): FO/1830
Museum für Kunst und Kulturgeschichte, Lübeck

According to Luke 2:41–50 the twelve-year-old Jesus went to Jerusalem with his parents for the festival of Passover. He was missing for three days, until found in the temple, engaged in a dialogue with the doctors. This drawing depicts Jesus surrounded by the doctors, who are "astonished at his understanding and answers."

 Overbeck illustrated this subject many times; the present work is closely related to a large pencil drawing in the Kunstmuseum Basel. On the basis of its more fluid style, Jens Christian Jensen hypothesizes that the present work is a later version of the Basel drawing, rather than a preparatory study for it.

References: Jensen, 1969 [IV], p. 35, no. 134, see also p. 36, no. 139, p. 65, no. 236; Bernhard, 1974 [II] (vol. 2), p. 1103.

d31. Johann Friedrich Overbeck

The Apostles Thomas and Philip, 1835–44
(Die Apostel Thomas und Philippus)

Chalk, 63 x 51.5 cm (24¾ x 20¼")
Inscribed (at bottom, center, in another hand): Disegni Originali del Sig. Overbeck
Museum für Kunst und Kulturgeschichte, Lübeck

Between 1835 and 1844 Overbeck was commissioned by Don Carlo Torlonia to execute chalk drawings of the twelve Apostles—among them Thomas and Philip—and the four Evangelists. These works then served as models for Maximilian Seitz's Small Frescoes, 1848, in the Villa Torlonia in Castel Gandolfo.

References: Howitt, 1886 [IV] (vol. 2), p. 423; Jensen, 1969 [IV], p. 39, no. 144, pl. p. 50, see also pp. 38–39, no. 143.

d32. Johann Friedrich Overbeck

Self-Portrait, 1843–44
(Selbstbildnis)

Brown chalk on paper, 33.9 x 28 cm (13⅜ x 11″)
Museum für Kunst und Kulturgeschichte, Lübeck

According to the Frankfurt catalogue (1977) this self-portrait is of Over-
beck at the age of about fifty-four and is a preparatory study for a painting,
also dated 1843–44, in the Uffizi, Florence. The indentation that traces
the outlines of the composition was presumably made after the completion
of the drawing, for transfer from paper to canvas. Jens Christian Jensen
(1963), however, contends that this work is a copy of a lost preparatory
study for the painting, and that the indentation was used to transfer the
lost drawing to the present page.

References: Howitt, 1886 [IV] (vol. 2), see pp. 147–48; Jensen, 1963 [IV], pp.
42–43, no. 16, pl. 17 p. 27; idem, 1969 [IV], p. 42, no. 152; Paris, 1976 [III], p. 146,
no. 168, illus. p. 168; Frankfurt am Main, 1977 [III], pp. 192–93, no. E 20.

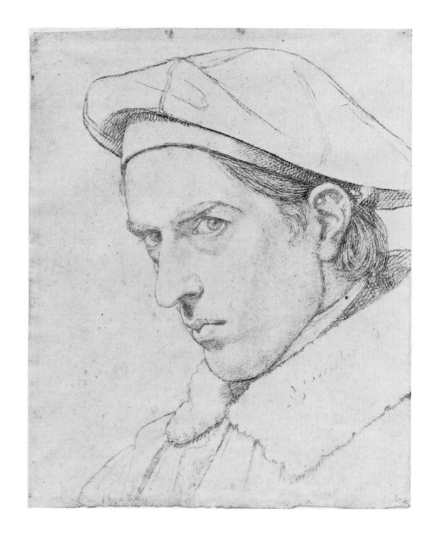

d33. Johann Friedrich Overbeck

The Healing of the Lame Man, 1868
(Die Heilung des Lahmen)

Pencil, 31.7 x 42 cm (12½ x 16½″)
Monogrammed and dated (lower left): FO Roma.
 1868
Hamburger Kunsthalle, Hamburg

Overbeck's later works were devoted
exclusively to religious subjects. In this late
drawing Overbeck depicts Christ as he heals the
lame man (Matt. 9:1–8): "Arise, take up thy
bed, and go unto thine house." In theme, full-
ness of form, and unification of composition
through gesture, this is a typical Nazarene
work, with characteristic allusions to Raphael,
Michelangelo, and other High Renaissance
artists.

References: Frankfurt am Main, 1977 [III], p. 202, no.
E 54, pl. p. 238.

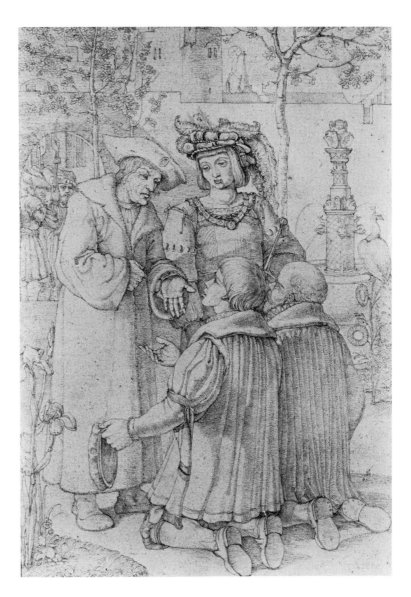

d34. Franz Pforr

Adelheid and Weislingen, 1811
(Adelheid und Weislingen)

Pencil, 21.3 x 15.3 cm (8⅜ x 6″)
Städelsches Kunstinstitut und Städtische Galerie, Frankfurt am Main
 (on loan from the Frankfurter Künstler-Gesellschaft)

In 1810, when he was still living in Vienna, Pforr began a cycle of drawings for illustrations to Goethe's drama *Götz von Berlichingen,* which recounts the adventures of Götz, a sixteenth-century knight whose conduct is based on a philosophy of individual freedom. In this scene from the second act, Götz's friend Weislingen is rebuffed by Adelheid, who resides at the court of the bishop of Bamberg.

Although the *Götz* project was never completed, Pforr reworked most of the scenes several times. The present drawing, together with *The Nürnberg Merchants Before Emperor Maximilian* (d35), is one of four more finished versions executed by Pforr in Rome in 1811, which are based on the Viennese drawings of 1810 (Nationalgalerie, Berlin). A fifth drawing is now lost. In their elegant linearity, attention to detail, and delicate, hatched modeling, these drawings reflect the graphic techniques of Dürer. Sixteenth-century German art is alluded to in the present work by the costumes and by the portraits of emperors on the back wall, which recall examples by Dürer.

References: Lehr, 1924 [IV], p. 349, no. 124, pl. 33, see also pp. 135–53, 328–30; Bernhard, 1974 [II] (vol. 2), p. 1141; Paris, 1976 [III], pp. 148–49, no. 170, pl. p. 148; Frankfurt am Main, 1977 [III], pp. 207–8, no. E 82.

d35. Franz Pforr

The Nürnberg Merchants Before Emperor Maximilian, 1811
(Die Nürnberger Kaufleute vor Kaiser Maximilian)

Pencil, 21.3 x 15.3 cm (8⅜ x 6″)
Städelsches Kunstinstitut und Städtische Galerie, Frankfurt am Main
 (on loan from the Frankfurter Künstler-Gesellschaft)

Like *Adelheid and Weislingen,* 1811 (d34), this is a preparatory drawing for Pforr's illustrations to Goethe's drama *Götz von Berlichingen* and is a more finished version of an earlier representation of the same subject. This scene from the beginning of the third act depicts two Nürnberg merchants appealing to Emperor Maximilian for help to counter Götz, who has robbed thirty of their fellow merchants. As Hanna Hohl has noted (Paris, 1976), Pforr's likeness of Emperor Maximilian is based upon Dürer's woodcut portraits of him.

References: Lehr, 1924 [IV], p. 350, no. 126, pl. 37, see also pp. 135–53, 328–30; Bernhard, 1974 [II] (vol. 2), p. 1143; Frankfurt am Main, 1977 [III], p. 208, no. E 83, see also pp. 207–8; Paris, 1976 [III], p. 149, no. 171, pl. p. 148.

d36. Philipp Otto Runge

Portrait of the Artist's Brother Karl Hermann Runge, 1801(?)
(Bildnis des Bruders Karl Hermann Runge)

Black and white chalk on brown paper, 52.5 x 39.3 cm (20⅝ x 15½")
Gemäldegalerie der Stiftung Pommern, Kiel

The identification of this figure as Runge's brother Karl Hermann is
based on family tradition. Traeger dates this drawing 1801, based
on stylistic similarities with other portrait drawings executed during
Runge's visit to his family that year. Karl was two years younger
than the artist, and the emotional bond between them was strong. In
another drawing, *Return of the Sons,* 1800 (Hamburger Kunsthalle),
Runge warmly embraces Karl. A less formal sketch of Karl dates
from approximately the same period (Georg Schäfer Collection,
Schweinfurt).

References: Kiel, 1975 [IV; under Friedrich], no. 54; Traeger, 1975 [IV],
p. 307, no. 188, see also p. 307, no. 189; Hamburg, 1977 [IV], p. 223,
no. 210, see also p. 224, no. 211; Berlin, 1978 [III], p. 46, no. 43.

d37. Philipp Otto Runge

Four Times of Day, 1803
(Vier Tageszeiten)

1st state
Copperplate engravings, each 71 x 48 cm (28 x 18⅞")
Museum für Kunst und Gewerbe, Hamburg

The drawings for this group of engravings were begun in 1802–3. The de-
signs were originally conceived as wall decorations. The numerous prepar-
atory drawings for the four plates include preliminary sketches, *Konstruk-
tionszeichnungen* (construction drawings), and drawings made specifically
for transfer to the copper plates (Hamburger Kunsthalle, and Stiftung
Oskar Reinhart, Winterthur).

 The first edition of *Four Times of Day* was published in 1803–5 by the
Dresden printers Darnstedt, Krüger, and Seyfert. In 1807, at the request
of the Weimarer Kunstfreunde, Runge published a second edition with
Perthes of Hamburg. The elegant linear style of these prints and of related
studies reflects the influence of John Flaxman's outline drawings, Dürer's
marginal designs for the prayer book of Emperor Maximilian I, and
Raphael's *grottesche* in the Vatican Logge.

References: Bernhard, 1974 [II] (vol. 2), see pp. 1527–31; Traeger, 1975 [IV], pp.
356–61, nos. 280–83, see also pp. 343–56, nos. 265–79; Hamburg, 1977 [IV],
pp. 200–3, nos. 169–72, see also pp. 188–92, 192–202, nos. 160–68.

Morning

Midday

Evening

Night

d38. Philipp Otto Runge

The Christ Child, 1805
(Das Jesuskind)

Pen over pencil, 21.3 x 27.9 cm (8⅜ x 11″)
Hamburger Kunsthalle, Hamburg

One of the preparatory studies for the painting *Rest on the Flight into Egypt,* 1805–6 (no. 71), this drawing was presumably among those submitted by Runge to the Greifswald competition for the Marienkirche altar painting, for which Runge executed numerous other studies (Hamburger Kunsthalle). In these, as well as in the finished work, the pose of the Christ Child is the same; in this drawing, however, he holds a bouquet of flowers.

On the reverse is a red chalk and pencil study for Joseph's legs.

References: Traeger, 1975 [IV], p. 383, no. 317, see also pp. 382–86, nos. 316–22; Hamburg, 1977 [IV], p. 178, no. 146, see also pp. 174–78, pp. 178–81, nos. 145–51.

d39. Philipp Otto Runge

Study for the Upper Part of *Morning (Small Version),* 1808
(Entwurf zum oberen Teil des *Morgens* [*der kleine Morgen*])

Pen over pencil, with tracing holes, 73.2 x 55 cm (28⅞ x 21⅝″)
Signed (by Daniel Runge?) on reverse: Original von Philipp Otto Runge 1808
Gemäldegalerie der Stiftung Pommern, Kiel

After publishing *Four Times of Day* (d37) Runge began to rework the designs as paintings. In 1808 he executed *Morning (Small Version)* (Hamburger Kunsthalle), the only one of the four in the series to be completed; the following year he finished *Morning (Large Version)* (no. 73). The present drawing is the cartoon for the upper part of *Morning (Small Version)*; no cartoon for the lower part now exists, but there are studies for individual figures and groups of figures (Hamburger Kunsthalle) as well as a finished drawing for the work as a whole (Nationalgalerie, East Berlin).

References: Cambridge, 1972 [III], no. 77; Kiel, 1975 [IV; under Friedrich], no. 57; Traeger, 1975 [IV], pp. 432–33, no. 411, see also pp. 417–33, nos. 382–414; Hamburg, 1977 [IV], p. 212, no. 188, see also pp. 204–6, pp. 207–19, nos. 175–203; Berlin, 1978 [III], pp. 46–48, no. 44.

d40. Philipp Otto Runge

Genie on the Amaryllis at the Left, 1809
(Der linke Genius auf der Amaryllisblüte)

Black pen over traces of pencil, 61.6 x 18.2 cm (24¼ x 7⅛″)
Dated (by Daniel Runge?) on reverse: 1809
Hamburger Kunsthalle, Hamburg

This drawing and another of its near-mirror image are studies for the
frame ornamentation of *Morning (Large Version),* 1809 (no. 73).

Traeger, 1975 [IV], p. 469, no. 501, see also pp. 466–72, nos. 497–506;
Hamburg, 1977 [IV], p. 219, no. 201, see also pp. 213–19, nos. 190–203.

d41. Philipp Otto Runge

The Two Rose-Bearing Genii and the Child, 1809
(Die beiden vorderen Rosengenien und das Kind)

Black pen over pencil, gray and black brush, 51.4 x 110 cm (20¼ x 43⅜″).
Hamburger Kunsthalle, Hamburg

This drawing of genii bearing roses to the child is one of the last
preparatory designs for the lower part of *Morning (Large Version)*, 1809
(no. 73).

References: Bernhard, 1974 [II] (vol. 2), p. 1543; Traeger, 1975 [IV], pp. 457–58,
no. 478, see also pp. 466–72, nos. 497–506; Hamburg, 1977 [IV], p. 215, no.
193, see also pp. 213–19, nos. 190–203.

d42. Julius Schnorr von Carolsfeld

Knight in the Ruins, 1819
(Der Ritter in der Ruine)

Pen and brown ink, 19.1 x 26.4 cm (7½ x 10⅜")
Monogrammed and dated (lower right): 18 JS 19/d. 14. Dec.
Wallraf-Richartz-Museum, Cologne

Together with *Meeting on the Terrace,* 1819 (d43), this draw-
ing is one of seventeen executed in Rome by Schnorr
during the winter of 1819–20, at the home of Clara Bianca
and Johann Gottlob von Quandt. Although the drawings
appear initially to be illustrations for a text, Quandt in fact
composed stories for the drawings. These prose sketches
are now lost. Schnorr wrote to his father that these works
were inspired by his long walks with Quandt through
Rome, when, paradoxically, they felt a spiritual affinity for
medieval times.

References: Cologne, 1967 [V], see p. 102; Cologne, 1972 [III], no.
33, see also no. 32; Bernhard, 1974 [II] (vol. 2), pp. 1697, 1698,
1702, 1706; Paris, 1976 [III], pp. 205–6, no. 233, illus. p. 206, see
also pp. 206–7, nos. 234–36; Darmstadt, 1977 [III], no. 57.

d43. Julius Schnorr von Carolsfeld

Meeting on the Terrace, 1819
(Begegnung auf der Terrasse)

Pen and brown ink, 19.2 x 26.2 cm (7½ x 10⅜")
Monogrammed and dated (lower right): 18 JS 19/d. 23. Dec.
Staatliche Graphische Sammlung, Munich

Like *Knight in the Ruins,* 1819 (d42), this drawing is one of
seventeen executed by Schnorr for the Quandts during the
winter of 1819–20. Again, the figures are dressed in medie-
val costume and appear to be engaged in leisurely, courtly
activity.

References: Cologne, 1967 [V], see p. 102; Cologne, 1972 [III], see
nos. 32, 33; Bernhard, 1974 [II] (vol. 2), pp. 1697, 1698, 1702,
1706; Paris, 1976 [III], pp. 205–7, nos. 233–36.

d44. Julius Schnorr von Carolsfeld

Frau von Quandt, 1820

Pen and brown ink over pencil with wash, 37.3 x 25.5 cm (14⅝ x 10″)
Städtische Galerie im Lenbachhaus, Munich

This drawing is the last preparatory study for an unfinished oil portrait
of Clara Bianca von Quandt, 1820 (Nationalgalerie, Berlin), for which
there are also two earlier pen and watercolor studies (Kupferstichkabi-
nett und Sammlungen der Zeichnungen, East Berlin). Like *Mary with the
Christ Child*, 1820 (no. 78), a thinly disguised portrait of Frau von
Quandt, the oil portrait was commissioned in 1819, soon after the re-
cently married von Quandts arrived in Rome. As the Frankfurt cata-
logue (1977) notes, Frau von Quandt's pose, coiffure, and costume are
similar to those of Joanna of Aragon in her school-of-Raphael portrait in
the Louvre, of which there is a version in the Palazzo Doria Pamphili,
Rome. Schnorr, however, has added the view through the arched win-
dows of the hilly landscape and the mandolin, in keeping with his vision
of the subject as a lady of a medieval court.

References: Bernhard, 1974 [II] (vol. 2), see p. 1705; Berlin, 1977 [V], see pp.
366–68, pl. p. 367; Frankfurt am Main, 1977 [III], p. 161, no. D 26, pl. p. 176.

d45. Julius Schnorr von Carolsfeld

Seated Nude Youth, c. 1820
(Kauernder Jünglingsakt)

Pencil on white paper, 41.3 x 26 cm (16¼ x 10¼″)
Inscribed (lower center): Calzolaro
Hamburger Kunsthalle, Hamburg

The Nazarenes, in keeping with their renunciation of traditional
academic practices, made nude studies of young men and boys in
natural poses rather than of older, professional models in postures
reminiscent of antique statuary. The unstudied, even inelegant
pose of this figure and the oblique angle from which he is viewed
are consistent with Nazarene tenets of composition.

References: Keith Andrews, "Beobachtungen an zwei Nazarener Zeich-
nungen der Hamburger Kunsthalle," *Jahrbuch der Hamburger Kunstsamm-
lung,* 1961 (vol. 6), see pp. 109 ff.; idem, 1964 [II], see p. 113, no. 42a;
Lübeck, 1969 [III], see p. 90, no. 173, pl. p. 89; Bernhard, 1974 [II] (vol. 2),
see pp. 1717, 1726, 1727, 1729, 1730, 1731; Frankfurt am Main, 1977 [III],
see pp. 188–89.

d46. Julius Schnorr von Carolsfeld

Young Woman with Left Arm Raised, 1820
(Junge Frau mit erhobenem linken Arm)

Pen and pen wash in brown, over pencil, 29.9 x 26.3 cm (11¾ x 10⅜″)
Dated (lower right): d. 16. October 1820
Germanisches Nationalmuseum, Nürnberg

This drawing is one of many by Schnorr from the early 1820s of an innkeeper's daughter in Arrici (several are in the Kupferstich-Kabinett, Staatliche Kunstsammlungen, Dresden). It is a study for one of the figures in *Three Marys at the Grave,* a painting with life-size figures commissioned by Johann Gottlob von Quandt but never completed. Keith Andrews cites three studies for the composition as a whole, a full-length costume study for this figure, and a sketch of the raised hand. A fourth study for the entire work is in the Kupferstich-Kabinett, Dresden.

References: Singer, 1911 [IV], see pl. p. 33; London, 1959 [III], p. 394, no. 846; Andrews, 1964 [II], p. 113, no. 42b; Bernhard, 1974 [II] (vol. 2), see pp. 1712, 1713, 1728, 1735; Frankfurt am Main, 1977 [III], see pp. 188–89; Nürnberg, 1977. Germanisches Nationalmuseum. *125 Jahre Germanisches Nationalmuseum* [III], p. 38, no. 65.

d47. Julius Schnorr von Carolsfeld

Ruth on the Field of Boaz, 1826
(Ruth auf dem Acker des Boas)

Pen and gray black ink, 30.1 x 21 cm (11⅞ x 8¼″)
Monogrammed and dated (lower left): JS 1826
Hamburger Kunsthalle, Hamburg

As narrated in Ruth 2:1–23, Boaz grants Ruth permission to harvest wheat in his fields in gratitude for her kindness to her mother-in-law, Naomi, his kinswoman. Schnorr depicts a monumental and graceful Ruth, alone in the fields gathering wheat. In 1827 Schnorr made another version of the same subject that included Boaz, a servant, and other reapers (Hamburger Kunsthalle). As noted in the Frankfurt catalogue (1977), the later, more narrative drawing bears a strong resemblance to an 1818 rendition of the story of Ruth by Overbeck (Museen für Kunst und Kulturgeschichte, Lübeck).

References: Bernhard, 1974 [II] (vol. 2), see p. 1742; Frankfurt am Main, 1977 [III], p. 205, no. E 73, pl. p. 246, see also p. 201, no. E 51, pl. p. 237.

d48. Julius Schnorr von Carolsfeld

The Plight of the Nibelungen
 Illustrated with woodcuts based on drawings by Julius Schnorr
 von Carolsfeld and Eugen Neureuther. Text edited by Dr.
 Gustav Pfizer. Stuttgart and Tübingen: J. G. Cotta'scher
 Verlag, 1843
(Der Nibelungen Noth)
 (Illustriert mit Holzschnitten nach Zeichnungen von Julius
 Schnorr von Carolsfeld und Eugen Neureuther. Die
 Bearbeitung des Textes von Dr. Gustav Pfizer. Stuttgart und
 Tübingen: J. G. Cotta'scher Verlag, 1843)

Kunstbibliothek, Staatliche Museen Preussischer Kulturbesitz, Berlin

The *Nibelungenlied,* a medieval German epic, was a source of in-
spiration for several Nazarene projects, including a cycle of seven
prints by Cornelius that was published in 1817 (see d6). The illus-
trations by Schnorr and Neureuther in this book are essentially
transpositions of Schnorr's Nibelungen fresco cycle in the Munich
Residenz of King Ludwig of Bavaria.

References: Ulrich Schulte-Wülwer, *Das Nibelungenlied in der deutschen
Kunst und Kunstliteratur zwischen 1806 und 1871,* Ph. D. diss., Kiel, 1974,
no. 165; Frankfurt am Main, 1977 [III], p. 210, no. E 95, see also pp. 207,
209–11.

d49. Julius Schnorr von Carolsfeld

*The Bible in Pictures: 240 Representations Devised and Sketched on Wood
 by Julius Schnorr von Carolsfeld.* Leipzig: Georg Wigan, 1857–60
*(Die Bibel in Bildern: 240 Darstellungen gefunden und auf Holz gezeichnet
 von Julius Schnorr von Carolsfeld.* Leipzig: Georg Wigand, 1857–60)

Kunstbibliothek, Staatliche Museen Preussischer Kulturbesitz, Berlin

As early as 1815 Overbeck and Joseph Johann Sutter spoke of an illustrated Bible
as a possible undertaking for the Brotherhood of St. Luke. Most members of
the society made drawings for the project, and Overbeck was particularly in-
volved in the initial stages. The communal effort failed, however, because of
religious factionalism within the group and because of demands made on individ-
ual artists by paintings commissions. Schnorr was the only artist to devote him-
self consistently to the project, which he worked on from the early 1820s
through 1860. The work was published in 1857–60 and met with popular
success.

Schnorr worked through several versions of each scene before arriving at the
highly readable format—a limited number of large figures usually set against a
landscape background. As Keith Andrews has noted, the scheme was in all prob-
ability inspired by Raphael's frescoes in the Logge.

References: Singer, 1911 [IV], pp. 110–12, pp. 76–105, pls. 78–103; Andrews, 1964 [II],
pp. 64 ff.; Bernhard, 1974 [II] (vol. 2), see pp. 1743, 1752–55; Frankfurt am Main, 1977
[III], pp. 210–11.

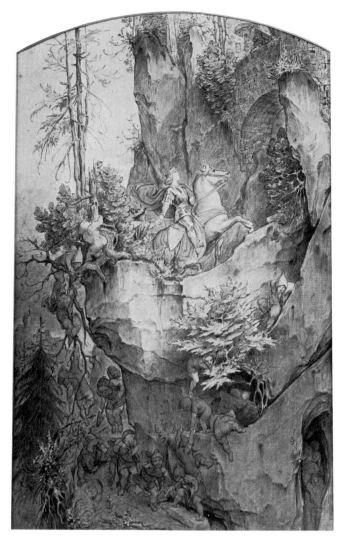

d50. Moritz von Schwind

Falkenstein's Ride, c. 1843–44
(Der Falkensteiner Ritt)

Pen and watercolor, 36.5 x 24.3 cm (14⅜ x 9⅝")
Städtische Galerie im Lenbachhaus, Munich

Like *Knight Kurt's Journey,* 1844 (d51), the present drawing is a study for a painting based on German folk literature. The painting, also titled *Falkenstein's Ride,* dates from 1843–44 and is now in the Museum der bildenden Künste, Leipzig. According to the fable, the knight Kuno von Falkenstein, to win the hand of the count's daughter, must scale the precipitous cliff to her castle on horseback. With the help of gnomes who have prepared his way, Falkenstein reaches his beloved.

A sheet of preliminary sketches for the various figure groups is in the Hessisches Landesmuseum, Darmstadt.

References: Weigmann, 1906 [IV] (vol. 9), see pl. p. 217; "Zeichnungen aus dem Kupferstichkabinett des Hessisches Landesmuseum zu Darmstadt," *Stift und Feder,* 1928 (vols. 1–4), see pl. 29 (Darmstadt); Kalkschmidt, 1943 [IV], p. 65, pl. III opp. p. 72, see also p. 66, pl. 34; Munich, 1956 [III], p. 63, no. 176.

d51. Moritz von Schwind

Knight Kurt's Journey, February–May 1844
(Ritter Kurts Brautfahrt)

Pencil on ivory paper with watermark: J. Whatman/1842;
 sheet 52.7 x 48.8 cm (20¾ x 19¼"), image 50.9 x 46.1 cm (20 x 18⅛")
Inscribed in three places in pencil: far right, on sheet held by man: Ritter/Kvrt's/
 Bravt-/Fahrt./v. Goethe; lower right, on sheet on ground: Comoedia;
 below center, below border: 8
Staatliche Kunsthalle, Karlsruhe

This drawing is a copy by Schwind of his painting *Knight Kurt's Journey,* 1835–39 (formerly Staatliche Kunsthalle, Karlsruhe; destroyed by fire 1931), which was based on Goethe's ballad of the same title. Schwind's first studies for the painting (Staatliche Kunsthalle, Karlsruhe, and Hessisches Landesmuseum, Darmstadt) date from the 1820s and early 1830s, when he was living in Vienna, Munich, and Rome. An etching of the first version, a horizontal composition showing only events in the square, was made by the printer Julius Caesar Thaeter in 1830. From Schwind's correspondence, Theilmann and Ammann (Karlsruhe, 1978) conclude that the present copy after the finished painting was executed between February and May 1844. In 1846 Thaeter published a print based on the present drawing.

In a medievalizing manner, Schwind represents simultaneously several of Knight Kurt's misadventures. Above, wedding preparations are under way outside the castle. Knight Kurt's problems begin when an artisan approaches with an unpaid bill. At the middle right, as he tries to escape the castle, Knight Kurt is stopped by his former lover, who holds a child in her arms. At center, in the marketplace below, he is once again accosted by creditors. At the left, the prospective bride swoons. Most of the figures at the extreme right are portraits of Schwind's friends from Vienna, and beyond the fountain Schwind himself, seen from the rear, presents a drawing to Julius Schnorr von Carolsfeld and Peter von Cornelius.

References: Weigmann, 1906 [IV] (vol. 9), see pl. p. 64; "Zeichnungen aus dem Kupferstichkabinett des Hessisches Landesmuseum zu Darmstadt," *Stift und Feder,* 1928 (vols. 9–10), see pls. 205, 206 (Darmstadt); Kalkschmidt, 1943 [IV], pp. 48–50, 54–59, pls. pp. 26–28, 30, 55–57, 59; Karlsruhe, 1978 [V] (text vol.), p. 602, no. 3956, pl. p. 84.

d52. Moritz von Schwind

Study Page with Compositional Design and Individual
Sketches for *King Krokus and the Wood Nymph*,
1848—49
(Studienblatt mit Konpositionsentwurf und Einzelskizzen
zu *König Krokus und die Waldnymphe*)

Pen and brown ink on light beige paper, 33.7 x 20.4 cm (13¼ x 8″)
Staatliche Kunsthalle, Karlsruhe

This page contains preparatory compositional and figural
sketches for the painting *King Krokus and the Wood Nymph,*
which was begun in the late 1840s and completed about 1860
(Schack-Galerie, Munich). There are numerous other studies as
well (Staatsgalerie Stuttgart; Kupferstichkabinett der Öffen-
tlichen Kunstsammlungen, Basel; Staatliche Graphische
Sammlung, Munich; Albertina, Vienna).

References: Weigmann, 1906 [IV] (vol. 9), see pls. pp. 74—75, 423,
554; Munich, 1969 [V] (text vol.), see pp. 345—49; Stuttgart, 1976 [V],
see p. 186, no. 1442; Karlsruhe, 1978 [V] (text vol.), no. 3970, pl.
p. 198.

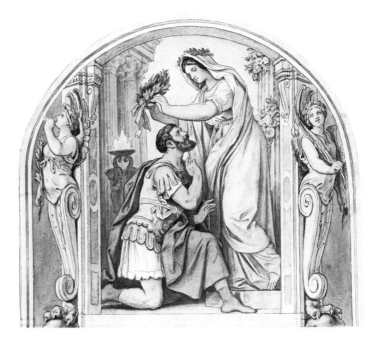

d53. Moritz von Schwind

Julia Crowns the Victor Licinius with a Garland
(The Vestal Virgin Crowns a Warrior), 1866—67
(*Julia bekränzt den Triumphator Licinius*
[*Vestalin krönt einen Krieger*])

Watercolor, 20 x 32.5 cm (11⅝ x 12¾″)
Nationalgalerie, Staatliche Museen Preussischer Kulturbesitz, Berlin

Between 1863 and 1867 Moritz von Schwind designed and
executed frescoes based on scenes from Mozart's
Magic Flute for the Vienna Opera House. In 1865
he received an additional commission for a second
series of operatic scenes for the lunettes of the lobby.
Schwind executed fourteen cartoons of scenes from
famous operas, but the frescoes themselves were painted
by other artists. The present watercolor is believed to be
a sketch for one of the fourteen cartoons. It illustrates a
scene from Gaspare Spontini's *The Vestal Virgins*, 1807.

d54. Moritz von Schwind

Daughters of the Rhine, 1869
(*Töchter des Rheins*)

Pen and India ink and watercolor over pencil on paper, mounted on
canvas, 49.1 x 135 cm (19¼ x 53¼″)
Signed and dated (lower right): M V Schwind 1869
Nationalgalerie, Staatliche Museen Preussischer Kulturbesitz, Berlin
(property of the Federal Republic of Germany)

Schwind late in life executed a series of illustrations of scenes from
operas, among them *Magic Flute, Tannhäuser,* and *Der Freischütz.*
This drawing probably depicts a scene from Wagner's *Das
Rheingold,* which was first presented in 1869.

Artists' Biographies

Artists whose work is included in the exhibition are set in SMALL CAPS.

KARL BLECHEN
Cottbus 1798–1840 Berlin

Trained in Berlin for a career in banking, Blechen followed this profession for eight years before deciding to devote himself to painting. In 1822 he enrolled in the Berlin Academy, where he studied under the landscapist Peter Ludwig Lütke. In 1823 he traveled to Dresden where he met the painter Johann Christian Clausen Dahl and may also have become acquainted with FRIEDRICH and CARUS. He left the Academy in 1824, and through the intervention of the architect and painter Karl Friedrich Schinkel obtained a post as set designer for the Königstädtisches Theater, where he worked until 1827. The imagery of his painting was at this time deeply Romantic, frequently consisting of views of ruined cloisters and abbeys animated by a single figure. In 1828 Blechen went to Italy where he spent thirteen months, staying in Florence, Rome, and Naples. Like his contemporary Camille Corot, who was in Italy at about the same time, Blechen drew inspiration less from the old masters than from the brilliant Italian light. His travel sketches are remarkable for their direct, unadorned naturalism. On his return to Berlin, Blechen began to assimilate this newly discovered mode into his paintings. From 1831 to 1835 he was professor of landscape painting at the Berlin Academy; in 1835 he was made a member of the Academy. In 1833 he toured the Harz Mountains. He traveled to Paris for a brief visit in 1835. In 1836 he first showed symptoms of a mental illness that led to his temporary hospitalization in Berlin the following year. Despite the aid offered by his patron, Bettina von Arnim, Blechen succumbed to a progressive disease of the nervous system and died insane.

ARNOLD BÖCKLIN
Basel 1827–1901 San Domenico

The son of a merchant, Böcklin received his first artistic training from Ludwig Adam Kelterborn in 1841. From 1845 to 1847 he studied with the landscapist Johann Wilhelm Schirmer at the Düsseldorf Academy. There he met FEUERBACH, with whom he later associated in the 1860s and 1870s. In 1847 he traveled to Belgium in the company of Rudolf Koller, and studied in Geneva under Alexandre Calame. Koller and Böcklin visited Paris the following year, becoming acquainted with the work of Corot and Couture, among others. In 1849 Böcklin served in the military in Basel. The same year he was betrothed to Luise Schmidt, but she died within a year, and Böcklin traveled to Rome in an effort to overcome his grief. With the exception of a few brief visits north, he remained in Rome from 1850 to 1857; there he associated with Heinrich Franz-Dreber and the circle of German artists who called themselves the "Tugendbund." After 1852 he became friends with the writer Paul Heyse. In 1853 Böcklin married an Italian woman, Angela Pascucci, with whom he had fourteen children, only six of whom lived to survive their father. He began to paint idealized, mythological pictures in 1854. He returned to Basel in 1857. In 1858 he painted the dining hall of Consul Wedekind in Hannover, and then moved to Munich. This was a period of extreme poverty and illness for Böcklin that was alleviated in 1858 when he met Count Adolf Friedrich von Schack and was invited to teach landscape painting at the newly founded Kunstschule in Weimar. Böcklin's improved financial situation permitted him in 1862 to return to Rome, where he renewed his acquaintance with Feuerbach and met MARÉES. He returned to Basel in 1866, and in 1871 was again in Munich where he became friends with THOMA. He exhibited with limited success at the 1873 Vienna World Exhibition. From 1874 to 1885 he lived in Florence. In the mid-1880s Böcklin began to achieve recognition. In 1884 he was named a member of the Berlin Academy. From 1885 to 1892 he lived in Hottingen, near Zürich, and in 1889 was named honorary doctor at the University of Zürich. In 1893 he moved to Florence; two years later he purchased the Villa Bellagio in San Domenico, near Florence. Böcklin's seventieth birthday was commemorated by retrospective exhibitions in Basel, Berlin, and Hamburg, and by 1900 his works were the most expensive contemporary paintings in Germany. He died of tuberculosis.

CARL GUSTAV CARUS
Leipzig 1789–1869 Dresden

Carus entered the university in Leipzig in 1804 to study chemistry, physics, and natural science. In 1806 he began his medical training. He also received instruction in drawing under Julius Dietz. In 1814 he went to Dresden where he became professor of medicine at the new academy for surgery and medicine. He was later named a member of the faculties of medicine and philosophy in Leipzig. During this period Carus began to develop his interest in art; he became close friends with FRIEDRICH after 1816. He joined the circle of Romantics then working in Dresden, and formed friendships also with Ludwig Tieck, Bertel Thorvaldsen, Alexander von Humboldt, Carl Maria von Weber, and GOETHE. Following Friedrich's example he visited the island of Rügen in 1819 and the Riesengebirge in 1820. In 1821 he visited Goethe in Weimar and then traveled through Switzerland to Italy. During these years Carus's primary vocation continued to be medicine, and in 1827 he was appointed court doctor to King Anton of Saxony in Weimar. The following year he traveled to Italy. His *Nine Letters on Landscape Painting,* based on his writings from 1815 to 1824, appeared in 1831. His published work was extensive, much of it devoted to the linking of natural philosophy, science, and art. In 1835 Carus visited Paris; in 1841 he again visited Italy; and in 1844 he went to England and Scotland. He became an honorary member of the Dresden Academy in 1861. He was named president of the Leopoldina-Carolina Academy of Natural History in 1862. His oeuvre consists largely of landscapes, many of which are strongly influenced by Friedrich. Carus's paintings are distinct from those of other artists of the Dresden school in their concentration on scientific precision.

LOVIS CORINTH
Tapiau 1858–1925 Zandvoort

Born in Tapiau, East Prussia, Corinth was the son of a tanner. He began drawing in 1873, shortly after his mother's death, and from 1876 to 1880 studied at the Academy in Königsberg under Otto Günther. In 1878 he made a study trip with his professor to Weimar, Berlin, and Thuringia. He moved to Munich in 1880 and attended classes at the Academy under Franz von Defregger and Ludwig Löfftz. In 1882 Corinth served in the military in Munich and at about the same time came in contact with the Realist painters of the Leibl circle. He visited the painter Paul Eugène Gorge in Antwerp in 1884 and then proceeded to Paris where he studied at the Académie Julian under Adolphe William Bouguereau and Robert Fleury. He visited Germany briefly in 1885, returning to Paris the following year. From 1887 to 1891 Corinth lived in Berlin and Königsberg, and became acquainted with Max Klinger and Karl Stauffer-Bern. He settled in Munich in 1891. During this period he began to work in graphics, following the suggestion of Otto Eckmann. He also continued to associate with the younger members of the Leibl circle. During summers spent in Bernried, Dachau, Kraiburg, and Apkind he painted from nature; his works of this period reflect many of the concerns of the French Impressionists. He moved to Berlin in 1900 and two years later was named to the executive committee of the Berlin Secession. The same year he opened an art school for young women. In 1903 Corinth married Charlotte Berend, his pupil and later his favorite model. Over the next years he traveled extensively: in 1906 to Florence, 1908 to Holland, 1909 to Paris. In 1911 he was named chairman of the Berlin Secession. Later that year he suffered a severe stroke that caused partial paralysis from which he never fully recovered. He resumed painting in 1912–13 while recuperating on the Riviera. His work after this period was increasingly expressive and painterly. In 1915 he was named president of the Berlin Secession. During the last years of his life Corinth received many honors: in 1917 he was made an honorary citizen of Tapiau, in 1918 professor at the Berlin Academy; in 1924 a retrospective exhibition of his work was held in Königsberg; and in 1925 he became an honorary member of the Munich Academy. Corinth died in Zandvoort during a visit to Holland, where he had gone to study Rembrandt and Hals.

PETER VON CORNELIUS
Düsseldorf 1783–1867 Berlin

Cornelius received his first training in art from his father, who was superintendent of the Düsseldorf Gallery and professor of art at the Düsseldorf Academy, and from the age of twelve attended drawing classes at the Academy under Peter von Langer. After the death of his father in 1800 he supported his family as a portraitist and illustrator. In 1803 and 1805 he participated, unsuccessfully, in the competitions organized by the Weimarer Kunstfreunde. In 1803, through the art patron Canon Wallraf of Cologne, he was commissioned to decorate the church in Neuss, on the Rhine. Two publications that appeared in 1808 made a decisive impression on Cornelius: Goethe's *Faust* and a facsimile edition of Dürer's prayer book for Emperor Maximilian I. From 1809 to 1811 Cornelius worked in Frankfurt. In 1811 he began his illustrations for *Faust,* adopting the linear style of Dürer. The same year he traveled to Rome, where he joined the Nazarenes under the leadership of OVERBECK. Cornelius continued to work on his *Faust* series and also illustrated the *Nibelungenlied* and Shakespeare's *Romeo and Juliet* (unfinished). In 1816 he collaborated with Overbeck, SCHADOW, and VEIT on a cycle of frescoes (now in Berlin) in the Casa Bartholdy. From 1817 he made sketches for Dante frescoes in the Casino Massimo (Rome), a project that he abandoned when summoned to Munich in 1819 by Crown Prince Ludwig of Bavaria. Ludwig commissioned Cornelius to decorate the Munich Glyptothek, designed by Leo von Klenze in 1816 to house the royal collection of antique sculpture. The Glyptothek frescoes of mythological subjects occupied Cornelius until 1830. In 1821 he was made director of the Düsseldorf Academy, and four years later, upon Ludwig's succession to the throne, was appointed director of the Munich Academy. He continued to maintain contact with his colleagues and fellow artists in Italy, visiting Rome repeatedly and living there from 1853 to 1861. In Munich he worked extensively for King Ludwig, painting frescoes depicting scenes from Genesis and of the Last Judgment in the Ludwigskirche from 1836 to 1839. His work, an attempt to revive the monumental art of the Renaissance, was not well received, and in 1840 Cornelius left Ludwig's employ for that of Frederick William IV of Prussia in Berlin. His last important commissions were frescoes for the Berlin Campo Santo, 1843 (a mausoleum for the royal family), and the renovated cathedral. Although these projects were officially canceled after the Revolution of 1848, Cornelius, working in increased isolation, continued for the rest of his life to expand and refine his studies for them.

JOHANN GEORG VON DILLIS
Grüngiebing 1759–1841 Munich

Born in Grüngiebing, Upper Bavaria, where his father was a gamekeeper, Dillis was sent to live with his brother in Munich so that he could attend the Gymnasium. There he received his first drawing lessons from Johann Jakob Dorner the Elder. From 1777 to 1781 he studied philosophy and theology at the Collegium Albertinum in Munich and at the university in Ingolstadt, where, following his father's wishes, he was ordained a priest in 1782. He later decided to study art and enrolled in the Munich Academy, where Dorner and Franz Ignaz Öffele were his teachers. In 1786 Dillis was released from his ecclesiastical duties. During this period he earned his living by giving drawing lessons to the aristocratic families of Munich. In 1788 he accompanied Count Max Preysing on a tour of the art collections of Strasbourg and the Palatinate, an experience that led him to study art history and to pursue a museum career. In 1790 he was named Inspector of the Munich royal picture gallery and served as the principal advisor on art to Crown Prince Ludwig of Bavaria. He first visited Italy from 1794 to 1795; his travel sketches of this trip inspired him to employ a naturalistic view of landscape in his paintings, making him a notable precursor of the nineteenth-century Realists. Dillis returned to Rome in 1805 with his brother Cantius, also a landscape artist, and became acquainted with the Neoclassicists Johann Martin von Rohden and KOCH. In 1806 he traveled to Paris where he was deeply impressed by the newly created Musée Napoléon. He returned to Munich in 1807 and was elevated to the nobility

the following year. He was also appointed professor of landscape painting at the Munich Academy, a position he held until 1814. During this period he traveled frequently on state commissions. In 1817–18 he accompanied Crown Prince Ludwig to Rome, Naples, and Sicily. In 1822 he was named Central Gallery Director of the Bavarian royal collections. Over the next sixteen years he assisted in the organization of the Alte Pinakothek. In 1830 and 1832 he accompanied Ludwig, now king of Bavaria, on further journeys to Italy. Toward the end of the 1830s Dillis withdrew from public life; he died in retirement.

LOUIS EYSEN
Manchester 1843–1899 Munich

Louis Eysen was born in Manchester, England. His father was a merchant from Frankfurt, and the family returned there in 1850. Having completed his studies at the Gymnasium, Eysen entered the Frankfurt Städelsches Kunstinstitut in 1861. There he studied under the history and landscape painter Karl Friedrich Hausmann. He also studied wood-block printing under Alexander Stix. In 1866 he traveled to Berlin and Munich. In Munich he became acquainted with Viktor Müller and LEIBL, both of whom had a great influence on his artistic development. Eysen went to Paris in 1869 and studied there with Otto Scholderer and Léon Bonnat. He also met Gustave Courbet. He returned to Frankfurt in 1870, at the outbreak of the Franco-Prussian War; however, he did maintain contact with the Munich circle of German Realists associated with Leibl, in particular THOMA. In 1873 he moved to Kronberg, in the Taunus Mountains, where he remained for five years. There he concentrated on landscape painting. Illness forced him to live in a milder climate; after 1879 he moved with his mother and two sisters to Merano. He continued to paint during the last twenty years of his life, although he maintained contact with artistic circles only through his correspondence with Thoma. Eysen achieved posthumous recognition through the memorial exhibition arranged by Thoma in 1900 which was shown in Karlsruhe, Munich, Berlin, and Frankfurt.

ANSELM FEUERBACH
Speyer 1829–1880 Venice

Anselm Feuerbach was born in southern Germany to a highly cultured family. His father was a noted archaeologist, and his uncle was the philosopher Ludwig Feuerbach. The artist's mother died shortly after his birth, and his father married Henriette Heydenreich. Feuerbach was devoted to his stepmother; they maintained a very close relationship until his death. From 1845 to 1848 Feuerbach studied at the Düsseldorf Academy under Johann Wilhelm Schirmer, SCHADOW, and Carl Sohn. From 1848 to 1850 he studied at the Munich Academy and was influenced by his Viennese friend Karl Rahl. In 1850 Feuerbach, dissatisfied with the Munich Academy, left with other students for Antwerp, where he studied under Gustaaf Wappers at the Academy. He moved to Paris in 1851 and studied under Thomas Couture from 1852 to 1854. In 1854 Feuerbach received a stipend from Grand Duke Friedrich von Baden to travel to Venice, and from Venice he went to Rome via Florence. He settled in Rome where he remained, with brief visits to Germany, until 1873. In 1861 he met Anna (Nanna) Risi, who was his model and mistress until 1865. In 1862 Feuerbach met Count Adolf Friedrich von Schack, who offered him financial support in exchange for copies of Italian old masters. This arrangement continued until 1866. Through Schack he met BÖCKLIN and MARÉES. Their preference for Italy over Germany earned for them the name "Deutsch-Römer." In 1866 he met Lucia Bruncacci, the wife of an innkeeper, who bore a striking resemblance to Nanna Risi and who became his model for paintings of Medea. In 1873 Feuerbach was appointed professor of history painting at the Vienna Academy. There he painted the vast decorations for the assembly hall. In 1874 an exhibition of his work in Vienna was severely criticized; however, he was awarded the gold medal at the Munich Exhibition of 1876.

He left the Vienna Academy that year because of administrative interference and in 1877 returned to Venice where, except for occasional visits to Rome, he spent the last four years of his life.

CARL PHILIPP FOHR
Heidelberg 1795–1818 Rome

The eldest son of a teacher, Fohr was a precocious draftsman and began taking lessons in 1808 from Friedrich Rottmann, drawing master at Heidelberg University (and father of the artist ROTTMANN). In 1810 he met the Hessian privy councilor and amateur landscape painter Georg Wilhelm Issel, who invited him to Darmstadt. There he met Philipp Dieffenbach, a teacher under whose influence he studied the national heritage of Germany, focusing on mythology and sixteenth-century art. Dieffenbach also introduced Fohr to Crown Princess Luise, grand duchess of Hesse, who was to be Fohr's patron for the rest of his life. Under her auspices he attended the Munich Academy in 1815; Peter von Langer was his teacher. He was soon dissatisfied with the rigid doctrine of the Academy and spent the autumn of that year traveling through the southern Tirol and northern Italy. His travel sketches of this journey are a series of exquisite landscapes executed in watercolor. In 1816 he again studied briefly at the Munich Academy and was introduced to the writings of the Romantics. After a visit to Heidelberg Fohr left for Rome with a stipend from the crown princess. Arriving in autumn 1816 he immediately joined the circle of the classical landscapist KOCH. The following year he studied under Koch and came in contact with the Nazarenes. He portrayed many of the German artists then living in Rome in a series of studies for an engraving of gatherings at the Caffè Greco, a project that was never completed. Fohr's career was brought to an abrupt end when, at the age of twenty-three, he drowned while swimming in the Tiber. Philipp Dieffenbach wrote a biography of Fohr which was published in 1823.

CASPAR DAVID FRIEDRICH
Greifswald 1774–1840 Dresden

Caspar David Friedrich, the son of a chandler, was born in Greifswald, a large port on the Baltic coast. His upbringing was strictly Protestant. When he was thirteen he witnessed the death by drowning of his younger brother, Christopher, an event that deeply affected him and was perhaps a contributing factor in his suicide attempt. Friedrich showed precocious ability in drawing and in 1790 began formal art study under Johann Friedrich Quistorp at Greifswald University. In 1794 he entered the Copenhagen Academy, then a northern center of Neoclassicism, where Christian August Lorentzen, Jens Juel, and Nicolai Abraham Abildgaard were his teachers. In 1798 he moved permanently to Dresden, where he became associated with the Dresden school of landscape painting. In 1801–2 he visited Greifswald and traveled to the island of Rügen, where he met RUNGE. In 1805 he submitted two drawings to the competition organized by the Weimarer Kunstfreunde; they were awarded second prize and elicited praise from, among others, GOETHE. He began to devote more time to painting, rather than to drawing, and to attract a wider patronage. At this time Friedrich became increasingly associated with the Dresden circle of Romantic poets and scholars: Gotthilf Heinrich von Schubert, Ludwig Tieck, Heinrich von Kleist, and Runge. Later, Friedrich had his own following among painters such as KERSTING, CARUS, the OLIVIER brothers, and Johann Christian Clausen Dahl. In 1810 he toured the Riesengebirge in the company of Kersting. The same year Goethe visited his studio, and he was elected a member of the Berlin Academy. Six years later he became a member of the Dresden Academy. He was professor of landscape painting at the Academy from 1824, although he was never offered a chair. In 1818 he was married to Caroline Bommer. From 1801 through 1820 Friedrich made frequent trips to his native Greifswald, as well as to other northern provinces—the Harz Mountains, the island of Rügen, northern Bohemia—whose austere landscapes are depicted in his work. While these paintings are naturalistic, based on careful observation and detailed sketches, they also express a mystic sensibility. Fried-

rich's later works become increasingly ascetic and severe, qualities that cost him much of his former patronage. He also suffered increasingly from ill health. In 1835 his arm was paralyzed by a stroke; except for a brief period of recuperation in 1837, he was unable to paint again.

JOHANN WOLFGANG VON GOETHE
Frankfurt am Main 1749–1832 Weimar

Goethe's family was highly cultured; he grew up in a household that encouraged all the arts. More than any other of his contemporaries, Goethe came to personify the Enlightenment man, being well versed in all the arts as well as in the sciences. He is considered the greatest poetic genius in the German language. In 1765 he moved to Leipzig to study law. The following year he took lessons in drawing from Adam Friedrich Oeser, director of the Pliessenburg Academy; however, he was more interested in art theory than in practice. He also began writing his first lyric poems during this period. From 1768 to 1770 he was seriously ill with tuberculosis and remained convalescent in his parents' home. In 1770 he moved to Strasbourg upon his father's insistence that he continue to study law. There he began his activities as a man of letters. He also studied medicine during this period. He received his licentiate in law in 1771, but never obtained a degree in medicine. In 1772 he published a treatise on German architecture which reflects the contemporary Romantic and nationalistic *Sturm und Drang* movement. Two years later, following his unrequited love for Charlotte Buff, Goethe published *The Sorrows of Young Werther,* which became one of the most influential Romantic novels. He moved to Weimar in 1775 at the request of Charles Augustus, duke of Saxe-Weimar, at whose court he remained for the rest of his life; he was chief minister of state until 1786. In 1782 he was elevated to the nobility. In 1777 he toured the Harz Mountains, in 1779 Switzerland. Goethe's trip to Italy from 1786 to 1788 marks the beginning of his orientation toward Neoclassicism. In Rome he befriended the painters Johann Heinrich Wilhelm Tischbein and Angelica Kauffmann; in Naples he visited the landscape painter Jakob Philipp Hackert. During this period he adopted the views of Johann Joachim Winckelmann about the absolute preeminence of Greek art. In 1788 Goethe returned to Weimar where he met Christiane Vulpius, with whom he had a son in 1789; they were married in 1806. He also had many other romantic attachments. His poetry and drama of this period reflect his new Neoclassical leanings (*Iphigenia in Tauris,* 1787; *Egmont,* 1788; *Torquato Tasso,* 1789). In 1794 he befriended the poet Friedrich von Schiller. The novel *The Apprenticeship of Wilhelm Meister,* a major work which occupied Goethe for many years and eventually became the prototype for the German *Bildungsroman,* was published in 1796. From 1798 to 1805 Goethe was the publisher of the art review *Propyläen.* He also sponsored annual drawing competitions organized by the Weimarer Kunstfreunde, in which major artists, including FRIEDRICH and RUNGE, took part. In 1808 he published the dramatic poem *Faust Part I; Faust Part II* was published posthumously in 1832. Despite his avowedly Neoclassical stance, these plays were hailed by many of his contemporaries as Romantic, and they inspired Romantic artists throughout Europe. However, he rejected a large part of the Romantic movement, in particular the Nazarenes. In 1810 Goethe's theory of color was published, as was Runge's. Goethe had carried on an extensive correspondence with Runge and with many other painters, as well as with almost all the major literary and political figures of his day. His activities as a writer and connoisseur were accompanied by a vast graphic oeuvre of over 2,000 drawings. While these are the work of an amateur, their historical importance is considerable. He died in Weimar and was buried in the ducal crypt next to Schiller.

GEORG FRIEDRICH KERSTING
Güstrow 1785–1847 Meissen

Kersting first studied under his father who was a glazier. In 1805 he enrolled in the Copenhagen Academy where Jens Juel, Nicolai Abraham Abildgaard,

and Christian August Lorentzen were his teachers. In 1808 he transferred to the Dresden Academy. In Dresden he met FRIEDRICH, with whom he formed a close friendship and by whom he was profoundly influenced. Their friends included the painter CARUS, the poets Louise Seidler and Karl Theodor Körner, and the writer Heinrich von Kleist. In 1810 and 1811 he accompanied Friedrich on walking tours of the Riesengebirge and the environs of Dresden. In 1811 he exhibited two paintings in Weimar and two at the Dresden Academy, where they were well received. He met GOETHE in 1813. The poet was impressed by Kersting's work and arranged a lottery to raise money for him. Kersting was a volunteer in the Lützow Free Corps during the 1813–14 War of Liberation. He led a charge on enemy posts and was awarded the Iron Cross. From 1816 to 1818 he was court painter in Warsaw. Returning to Dresden in 1818 he attempted, unsuccessfully, to obtain a position as instructor at the Academy. The same year, however, he was made director of the painting department at the royal porcelain factory in Meissen, later becoming head of the drawing school there. He made brief trips to Berlin in 1822 and 1844. Kersting's quiet, domestic interiors are his finest works, and his two portraits of Friedrich (1811, Hamburger Kunsthalle; 1812, no. 37) his most famous.

JOSEPH ANTON KOCH
Obergibeln, Tirol 1768–1839 Rome

Joseph Anton Koch came from a peasant background. He received his preliminary training in art in Dillingen and Wittislingen and was sponsored by the bishop of Augsburg, Baron Johann von Ungelter. In 1784 he studied in Augsburg under the sculptor Martin Ignaz Ingerl and the painter Johann Jakob Metterleiter. From 1781 to 1791 he attended the Stuttgart Hohe Karlsschule, where he studied under the landscape painter Adolf Friedrich Harper and the portraitist and history painter Philipp Friedrich von Hetsch. Koch rejected the restraints of academic discipline and left Stuttgart in 1791 for Strasbourg. From 1792 to 1794 he traveled through Switzerland, visiting Basel, Bern, Biel, and Neuchâtel. During these travels he made many studies of the Alpine landscape. In 1794 the English theologian and patron of the arts George Frederick Nott gave Koch a three-year stipend which enabled him to live in Italy. Koch first toured Italy on foot, stopping in Milan, Bologna, Florence, Rome, and Naples. He settled in Rome in 1795. At that time the Neoclassicist Asmus Jakob Carstens was the leading German artist in Rome; under his influence Koch began to paint mythological and literary subjects, especially from the work of Dante. In 1802 he was encouraged by Gottlieb Schick to work in oils. His paintings of this period were termed "heroic landscapes"; these classical and idealized mountain scenes created a significant new genre in painting. Koch left Rome for Vienna in 1812 because of the political and economic unrest of Napoleonic Italy and there met the landscapist FERDINAND OLIVIER. He was at that time deeply impressed by the work of Rubens, especially by the Flemish master's use of color. He returned to Rome in 1815. From 1825 to 1828 he was associated with the Nazarenes and worked on the frescoes in the Casino Massimo. In 1834 he published his polemical theories on art. At the end of his life he experienced severe financial difficulties, which were to some extent alleviated by the intervention of CORNELIUS.

● WILHELM LEIBL
Cologne 1844–1900 Würzburg

Wilhelm Leibl was born in Cologne, where his father was director of the cathedral choir. He served as apprentice to a locksmith before deciding to become a painter. His first instruction in art, 1861–64, was under Hermann Becker in Cologne. In 1864 he transferred to the Munich Academy, where he studied under Hermann Anschütz. From 1866 to 1868 he attended the master classes of the genre painter Arthur von Ramberg, and in 1869 he studied briefly with the history painter Karl Theodor von Piloty. He shared a studio with Theodor Alt, Rudolf Hirth du Frênes, and SPERL. At the Alte Pinakothek Leibl copied many works of the Netherlandish old masters. At the first International Exhibition in Munich in 1869, his *Portrait of Frau Gedon,*

1869 (Neue Pinakothek, Munich), attracted the attention of Gustave Courbet, who invited him to Paris. While in Paris Leibl was introduced to Edouard Manet. The outbreak of the Franco-Prussian War forced Leibl to return to Munich in 1870, and there he worked as a portraitist. During the following years he was the leader of a group of young artists whose major concerns paralleled those of the Paris Realists. The so-called Leibl circle included THOMA, Ernst Sattler, Carl Schuch, TRÜBNER, and Albert Lang. Leibl eventually grew dissatisfied with Munich society and chose to live in a succession of Upper Bavarian villages. In 1873 he went to Grasslfing, near Dachau. In 1875 he moved to Unterschondorf am Ammersee; in 1878 to Berbling; and in 1882 to Bad Aibling, where he shared a house with Sperl. In 1886 he was made an honorary member of the Munich Academy, but he did not return to that city. In 1892 he moved, again with Sperl, to Kutterling. The same year he formed a friendship with Julius Mayer, who was later the artist's biographer. He submitted nineteen works to the Berlin International Exhibition of 1895 and was awarded the gold medal. In 1898 he visited Holland. His work was included in the Berlin Secession exhibition of 1899. Throughout his career he concentrated on portraiture. The painterly quality of his first works was superseded by the meticulous realism inspired by Hans Holbein the Younger and later by Courbet. Leibl's last works show a limited Impressionist influence in their loosened brushstroke. Unlike his French contemporaries, however, his expression of nature and of the human figure is calm and austere.

FRANZ VON LENBACH
Schrobenhausen 1836–1904 Munich

Lenbach's father was a building contractor, and from about 1850 Lenbach was apprenticed to him as a mason. In 1850 he took his first lessons in art from the genre painter Johann Baptist Hofner in Schrobenhausen. After the death of his father in 1852 Lenbach studied for a year at the polytechnic school in Augsburg. There he began to paint independently, copying the old masters. In 1854 he entered the Munich Academy, but during the summer months continued to take lessons from Hofner in Schrobenhausen. In 1857 he was a pupil in Karl Theodor von Piloty's master class at the Academy. From 1857 to 1858 he traveled through Italy to Rome with Piloty. He taught at the newly founded Weimer Kunstschule from 1860 to 1862 with BÖCKLIN and the sculptor Reinhold Begas. He then returned to Munich where he met Count Adolf Friedrich von Schack. Schack sent Lenbach, together with MARÉES, to Rome in 1864 to make copies of sixteenth- and seventeenth-century masters. In 1867 he was sent by Schack to southern Spain and Madrid. He returned to Munich in 1868 and began to win national acclaim for his portraits. Between 1871 and 1874 he traveled to Vienna, Berlin, and Italy in order to fulfill portrait commissions. In 1875–76 he visited Egypt with Hans Makart. In 1878 he met Bismarck, of whom he eventually made eighty portraits. He spent the winter months from 1882 to 1887 in Rome, where he had a studio in the Palazzo Borghese. In 1883 he began the construction of the Villa Lenbach in Munich, collaborating with the architect Gabriel von Seidl. The villa was completed in 1889. For the last fifteen years of his life Lenbach remained at the center of the Munich art world.

MAX LIEBERMANN
Berlin 1847–1935 Berlin

Max Liebermann, the son of a wealthy merchant, first began to draw under the guidance of Karl Heinrich Steffeck in 1863. He entered Berlin University in 1866, while he continued to study art informally. In 1868 he enrolled in the Weimar Kunstschule, where he remained for five years. His professors included the Belgian history painters Ferdinand Pauwels and Charles Verlat. In 1871 he made the first of many visits to Holland, stopping also in Düsseldorf. Liebermann went to Paris in 1872 and was deeply impressed by the paintings of Gustave Courbet and the Barbizon school. He also visited Holland that year, and his art began to display the influence of the Dutch genre and landscape

tradition. He lived in Paris from 1873 to 1878, and formed a close friendship with the painter Mihály von Munkácsy, whom he had met in Düsseldorf. In 1876 he exhibited *Workers in a Turnip Field* (Niedersächsisches Landesmuseum, Hannover) at the Paris Salon. In 1875, 1876, and 1877 he visited Holland. From 1878 to 1884 he lived in Munich where he met LEIBL and LENBACH. After 1880 he spent summers in Holland and exhibited frequently in Paris. He moved to Berlin in 1884. Liebermann's art at this time underwent a stylistic change, becoming more colorful and later showing the influence of the French Impressionists. He was a founding member in 1892 of the Group of XI, an alliance that later formed the nucleus of the Berlin Secession. In 1896 he visited Paris and London. In 1897 he was given a one-man exhibition at the Berlin Academy and named professor there; the following year he was made a member. Also in 1898 he was a founding member of the Berlin Secession, and from 1899 to 1911 its president. He visited Rome and Florence in 1902. In 1912 he received an honorary doctor's degree from the university in Berlin. He was president from 1920 to 1932 of the Berlin Academy, where a retrospective exhibition of his work was held in 1927. While his paintings were based on Realist art, such as that of Courbet, Liebermann developed in his late works a painterly freedom and a bright palette that ally him with the French Impressionists. In 1933 he was stripped of his many honors by the Nazi government, which labeled his art "degenerate"; exhibitions of his work were prohibited.

HANS VON MARÉES
Elberfeld 1837–1887 Rome

Hans von Marées was born to a banking family in Elberfeld, near Wuppertal. In 1847 the family moved to Koblenz. There Marées studied at the Gymnasium, showing a precocious talent for drawing. From 1853 to 1855 he studied at the Berlin Academy. In 1854 he entered the studio of the painter and printmaker Karl Heinrich Steffeck, from whom he learned a draftsmanlike painting style. Marées served in the military between 1855 and 1857, after which he traveled to Munich, where he met LENBACH. During his time in Munich Marées worked independently of the Academy, concentrating on portraiture. In 1864 he attracted the patronage of Count Adolf Friedrich von Schack, who sent Marées, together with Lenbach, to Italy to copy the old masters. In Italy Marées became friends with Konrad Fiedler, later his patron, and the artist Adolf von Hildebrand. In 1868 he broke with Schack and traveled with Fiedler to Spain, France, Belgium, and Holland. He was recalled to military duty in 1870 during the Franco-Prussian War. From 1870 to 1873 Marées lived in Berlin and Dresden. In 1873 he was commissioned by Anton Dohrn to decorate the library of the German Marine Zoological Station in Naples. He carried out this fresco project with Hildebrand. The two moved to Florence in 1874 and shared a studio in the cloister of San Francesco. In 1875 Marées terminated his friendship with Hildebrand and moved to Rome, where he met BÖCKLIN and FEUERBACH; they later were referred to as the "Deutsch-Römer" (German Romans). In his late work he focused increasingly on themes from Greek mythology and medieval legend, which he painted in an unusual method of wax and oil glazes. He spent his last years in Rome, supported by Fiedler, working for the most part in isolation, and teaching his two pupils.

ADOLPH VON MENZEL
Breslau 1815–1905 Berlin

Adolph von Menzel was born in Breslau (now Wroclaw, Poland), where his father was director of a school for girls. In 1828 his father opened a lithography studio, and two years later the family moved to Berlin. During the summer of 1830, when he was fourteen years old, Menzel attended classes at the Berlin Academy; this was to be his only formal training in art. He then studied lithography under his father and continued to sketch independently. After his father's death in 1832, Menzel took over the lithography studio and supported his family through commercial work. By 1833 he was beginning to enjoy

270

financial success; in 1834 he became a member of the Jüngerer Berliner Kunst-verein. He began to paint in 1836. Between 1840 and 1842 he worked on the commission that brought him national recognition, 400 woodcut illustrations for Franz Kugler's *History of Frederick the Great*. The life and times of the eighteenth-century king of Prussia became for Menzel a subject of continuing interest. Later projects included illustrations for *The Works of Frederick the Great,* 1844–49, and *The Armies of Frederick the Great,* 1845–51, as well as paintings based on these woodcuts. In 1845 he saw the Berlin exhibition of John Constable's landscapes, and to a certain extent adopted the English master's atmospheric style and loose handling of paint. He also began to explore Realist themes, depicting the gradual industrialization of the country-side around Berlin. In 1853 Menzel became a member of the Berlin Academy and three years later was named professor of art. He visited Paris briefly in 1855, 1867, and 1868; it is thought that he met Gustave Courbet during the last visit. He traveled to Vienna in 1873 and to Verona in 1880, 1881, and 1883. Toward the end of his career many honors were bestowed upon him in recognition of his achievements. He received an honorary doctorate at the university in Berlin in 1885. He was made an honorary citizen of Breslau, and an honorary member of the Royal Academy, London, and the French Academy. Menzel's paintings from the last decades of his life chronicle the events of the society that honored him.

FERDINAND OLIVIER
Dessau 1785–1841 Munich

Ferdinand Olivier was born to a family of French-Swiss descent. His father was a philanthropist and teacher. His two younger brothers, Heinrich and Friedrich Olivier, also became artists. Olivier took his first drawing lessons in 1801 with Carl Wilhelm Kolbe the Elder in Dessau. He also studied, from 1802 to 1803, under the wood-block printers Christian Haldenwang and Johann Friedrich Unger. In 1804 he moved to Dresden with his brother Heinrich. There he copied the old masters in the Gemäldegalerie and became acquainted with FRIEDRICH and RUNGE. From 1807 to 1810 Olivier was secretary to the diplomatic mission in Paris, again accompanied by his brother Heinrich. He frequently visited the Musée Napoléon and admired in particular the works of such Northern Renaissance artists as Jan van Eyck and Hans Memling, prototypes that were central to his stylistic development. In 1810 he returned to Dessau and was joined by his other brother, Friedrich. Together they toured the Harz Mountains and in 1811 settled in Vienna. Olivier soon entered the circle of the Romantics which included, among others, SCHNORR VON CAROLSFELD, Theodor Körner, Friedrich Schlegel, and VEIT. He was particularly impressed by the classical landscape artist KOCH, who was living at the time in Vienna, and was also greatly influenced by the sixteenth-century German masters. Olivier traveled to Salzburg in 1815 and 1817, and made several landscape studies that in 1822 formed the basis of a series of lithographs of Salzburg in which landscape is the vehicle of Christian iconography. In 1817 he joined the Brotherhood of St. Luke, becoming the only member never to have visited Italy. He was coeditor and author of the magazine *Janus* from 1818 to 1819. In 1830 he moved to Munich, where he associated with CORNELIUS, ROTTMANN, and Schnorr, whom he assisted with frescoes for the Munich Residenz. In 1833 Olivier was named secretary of the Munich Academy and professor of art history.

JOHANN FRIEDRICH OVERBECK
Lübeck 1789–1869 Rome

Born northeast of Hamburg, Overbeck was the son of Christian Adolf Overbeck, an accomplished poet, senator, and after 1814, mayor of Lübeck. Overbeck began studying art in 1805 in the private academy of Joseph Nicolaus Peroux. In 1806 he visited Hamburg, where he met Wilhelm Tischbein and RUNGE, and Hannover, where he met August Kestner. Kestner introduced him to drawings after Italian old masters by the Riepenhausen brothers, which made a lasting impression on Overbeck. The same year he entered the Vienna

Academy, whose director was Friedrich Heinrich Füger. He was also at this time an admirer of the Neoclassical painter Asmus Jakob Carstens. In 1809, however, he broke with the Academy and was a founding member of the Brotherhood of St. Luke, together with PFORR, Johann Konrad Hottinger, Joseph Wintergerst, Georg Ludwig Vogel, and Joseph Johann Sutter. Renouncing the arid classicism of the Academy and the teachings of Füger, the group advocated a return to the art of Dürer and the Early Renaissance. In 1810 Overbeck, Pforr, Hottinger, and Vogel moved to Rome. After a brief stay at the Villa Malta, they settled for two years in the abandoned cloister of Sant'Isidoro, where they lived and worked together in a monastic community. Other German artists working in Rome were soon drawn to this group: CORNELIUS, SCHADOW, VEIT, and SCHNORR VON CAROLSFELD, among others. Their flamboyant attire and long flowing hair earned them the so-briquet "the Nazarenes." In 1813 Overbeck converted to Catholicism. From 1816 to 1817 he collaborated with Cornelius, Schadow, and Veit on the frescoes (Nationalgalerie, East Berlin) for the Casa Bartholdy. And the same year he began studies for a series of paintings illustrating Tasso's *Jerusalem Delivered* commissioned by Marchese Carlo Massimo for his villa near the Lateran. This project Overbeck discontinued because he no longer wished to paint secular subjects. In 1818 he married Anna Schiffbauer-Hartl, who was in large part responsible for the failure of efforts to bring Overbeck back to Germany. He did, however, make two trips to southern Germany, in 1831 and 1855, but never to his northern homeland. From 1833 he worked on *The Triumph of Religion in the Arts* (Nationalgalerie, East Berlin), commissioned by the Frankfurt Städelsches Kunstinstitut, then under the direction of Veit. In 1840 his son died; his wife became increasingly reclusive. Unlike the other Nazarenes, Overbeck chose to remain for the rest of his life in Rome.

FRANZ PFORR
Frankfurt am Main 1788–1812 Albano

Franz Pforr was the eldest son of a painter of equestrian and battle scenes. Johann Georg Pforr. He moved to Kassel in 1801, following his father's death, to study at the Academy under his uncle, Johann Heinrich Tischbein the Younger. During this period he became friends with the future art historian Johann David Passavant. In 1805 he moved to Vienna where he studied at the Academy for five years with, among others, Friedrich Heinrich Füger. By 1808 he had formed a close friendship with OVERBECK. The two artists made frequent visits to the newly renovated imperial gallery in the Belvedere and were particularly affected by the works of Perugino, Raphael, and the early German masters. Their circle of friends included Joseph Wintergerst, Georg Ludwig Vogel, Johann Konrad Hottinger, and Joseph Johann Sutter. In July 1809 these artists were formally united as the Brotherhood of St. Luke. They took a firm stand against the Academy and called for a revival of Christian art, specifically that of the German Middle Ages and the Italian Early Renaissance. In 1810 Pforr, Overbeck, Vogel, and Hottinger went to Rome where they lived and worked together in the abandoned cloister of Sant'Isidoro. Pforr's subject matter was drawn from medieval history and Germanic legends. His technique was deliberately primitive, recalling the style of Early Renaissance masters. In 1811 he traveled to Nemi and Naples, where he suffered his first attacks from tuberculosis. The following year he died in Albano, near Rome, at the age of twenty-four.

CARL ROTTMANN
Handschuhsheim 1797–1850 Munich

Rottmann received his first training in art from his father, Christian Friedrich Rottmann, a drawing teacher at Heidelberg University. He also studied under Johann Christian Xeller; however, FOHR and the Scottish landscape painter George Augustus Wallis (who worked in Heidelberg from 1812 to 1816) had a greater influence on Rottmann's early work. In 1818 he traveled through the Rhine and Mosel valleys in the company of Xeller and his friends Daniel Fohr and Ernst Fries, sketching panoramic views for the publisher Joseph

Engelmann. In 1819 he began to paint in oils. He moved to Munich in 1821 where he studied at the Academy. He was particularly impressed by the work of KOCH, and his paintings of this period are a series of "heroic landscapes" in the manner of the Neoclassical master. In 1822 Rottmann toured the Tirol and visited Salzburg. In 1824 he married Maria Friederike von Sckell, daughter of the creator of the Munich court garden, Friedrich Ludwig von Sckell. He went to Italy in 1826, and in Rome was commissioned by Ludwig I of Bavaria to paint a view of Palermo. In 1827, after a visit to southern Italy and Sicily, Rottmann returned to Munich and presented a proposal for a cycle of Italian landscapes for the arcades of the court garden, which had been remodeled by Leo von Klenze in 1822. Ludwig agreed to this proposal and sponsored Rottmann's second visit to Italy in 1829. From studies made on this trip Rottmann painted twenty-eight landscapes for the arcade, 1830–33. A similar project depicting Greek landscapes occupied him for the rest of his life; from 1834 to 1835 he traveled in Greece, and from 1838 to 1850 he painted the landscapes (Neue Pinakothek, Munich). In 1840 he was invited to the Prussian court in Berlin, but he chose to remain in Munich where King Ludwig named him court painter with an annual pension. Rottmann was able to complete the Greek cycle before he died.

PHILIPP OTTO RUNGE
Wolgast 1777–1810 Hamburg

Runge's father was a prosperous shipowner in Wolgast, a town in Swedish Pomerania. Runge's artistic talent first manifested itself in delicate paper cut-outs of flowers. He studied with the novelist and poet Ludwig Theobul Kosegarten, whose pantheistic outlook had a deep influence on his pupil. In 1795 Runge began a four-year business apprenticeship in a Hamburg shipping firm where his brother Daniel worked. There he became associated with his brother's circle of friends, which included the writer Ludwig Tieck. In 1797 he studied drawing with Heinrich Joachim Herterich, after which he went on to devote himself to painting. He entered the Copenhagen Academy in 1799. There he studied under Jens Juel, a portraitist, and Nicolai Abraham Abildgaard, a history painter. Runge adopted the school's Neoclassical teaching and was particularly influenced by the fine-line drawings of the English sculptor and draftsman John Flaxman. He entered the 1801 Weimarer Kunstfreunde competition, but his drawings were severely criticized. Thereafter he abandoned Neoclassical themes and began to evolve his own highly idiosyncratic art. In 1801 Runge visited FRIEDRICH in Greifswald, less than thirty miles from his native Wolgast, and the same year he moved to Dresden. Toward the end of 1802 he began his cycle of paintings *Four Times of Day,* which was of central importance for the early Romantic period. He visited GOETHE in Weimar in 1803. In 1804 he made his first major oil paintings, concentrating on portraits of his family and friends. He was married the same year to Pauline Bassenge, after which he returned to Hamburg. About this time he evolved his elaborate color theory, a development which is charted by his lengthy correspondence with Goethe. From 1806 to 1807 he stayed in Wolgast, and then once again returned to Hamburg. In 1807 he showed the first signs of tuberculosis, the disease to which he eventually succumbed. Despite his extremely short career, Runge is one of the most important Romantic artists. His aim was to rejuvenate the traditions of Christian art by replacing biblical iconography with allegories of nature; his radical outlook is documented both by his paintings and extensive writings. He lived to see the publication of his color theory in 1810. Thirty years later his brother Daniel prepared an edition of his letters.

WILHELM VON SCHADOW
Berlin 1788–1862 Düsseldorf

Schadow's father, Johann Gottfried Schadow, was a sculptor and director of the Berlin Academy. Schadow received his first instruction in art from his father; in 1808 he entered the Berlin Academy where Friedrich Georg Weitsch was his teacher. In 1810 he was granted a stipend by Alexander von Humboldt,

which allowed him and his older brother Rudolf, a sculptor, to travel to Rome in 1811. There he entered the Nazarene circle of OVERBECK, and in 1813 he became an official member of the Brotherhood of St. Luke. The following year he converted to Catholicism. In 1816 he collaborated with Overbeck, CORNELIUS, and VEIT on the Casa Barthody fresco cycle. In 1819 Schadow returned to Berlin where he was a professor at the Academy. In 1826, replacing Cornelius, he was appointed director of the Düsseldorf Academy. During this period he executed portraits, religious paintings, and designs for the theater. In 1830–31 he traveled to Rome, returning there in 1839–40. In 1842 he received an honorary degree from Bonn University, and was ennobled in 1845. He resigned from the Academy in Düsseldorf in 1859. During his tenure there Schadow implemented a major program of reorganization, making the school one of the most progressive art centers in Europe. Among his students were Johann Wilhelm Schirmer, Carl Friedrich Lessing, Alfred Rethel, and FEUERBACH. Schadow suffered a stroke in 1857; he died five years later.

KARL FRIEDRICH SCHINKEL
Neuruppin 1781–1841 Berlin

Karl Friedrich Schinkel was born in Neuruppin, north of Berlin. His father, who was superintendent of the churches and schools of Neuruppin, was killed in 1787 during a fire that destroyed much of the town. In 1794 the family moved to Berlin. Schinkel began to study architecture under Friedrich Gilly and his son David in 1798. When the Berlin Academy of Architecture opened in 1799 Schinkel enrolled in its first classes. He also continued his apprenticeship under the Gillys and, following Friedrich Gilly's death in 1800, completed several of his commissions. He left Berlin in 1803 for a two-year study tour of Saxony, Austria, Italy, Sicily, and France. During this tour he met the Neoclassicist KOCH in Rome. The political situation in Berlin upon his return in 1805 made it impossible for Schinkel to find architectural commissions, and he devoted the following ten years largely to painting and lithography. In 1809 he married Susanna Berger and became acquainted with the Berlin literary circle, which included Achim and Bettina von Arnim, Clemens von Brentano, and Ernst Theodor Amadeus Hoffmann. In 1810 Schinkel received an official appointment to the public works commission. That year he saw the paintings of FRIEDRICH, then on display in Berlin, and was deeply influenced by them. In 1816 Schinkel began to work as a set designer for the Berlin Nationaltheater. After the fall of Napoleon he began to find greater opportunities as an architect and was one of the major planners of the reconstruction of Berlin; among his major architectural works, Greek in style and national in philosophical approach, are the Royal Guard House (1816–18), the Schauspielhaus (1819–21), and the Altes Museum (1824–28). In 1816, 1820, and 1824 he visited GOETHE in Weimar. In 1820 Schinkel was named professor of architecture at the Berlin Academy. In 1824 he visited Italy, and in Rome collaborated with the sculptor Bertel Thorvaldsen in designing a funerary monument to Pope Pius VII. In 1826 he visited Paris and London, where he studied the innovations of industrial architecture. In 1830 he became head of the public works commission, and in 1838 he was named Geheimer Oberlandesbaudirektor, a title signifying his position as architect to the state. While Schinkel is renowned for his Neoclassical architecture, his paintings are in the forefront of the early Romantic movement. His designs for the theater have been preserved and are remarkable for their visionary and mystic character. In 1840 Schinkel suffered a stroke from which he never recovered.

JULIUS SCHNORR VON CAROLSFELD
Leipzig 1794–1872 Dresden

Schnorr took his first lessons from his father, Hans Veit Schnorr von Carolsfeld, a noted engraver and portraitist. In 1811 he went to the Vienna Academy, where he studied under Friedrich Heinrich Füger. More important to his developing style was his friendship with KOCH and FERDINAND OLIVIER. He lived in the Olivier household from 1814 to 1817. He made a brief trip to Rome early in 1817, but returned to the north and visited Salzburg with the Olivier brothers before settling in Rome. There he became acquainted

with the Nazarene circle of OVERBECK and was accepted into the Brotherhood of St. Luke. In 1818 he was joined in Rome by Friedrich Olivier, and in 1819 they lived and worked together with Theodor Rehbenitz in the Palazzo Caffarelli. From 1821 to 1827 he decorated a room in the Casino Massimo with frescoes illustrating Ariosto's *Orlando Furioso*. In 1825 he was commissioned to create a cycle of paintings for the Munich Residenz of King Ludwig of Bavaria. He remained in Italy for two more years, however, touring southern Italy and Sicily in 1826. In 1827 Schnorr married Maria Heller, the stepdaughter of Ferdinand Olivier and the sister-in-law of Friedrich Olivier. He moved to Munich in 1827 and began designing the decorative scheme for two projects in the Residenz. The first was a fresco cycle illustrating the *Nibelungen*, which was not completed until 1867. The second, executed from 1835 to 1842, was a series depicting scenes from German history. Schnorr was aided in this endeavor by the Olivier brothers and many students. In 1846 he moved to Dresden where he became a professor at the Academy. The following year he was named director of the Gemäldegalerie. He visited London in 1851. The last major project of Schnorr's life was a series of illustrations, the *Bible in Pictures*, on which he worked from 1852 to 1860, executing a total of 240 plates. This project was published in 1860 and was enormously popular, bringing the artist international recognition.

MORITZ VON SCHWIND
Vienna 1804 – 1871 Niederpöcking am Starnberger See

Moritz von Schwind was born in Vienna, where his father was a court secretary and counsel at the embassy. From 1818 to 1821 he was a student of philosophy at the university, and after his father's death in 1818 supported himself as an illustrator. He showed an early talent for music and became an accomplished violinist. In 1821 he entered the Vienna Academy, where he studied for two years under SCHNORR VON CAROLSFELD and Peter Krafft. His circle of friends included the painters Leopold Kupelwieser and the OLIVIER brothers; the poets Eduard von Bauernfeld, Nikolaus Lenau, and Franz Grillparzer; and the composer Franz Schubert. In 1828 Schwind moved to Munich where he lived until 1839. He briefly attended the Munich Academy, where he studied under CORNELIUS, who had a deep influence on his developing style. Through Cornelius, Schwind received a commission to decorate a room in the new Munich Residenz with illustrations of the plays of Ludwig Tieck. He made additional frescoes for the Residenz in later years. In 1834 he returned to Vienna. He toured Italy extensively the following year, spending time with the Nazarenes in Rome. In 1836 Schwind executed frescoes in the Munich Festsaalbau and in Hohenschwangau Palace. He moved to Karlsruhe in 1840 where he remained for four years, completing a large mural for the staircase area of the Kunsthalle. In 1840 Schwind became professor of history painting at the Frankfurt Städelsches Kunstinstitut, contributing also to the building's decoration. In 1847 he returned to Munich where he was appointed professor at the Academy. He contributed illustrations to the Munich journals *Fliegende Blätter* and *Münchner Bilderbogen*. From 1848 to 1864 he made a series of narrative oil paintings set in scenic locales, the so-called travel pictures. Thirty-three of these works were purchased about 1869 by Count Adolf Friedrich von Schack. His other major commissions were frescoes for the Wartburg, 1853–55, illustrating from Wagner's *Tannhäuser* the contest of the minstrels, which had taken place there in 1207, and for the Vienna Opera, 1863–67, illustrating scenes from the *Magic Flute*. In 1857 he visited London and Manchester. Schwind's poetic and frequently humorous scenes celebrate the world of legend and fantasy. He became, together with SPITZWEG and Adrian Ludwig Richter, one of the principal representatives of Biedermeier Romanticism.

MAX SLEVOGT
Landshut 1868 – 1932 Neukastel

Max Slevogt was born in Landshut, once the capital of Lower Bavaria, to a military family. He spent his childhood in Würzburg. In 1885 he moved to Munich and entered the Academy; initially he studied under Johann Caspar

Herterich. In 1886 and 1888 he studied under Wilhelm von Diez. In the spring of 1889 he attended the Académie Julian in Paris, where he came in contact with the French Impressionists. Later that year he visited Italy. In 1890 he returned to Munich, where he became acquainted with TRÜBNER and the art historian Karl Voll. Slevogt's paintings were included in the 1892 exhibition of the Munich Kunstverein. His work of this period shows the influence of Trübner and, to some extent, of BÖCKLIN. In 1896 he began to contribute illustrations to the journals *Jugend* and *Simplicissimus*. In 1898 he traveled with Voll to see the major Rembrandt exhibition in Amsterdam. In 1900 he returned to Paris and began to assimilate the techniques of Manet and the Impressionists. Slevogt spent 1900–1 in Frankfurt, painting some thirty pictures of animals at the Frankfurt zoo. He moved to Berlin in 1901, to Munich in 1908. In 1912 he painted a mural cycle in the garden pavilion of Dr. Johannes Guthmann in Neu-Cladow, near Berlin. He visited Egypt in 1913–14. At the outbreak of World War I he went to the German front lines to paint battle scenes. Slevogt became a member of the Berlin Academy in 1914, and a year later a member of the Dresden Academy. His oeuvre is comprehensive; he painted portraits, still lifes, landscapes, mythical subjects, murals, and stage sets. He also produced a large number of graphic illustrations, the most famous being his 1922 drawings for the *Thousand and One Nights* and *Faust Part II*, 1925–27. His last major work was a mural of Golgotha for the Friedenskirche in Ludwigshafen am Rhein. Slevogt died in his country residence in Neukastel in the Pfalz district, southeast of Frankfurt.

JOHANN SPERL
Buch 1840 – 1914 Bad Aibling

Born to a simple, rural family, Sperl received his early training in Nürnberg as a lithographer; from 1860 to 1863 he attended the Nürnberg school of applied arts. He established his own lithography studio in Arnstadt, Thuringia, in 1863. In 1865 he moved to Munich where he attended the Academy. He studied first with Hermann Anschütz and later, in 1866, with the genre painter Arthur von Ramberg. He was close friends with several students there: LEIBL, Theodor Alt, and Rudolf Hirth du Frênes. These four artists shared a studio and formed the nucleus of what came to be known as the Leibl circle. Sperl established a lifelong friendship with Leibl, who encouraged him to concentrate on landscape painting rather than genre scenes and still lifes. In 1869 Sperl saw the work of Gustave Courbet at the International Exhibition in Munich, work he emulated as he did that of the Barbizon painters. In 1873 he visited Leibl in Grasslfing, near Dachau, and over the next three decades lived and worked with Leibl in various Bavarian villages: Unterschondorf am Ammersee, Berbling, Bad Aibling, and Kutterling. Together the artists executed nine canvases, Sperl painting the landscapes, Leibl the figures. After Leibl's death in 1900 Sperl remained in Kutterling for another ten years. On suffering a stroke, he returned to Bad Aibling, where he died four years later. He was buried next to Leibl in Würzburg.

CARL SPITZWEG
Munich 1808 – 1885 Munich

The son of an affluent tradesman, Spitzweg trained as a pharmacist. He traveled through Italy in 1832. The following year he became ill, and while recuperating at the spa Bad Sulz he made the acquaintance of the painter Christian Heinrich Hansonn, who instructed him in drawing and encouraged him to devote his career to painting. Largely a self-taught artist, Spitzweg was greatly influenced by the French and Dutch masters. In 1834 and 1836 he traveled through Germany and Austria, making studies of local communities. By 1839 he had mastered the anecdotal style for which he is best known, although *The Poor Poet*, 1839 (no. 87), exhibited at the Munich Kunstverein the same year, was not well received. In the 1840s he made several trips to Italy. After 1844 he was an illustrator for several newspapers and journals, among them the Munich *Fliegende Blätter*. In 1847 he was introduced to SCHWIND with whom he shared many of the same artistic concerns. He visited Paris, London, Brussels, and

273

Antwerp in 1851 in the company of the painter Eduard Schleich. During this journey he was particularly affected by the landscapes of the Barbizon painter Narcisse Diaz and by those of John Constable. He was also influenced by the work of Eugène Delacroix. After 1852 Spitzweg remained in Munich, where he attracted an enthusiastic following. In 1868 he was made an honorary member of the Munich Academy. Toward the end of his life he made many short trips to Bavaria and Austria. His genre scenes represent the essence of Munich Biedermeier art, a style that depicts lower middle-class life with humor and irony. Spitzweg was widely acclaimed during his lifetime.

HANS THOMA
Bernau 1839–1924 Karlsruhe

Born in the Black Forest to a family of manual laborers, Thoma studied lithography in Basel in 1853, and after 1855 worked in Furtwangen with a miniaturist, painting watches and jewelry cases. He entered the Karlsruhe Kunstschule in 1858 where his teachers included Ludwig Descoudres, Johann Wilhelm Schirmer, and Hans Canon. His major interest during this period was landscape. In 1867 he went to the Düsseldorf Academy, where he became acquainted with Otto Scholderer. He visited Paris with Scholderer in 1868; the work of Gustave Courbet had a deep influence on him. From 1868 to 1870 he lived in Bernau and Karlsruhe; he spent the summer months with his mother and sister, and in the winter taught at the Karlsruhe Kunstschule. In 1870 he moved to Munich, where he became associated with the Leibl circle and with the painters Viktor Müller, Wilhelm Steinhausen, and BÖCKLIN. In 1874 Thoma went to Italy with Emil Lugo and Albert Lang; in Rome he met MARÉES. Returning to Germany in 1876, he lived in Frankfurt, where he shared a studio with Wilhelm Steinhausen. The following year he married his student Bonicella Berteneder. Thoma's oeuvre of naturalistic portraits, landscapes, and still lifes expanded to include mythological scenes inspired by the work of Böcklin. He returned to Italy many times; in 1880 he stayed in Rome for several months, and in 1886 he visited Adolf von Hildebrand in Florence. The 1890 exhibition of his paintings at the Munich Kunstverein brought wider recognition of his work. In 1899 he moved to Karlsruhe, where he had been named professor of the Kunstschule and director of the Karlsruhe Gallery. His seventieth birthday was marked by the founding of the Thoma museum in Karlsruhe. Shortly before his death, major retrospective exhibitions of his work were held in Basel and Zürich.

WILHELM TRÜBNER
Heidelberg 1851–1917 Karlsruhe

Trübner was originally trained as a goldsmith, following the profession of his father. In 1867 he met FEUERBACH, who urged him to pursue a career in art. He received his first instruction at the Karlsruhe Kunstschule from 1867 to 1868, where he studied under the painter of battle scenes Fedor Dietz. In 1869 he transferred to the Munich Academy and studied with Alexander Wagner. He saw the work of Gustave Courbet and LEIBL at the 1869 International Exhibition in Munich and was deeply influenced by their example. Trübner moved to Stuttgart in order to study with Hans Canon; however, he returned to the Munich Academy in 1870. During this period he studied under Wilhelm von Diez and became acquainted with Albert Lang and Carl Schuch, with whom he painted the landscape around the Starnberger See at Bernried, near Munich. There he met Leibl who advised him to work independently. Trübner soon became associated with the Leibl circle and in 1872 shared a studio with THOMA and Lang in Munich. Also in 1872 he visited Italy with Schuch and Lang, and over the next three years traveled to Italy, Holland, and Belgium before settling in Munich in 1875. After 1877 he began to paint mythological and literary themes in a naturalistic manner. In 1879 he visited Paris. During the next decades he associated with Thoma, CORINTH, SLEVOGT, and LIEBERMANN. He visited London in 1884–85. In 1889 the Gurlitt Gallery in Berlin sponsored an exhibition of his work, and Trübner again visited Paris. About this time he began to concentrate increasingly on landscape painting.

He moved to Frankfurt in 1895 to teach at the Städelsches Kunstinstitut. His theories of art were published in 1892 and 1898. He became a member of the Berlin Secession in 1901. From 1903 to 1917 he was professor at the Karlsruhe Academy, and director there in 1904 and 1910. In 1907 he became a member of the Munich Secession. In 1911 his paintings were exhibited at the Karlsruhe Kunstverein. This was followed in 1913 by a major exhibition of his work with the Berlin Secession. In 1917 Trübner was invited to teach at the Berlin Academy, but illness prevented him from accepting the post; he died the same year.

PHILIPP VEIT
Berlin 1793–1877 Mainz

Veit's maternal grandfather was the philosopher Moses Mendelssohn, another of whose grandsons was the composer Felix Mendelssohn. His parents were separated while he was a child, as his mother eloped with, and later married the philosopher Friedrich Schlegel. In 1808 he moved to Dresden with his brother, Johannes; they both entered the Dresden Academy the following year. He studied under Johann Friedrich Matthaei and briefly under FRIEDRICH. In 1810, following the example of his mother and stepfather, he converted to Catholicism. In 1811 he moved to Vienna, where he lived with his stepfather, and through him met KOCH and the poets Joseph Eichendorff and Theodor Körner. Veit's work at this time consisted largely of portraits. During the 1813–14 War of Liberation Veit was a volunteer in the Lützow Free Corps. When peace was declared he returned to Vienna, and the following year went to Rome, where he joined the Nazarene circle of OVERBECK and CORNELIUS; he was accepted into the Brotherhood of St. Luke in 1815. Veit collaborated with Overbeck, Cornelius, and SCHADOW on the decoration of the Casa Bartholdy, 1816–17. From 1818 to 1824 he painted the ceiling of the Dante room in the Casino Massimo. In 1821 he married a Roman girl, fifteen-year-old Karolini Pulini. Veit remained in Rome until 1830, when he left for Frankfurt and assumed the directorship of the Städelsches Kunstinstitut. He held this post for thirteen years; during his tenure he commissioned mural decorations for the Städel by Overbeck, and himself contributed one large fresco, *The Introduction of the Arts in Germany Through Christianity,* 1832–37. In 1854 he was named director of the Städtischen Galerie in Mainz. His last major commission was a fresco cycle for the dome of Mainz cathedral, 1859–64, a work that was largely carried out by his assistants. Veit's prolific writings on art were published posthumously.

Selected Bibliography

I.

Beenken, Hermann T. *Das neunzehnte Jahrhundert in der deutschen Kunst: Aufgaben und Gehalte, Versuch einer Rechenschaft.* Munich, 1944.

Boetticher, Friedrich von. *Malerwerke des neunzehnten Jahrhunderts.* 2 vols. 1891–1901. Reprint: Leipzig, 1948.

Brion, Marcel. *German Painting.* New York, 1959.

Bünemann, Hermann. *Deutsche Malerei des 19. Jahrhunderts.* Königstein, 1961.

Finke, Ulrich. *German Painting from Romanticism to Expressionism.* London, 1974.

Geismeier, Willi. *Deutsche Malerei des 19. Jahrhunderts.* Leipzig, 1966.

————. "Die Nazarener Fresken der Casa Bartholdy." *Forschungen und Berichte Staatliche Museen.* Vol. 9. East Berlin, 1967.

Gurlitt, Cornelius. *Die deutsche Kunst seit 1800: Ihre Ziele und Taten.* 4th ed. Berlin, 1924.

Hamann, Richard. *Die deutsche Malerei im 19. Jahrhundert.* Leipzig/Berlin, 1914.

Hamilton, George Heard. *Painting and Sculpture in Europe 1880–1940.* 2nd rev. ed. The Pelican History of Art. Harmondsworth, England, 1972. Reprint: 1979.

Hofmann, Werner. *The Earthly Paradise: Art in the Nineteenth Century.* Translated by Brian Battershaw. New York/London, 1961.

————. *Das irdische Paradies: Kunst im 19. Jahrhundert.* 2nd ed. Munich, 1974.

Keller, Horst. *Deutsche Maler des 19. Jahrhunderts.* Munich, 1979.

La Mazelière, Marquis de. *La Peinture allemande au XIX siècle.* Paris, 1900.

Lankheit, Klaus. "Nibelungen-Illustrationen der Romantik, zur Säkularisierung christlicher Bildformen im 19. Jahrhundert." *Zeitschrift für Kunstwissenschaft,* 7 (1953): 95–112.

————. *Revolution und Restauration.* Kunst der Welt. Baden-Baden, 1965.

Lindemann, Gottfried. *History of German Art: Painting, Sculpture, Architecture.* New York, 1971.

Novotny, Fritz. *Painting and Sculpture in Europe 1780–1880.* 3rd ed. The Pelican History of Art. Harmondsworth, England/New York, 1978.

Osborn, Max. *Das 19. Jahrhundert: Die Kunst von 1800 bis zur Gegenwart.* 9th ed. Leipzig, 1925.

Pauli, Gustav. *Das neunzehnte Jahrhundert.* Geschichte der deutschen Kunst, 4, edited by Georg Gottfried Dehio. Berlin/Leipzig, 1934.

Rave, Paul Ortwin. *Deutsche Malerei des 19. Jahrhunderts.* Berlin, 1945.

Rosenblum, Robert. *Modern Painting and the Northern Romantic Tradition: Friedrich to Rothko.* New York/London, 1975.

Schultze, Jürgen. *Art of Nineteenth Century Europe.* New York, 1972.

Schümann, C. W. *Deutsche Malerei des 19. Jahrhunderts.* Cologne, 1971.

Zeitler, Rudolf W. *Die Kunst des 19. Jahrhunderts.* Propyläen-Kunstgeschichte, 11. Berlin, 1966.

II.

Andrews, Keith. *The Nazarenes: A Brotherhood of German Painters in Rome.* Oxford, 1964.

Bachleitner, Rudolf. *Die Nazarener.* Munich, 1976.

Badt, Kurt. *Wolkenbilder und Wolkengedichte der Romantik.* Berlin, 1960.

Baumgart, Fritz. *Vom Klassizismus zur Romantik.* Cologne, 1974.

Becker, Wolfgang. *Paris und die deutsche Malerei 1740–1850.* Studien zur Kunst des neunzehnten Jahrhunderts, 10. Munich, 1971.

Bernhard, Klaus. *Idylle: Theorie, Geschichte, Darstellung in der Malerei 1750–1850, zur Anthropologie der deutschen Seligkeitsvorstellungen.* Dissertationen zur Kunstgeschichte, 4. Cologne/Vienna, 1977.

Bernhard, Marianne. *Deutsche Romantik Handzeichnungen.* Afterword by Petra Kipphoff. 2 vols. 2nd rev. ed. Munich, 1974.

Börsch-Supan, Helmut. *Deutsche Romantiker: Deutsche Maler zwischen 1800 und 1850.* Munich, 1972.

Brieger, Peter. *Die deutsche Geschichtsmalerei des 19. Jahrhunderts.* Kunstwissenschaftliche Studien, 7. Berlin, 1930.

Brion, Marcel. *Art of the Romantic Era: Romanticism, Classicism, Realism.* New York, 1966.

Cassirer, Else, ed. *Künstlerbriefe aus dem 19. Jahrhundert.* Berlin, 1923.

Christoffel, Ulrich. *Die romantische Zeichnung von Runge bis Schwind.* Munich, 1920.

Deusch, Werner Richard. *Malerei der deutschen Romantiker und ihrer Zeitgenossen.* Berlin, 1937.

Einem, Herbert von. *Deutsche Malerei des Klassizismus und der Romantik: 1760 bis 1840.* Munich, 1978.

Eitner, Lorenz Edwin Alfred. "The Open Window and the Storm-Tossed Boat: An Essay in the Iconography of Romanticism." *Art Bulletin* 37 (Dec. 1955): 281–90.

Eitner, Lorenz Edwin Alfred, ed. *Neoclassicism and Romanticism: 1750–1850, Sources and Documents.* 2 vols. Sources and Documents in the History of Art, edited by H. W. Janson. Englewood Cliffs, N. J., 1966.

Franke, Dr. Ernst A. *Publikum und Malerei in Deutschland vom Biedermeier zum Impressionismus.* Emsdetten [1937]

Geck, Martin. *Die Bildnisse Richard Wagners.* Studien zur Kunst des 19. Jahrhunderts, 9. Munich, 1970.

Geismeier, Willi. *Biedermeier: Das Bild vom Biedermeier, Zeit und Kultur des Biedermeier.* Leipzig, 1979.

Geller, Hans. *Deutsche Künstler in Rom. Von Raphael Mengs bis Hans von Marées (1741–1887): Werke und Erinnerungsstätten.* Rome, 1961.

Grote, Ludwig, ed. *Beiträge zur Motivkunde des 19. Jahrhunderts.* Studien zur Kunst des 19. Jahrhunderts, 6. Munich, 1970.

Hamann, Richard, and Hermand, Jost. *Deutsche Kunst und Kultur von der Gründerzeit bis zum Expressionismus.* 3 vols. Berlin, 1959–65.

Haverkamp-Begemann, Egbert, ed. *Correlations Between German and Non-German Art in the Nineteenth Century; A Symposium Held at Yale University, November 1970.* Yale University Art Gallery Bulletin (Oct. 1972).

Heise, Carl Georg. *Deutsche Zeichner des XIX. und XX. Jahrhunderts.* Berlin, 1946.

Holt, Elizabeth Basye Gilmore, ed. *From the Classicists to the Impressionists: A Documentary History of Art and Architecture in the 19th Century.* A Documentary History of Art, 3. New York, 1966.

Honour, Hugh. *Romanticism.* New York, 1979.

Jensen, Jens Christian. *Aquarelle und Zeichnungen der deutschen Romantik.* Cologne, 1978.

Justi, Ludwig, and Weissgärber, H. *Zeichnungen deutscher Meister vom Klassizismus bis zum Impressionismus.* Berlin, 1954.

Kaiser, Konrad. *Patriotische Kunst. Patriotische Kunst aus der Zeit der Befreiungskriege.* Berlin, 1953.

Kleinmayr, Hugo von. *Die deutsche Romantik und die Landschaftsmalerei.* Studien zur Deutschen Kunstgeschichte, 147. Strassburg, 1972.

Lankheit, Klaus. *Das Freundschaftsbild der Romantik.* Heidelberger Kunstgeschichtliche Abhandlungen, new series, 1, edited by Walter Paatz. Heidelberg, 1952.

Ludwig, Horst. *Münchner Malerei im 19. Jahrhundert.* Munich, 1978.

Neidhardt, Hans Joachim. *Die Malerei der Romantik in Dresden.* Leipzig, 1976.

Nochlin, Linda. *Realism.* Baltimore, 1971.

Nochlin, Linda, ed. *Realism and Tradition in Art: 1848–1900, Sources and Documents.* Sources and Documents in the History of Art, edited by H. W. Janson. Englewood Cliffs, N. J., 1966.

Pevsner, Nikolaus. *Academies of Art, Past and Present.* New York, 1973.

Plagemann, Volker. *Das deutsche Kunstmuseum, 1790–1870: Lage, Baukörper, Raumorganisation, Bildprogramm.* Studien zur Kunst des 19. Jahrhunderts, 3. Munich, 1967.

Rümann, A. *Die illustrierten deutschen Bücher des 19. Jahrhunderts.* Stuttgart, 1926.

Scheidig, Walther. *Goethes Preisaufgaben für bildende Künstler 1799–1805.* Schriften der Goethe-Gesellschaft, 57. Weimar, 1958.

Schmidt, Paul Ferdinand. *Deutsche Landschaftsmalerei von 1750–1830.* Munich, 1922.

Schrade, Hubert. *Deutsche Maler der Romantik.* Cologne, 1967.

———. *German Romantic Painting.* Translated by Maria Pelikan. New York, 1977.

Stechow, Wolfgang, comp. *Deutsche Bildnisse aus zwei Jahrhunderten (1700–1875).* Göttingen, 1925.

Stehle, R. L. "The Düsseldorf Gallery of New York." *New-York Historical Society Quarterly,* 58 (Oct. 1974): 304–14, with a note on "Düsseldorf Artists," by Kathleen Luhrs, pp. 315–17.

Vaughan, William. *Romantic Art.* New York/Toronto, 1978.

———. *German Romanticism and English Art.* New Haven/London, 1979.

———. *German Romantic Painting.* New Haven/London, 1980.

Waldmann, Emil. *Die Kunst des Realismus und des Impressionismus im 19. Jahrhundert.* 3rd ed. Propyläen-Kunstgeschichte, 15. Berlin, 1942.

Wichmann, Siegfried. *Realismus und Impressionismus in Deutschland.* Stuttgart, 1964.

III.

Berlin, 1906. Königliche Nationalgalerie. *Deutsche Kunst aus der Zeit von 1775–1875.* By Hugo von Tschudi. 2 vols. Munich.

Berlin, 1957. Nationalgalerie. *Deutsche Landschaftsmalerei 1800–1914.*

Berlin, 1978. Schloss Charlottenburg. *Zeichnungen und Aquarelle deutscher Meister 1750 bis 1900. Aus den Sammlungen der Stiftung Pommern, Kiel.*

Bern, 1936. Kunsthalle. *Deutsche Malerei im 19. Jahrhundert.*

Bremen, 1959. Kunsthalle. *Um 1800: Deutsche Kunst von Schadow bis Schwind.*

Bremen, 1967. Kunsthalle. *Berliner Biedermeier von Blechen bis Menzel: Gemälde, Handzeichnungen, Aquarelle, Druckgraphik aus dem Besitz Berliner Museen und der Kunsthalle Bremen.* By Henning Bock et al.

Cambridge, Mass., 1972. Busch-Reisinger Museum, Harvard University. *German Master Drawings of the Nineteenth Century.*

Cincinnati, 1978. Cincinnati Art Museum. *Munich and American Realism in the 19th Century.* By Richard V. West. Essays by Michael Quick and Eberhard Ruhmer.

Cologne, 1949. Wallraf-Richartz-Museum. *Deutsche Malerei und Zeichenkunst im Zeitalter Goethes.*

Cologne, 1971. Kunsthalle. *Deutsche Malerei des 19. Jahrhunderts.* By Carl-Wolfgang Schümann.

Cologne, 1972. Wallraf-Richartz-Museum. *Sehnsucht nach Italien; Deutsche Zeichner im Süden. 1770–1830. Eine Ausstellung für Horst Keller zum 60. Geburtstag.*

Darmstadt, 1977. Hessisches Landesmuseum. *Es ist nur ein Rom in der Welt.*

Darmstadt, 1979. Matildenhöhe. *Darmstadt in der Zeit des Klassizismus und der Romantik.*

Detroit, 1949. Detroit Institute of Arts. *German Paintings and Drawings from the Time of Goethe in American Collections.* Essay by Ernst Scheyer.

Dortmund, 1956. Museum für Kunst und Kulturgeschichte der Stadt Dortmund. *Blick aus dem Fenster: Gemälde und Zeichnungen der Romantik und des Biedermeiers.*

Dublin, 1976. National Gallery of Ireland. *Nineteenth Century German Drawings and Water-colours from the Collections of the Kunstmuseum, Düsseldorf.* By Dieter Graf. Düsseldorf.

Duisburg, 1969. Wilhelm-Lembruck Museum. *Industrie und Technik in der deutschen Malerei von der Romantik bis zur Gegenwart.*

Düsseldorf, 1976. Kunstmuseum. *The Hudson and the Rhine: Die amerikanische Malerkolonie in Düsseldorf im 19. Jahrhundert.* By Wend von Kalnein, Rolf Andree, and Ute Ricke-Immel.

Düsseldorf, 1979. Kunstmuseum. *Die Düsseldorfer Malerschule.* Edited by Wend von Kalnein.

Düsseldorf, 1980. Kunsthalle. *Deutsche Malerei des 19. Jahrhunderts: 60 Meisterwerke aus der Nationalgalerie Berlin Staatliche Museen Preussischer Kulturbesitz.*

East Berlin, 1965. Nationalgalerie, Staatliche Museen zu Berlin. *Deutsche Romantik: Gemälde, Zeichnungen.* Compiled by Willi Geismeier and Gottfried Riemann.

East Berlin, 1966. Nationalgalerie, Staatliche Museen zu Berlin. *Deutsche Kunst 19./20. Jahrhundert.* Introduction by Willi Geismeier.

East Berlin, 1976. Nationalgalerie, Staatliche Museen zu Berlin. *Malerei der Deutschen Impressionisten.* By Lothar Brauner.

Frankfurt am Main, 1966. Frankfurter Kunstverein. *Frankfurter Malerei im 19. Jahrhundert.* By Ewald Rathke.

Frankfurt am Main, 1977. Städelsches Kunstinstitut und Städtische Galerie. *Die Nazarener.* Edited by Klaus Gallwitz, with Hans Ziemke et al.

Frankfurt am Main, 1978. Städelsches Kunstinstitut und Städtische Galerie. *Deutsche Malerei 1890–1918: Eine Ausstellung für die Eremitage in Leningrad.*

Hamburg, 1978. Kunsthalle. *Courbet und Deutschland.* By Werner Hofmann, Helmut R. Leppien et al.

Heidelberg, 1965. Kurpfälzisches Museum im Ottheinrichsbau des Heidelberger Schlosses. *Schlösser, Burgen, Ruinen in der Malerei der Romantik; Gemälde, Aquarelle und Graphik deutscher, österreichischer und schweizer Künstler 1770 bis 1860.*

Innsbruck, 1970. *Österreichische Malerei des 19. Jahrhunderts aus Privatbesitz.*

Karlsruhe, 1965. Badischer Kunstverein. *Romantiker und Realisten; Maler des 19. Jahrhunderts in Baden.* Essay by Klaus Gallwitz.

Laxenburg, 1968. Schloss Laxenburg. *Romantik und Realismus in Österreich: Gemälde und Zeichnungen aus der Sammlung Georg Schäfer, Schweinfurt.* By Konrad Kaiser et al. Schweinfurt.

Leipzig, 1926. Museum der bildenden Künste and Leipziger Kunstverein. *Deutsch-römische Malerei und Zeichnung 1790–1830.*

London, 1956. Tate Gallery. *A Hundred Years of German Painting.* Compiled by Dr. Peter Anselm Riedl.

London, 1959. Tate Gallery and Arts Council Gallery. *The Romantic Movement.* Fifth Exhibition of the Council of Europe. Arts Council of Great Britain.

London, 1968. Victoria and Albert Museum. *Nineteenth-century German Drawings and Water-colours.*

London, 1972. Royal Academy of Arts and Victoria and Albert Museum. *The Age of Neo-Classicism.* Fourteenth Exhibition of the Council of Europe. Arts Council of Great Britain.

London, 1979. Royal Academy of Arts. *Post-Impressionism: Cross-Currents in European Painting.* Edited by John House and Mary Anne Stevens.

Lübeck, 1957. St. Annen-Museum and Overbeck Gesellschaft Lübeck. *Die Bildniszeichnung der deutschen Romantik.* By Jens Christian Jensen.

Lübeck, 1969. Museen für Kunst und Kulturgeschichte der Hansestadt Lübeck. *Deutsche Zeichnungen 1800–1850 aus der Sammlung Winterstein: Zum 100. Todestages Friedrich Overbecks.*

Lucerne, 1950. Kunstmuseum. *Wiener Biedermeier—Maler und Carl Spitzweg aus den Sammlungen des Fürsten von Liechtenstein.* By Gustav Wilhelm.

Moscow, 1974. Pushkin Museum. *Deutsche Malerei im 19. Jahrhundert: Eine Ausstellung für Moskau und Leningrad.*

Munich, 1914. Königliche Neue Pinakothek. *Sammlung Stransky: Deutsche Meister des XIX. Jahrhunderts.* Foreword by Dr. Heinz Braune.

Munich, 1950. Städtische Galerie. *Deutsche Romantiker in Italien.*

Munich, 1956. Haus der Kunst. *Deutsche Zeichnungen 1400–1900.*

Munich, 1958. Haus der Kunst. *München 1869–1958: Aufbruch zur modernen Kunst (Rekonstruktion der Ersten Internationalen Kunstausstellung 1869, Leibl und sein Kreis, Vom Jugendstil zum Blauen Reiter, Gegenwart).*

Munich, 1958. Staatliche Graphische Sammlung. *Deutsche Zeichenkunst der Goethezeit: Handzeichnungen und Aquarelle aus der Sammlung Winterstein.* By Peter Halm.

Munich, 1979. Bayerische Staatsgemäldesammlungen and Ausstellungsleitung Haus der Kunst. *Die Münchner Schule: 1850–1914.* By Dr. Eberhard Ruhmer.

New Haven, 1970. Yale University Art Gallery. *German Painting of the 19th Century.* By Kermit S. Champa, with Kate H. Champa.

New York, 1909. Metropolitan Museum of Art. *Exhibition of Contemporary German Art.* Essay by Paul Clemen. Translated by G. E. Maberly-Oppler. Berlin.

New York, 1967. Brooklyn Museum. *The Triumph of Realism.* By Donelson F. Hoopes and Axel von Saldern. Introduction by Axel von Saldern.

Nürnberg, 1966. Germanisches Nationalmuseum. *Klassizismus und Romantik in Deutschland: Gemälde und Zeichnungen aus der Sammlung Georg Schäfer, Schweinfurt.* By Konrad Kaiser, Jens Christian Jensen et al.

Nürnberg, 1967. Germanisches Nationalmuseum. *Der frühe Realismus in Deutschland 1800–1850: Gemälde und Zeichnungen aus der Sammlung Georg Schäfer, Schweinfurt.* By Konrad Kaiser et al.

Nürnberg, 1977. Germanisches Nationalmuseum. *125 Jahre Germanisches Nationalmuseum 1852–1977: Meisterwerke aus dem Kupferstichkabinett.*

Nürnberg, 1977. Germanisches Nationalmuseum. *Sammlung Georg Schäfer, Schweinfurt: Deutsche Malerei im 19. Jahrhundert.* By Jörn Bohns. Forewords by Georg Schäfer and Arno Schönberger. Essays by Wulf Schadendorf and Jens Christian Jensen.

Oxford, 1977. Ashmolean Museum. *A Selection of Drawings by the Nazarenes and Their Associates.* Compiled by Colin J. Bailey.

Paris, 1976. Orangerie des Tuileries. *La Peinture allemande à l'époque du romantisme.*

Philadelphia, 1936. Philadelphia Museum of Art. *German Art from the Fifteenth to the Twentieth Century: An Exhibition of Paintings, Watercolors, and Drawings Held Under the Auspices of the Oberlaender Trust (The Carl Schurz Memorial Foundation).*

Stendal and Weimar, 1975–76. Winckelmann-Museum and Kunstsammlungen. *Italia und Germania: Deutsche Klassizisten und Romantiker in Italien.*

Utica, 1973. Munson-Williams-Proctor Institute. *The Düsseldorf Academy and the Americans: An Exhibition of Drawings and Watercolors.* By Donelson F. Hoopes. Essays by Wend von Kalnein and Donelson F. Hoopes.

Venice, 1977. Napoleonica. *Classici e romantici tedeschi in Italia: Opera d'arte dei Musei della Repubblica Democratica Tedesca.* By Claude Keisch. Introduction by Giulio Carlo Argan.

Wiesbaden, 1947. Landesmuseum. *Deutsche Malerei des neunzehnten Jahrhunderts.* Central Collecting Point.

Winterthur, 1933. Kunstmuseum. *Deutsche und Schweizer Maler des 19. Jahrhunderts aus der Sammlung Oskar Reinhart.*

IV.

Karl Blechen

Heider, Gertrud. *Karl Blechen.* Leipzig, c. 1970.

Rave, Paul Ortwin. *Karl Blechen: Leben, Würdigungen, Werk.* Denkmäler Deutscher Kunst. Berlin, 1940.

Exhibition catalogues

East Berlin, 1973. Nationalgalerie, Staatliche Museen zu Berlin. *Karl Blechen, 1798–1840: Ölskizzen, Aquarelle, Sepiablätter, Zeichnungen, Entwürfe.* Compiled by Lothar Brauner.

Munich, 1973. Haus der Kunst. *Karl Blechen.*

Arnold Böcklin

Andree, Rolf. *Arnold Böcklin: Beiträge zur Analyse seiner Bildgestaltung.* Düsseldorf, 1962.

Andree, Rolf, et al. *Arnold Böcklin: Die Gemälde.* Schweizerisches Institut für Kunstwissenschaft, Zürich. Oeuvrekataloge Schweizer Künstler, 6. Basel/Munich, 1977.

Dollinger, Hans, comp. *Böcklin.* Translated by Thomas Bourke. Munich, 1975.

Schmid, Heinrich Alfred. *Arnold Böcklin.* 2nd ed. Munich, 1923.

Tittel, Lutz. *Arnold Böcklin: Leben und Werk in Daten und Bildern.* 2nd ed. Insel Taschenbuch, 284. Frankfurt am Main, 1978.

Exhibition catalogues

Basel, 1977. Kunstmuseum. *Arnold Böcklin, 1827–1901: Gemälde, Zeichnungen, Plastiken. Ausstellung zum 150. Geburtstag.* Basel/Stuttgart.

Düsseldorf, 1974. Städtisches Kunstmuseum. *Arnold Böcklin: 1827–1901.* Compiled by Rolf Andree.

London, 1971. Hayward Gallery. *Arnold Böcklin: 1827–1901.* By Rolf Andree. Translated by D. Cook Radmore. Sponsored by the Arts Council of Great Britain and the Pro Helvetia Foundation of Switzerland.

Carl Gustav Carus

Carl Gustav Carus (1798–1840) Lebenserinnerungen und Denkwürdigkeiten. Edited by E. Jansen. Weimar, 1966.

Carus, Carl Gustav. *Psyche: On the Development of the Soul. Part One: The Unconscious.* Translated by Renata Welch (from the 2nd corrected and expanded ed., Stuttgart, 1851). Dunquin Series, 3. New York, 1970.

_____. *Briefe über Landschaftsmalerei; Zuvor ein Brief von Goethe als Einleitung* (facsimile edition of 2nd enlarged ed., Leipzig, 1835). Edited by Dorothea Kuhn. Deutsche Neudrucke, Reihe: Goethezeit. Heidelberg, 1972.

Prause, Marianne. *Carl Gustav Carus: Leben und Werk.* Berlin, 1968.

Schlösser, Manfred. *Denkwürdigkeiten aus Europa, mitgeteilt von Carl Gustav Carus, zu einem Lebensbild. . . .* Hamburg, 1963.

Exhibition catalogues

Schweinfurt, 1970. Altes Rathaus. *Carl Gustav Carus und die zeitgenössische Dresdner Landschaftsmalerei: Gemälde aus der Sammlung Georg Schäfer.*

Lovis Corinth

Berend-Corinth, Charlotte. *Die Gemälde von Lovis Corinth: Werkkatalog.* Introduction by Hans Konrad Röthel. Munich, 1958.

Corinth, Lovis. *Gesammelte Schriften.* Malerbücher, 1. Berlin, 1920.

_____. *Selbstbiographie.* Leipzig, 1926.

Von der Osten, Gert. *Lovis Corinth.* 2nd ed. Munich, 1959.

Exhibition catalogues

Boston, 1950. Institute of Contemporary Art. *Lovis Corinth, 1858–1925: A Retrospective Exhibition.* By Julius S. Held.

Bremen, 1975. Kunsthalle. *Lovis Corinth: Handzeichnungen und Aquarelle 1875–1925.*

Cologne, 1976. Wallraf-Richartz-Museum and Kunsthalle. *Lovis Corinth: Gemälde, Aquarelle, Zeichnungen und druckgraphische Zyklen.*

Indianapolis, 1975. Indianapolis Museum of Art. *Lovis Corinth.*

London, 1959. Tate Gallery. *Lovis Corinth: An Exhibition of Paintings.* By H. K. Röthel.

Munich, 1975. Städtische Galerie im Lenbachhaus. *Lovis Corinth 1858–1925: Gemälde und Druckgraphik.* Compiled by Armin Zweite.

New York, 1964. Gallery of Modern Art. *Lovis Corinth: A Retrospective Exhibition.*

San Francisco, 1965. San Francisco Museum of Art. *Lovis Corinth 1858–1925.*

Peter von Cornelius

Einem, Herbert von. "Peter Cornelius." *Wallraf-Richartz-Jahrbuch,* 16 (1954): 104–60.

Graberg, Maria Luise von. *Die Nibelungen—Illustrationen von Johann Heinrich Füssli und Peter Cornelius.* Freie Universität, Berlin, 1970.

Kuhn, Alfred. *Peter Cornelius und die geistigen Strömungen seiner Zeit; mit den Briefen des Meisters an Ludwig I. von Bayern und an Goethe.* Berlin, 1921.

Markowitz, Irene. " 'Odysseus bei Polyphem,' eine verloren gemeldete Arbeit des Peter Cornelius." *Wallraf-Richartz-Jahrbuch XXII.* Cologne, 1960.

Salomon, Felix. *Die Faustillustrationen von Cornelius und Delacroix: Eine Parallele. . . .* Würzburg, 1930.

Exhibition catalogues

Berlin, 1956. Nationalgalerie, Staatliche Museen Preussischer Kulturbesitz. *Peter von Cornelius.*

Johann Georg von Dillis

Böttger, Peter. *Die Alte Pinakothek in München: Architektur, Ausstattung und museales Programm. Mit einem Anhang: Abdruck des frühesten Gemäldeverzeichnisses der Pinakothek aus dem Jahre 1838 von Georg von Dillis.* Studien zur Kunst des neunzehnten Jahrhunderts, 15. Munich, 1972.

Lessing, Waldemar. *Johann Georg von Dillis als Künstler und Museumsmann, 1759–1841.* Munich, 1951.

Messerer, Richard. "Georg von Dillis, Leben und Werk." *Oberbayerisches Archiv für vaterländische Geschichte* 84 (1961).

Messerer, Richard, ed. *Briefwechsel zwischen Ludwig I. von Bayern und Georg von Dillis, 1807–1841.* Schriftenreihe zur bayerischen Landesgeschichte, 65. Munich, 1966.

Exhibition catalogues

Munich, 1959. Bayerische Staatsgemäldesammlungen and Staatliche Graphische Sammlung. *Johann Georg von Dillis.*

Louis Eysen

Zimmermann, Werner. *Der Maler Louis Eysen.* Frankfurt am Main, 1963.

Anselm Feuerbach

Anselm Feuerbachs Briefe an seine Mutter. . . . Edited by G. J. Kern and Hermann Uhde-Bernays. 2 vols. Berlin, 1911.

Feuerbach, Anselm. *Ein Vermächtniss.* Vienna, 1882.

Uhde-Bernays, Hermann. *Feuerbach: Des Meisters Gemälde in 200 Abbildungen.* Stuttgart, 1913.

_____. *Feuerbach: Beschreibender Katalog seiner sämtlichen Gemälde.* Klassiker der Kunst, 22. Munich, 1929.

Exhibition catalogues

Karlsruhe, 1976. Kunsthalle. *Anselm Feuerbach: Gemälde und Zeichnungen.* Edited by Horst Vey. Munich.

Carl Philipp Fohr

Hardenberg, K., and Schilling, E. *Karl Philipp Fohr.* Freiburg-im-Breisgau, 1925.

Jensen, Jens Christian. *Carl Philipp Fohr in Heidelberg und im Neckartal: Landschaften und Bildnisse.* Edited by Georg Poensgen. 4th ed. Karlsruhe, 1968.

Exhibition catalogues

Frankfurt am Main, 1968. Städelsches Kunstinstitut. *Karl Philipp Fohr: 1795–1818.* Compiled by Hans Joachim Ziemke.

Caspar David Friedrich

Börsch-Supan, Helmut. "Caspar David Friedrich's Landscapes with Self-Portraits." *Burlington Magazine* (Sept. 1972): 620–30.

_____. *Caspar David Friedrich.* Translated by Sarah Twohig. New York, 1974.

_____. *L'opera completa di Friedrich.* Classici dell'arte, 84. Milan, 1976.

Börsch-Supan, Helmut, and Jähnig, Karl Wilhelm. *Caspar David Friedrich: Gemälde, Druckgraphik und bildmässige Zeichnungen.* Studien zur Kunst des 19. Jahrhunderts. Munich, 1973.

C. D. Friedrich, Bekenntnisse. Edited by K. K. Eberlein. Leipzig, 1924.

Caspar David Friedrich: Das gesamte graphische Werk. Afterword by Hans H. Hofstätter. Munich, 1974.

Eberlein, K. K. *Caspar David Friedrich, der Landschaftsmaler.* Leipzig, 1940.

Einem, Herbert von. *Caspar David Friedrich.* 3rd ed. Berlin, 1958.

Ettlinger, Leopold David. *Caspar David Friedrich: 1774–1840.* The Masters, 87. London, 1967.

Fiege, Gertrud. *Caspar David Friedrich in Selbstzeugnissen und Bilddokumenten.* Rowohlt's Monographien, 252. Hamburg, 1977.

Geismeier, Willi. *Caspar David Friedrich.* Leipzig, 1973.

Henz, Berthold, et al. *Bürgerliche Revolution und Romantik: Natur und Gesellschaft bei Caspar David Friedrich.* Kunstwissenschaftliche Untersuchungen des Ulmer Vereins, Verband für Kunst- und Kulturwissenschaften, 6. Giessen, 1976.

Hinz, Sigrid, ed. *Caspar David Friedrich in Briefen und Bekenntnissen.* Berlin/Munich, 1968.

Hofmann, Werner, ed. *Caspar David Friedrich und die deutsche Nachwelt: Aspekte zum Verhältnis von Mensch und Natur in der bürgerlichen Gesellschaft.* 2nd ed. Frankfurt am Main, 1974.

Jensen, Jens Christian. *C. D. Friedrich: Leben und Werk.* DuMont Kunst-Taschenbucher, 14. Cologne, 1974.

McKenna, Stephen. "Caspar David Friedrich." *Studio International* 184, no. 947 (Paris, 1972): 69–72.

Rautmann, Peter. *Caspar David Friedrich: Landschaft als Sinnbild entfalteter bürgerlicher Wirklichkeitsaneignung.* Kunstwissenschaftliche Studien, 7. Frankfurt am Main/Las Vegas, 1979.

Rosenblum, Robert. "Caspar David Friedrich and Modern Painting." *Art and Literature* 10 (Fall 1966): 134–46.

————. "Caspar David Friedrich. A Reappraisal." *Studio International* 184, no. 947 (Paris, 1972): 73–75.

Schmidz, Dr. Matthias. *Caspar David Friedrich: His Life and Work.* New York, 1940.

Schmied, Wieland. *C. D. Friedrich.* DuMont's Bibliothek grosser Maler. Cologne, 1975.

Sumowski, Werner. *Caspar David Friedrich: Studien.* Wiesbaden, 1970.

Traeger, Jörg, ed. *Caspar David Friedrich.* Translated by Gillian Turner. New York, 1976.

Wolfradt, Willi. *Caspar David Friedrich und die Landschaft der Romantik.* Berlin, 1924.

Exhibition catalogues

Dresden, 1974. Albertinum, Staatliche Gemäldegalerie Neue Meister. *Caspar David Friedrich und sein Kreis: Ausstellung im Albertinum.* Edited by Hans Joachim Neidhardt.

Hamburg, 1974. Kunsthalle. *Caspar David Friedrich: 1774–1840.* Edited by Werner Hofmann.

Kiel, 1975. Stiftung Pommern. *Caspar David Friedrich und sein Kreis.*

London, 1972. Tate Gallery. *Caspar David Friedrich 1774–1840: Romantic Landscape Painting in Dresden.* By William Vaughan, Helmut Börsch-Supan, and Hans Joachim Neidhardt.

Georg Friedrich Kersting

Leonhardi, Klaus. *G. Fr. Kersting: Bilder und Zeichnungen.* Die Silbernen Bücher, Kleine Reihe, 15. Berlin, 1939.

Vriesen, Gustav. *Die Innenraumbilder Georg Friedrich Kerstings.* Forschungen zur deutschen Kunstgeschichte, 16. Berlin, 1935.

Joseph Anton Koch

Lutterotti, Otto R. von. *Joseph Anton Koch 1768–1839.* Denkmäler der deutschen Kunst. Berlin, 1940.

Musper, Th. "Das Reiseskizzenbuch Josef Anton Koch's von einer Wanderung an den Bodensee und den Rheinfall bei Schaffhausen im Jahre 1791." *Das Bodenseebuch,* 25 (1938): 29–45.

Zeitler, Rudolf W. *Klassizismus und Utopia: Interpretationen zu Werken von David, Canova, Carstens, Thorvaldsen, Koch.* Figura, 5. Stockholm, 1954.

Exhibition catalogues

Vienna, 1968. Akademie der Bildenden Künste, Bibliothek. *Joseph Anton Koch: 1768–1839.* By Herbert Hutter and Wanda Lhotsky.

Wilhelm Leibl

Langer, Alfred. *Wilhelm Leibl.* Leipzig, 1961.

Neuhaus, Robert. *Die Bildnismalerei des Leibl-Kreises: Untersuchungen zur Geschichte und Technik der Malerei der zweiten Hälfte des 19. Jahrhunderts.* Marburg, 1953.

Waldmann, Emil. *Wilhelm Leibl: Eine Darstellung seiner Kunst, Gesamtverzeichnis seiner Gemälde.* 2nd ed., rev. Berlin, 1930.

————. *Wilhelm Leibl als Zeichner.* Munich, 1942.

Exhibition catalogues

Munich, 1974. Städtische Galerie im Lenbachhaus. *Wilhelm Leibl und sein Kreis.* Edited by Michael Petzet.

Franz von Lenbach

Behr, Hermann. *Der Malerfürst: Franz von Lenbach und seine Zeit.* Munich, 1960.

Fourcaud, L. de. "Franz von Lenbach (1836–1904)." *Revue de l'Art Ancien et Moderne,* 19 (1906): 63.

Herkomer, Hubert von. "Franz von Lenbach. An Appreciation." *International Studio* 27 (New York, 1906): 193–99.

Mehl, Sonja. *Franz von Lenbach in der Städtischen Galerie im Lenbachhaus, München.* Vol. 1. Munich, 1980.

Rosenberg, Adolf. *Lenbach.* Künstler-Monographien, 34. Bielefeld/Leipzig, 1903.

Wichmann, Siegfried. *Franz von Lenbach und seine Zeit.* Cologne, 1973.

Max Liebermann

Gesammelte Schriften von Max Liebermann. Berlin, 1922.

Hancke, Erich. *Max Liebermann: Sein Leben und seine Werke.* Berlin, 1914.

Kahn, Gustave. "Max Liebermann." *Gazette des Beaux-Arts* (Oct. 1901): 285–98.

Liebermann, Max. *Die Phantasie in der Malerei, Schriften und Reden.* Edited by Günter Busch. Frankfurt am Main, 1978.

Lütticke, A. E. "The Work of Max Liebermann." *The Studio* 15, no. 137 (1904): 203–12.

Meissner, Günther. *Max Liebermann.* Leipzig, 1974.

✓ Osborn, Max. "The Liebermann Saga: Personal Reminiscences of the Painter." *Menorah Journal* (Autumn 1947): 284–98.

✓ Werner, Alfred. "The Forgotten Art of Max Liebermann." *Art Journal* 23, no. 3 (1964): 214–21.

Exhibition catalogues

✓ Berlin, 1979. Nationalgalerie, Staatlicher Museen Preussischer Kulturbesitz. *Max Liebermann in seiner Zeit.* By Sigrid Achenbach and Matthias Eberle.

The Hague, 1980. Haags Gemeentemuseum. *Max Liebermann en Holland.* By John Sillevis, Nini Jonker, and Margreet Mulder.

Hans von Marées

Degenhart, Bernhard. *Hans von Marées: Die Fresken in Neapel.* Munich, 1958.

————. *Marées Zeichnungen.* 2nd ed. Berlin, 1963.

Einem, Herbert von. *Hans von Marées (Vorträge).* Bayerische Akademie der Wissenschaften, Munich. Philosophisch-historische Klasse. Sitzungsberichte, Jahrgang 1967, 4. Munich, 1967.

Ettlinger, L. D. "Hans von Marées and the Academic Tradition." *Yale University Art Gallery Bulletin* (Oct. 1972): 67–84.

Liebmann, Kurt. *Hans von Marées.* Dresden, 1972.

Meier-Graefe, Julius. *Hans von Marées: Sein Leben und sein Werk.* 3 vols. Munich/Leipzig, 1909-10.

Neumeyer, A. "Hans von Marées and the Classical Doctrine in the Nineteenth Century." *Art Bulletin* (Sept. 1938): 291–311.

Schiff, Gert. "Hans von Marées and His Place in Modern Painting." *Yale University Art Gallery Bulletin* (Oct. 1972): 85–102.

Adolph von Menzel

Ebertshauser, Heide. *Adolf von Menzel: Das graphische Werk.* Foreword by Jens Christian Jensen. Essay by Max Liebermann. Munich, 1976.

Forster-Hahn, Françoise. "Adolph Menzel's 'Daguerreotypical' Image of Frederick the Great: A Liberal Bourgeois Interpretation of German History." *Art Bulletin* (June 1977): 242–61.

Hütt, Wolfgang. *Adolf Menzel.* Vienna, 1965.

Kaiser, Konrad. *Adolph Menzel: Der Maler.* Stuttgart, 1965.

Menzel. Introduction by Konrad Kaiser. Translated by Thomas Bourke. New York/Munich, 1975.

Tschudi, Hugo von, ed. *Adolph von Menzel: Abbildungen seiner Gemälde und Studien.* Munich, 1905.

Weinhold, Renate. *Menzel Bibliographie.* Veröffentlichung der Deutschen Akademie der Künste, Berlin. Leipzig, 1959.

————. "Menzel und die Eisenbahn." *Wissenschaftliche Zeitschrift der Karl-Marx-Universität, Leipzig,* vol. 5, no. 2, 1955–56.

Wirth, Irmgard. *Mit Adolf Menzel in Berlin.* Bilder aus deutscher Vergangenheit, 25/26. Munich, 1965.

————. *Mit Menzel in Bayern und Österreich.* Bilder aus deutscher Vergangenheit, 34. Munich, 1974.

Exhibition catalogues

Berlin, 1955. Nationalgalerie, Staatliche Museen Preussischer Kulturbesitz. *Adolf Menzel. Aus Anlass seines 50. Todestages.*

Essen, 1977. Museum Folkwang. *Adolf von Menzel Graphik.* By Klaus Ertz.

✓ London, 1965. Arts Council Gallery. *Drawings and Watercolours by Adolf Menzel 1815–1905.* Arts Council of Great Britain.

Ferdinand Olivier

Grote, Ludwig. *Die Brüder Olivier und die deutsche Romantik.* Forschungen zur Deutschen Kunstgeschichte, 31. Berlin, 1938.

Novotny, Fritz. *Ferdinand Oliviers Landschaftszeichnungen von Wien und Umgebung.* Graz, 1971.

Schwarz, Heinrich. *Salzburg und das Salzkammergut: Eine künstlerische Entdeckung der Stadt und der Landschaft in Bildern des 19. Jahrhunderts.* 4th ed. Salzburg, 1977.

Johann Friedrich Overbeck

Atkinson, J. Beavington. *Overbeck.* Illustrated Biographies of the Great Artists. New York/London, 1882.

Heise, Carl Georg. *Overbeck und sein Kreis.* Munich, 1928.

Howitt, Margret. *Friedrich Overbeck. Sein Leben und Schaffen: Nach seinen Briefen und andren Documenten des handschriftlichen Nachlasses.* Edited by Franz Binder. 2 vols. Freiburg im Breisgau, 1886. Reprint: Bern, 1971.

Jensen, Jens Christian. *Friedrich Overbeck: Die Werke im Behnhaus.* Lübecker Museumshefte, 4. Lübeck, 1963.

————. *Die Zeichnungen Overbecks in der Lübecker Graphiksammlung.* Lübecker Museumshefte, 8. Lübeck, 1969.

Mandolini, G. B. *Brevi notizie intorno alla vita e alle opere di Giovanni Federico Overbeck.* Naples, 1872.

Exhibitions catalogues

Lübeck, 1926. Behn-Haus. *Overbeck und sein Kreis.*

Franz Pforr

Jensen, Jens Christian. "Gedenkblatt für den Maler Franz Pforr, den Freund Friedrich Overbecks." *Der Wagen: Ein Lübeckisches Jahrbuch* (1963): 83–92.

Lehr, Fritz Herbert. *Die Blütezeit romantischer Bildkunst: Franz Pforr, der Meister des Lukasbundes.* Marburg-an-der-Lahn, 1924.

Carl Rottmann

Bierhaus-Rödiger, Erika, et al. *Carl Rottmann 1797–1850: Monographie und kritischer Werkkatalog.* Munich, 1978.

Decker, Hugo. *Carl Rottmann.* Berlin, 1957.

Philipp Otto Runge

Bisanz, Rudolf M. *German Romanticism and Philipp Otto Runge: A Study in Nineteenth-Century Art Theory and Iconography.* DeKalb, Ill., 1970.

Feilchenfeldt, Konrad, ed. *Clemens Brentano—Philipp Otto Runge, Briefwechsel.* Insel Bücherei, 994. Frankfurt am Main, 1974.

Isermeyer, Christian Adolf. *Philipp Otto Runge.* Berlin, 1940.

Jensen, Jens Christian. *Philipp Otto Runge: Leben und Werk.* DuMont Kunst-Taschenbücher. Cologne, 1977.

Kallienke, Gerhard S. *Das Verhältnis von Goethe und Runge im Zusammenhang mit Goethes Auseinandersetzung mit der Frühromantik.* Hamburg, 1973.

Maltzahn, Hellmuth Freiherr von, ed. *Philipp Otto Runges Briefwechsel mit Johann Wolfgang von Goethe.* Schriften der Goethegesellschaft, 51. Weimar, 1940.

Matile, Heinz. *Die Farbenlehre Philipp Otto Runges: Ein Beitrag zur Geschichte der Künstlerfarbenlehre.* Berner Schriften zur Kunst, 13. Bern, 1973.

Philipp Otto Runge: Briefe in der Urfassung. Edited by Karl Friedrich Degner. Bekenntnisse deutscher Kunst, 1. Berlin, 1940.

Philipp Otto Runge: Hinterlassene Schriften. Edited by Johann Daniel Runge. 2 vols. Göttingen, 1965.

Privat, Karl. *Philipp Otto Runge: Sein Leben in Selbstzeugnissen, Briefen und Berichten.* Berlin, 1942.

Simson, Otto Georg von. "Philipp Otto Runge and the Mythology of Landscape." *Art Bulletin* (Dec. 1942): 336–50.

Syamken, Georg. "Die 'Tagezeiten' von Philipp Otto Runge und 'The Book of Job' von William Blake." *Jahrbuch der Hamburger Kunstsammlungen* 20 (1975): 61–9.

Traeger, Jörg. *Philipp Otto Runge und sein Werk: Monographie und kritischer Katalog.* Studien zur Kunst des 19. Jahrhunderts. Special volume. Munich, 1975.

———. *Philipp Otto Runge oder die Geburt einer neuen Kunst.* Munich, 1977.

Exhibition catalogues

Hamburg, 1977. Kunsthalle. *Runge in seiner Zeit.* Kunst um 1800, edited by Werner Hofmann. Munich.

Wilhelm von Schadow

Exhibition catalogues

Düsseldorf, 1962. Kunsthalle. *Friedrich Wilhelm von Schadow 1788–1862. Gedächtnisausstellung aus Anlass seines 100. Todesjahres.*

Karl Friedrich Schinkel

Akademie des Bauwesens. *Karl Friedrich Schinkel: Lebenswerk.* Vol. 1. Berlin, 1939.

Koch, Georg Friedrich. "Schinkels architektonische Entwürfe im gotischen Stil 1810–1815." *Zeitschrift für Kunstgeschichte,* 32, nos. 3/4 (1969): 270–75.

Knopp, Norbert. "Schinkels Idee einer Stilsynthese."

In *Beiträge zum Problem des Stilpluralismus,* pp. 245–54. Studien zur Kunst des neunzehnten Jahrhunderts, 38, edited by Werner Hager and Norbert Knopp. Munich, 1977.

Pundt, Hermann G. *Schinkel's Berlin: A Study of Environmental Planning.* Cambridge, Mass., 1972.

Rave, Paul Ortwin. *Karl Friedrich Schinkel.* Deutsche Lande, Deutsche Kunst. Munich, 1953.

Sydow, Eckart von. "Karl Friedrich Schinkel als Landschaftsmaler." *Monatshefte für Kunstwissenschaft* 14, vol. 2 (1921): 262–363.

Wolzogen, Alfred Freiherr von, ed. *Aus Schinkels Nachlass: Reisetagebücher, Briefe und Aphorismen . . . mit einem Verzeichniss sämtlicher Werke Schinkels versehen.* 4 vols. Berlin, 1862–64.

Exhibition catalogues

Berlin, 1961. Nationalgalerie. *Karl Friedrich Schinkel 1781–1841.*

Julius Schnorr von Carolsfeld

Holland, Dr. H. *The Nibelungen-Saga as Displayed in the Fresco Paintings of Julius Schnorr von Carolsfled in the Royal Palace at Munich. Photographed for His Majesty King Louis II of Bavaria by Jos. Albert.* Munich, 1868(?).

Hutter, Herbert, and Lhotsky, Wanda. *Julius Schnorr von Carolsfeld: Römisches Porträtbuch im Kupferstichkabinett der Akademie der Bildenden Künste in Wien.* Bildhefte der Akademie der Bildenden Künste in Wien, 7. Vienna, 1973.

Nowold, Inken. *Die Nibelungenfresken von Julius Schnorr von Carolsfeld im Königsbau der Münchner Residenz, 1827–1867.* Schriften der Kunsthalle zu Kiel, 3, edited by Jens Christian Jensen. Kiel, 1978.

Schnorr von Carolsfeld, Julius. *Briefe aus Italien, geschrieben in den Jahren 1817 bis 1827.* Gotha, 1886.

———. *Künstlerische Wege und Ziele.* Schriftstücke aus der Feder des Malers Julius Schnorr von Carolsfeld. Edited by F. Schnorr von Carolsfeld. Leipzig, 1909.

Singer, Hans Wolfgang. *Julius Schnorr von Carolsfeld.* Künstlermonographien, 103. Bielefeld/Leipzig, 1911.

Exhibition catalogues

East Berlin, 1974. Staatliche Museen zu Berlin, Kupferstichkabinett und Sammlungen der Zeichnungen. *Julius Schnorr von Carolsfeld 1794–1872: Aus dem zeichnerischen Werk: Blätter aus Berlin, Dresden, Leipzig, und Weimar.* By Gottfried Riemann and Ursula Riemann-Reyher.

Moritz von Schwind

Eggert-Windegg, Walther, ed. *Künstlers Erdwallen: Briefe von Moritz von Schwind.* Munich, 1912.

Haack, Friedrich. *Moritz von Schwind.* Bielefeld/Leipzig, 1898.

Hoffmann, Helga. *Die Fresken Moritz von Schwinds auf der Wartburg.* Berlin, 1976.

Hofner, Georg Michael. *Ikonographische Studien zum Werk Moritz von Schwinds.* Munich, 1977.

Kalkschmidt, Eugen. *Moritz von Schwind: Der Mann und das Werk.* Munich, 1943.

Löffler, Karl. *Ludwig Richter, Moritz von Schwind und Carl Spitzweg.* Leipzig, 1931.

Pommeranz-Liedtke, Gerhard. *Moritz von Schwind: Maler und Poet.* Vienna/Munich, 1974.

Weigmann, Otto. *Moritz von Schwind: Des Meisters Werk in 1265 Abbildungen.* Klassiker der Kunst in Gesamtausgaben, 9. Stuttgart/Leipzig, 1906.

Max Slevogt

Imiela, Hans-Jürgen. *Max Slevogt: Eine Monographie.* Karlsruhe, 1968.

Sievers, Johannes, and Waldmann, Emil. *Max Slevogt: Das druckgraphische Werk 1890–1914.* Edited by Hans-Jürgen Imiela. Heidelberg/Berlin, 1962.

Exhibition catalogues

Bremen, 1968. Kunsthalle. *Max Slevogt und seine Zeit: Gemälde, Handzeichnungen, Aquarelle, Druckgraphik.*

Kaiserslautern, 1968. Pfalzgalerie. *Max Slevogt: Religiöse Werke: Gemälde, Aquarelle, Graphiken 1887–1932.*

Kaiserslautern, 1968. Pfalzgalerie. *Max Slevogt: Zum 100. Geburtstag.* By Wilhelm Weber.

Johann Sperl

Diem, Eugen. *Johann Sperl: Ein Meister aus dem Leiblkreis.* Munich, 1955.

Exhibition catalogues

Munich, 1974. Städtische Galerie im Lenbachhaus. *Wilhelm Leibl und sein Kreis.* Edited by Michael Petzet.

Carl Spitzweg

Jensen, Jens Christian. *Carl Spitzweg.* Cologne, 1971.

Löffler, Karl. *Ludwig Richter, Moritz von Schwind und Carl Spitzweg.* Leipzig, 1931.

Roennefahrt, Günther. *Carl Spitzweg: Beschreibendes Verzeichnis seiner Gemälde, Ölstudien und Aquarelle.* Munich, 1960.

Exhibition catalogues

Kiel, 1972. Art Gallery. *Carl Spitzweg und sein Müchener Malerkreis: Gemälde aus der Sammlung Georg Schäfer, Schweinfurt.*

Munich, 1968. Haus der Kunst. *Carl Spitzweg und sein Freundeskreis.* By Siegfried Wichmann.

Hans Thoma

Lauts, Jan. *Hans Thoma.* Freiburg, 1963.

Thode, Henry, ed. *Thoma: Des Meisters Gemälde in 874 Abbildungen.* Klassiker der Kunst in Gesamtausgaben, 15. Stuttgart/Leipzig, 1909.

Exhibition catalogues

Karlsruhe, 1967. Badische Kunsthalle. *Hans Thoma: Handzeichnungen aus der Staatlichen Kunsthalle, Karlsruhe.*

Karlsruhe, 1974. Staattliche Kunsthalle. *Hans Thoma: Gedächtnisausstellung zum 50. Todestag.* By Werner Zimmermann.

Wilhelm Trübner

Corinth, Lovis. "Wilhelm Trübner." *Kunst und Künstler* 11 (1913): 452–63.

Rohrandt, Klaus. "Wilhelm Trübner (1851–1917). Kritischer und beschreibender Katalog sämtlicher Gemälde, Zeichnungen und Druckgraphik, Biographie und Studien zum Werk." 2 vols. Ph.D. diss., Universität, Kiel, 1972.

Trübner, Wilhelm. *Personalien und Prinzipien.* 3rd ed. Berlin, 1918.

Exhibition catalogues

Karlsruhe, 1951. Staatliche Kunsthalle. *Wilhelm Trübner und sein Kreis.*

V.

Berlin, 1977. Nationalgalerie, Staatliche Museen Preussischer Kulturbesitz. *Verzeichnis der Gemälde und Skulpturen des 19. Jahrhunderts.* Compiled by Barbara

Dieterich, Peter Krieger, and Elisabeth Krimmel-Decker.

Berlin, 1980. Nationalgalerie, Staatliche Museen Preussischer Kulturbesitz. *Bilder vom Menschen in der Kunst des Abendlandes.*

Bremen, 1973. Kunsthalle. *Katalog der Gemälde des 19. und 20. Jahrhunderts.* 2 vols. By Gerhard Gerkens and Ursula Heidrich.

Coburg, 1970. Kunstsammlungen der Veste Coburg. *Coburger Landesstiftung, ausgewählte Handzeichnungen von 100 Künstlern aus fünf Jahrhunderten 15.–19. Jahrhunderten. Aus dem Kupferstichkabinett der Veste Coburg.*

Cologne, 1964. Wallraf-Richartz-Museum. *Katalog der Gemälde des 19. Jahrhunderts.* By Rolf Andree. Kataloge des Wallraf-Richartz-Museums, 1, edited by Gert von der Osten and Horst Keller.

Cologne, 1967. Wallraf-Richartz-Museum. *Ausgewählte Handzeichnungen und Aquarelle im Wallraf-Richartz-Museum.*

Düsseldorf, 1968. Kunstmuseum. *Die Gemälde des 19. Jahrhunderts, mit Ausnahme der Düsseldorfer Schule.* By Rolf Andree. Kataloge des Kunstmuseums Düsseldorf 4; Malerei 1.

Düsseldorf, 1969. Kunstmuseum. *Die Düsseldorfer Malerschule.* By Irene Markowitz. Kataloge des Kunstmuseums Düsseldorf 4; Malerei 2.

Essen, 1956. Museum Folkwang. *Deutsche Zeichnungen des Museums Folkwang.*

Essen, 1971. Museum Folkwang. *Katalog der Gemälde des 19. Jahrhunderts.* By Jutta Held.

Frankfurt am Main, 1972. Städelsches Kunstinstitut. *Die Gemälde des 19. Jahrhunderts.* By Hans Joachim Ziemke. 2 vols. Kataloge der Gemälde im Städelschen Kunstinstitut, Frankfurt am Main, 1.

Hamburg, 1969. Kunsthalle. *Katalog der Meister des 19. Jahrhunderts in der Hamburger Kunsthalle.* By Eva Maria Krafft and Carl-Wolfgang Schümann.

Hamburg, 1969. Kunsthalle. *Katalog der Meister des 20. Jahrhunderts in der Hamburger Kunsthalle.* By Helga Hofmann and Janni Müller-Hauck.

Hannover, 1969. Niedersächsische Landesgalerie Hannover. *Niedersächsische Landesgalerie Hannover.* By Harald Seiler. Cologne.

Hannover, 1973. Niedersächsische Landesgalerie Hannover. *Die Gemälde des neunzehnten und zwanzigsten Jahrhunderts in der Niedersächsischen Landesgalerie Hannover.* By Ludwig Schreiner. 2 vols. Kataloge der Niedersächsischen Landesgalerie Hannover, 3, edited by Harald Seiler. Munich.

Kaiserslautern, 1975. Pfalzgalerie des Bezirksverbands. *Katalog der Gemälde und Plastiken des 19. und 20. Jahrhunderts.* By William Weber et al.

Karlsruhe, 1964. Staatliche Kunsthalle. *Deutsche Meister 1800–1850 aus der Staatlichen Kunsthalle Karlsruhe.* By Jan Lauts.

Karlsruhe, 1971. Staatliche Kunsthalle. *Katalog Neuere Meister, 19. und 20. Jahrhundert.* By Jan Lauts and Werner Zimmermann. 2 vols.

Karlsruhe, 1974. Badische Kunsthalle. *Deutscher Meister 1800–1930 aus der Staatlichen Kunsthalle, Karlsruhe.* By Werner Zimmermann. 2nd corrected and expanded ed.

Karlsruhe, 1978. Kupferstichkabinett, Badische Kunsthalle. *Die deutschen Zeichnungen des 19. Jahrhunderts.* Edited by Rudolf Theilmann and Edith Ammann. 2 vols.

Kiel, 1971. Gemäldegalerie der Stiftung Pommern. *Verzeichnis der ausgestellten Gemälde.*

Kiel, 1973. Kunsthalle. *Katalog der Gemälde.* By Johann Schlick.

Munich, 1967. Bayerische Staatsgemäldesammlungen, Neue Pinakothek and Neue Staatsgalerie. *Meisterwerke der Deutschen Malerei des 19. Jahrhunderts. Ausgestellte Werke, 2.*

Munich, 1969. Bayerische Staatsgemäldesammlungen. *Schack-Galerie.* By Eberhard Ruhmer, with Rosel Gollek, Christoph Heilmann, Hermann Kuhn, and Regina Löwe. 2 vols. Bayerische Staatsgemäldesammlungen Gemäldekataloge 2.

Munich, 1977. Bayerische Staatsgemäldesammlungen, Neue Pinakothek. *Malerei der Gründerzeit.* By Horst Ludwig. Bayerische Staatsgemäldesammlungen, Neue Pinakothek, Gemäldekataloge 6.

Münster, 1975. Westfälisches Landesmuseum für Kunst und Kulturgeschichte. *Katalog der Gemälde des 19. Jahrhunderts.* By Hildegaard Westoff-Krummacher. Kataloge des Westfälischen Landesmuseums für Kunst und Kulturgeschichte im Auftrage des Landschaftsverbandes Westfalen-Lippe, edited by Paul Pieper.

Stransky Collection: Modern Paintings by German and Austrian Masters. Collected and catalogued by Josef Stransky. New York, 1916.

Stuttgart, 1968. Staatsgalerie. *Katalog der Staatsgalerie Stuttgart: Neue Meister.* By Peter Beye and Kurt Löcher.

Stuttgart, 1976. Staatsgalerie. *Die Zeichnungen und Aquarelle im 19. Jahrhunderts in der Graphischen Sammlung der Staatsgalerie Stuttgart.*

Wiesbaden, 1967. Museum Wiesbaden. *Gemäldegalerie, Katalog.*

Wuppertal, 1974. Von der Heydt-Museum. *Katalog der Gemälde des 19. Jahrhunderts.* By Uta Laxner-Gerlach.

VI.

Bibliographie zur Kunstgeschichte Österreichs. Kunsthistorisches Institut der Universität Wien, Lehrkanzel für Österreichische Kunstgeschichte. Vienna, 1966–.

Börsch-Supan, Helmut. "Die Erwerbungstätigkeit der Verwaltung der Staatlichen Schlösser und Gärten in Berlin seit 1945." In *Schloss Charlottenburg. Berlin, Preussen, Festschrift für Margarete Kühn.* Munich/Berlin, 1975.

Leitzmann, Hilda. *Bibliographie zur Kunstgeschichte des 19. Jahrhunderts: Publikationen der Jahre 1940–1966.* Studien zur Kunst des 19. Jahrhunderts, 4. Munich, 1968.

Prause, Marianne, comp. *Die Kataloge der Dresdner Akademie: Ausstellungen 1801–1850.* 2 vols. Quellen und Schriften zur bildenden Kunst, 5. Berlin, 1975.

Schmitt, Otto, ed. *Reallexikon zur deutschen Kunstgeschichte.* Stuttgart, 1937–.

Schriften zur Kunstgeschichte. Deutsche Akademie der Wissenschaft zu Berlin, Arbeitsstelle für Kunstgeschichte. East Berlin, 1960–.

Schrifttum zur deutschen Kunst. Deutscher Verein für Kunstwissenschaft, Berlin. Berlin, 1934–.

Schrifttum zur deutsch-baltischen Kunst. Compiled by Hans Peter Kügler. Berlin, 1939.

Zeitschrift für Kunstgeschichte: Bibliographie des Jahres. Munich, 1949–.